ЦV) 30 MAY 2018	

Richmond upon Thames Libraries

Renew online at www.richmond.gov.uk/libraries

WILD RIDE TO FREEDOM

William McLellan

London Borough of Richmond Upon Thames		
RTHAW		
90710 000 342 957		
Askews & Holts		
B SMA	£8.99	
	9781910400494	

First published in Great Britain in 2015 by Old Street Publishing,

This revised edition published in 2018 by Old Street Publishing

Yowlestone House, Tiverton, Devon EX16 8LN

www.oldstreetpublishing.co.uk

ISBN 978-1-910400-49-4

Copyright in the text and illustrations © William McLellan 2018

The right of William McLellan to be identified as the author of this work has been asserted by him in accordance with the Copyright, Designs and Patents Act 1988.

All rights reserved. No part of this publication may be reproduced, stored in or introduced into a retrieval system, or transmitted, in any form, or by any means (electronic, mechanical, photocopying, recording or otherwise) without the prior written permission of the publisher.

10987654321

A CIP catalogue record for this title is available from the British Library.

Typeset by JaM

Printed and bound by CPI Group (UK) Ltd, Croydon, CR0 4YY

For my sons Thomas & Joshua

This is pretty much exactly what happened. A few things have been left out, but nothing's been added.

BROKEN

Hey, that's no way to say goodbye Leonard Cohen

Joined the long line of dark heads, shuffling down a zigzag stairway into the gallery below. A guard yelled and we stopped in the shadows of a barn-sized door. The next thing I knew, my eyes were slits in the blinding sunlight.

Ragged groups of prisoners stood around a wide yard in the shade of a high, yellow wall. It looked like the siege of the Alamo. A cloaked guard with a gun slung over his shoulder patrolled the crumbling parapet. My legs gave way and I sank to my heels on the edge of the yard. I simply couldn't stand. It wasn't just the pain in my back. I couldn't cope with being trapped in such an horrendous place.

There must have been a hundred men in the yard, but I didn't see any of them. My whole body was numb. Not just from the beating. I'd gone over my arrest so many times, my brain had shut down. Only two things were clear: they weren't going let me see a doctor and they weren't going to let me out.

The dusty yard felt warm as I eased myself into a sitting position. I scraped up a handful of gravel and mindlessly threw each tiny pebble at the blurred patch of ground between my feet, keeping my whole body still, moving only my hand to avoid the pain. My eyes were locked in tunnel vision as chips of stone bounced off rocks embedded in the dry, sandy earth. How long this went on for I have no idea. Time passed over me like water over a riverbed.

A bell rang and we were herded back to the stone and bars of the cells. I immediately crashed out on the bunk, then a bugle blew and we were back out in the yard. I slumped to the ground and began throwing again. Stone after stone, handful after handful, until my scuffed fingernails had scraped a deep groove in the earth beside me. I had no idea what day or time it was. Hours passed before I summoned the strength to find out.

I eased back the sleeve of my Levi jacket. The bruising on my back went all the way down to my wrists, still raw from the bone-tight handcuffs. My neck refused to turn as I held the cracked face of my watch to my ear. Nothing. All it told was the time of the beating. Everything seemed to be broken. Nothing made sense anymore. The plan had been crazy. It was no wonder I'd been arrested – although that wasn't what was confusing me. It was impossible to get my head round the fact that trying to get into art school had got me into a Spanish prison. But it had.

It had nearly got me killed. I blanked out the memory of my stupid attempt to escape. There was no point in going over that again. I had to go further back. Back to when it all started.

I'd always wanted to be an artist. I drew all the time. All

through my lessons, right up until I left school. It didn't get me anywhere. My only academic achievement was a history of truancy so they wouldn't have let me into art college, and anyway I was too young.

It didn't stop me drawing. I'd draw at weekends and after work. I drew when I was at work, tracing profiles in the condensation on the windows I was meant to be painting, waving my outspread fingers across the pane to make Renaissance hair. That impressed my workmates, but they laughed when I told them I wanted to be an artist. It didn't stop me trying. I even took my drawings down to the art college. It wasn't a proper interview – I just turned up, with my artwork tied between two sides of a cardboard box.

I stopped throwing stones to work out how old I had been back then. It was the year Jumpin' Jack Flash came out. That was 1968, so I must have been 18. I started throwing again, squinting my eyes against the bright Spanish sun. I remembered watching my shadow rippling up the stone steps of Leeds College of Art as I weaved through the trendy students. They could tell by the spots of emulsion on my trainers that I was a painter and decorator trying to look like an artist. My pink chiffon scarf floated over the wide lapels of the blue granny coat that I'd cut down to make into a jacket. The stitching was lumpy and the blue velvet inserts I'd sewn into my jeans were as frayed as my nerves.

The principal leafed through my drawings on his desk, carefully picking up each corner as though the paper might fall apart. His dark hair didn't quite reach his collar and he wore a soft, black leather jacket with a paisley tie and jeans. It made him look fake – halfway between a hippy and a straight.

His hand stopped over a portrait of my brother's motorcycle mates. I'd drawn them with pen and ink, then used a wet brush to bleed the outline for shading. He looked up at me through a straggly fringe:

'I presume you have Art O level. What other qualifications do you have?'

I'd been dreading that question and I said something like: 'Er... none. I left school at fifteen and just started painting.' He looked vaguely interested. 'Oh? What did you paint?' I said, 'Houses, mainly,' and he smiled.

At least he ploughed through the rest of the pictures. Then he leant back in his leather chair and said, 'If it was up to me, I'd accept you. Not just on the strength of your work' – he waved his arm at my pile of drawings – 'but on the sheer volume of it...' I knew what was coming next and started to gather up my stuff. 'However, there's little point in offering you a place. Without qualifications, Leeds Council won't give you a grant.'

There was an embarrassing silence as I struggled to reassemble the cardboard and string. In the end I just crammed it all together so I could get out before the rising blush hit my cheeks.

I scraped up another handful of stones and started throwing again. The slow, rhythmic action helped me to think. Three years had passed before I'd worked up enough courage and drawings to apply again, so that would make it 1971. This time I'd borrowed a proper portfolio and arranged a real interview at David Hockney's old college in Bradford. He'd got in without qualifications, so I was hoping they'd do the same for me.

I didn't stay around long enough to find out. Straight after the interview, Hanna and I split up. We'd been living together for two years, so the fallout was heavy. She spent most nights crying outside my flat with two family-size jars of aspirin stuffed inside her handbag. It terrified the both of us. What made it worse was Daisy Dave had gone to Morocco, so I had no one to talk to. Daisy and I had been working for Leeds Parks Department and we'd formed an art movement called the Avant Gardeners. It was meant to be a joke, but it wasn't funny. After five years of painting, we hadn't sold a thing.

Leeds had nothing to hold me anymore, so I packed in my job, grabbed my guitar and hitch-hiked down to London.

I got a job in a supermarket and my brother let me have a tiny room in his Kilburn flat. The canary-coloured bedspread and yellow woodchip wallpaper made it look like a box made out of scrambled eggs. A couple of weeks after I arrived, Jeremy shoved an impressive letter under the door. My fingers trembled as I peeled open the embossed envelope. When I saw the crest of Bradford School of Art, my eyes could hardly focus. But when I found they'd offered me a place, my whole world turned around. I'd been waiting all my life for that moment. The rush only lasted until the next line: without qualifications Bradford Council wouldn't give me a grant. There was no way I could save enough money to get through a term, never mind three years. I went back to the nearest thing I could find to being an artist – hanging my pictures on the railings at Hyde Park with the rest of the no-hopers.

I always sprinted up the staircase of Saint Lawrence Mansions when I got home after a day of stacking shelves. About five months after moving to London, I hit an invisible wall on the top landing. It was the smell of old chip fat mixed with the Arabian tang of burnt hashish. I knew immediately that Daisy Dave was back from Morocco.

Daisy was leaning back on the double bed that filled my miniature room. The desert rays had bleached his denim

shirt and tanned him into a bronzed sun god. I couldn't help laughing. His blond hair looked like it'd been zapped by a Van de Graaf generator. Daisy just sat there being Daisy Dave Stanhope, holding one of his desert boots as an ash tray. He tapped his joint into it and said with a coy smile:

'Have you missed me?'

Daisy bounced as I dropped onto the bed.

'Desperately. What happened to your hair? You look like Florence of Arabia.'

He nodded at my figure drawings, stuck onto the bobbly yellow wallpaper.

'Have you sold anything?'

'Nope, nothing. Got offered a place at Bradford, though.'

Daisy stretched to pass me the joint. Even the hairs on his arm were golden. 'So what are you doing down here?'

I took a long drag and held it in.

'They wouldn't give me a grant.'

'Bastards.' Daisy reached to the floor and pulled up a Moroccan leather bag. He opened the decorated flap and a colourful avalanche of drawings slid onto the bed.

Smoke drifted from my open mouth as I stared at the vibrant tones of the oil pastels. Bold, simple figures with dark purple shadows pushed themselves out of the sugar paper like bas-relief sculptures. I tried to keep the jealousy from my voice.

'Wow... they've got a Fauvist feel, like Vlaminck – or even Matisse...'

'Yeah! I'd been looking a lot at Derain. The light's bouncing around all over the place. You never know what ambient colour will be filling the shadows.'

I studied a stylised head of a young man. The thing was, Daisy could really paint. We'd both left school at fifteen, but even then he already had what all artists crave: a style of his own. The bed rocked with his enthusiasm.

'Everything's different out there – the architecture, the clothes, the faces. The kasbah's incredible. You can live on bugger-all and draw all day long.'

I was still in shock from the portraits. 'Who are all these people?'

Daisy plucked the joint from my numb fingers. 'Lush hippies. The place is full of them – and they're all loaded.'

That got me going. 'Did you flog any pictures?'

'Nah. All they want to buy is acid.'

I picked up another drawing. Just looking at the colours made you feel stoned. 'They must be tripped out of their skulls.'

Daisy shook his head. 'You can't get the stuff out there. They don't have the labs to make LSD.' He started putting his pictures away. 'You should try painting in Morocco. It's not going to happen for you here.'

I pictured myself with a suntan in a floppy white shirt, standing next to an easel. The image quickly faded.

'Yeah, but I couldn't get the money together.'

Daisy was still staring at me. 'What if you had something to sell?'

I sat up quickly when I realised he didn't mean paintings. Daisy had obviously worked it all out. 'You could live by selling one tab a week. Fifty would keep you painting for a year.'

The image of me in a white shirt came back, stronger this time.

'We'd have to save up. My mate, Clive, can score the acid. Then we'd need art equipment: brushes, canvas, pens, paper...' Daisy knocked the ash from his boot into the bin. 'How much are you getting at work?' 'Twelve quid a week. Fourteen if I do Saturdays.'

He pulled his shoelace tight and gave me a smug grin. 'I'm getting seventeen at the zoo.'

I laughed. 'The zoo?'

'Yeah. I got a gardening job at London Zoo.' Daisy stood up and slung the Moroccan bag over his shoulder. 'And if you're really nice to me, I might get you in there as well.'

'Far out! It'll be the Avant Gardeners all over again!'

2

BAD TRIP

Sunshine came softly through my window today Could've tripped out easy but I've changed my ways Donovan

A heat wave had hit London. It turned the zoo into a jungle in the early morning. The howler monkeys' calls echoed in the treetops, high above the empty-belly roar of the lions. I liked it. The musty smell of the animals reminded me of the farm I grew up on. I stabbed up sweet wrappers along the winding path between the camels and the sad old onager. He was really just an exotic donkey who kept trying to shag the wooden post they'd hammered into his yard. I felt sorry for him. You'd have thought they could afford to buy him a mate.

There was never any rubbish around the wolf enclosure, but I always jumped its low outer railing and headed towards the shrubs. The pack was waiting behind their chain-link fence for our morning ritual. First they pushed their wet noses through the wire and rubbed them onto mine. Then they pressed against the fence, their rough coats bristling through the gaps so I could scratch their backs. The one I'd named Wily Coyote always turned in a sly circle so my fingers worked their way towards his tail. Suddenly he whipped round and snapped at my hand like a steel trap.

'Yah! Missed me you bastard!'

Eager eyes watched me pull their favourite chewed-up stick from its hiding place under a bush. They attacked it as soon as I shoved it through the wire. Angry snarls bubbled through their teeth as we pulled each other backwards and forwards till they yanked me into the fence. Then we ran flatout around the perimeter, as though they were chasing me through a forest. I yodelled like Tarzan and tried to wrongfoot them, but they were on to me in a second. In a real hunt, I wouldn't have stood a chance.

London Zoo had Chi Chi the Panda, Guy the Gorilla and Goldie the Eagle. Everybody loved them, but it didn't take me long to suss out that most of the animals were neurotic. The big cats just paced up and down all day, but at least they had room to move. There was this big, beautiful eagle, crammed into a round cage. It was just wide enough for him to hold out his wings so he didn't bake in the blazing sun. He looked like he was being crucified, and it was sad to think that this was the nearest he'd ever get to flying. Close up, his eyes were incredible. He could see the swallows gliding around in the cool upper air, and you knew he longed to be up there with them. I felt the same. It was a bad scene and I couldn't wait to get away.

After four months of mowing and pruning, Daisy and I could afford to buy enough art supplies to last us a year. My gear looked beautiful spread out on my bright yellow bedspread. The black Rapidograph pens had coloured bands around the tops and shone like magicians' wands. Their nibs were amazing – like hypodermic syringes with fine wires running through the needles. There was a heavy weight attached to the wire that slid when you rocked the pen, cleaning the nib with a satisfying click.

I placed the Rotring inks next to the long tin of Derwent crayons, then laid my pencils and brushes alongside the big Bushey sketchbook. The black book felt heavy as a Bible as I opened it up. A title flashed into my mind, so I unscrewed my 0.5 Rapidograph and wrote it out:

The adventures began sooner than I'd expected. Jeremy was picking the kids up from school, when Clive turned up, fresh from a visit to his dealer. I quickly ushered him into my tiny yellow room.

'So did you get the stuff okay?'

'Yep. No problemo.' Clive snapped open the poppers of his Belstaff pocket and pulled out a looped strip of Sellotape with tiny, pale pink tablets sandwiched between the layers.

'They're all there. A hundred – and he gave us a couple to sample.'

That threw me. I'd let on I was something of a drug-head. I'd smoked a bit of weed and stuff, but my last acid trip had been so bad I'd vowed never to touch it again. Ever. I counted out his cash, desperately trying to think of a way out. But Clive popped a tab and pushed one towards me on the end of his finger.

'Here you go.'

It didn't take long before my mouth started to get dry and metallic as the acid began to take effect. For some reason I went into the hall, then couldn't remember why I was there. I turned back and opened my bedroom door to a blaze of yellow light. The scrambled-egg walls were breathing in and out. I could hear them. A wave of my hand sent ripples of colour floating through the air. They looked amazing as they bounced off the wallpaper, but all I could think was, *Oh God*, *here we go again...*

My legs swayed like circus stilts as I entered the room. I sank into the bed next to Clive and his huge head freaked me out as it swung in my direction.

'Hooowsssittt goooinggg, maaan?'

I couldn't answer. His face filled my vision like a landscape of flesh. Bloodshot veins ran through the cracked pores below his mountainous nose and his bulbous lips were almost dripping off his face. It occurred to me how strange it was that I'd never noticed before how ugly Clive really was.

I rolled across the swampy mattress and my arm folded beneath me like a deck chair. My fingers fumbled back my sleeve to reveal a spindly limb that bent in the middle like rubber. I plunged my head into the gap between the bed and the wall, but there was no escape. Hideous entrails squirmed in the dark canyon below me.

I heaved myself upright. 'Clive, you've got to stop it!'

His monstrous head loomed towards me. 'I caantssstopittt... Whaassswronggg?'

'It's horrible, Clive!'

'Whaasssuppp mannn? I thoooughttt youuu weeere heavyyy!'

'Well I'm not. I'm not heavy. I'm fuckin' freaked out, man.' I grabbed my notepad and held on tight as the pencil spun my hand in manic spirals. Drawing gave me a glimmer of comfort, so I scrabbled up a fistful of crayons and circled faster and faster. A whirlpool of colour sucked me into a cartoon world, where superheroes flew in and out of the spinning lines. It was only by concentrating on their every move that I could hold back the insane fear that threatened to destroy the dwindling speck of dust that was me.

When I got up the next morning, I knew that something was seriously wrong with my head. Reality had returned, but the terror of the night before kept coming back on me in waves. Now there was yet another thing in life I had to beat. I named it The Freak. I thought about giving up the whole plan right there and then, but after years of dead-end jobs, it was my only real chance of becoming an artist. I forced myself out to the Kilburn High Road and bought an old white suitcase in the Oxfam shop. There was a concealed pocket in its tartan lining. It was the perfect place to hide the acid.

3

GOOD TRIP

Je t'aime, je t'aime. Oh, oui, je t'aime! Jane Birkin et Serge Gainsbourg

I celebrated leaving the zoo with a slab of cake and a mug of tea in the works canteen. I'd adored cakes ever since the mobile baker used to park his van full of sugar-dusted buns in our farmyard. Soft glaće cherries burst through the thick sponge and I sank into a warm zone of pleasure until the strong tea swirled away the last of the crumbs.

The tall iron turnstile clunked as I edged through and walked around the perimeter fence to say a final farewell to the wolves. It seemed wrong to abandon them, but I'd spent most of the last seven years covered in paint and plaster, or shoving my mower through clouds of dried-up dog shit and I was desperate to move on. I waved goodbye to the ragged pack and walked home to begin my new life as an artist.

Two blonde pixies climbed all over me the moment I opened the door. They screamed, 'You're not going! You're

not going!' as I carried them into the front room. We stopped dead in the doorway. My mother was sitting in front of me, filling an armchair in her bulging kaftan. I'd completely forgotten Stella was coming down from Leeds. She beamed me a big smile with her usual, 'Hello, son!' then frowned straight back to her crossword. I knew why. She was supposed to be slimming for an operation and she didn't want me to mention it. The doctor had warned her that the weight of her fat would pull the stitches apart, but even that gruesome prospect couldn't keep Stella's jaws together.

Jeremy brought in bowls of food while I laid the table, doing an impression of a faulty robot. The girls burst into giggles at every silly mistake I made, but as soon as Mum sat down the whole mood changed. Her lips tightened as she spoke, 'Stop making them laugh at the table!'

I said, 'But that's what I do here.'

'Well, don't'.

I lowered myself into my chair thinking: *She can't order me around in my own place when I'm twenty-two years old*. I made the girls giggle again. Mum's huge fist swung out of nowhere, thumping into my head like a car crash. I staggered away from the table, dimly aware that my chair had fallen over.

It was weird afterwards. Nobody said anything. We just ate in silence, trying to pretend nothing had happened. I sneaked a quick look at the girls' faces. They looked as scared of her as I used to be. I thought: *I can't wait to get away*.

* * *

Daisy had already left for Paris. The plan was to make a base camp with a couple of French girls he knew. A few days later, I was on my way to join him.

The hovercraft was more like a bouncing bomb than a boat.

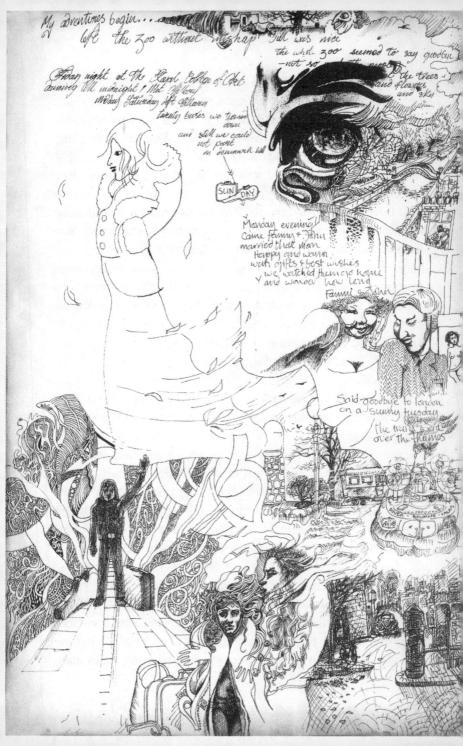

It made my first trip abroad feel like an adventure. Packing had been easy. I'd abandoned most of my stuff in Leeds when I left Hanna, so all I had in the world was a suitcase and a guitar. I looked at the ivory-coloured cases, admiring the way they matched, right down to the brown plastic trim and rusty chrome locks. They gave me a sense of completeness and freedom I'd never felt before.

The feeling didn't last. I was soon staring out of the saltscratched window, dreading going through customs. The sight of the crashing waves through the reflection of my face made me shudder. The Freak was like a ghost inside me. Anything could trigger it off.

The fat, black inner tube of the hovercraft finally collided with the coast of France. An owl-faced customs officer flicked his eyes over my long hair and the jewels pinned into the seams of my Levi jacket. I tried not to think of the microdots zipped into the tartan lining, in case he could see through the spaced-out atoms of my skull and read my guilty mind. I was more surprised than relieved when he waved me through.

The warm sewer smell of the Metro seemed like the breath of Paris itself as yellow and blue toy-town trains rolled silently through its black, gaping mouths. Now that I was about to meet up with Daisy, I felt guilty for not telling him how strong the acid was. We'd made a pact not to take any, but knowing Daisy Dave, that might easily be broken. I sat on the Metro's slatted wooden seat, trying to pronounce the station names as they slipped past the window, 'Arts et Métiers... Châtelet... Odéon...'

When I fumbled my cases out at Montparnasse, the view from the top of the stairway stunned me to a standstill. Before me was a lamp-lit cobbled street with glowing cafés and

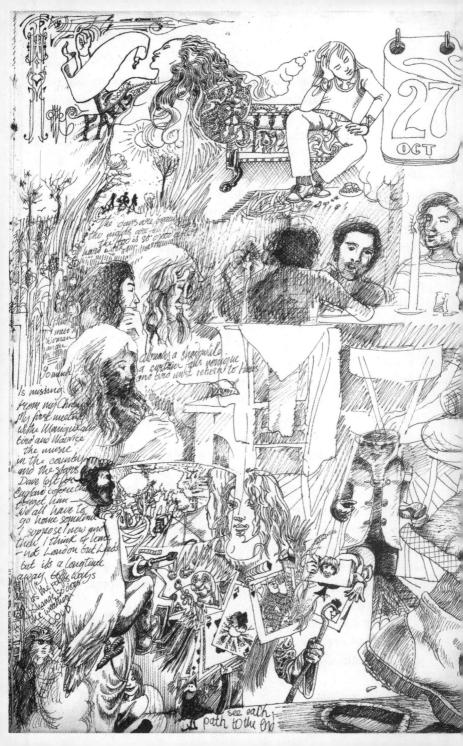

circular hoardings covered in posters. I blinked my eyes like a camera, taking a mental photograph to draw in my book later.

It must have been around midnight when I finally found 26 Rue Vavin. I knocked on the wide doors of the apartment block. An ancient concierge beckoned me through a tiny inner door into a dusky courtyard. She pointed a bony finger at the rising tiers of rusting balustrades that ran around the U-shaped building. I heaved my suitcase and guitar up the worn stone steps, hoping to God Daisy hadn't forgotten me.

He had. The apartment was dark. I rechecked the number and knocked again. Nothing. It was too risky to sleep rough carrying drugs, so I crept along the silent balconies, trying to find a friendly place to crash for the night. I spotted a Hendrix poster half-hidden by pot plants next to a faded grey door. I knocked, and it was opened by an unshaven hippy. He crouched before me in the hall, and except for a joint in his hand, he was totally naked. His pop-eyes furtively scanned the balcony. Then he hissed in English:

'Come in, man!'

'I've just arrived from...'

'Yeah, yeah. Come on in!

He waved me inside, then beetled off down the corridor like Groucho Marx. I followed the smell of incense into a large brown room with L-shaped sofas around a low coffee table. A cluster of fat candles threw a warm glow over a slim Japanese guy sitting on a couch. His long black hair hung cver a Fender Telecaster, pressed against his high-buttoned waistcoat. Lying next to him in a gipsy dress was a pretty girl with tangled blonde curls.

The unshaven guy hopped back into the room, pulling on a pair of velvet flares. He yanked his joint from a row of smiling teeth and jabbed it in my direction. 'Here, take it... my name is Maurice.'

'Thanks. I'm William. Pleased to meet you.' I took a slow draw while Maurice waved towards the Japanese guy.

'This is Bird.' Bird smiled and said:

'Hi. This is my girlfriend, Monique.'

The soft way she said, 'Bonsoir, William,' made me want to explain myself.

'Listen, I'm sorry. I was supposed to be staying with Annie and Brigitte over...'

Maurice interrupted. 'Hey, no problem. You can stay here.' 'Really?'

Maurice grinned, 'Sure, really. You're English. From London?' 'Yeah.'

Maurice grinned again. 'Far out!'

I'd only meant to stay for a night, but I was still there a week later. Maurice taught me how to cheat the Metro and the four of us span around the streets of Paris in a blue haze of diesel and dope fumes. Every day I knocked on Daisy's apartment door. It was always dark and deserted, but one afternoon, a blonde figure rippled towards me behind the panes of glass.

I'd only met Annie and Brigitte once before, in London. Brigitte had seemed to be happy then. She wasn't now. A faint smile of recognition flickered across her face as she opened the door.

'Ah, William. Come in. Daisy is here.'

Brigitte led me to a small dark room where Daisy was lying on a bed. He looked like a patient in a mental hospital. All he said was:

'So... You made it to France.'

I tried to sound cheerful. 'Yeah. Hey, it's true what they say about Paris – everybody's naked! I just met a girl called Sylvie. All she had on was a...' Daisy cut me short. 'Where've you been staying?'

I pointed through the grey window.

'Just over there. I knocked on a door and they let me move into their spare room.'

Daisy jerked up like a zombie. 'You can't just turn up at a strange place and move in!'

His staring eyeballs woke up The Freak in me. 'It wasn't like that. They asked me to stay.'

'But you can't expect to freeload forever!'

'It was only till you showed up. Where were you, anyway?'

Daisy picked a roach out of an overloaded ashtray and snapped his lighter at it. 'It's not about where I was. It's about where you are now!' He sucked the burning joint deep into his lungs and coughed through the smoke. 'Why do you always compete with me?'

I backed out of the room and headed over to Maurice's apartment. Daisy was my best friend. We were always making plans to be famous painters. Okay, most of them were stupid, but this one was going to work. We'd bought the gear, scored the stuff and Daisy had sussed out the scene in Morocco. And now he'd bombed out before we'd even started. I sat on the bed in my little room and scrawled in my book:

See each path to the end.

That was exactly what I did. Maurice hooked me up with Sylvie in a chateau commune on the outskirts of Paris. This time we were both naked, slowly recognising each other through the rainforest steam of the communal shower. I tried to draw my adventures as the weeks flashed by in a carousel of drink, drugs, songs and sex. It was fun, but The Plan was falling apart and a chill autumn wind was beginning to blow. There was only one thing left to do. Go on alone.

angela is sitting next to me with her head on my shoulder and my check veries on hes The is confortable so am of 1 group nchood music is playing I gomeone once The is compound all words are lies ! I did not know whether to belive himorist preases third to be a very good drawer 11.11.8 11 -11/(1) VINININ Bookinthe bookwoods again na no hodenley it was pekend games we planted Unit it is. Tubit has nov fan Sezenwood ak. Harsen Hitterfill d'anare It zeens, of lacknafter meratlast The Spes tonnuona I leave be Baralo tonite ill get deaux - Vin n Vin rocks at 40° a good was court your was sick of parts and love sick June some Love in angela She was wise to me as I to here ut (filie fuere silver tid us, hund ACQUES itall Fide the Querican express Paris I talka ride to Barcelala

4

BARCELONA

Wouldn't you know we're riding on the Marrakesh Express? Crosby, Stills and Nash

Mairice had told me you could get whatever you wanted if you waited outside the American Express building long enough. I hung around in the sun, wondering if I'd made the right decision. Sylvie had cried so much, I could taste the salt on her wet face. I kept rereading the piece of paper she'd pushed into my hand. It had a half-finished poem in broken English on one side, and on the back she'd drawn her lips under a huge pink question mark. My answer was parked across the road. It was an old campervan with a handwritten sign stuck in the window saying: 'Marrakesh Express'.

Eventually a bearded Italian called Mario turned up and the bus headed south. I was squashed in the middle seats with two Canadians, Michael and Steve. Michael had a Beatle haircut and a friendly face. He asked me how long I'd been on the road and it made me made me feel like my adventures were starting again. There was a weird English couple sitting behind us who looked like they'd been to a wedding, months ago and hadn't taken their gear off. I couldn't bear to look at the other couple in the back seats. Their constant kissing kept reminding me of Sylvie. The van broke out of the suburbs and I thought of the time Bird and Monique had driven us out to a wooden shack in the country. I'd drawn everybody's portraits in the candlelight like the impressionists used to do. It was the first time in my life that I'd felt like a real artist.

Mario's driving got worse in the dark. I had to keep waking him every time he swerved across the white lines. Michael took over the wheel when we ran off the road into a field and I managed to get The Freak back under control.

A pale blue dawn revealed cypress trees through the early morning mist. Smoke rose from a farmhouse chimney in a thin grey line. *No wonder they came down here to paint*, I thought. *It's like a dreamland*.

We didn't stop until just before the Spanish border. Mario got us out of the van and lined us up in the rocky countryside. The air smelled sweet and clean, which was more than you could say for us. We blinked in the sunlight as Mario gave us a speech:

'Okay. We are about to enter Generalissimo Franco's fascist police state.' He looked serious. 'So, if any of you is carrying drugs, you better take them now – or throw them away.'

That took me by surprise. Mario continued. 'Or you're gonna get six years and a day for possession, or ten years and a day for dealing.'

Shit, I thought. Daisy never told me about this.

Mario gave us a hard stare. 'Come on. Somebody must have *something*. Don't forget, the Spanish cops are armed and heavy. If one of us gets caught, we all go down.'

Michael raised his hand. 'Are they the guys in the shiny black hats?'

Mario spat into the dust. 'No, they're the Guardia Civil. Franco's version of the Gestapo – the cops wear military hats, but they're just as bad.'

The wedding bloke in the bowler cracked first. He skinned up the last of his stash while everybody else pulled the fluff out of their pockets. I kept quiet. I didn't want to land anybody in trouble, but if I threw the acid away, I'd be throwing away my only chance of being an artist, too.

I sat on a rock to think while they passed around the spliff. All I ever wanted to be was an artist. I was obsessed by painters and painting. I admired Michelangelo and adored Augustus John – not just their work, but the artists themselves. I wanted to learn how to draw and paint like Modigliani and Toulouse-Lautrec. I wanted to discover the secrets that made de Chirico's work so enigmatic and Chagall's so poetic. But I didn't want to spend ten years in a Spanish jail.

I was still struggling to make a decision as the others drifted back to the bus. They started climbing aboard so I stepped over my suitcase and followed them in.

I felt okay until we pulled in under the high rocks of the Spanish checkpoint. The sight of the guards' guns in their black leather holsters made my palms sweat. They ordered us out of the van and I wished I'd stuffed my case under the pile of rucksacks.

I tried to read the guards' expressions as they stared through the windows of the bus. It was packed with hippy gear and there could easily have been a ton of dope stashed inside. A car rolled past, its chrome mirror glinting in the blinding sunlight. It seemed like everyone was driving straight through the barriers and it was only us they'd stopped.

Mario tried to speak to the guards, but they didn't respond. One leaned inside the open door. Blood started thumping into my head. My case was right in front of him and I cursed myself for not throwing the stuff away when I'd had the chance. What was I thinking of? The secret pocket wasn't that well hidden. If they found the zip, they'd find the drugs.

Suddenly the guard span round and shouted in rapid Spanish to Mario. Instinctively I looked around for an escape route as he marched towards him. It was pointless. We were trapped in the compound.

Mario turned towards us and gestured with his thumb.

'Okay, everybody. Back in the bus. We'll grab some food when we get to Barcelona.'

I dried my palms on my jeans. The thought of eating made me feel sick.

For our stopover in Barcelona I was shacked up with Michael and Steve. We couldn't wait to get outside and each time we returned from the baking streets I'd make quick sketches of the things we'd seen. Wild cats creeping through spiky cactus. Our long silhouettes in the shadows of de Chirico arches. A careless blob of ink turned into flamenco guitars, swirling dresses, a waiter's face and moonlit kisses. Michael looked over my shoulder as I drew the old cowboy train that had taken Veronica back to Sweden. She was a girl who had suddenly kissed me one night while we sat talking on some steps. It shocked me because she must have been about thirty. Just before her train left she gave me a pretty string of love beads and told me to take care. I was thinking about the strange look in her eyes when Michael interrupted my thoughts.

'What's the book about?' he said.

I talked Michael through The Plan and let slip about the acid. Instead of freaking out, he said that he and Steve had been trying to score some for ages.

We went out into the midday sun looking for a place they could trip. A gaudy poster for Barcelona Zoo caught my eye. It would be a great place to keep them off the streets if they lost control, so I waved them over.

'Hey, look at this. I used to work at a zoo.'

Michael said, 'You're kidding. What was it like?

'Full of tourists. I used to talk to the tigers.'

Michael tipped up his sunglasses to study the list of attractions. 'Really?'

'Yeah. The keeper taught me how to say the tiger's greeting. I'd walk up to their cage when there were girls around and go, *Harrough*! They'd go, *HARROUGH*! right back to me – it was amazing!'

Michael pointed at the list.

'They've got an albino ape that looks like a human.'

Steve grinned. 'Oh man, we've gotta see that!'

Barcelona's fleapit was ten times worse than London Zoo. I hadn't dropped anything, but I kept picking up on the weird vibe the guys got from seeing all the manky animals.

Michael and Steve wandered about in a trance as I tried to herd them across an area of scrubby grassland to see the human ape. We'd almost reached the other side when a zoo official ran up, shouting and waving. He stopped us with his uniformed arms outstretched, trying to push us back in the direction we'd just come from. I ignored him, but he blocked my path and pointed to a sign. Michael guessed it said 'Keep off the grass'. My temper started to rise and so did my voice. 'So why does he want us to tramp all the way back over it?'

I tried to walk on, but the official stuck his hand out and shouted, '*Passaporte*! *Passaporte*!' I dodged around him and he started yelling, '*Policia*! *Policia*!' People were staring at us, but I kept going. Michael caught up with me and spoke gently with his arm around my shoulders.

'Listen, we're hippies tripping in Franco's police state, where you get an instant six years for possession. We've got to cool it, man.'

He went to work on the zoo official. Moments later, Steve was taking a smiley photo of them with their arms round each other. I took a long look at Michael Schneider, wondering how on earth he was able pull that off while tripping on acid.

5

PAIN IN SPAIN

I needed money 'cause I had none I fought the law and the law won. Bobby Fuller Four

We'd spent our last day in Barcelona looking at trippy Gaudi architecture. The hot sun had fried our brains and we were desperate for a cold drink. Michael and I left Steve sleeping and headed down Las Ramblas, then we turned off into the Placa de George Orwell. Michael ordered a couple of rum and cokes and joined me on the metal chairs that overlooked the open space. We watched drunken English sailors trying to form a human pyramid while I asked Michael about his home in Canada. It sounded like a palace.

'So how big is your bedroom?'

Ice cubes clinked as Michael sipped his rum. 'Bigger than the hotel room, that's for sure.'

'Have you got a stereo?' 'Sure. And a TV.' 'Far-out!' I ticked a list on my fingers as the sailors fell about in the distance. 'TV, stereo, car, pool, slot car racetrack – I bet you've got money in the bank too, yeah?'

Michael couldn't help smiling and we leaned over the table to touch our glasses. 'So what have you got to go back to?' he said.

I held out my arms. 'Nothing. All I have is what I've got with me.'

Michael's eyes opened wide. 'You're kidding. A suitcase and a guitar. That's literally all you've got?'

I smiled. Michael made being poor sound cool. He looked serious for a moment. 'What about your folks? They must have something?'

'All my mum's got is a load of old books.' I laughed. 'She still hasn't paid back the money she borrowed off us when we were kids!'

Michael tipped his head back to suck the last drops of rum out of his ice cubes. 'What does your old man do?'

'Dunno. He used to play piano in pubs and clubs. Then he ran off with a barmaid called Ruby. We never saw him again.'

Michael strummed an air guitar and drawled, 'Sounds like a Country and Western song.' We laughed as the sailors stumbled into the mysterious alleyways that led off the *placa*. I swigged back my rum and we went to join them.

Michael faced me over a barrel table in an underground cavern. It was the oldest bar we'd been into that night. Wine casks were cobwebbed to the walls and red candles had turned their bottles into wax volcanoes. Michael must have drunk the same amount as me but he still managed to sound sober.

'I don't really want to go back.'

I rolled Veronica's love beads around my fingers. 'What, to the hotel?'

Michael smiled. 'No. Back home.' He held his dark glass of rum up to the candle and looked through it. 'I've learnt more on the road than I ever did in school.'

'Yeah, you get used to the freedom. It makes you feel you can do anything.'

'Or go anywhere...'

'Or be anybody...'

Michael was still looking at the candle flame which was almost touching the other side of his glass. 'You're lucky, you know exactly what you want to be.'

'Yeah, but I don't know how to get there. At least you're going to university...'

'That's only because my parents want me to go.'

So what do you want to do?

Michael stared deeper into his drink. 'That's just it. I don't really know. I guess that's why I don't want to go back.'

With his glass in the candlelight, Michael looked like a Caravaggio painting. I couldn't help thinking of a phrase I'd liked at Sunday School, *Through a glass, darkly*. But all I said was: 'I've always known I wanted to be an artist. But when I really come to think of it, I don't know what *kind* of artist. That's what I'm hoping to find out.'

We fell quiet for the first time that evening. Each of us lost in our thoughts. I suddenly realised we were the only two left in the bar. Michael broke the silence.

'That's the difference between you and me. You've got nothing to tie you down, but I'm so locked into my life that I'll never really be free.'

That made me laugh. 'Hey, if I had your life, the last thing I'd want to be is free!'

Michael smiled, but he was still serious. 'Money's not all it's cracked up to be.'

I got what he meant, but Michael had kicked something off and the rum took over.

'I know it's not about the money, but when you don't have enough, it makes you feel different. Especially when you're a kid. People can tell just by looking at your haircut or your clothes or your shoes. You don't go to the shops for them, you take coupons to a warehouse. My mother always started crying because they'd only give each child one part of the school uniform. So I'd end up wearing jumble sale trousers that were so wide I had to bunch them up behind me and everybody laughs so you have to walk sideways with your back to the wall. It makes you feel second hand, like you're not a proper person...' I had to stop because the drink was saying more than I wanted Michael to hear. When I looked up, he was staring into his glass as though he hadn't noticed my outburst. I really liked him for that.

I grabbed my rum and said, 'Hey, we ought to be going!'

Michael didn't move. 'You're going to change all that one day.'

'You think so?'

'I know so. Anyone who'll smuggle drugs just to learn how to draw, has got to make it.'

Michael grinned and his hand weaved towards mine until our glasses clunked together. 'Here's to your art school in Moroccococo...'

'And here's to your university in Canadadada...'

We finished our drinks and carefully climbed the uneven stone stairway to the door. The booze only hit us when we got outside. I jumped onto a car bonnet and started walking over the roofs of parked cars like a human rollercoaster.

Michael called up to me. 'Hey, man. That's probably not a good idea.'

'It's okay. My shoes have got rubber soles, so they won't damage the paintwork.'

I jumped down when we came to a long line of Lambretta scooters.

'We should head back to the hotel,' Michael said. 'We've got a looong drive in the morning.'

He was right. Only I had a better idea. One of the scooters had keys in the ignition. I jumped onto the fat saddle and offered him a ride.

Michael shook his head. 'That's *definitely* not a good idea, man...'

I turned the key. The engine started with just one kick and I rocked the bike off its stand.

'Come on! Let's go!'

Michael looked around wildly. 'This is crazy. Turn it off before somebody comes.'

I revved the engine. Michael wasn't up for it, but I was. 'See you back at the hotel!' I twisted the handgrip into gear and eased out the clutch.

Michael's calls faded away as the bike surged out into the wide Barcelona Boulevard. A silky breeze blew over my face. I thought: *This is so cool. Michael was mad not to come.*

After a few blocks I leaned into a right turn, then from out of nowhere a couple of policemen on huge Moto Guzzis roared up alongside me. They forced me into the curb, so I decided to act drunk and fell in a heap on the road. They heaved me to my feet, snapping my wrists into handcuffs behind my back. I smiled in a friendly sort of way, as if to say, 'Hey, guys. I'm only drunk. Take it easy!'

Suddenly a police car squealed up beside us. They stuffed me inside and we sped away into the night. There was something serious about the chipped white paint on the grill in the back of the car, but it was still a bit of a laugh.

The police car jerked to a halt, throwing me forward into the wire mesh. Doors flew open and rough hands yanked me out. They dragged me across the road and the beads around my neck broke, falling to the ground in a tiny shower of colours. I thought, *Shit, my lucky love beads. I wanted to keep them forever.*

An officer loomed out of a doorway. He wore a peaked hat and a smart grey uniform with a black holster on his leather belt. He rapped out a question in Spanish and I answered him with a shrug and a dopey smile. Immediately three backhanders smacked my face from side to side, Nazi-style. I instantly hated him. Anybody could act tough to someone in handcuffs.

The cops holding my arms rushed me down a long, narrow corridor lit by dim overhead lights. We were going so fast I hardly needed to use my feet. The corridor led to a brick courtyard with a metal staircase running up one of the walls. They hauled me up the steps, round a corner and we burst into a wide, scruffy office.

My Levi jacket was almost yanked off my shoulders as the officers rifled through my pockets. The face-slapper tried to rip open the seams, obviously looking for drugs. They got excited when they found my tortoise-shell plectrum and sniffed it as though it was dope. It seemed crazy that people in the land of flamenco didn't recognise a guitar pick. I didn't like their vibe and their guns, but at least I knew I was clean.

They hauled me to a desk and I recognised that they were shouting for my passport. I said, 'Hotel, hotel,' and tried a small smile of apology.

Thankfully, they seemed to understand me. The face-slapper asked me the name of my hotel. Suddenly I was sober and my thoughts crystal clear. The acid was in my suitcase at the hotel. The front desk would hand it to the police with my passport when I didn't check out in the morning. They'd find the secret compartment and I'd be banged up for ten years. That was it. Checkmate. It was over.

They kept on relentlessly. '*Hotel*? *Oye, hombre, cuál es el nombre del hotel*? *No entiendes*?'

All I could do was pretend to forget the name to give me time to think.

They're not going to let me go without seeing my passport. When they get my passport, they'll find my drugs. I'm handcuffed so I can't run away. I'm totally fucked. I can't do ten years. I'll be over thirty when I get out! My life will be finished.

The face-slapper was filling out a form and I realised it wouldn't be long before they locked me up. The only option was to get the handcuffs off. If I could get them off I could escape.

I turned round with my back to the desk and twisted my hand towards a pencil. One of the officers put it in my grasp and I managed to draw a dick pissing into a pot on a yellow notepad. I figured they wouldn't want to pull it out for me, so they'd have to take the handcuffs off. The policemen laughed at the drawing. *That's good*, I thought, *they think I'm a funny drunk*.

The cuffs came off with a welcome click and the cop who'd hit me escorted me back down the metal staircase into the courtyard. At the bottom of the steps I glanced down the long corridor we'd come through on the way in. At the end I could see people in the street and cars flashing by. Freedom was so close I could almost feel it. We turned left and crossed the yard to the toilets. As I'd hoped, I went through the heavy door alone. The toilet was an absolute fortress. There was no way of escape. A plan formed in my mind as I stood at the pissstained stalls.

I'll knock him out, then leg it down the corridor. He deserves it for hitting me first. But he's got a gun, so I'll have to hit him hard before he shoots me.

I'd knocked people out before, and I was sure I could do it again. Also, I was a fast runner and the cops wore heavy boots. All I had to do was twist and turn through the back streets till I found my hotel. Then I'd get my hair cut, change my clothes and in the morning I'd be off to Morocco, hiding behind a pair of shades.

I zipped up and walked to the reinforced door. Then I paused to take a deep breath and gather my strength. 'Okay,' I said to myself. 'This is it.'

I pushed the door open with my left hand and walked out ready to punch him as hard as I could with my right. But he wasn't there. He was standing behind the door. I hadn't expected that. The door slammed shut and a shove in my back got me going. As we crossed the yard towards the steps, I sneaked another glance down the corridor. I could still see the street, but if I turned to hit him he'd see it coming and shout for help. I started up the metal steps that led to ten years in jail. My whole life seemed to be falling down on top of me.

I've done nothing in all my years. I've never even tried to accomplish anything. If I don't act now my life will be lost forever.

We were approaching the point where the stairs turned a corner. After that it would be too late. It was now or never.

I span round and grabbed the iron railing with my left hand, drawing my right foot back at the same time. I had a perfect view of the cop's surprised face as I aimed the sole of my shoe at his head. It connected with a heavy slam and he fell backwards. His skull banged hard against a concrete lintel before he landed on his back on the floor. Unbelievably, he reached for his pistol. I dived headfirst down the steps and punched his head as I landed on him, but instead of losing consciousness he started to shout. I jumped up and ran down the corridor, expecting a shot to crack out at any moment.

The corridor seemed to go on forever. I'd almost made it to the end when suddenly a whole team of cops piled out of a side door next to the exit. There was nothing I could do. I froze with my hands in the air.

They shoved me back into the courtyard and this time the cuffs went on really tight. A blow landed on my shoulder and I instinctively ducked. Then another hit the back of my head. Suddenly they all piled in and their nightsticks rained down on my back like hammers. I doubled over. Judging by their legs there were around six of them, shifting around, trying to get a better angle. I yelled out in pain as they beat me in a frenzy. Then my head was yanked up by my hair. I looked into the bulging face of the cop I'd kicked and saw him reach for his gun. He was about to shoot me! I turned away like Lee Harvey Oswald did when Jack Ruby pulled out his pistol. There was a sharp crack on my back, but it wasn't a bullet, they just started to beat me again. I'd been gang-bashed before - booted by black-suited navvies, dancing around to get a good kick in as I rolled on the tap-room floor - but nothing like this. The blows thundered down until they were too tired to hit me any more.

The handcuffs tore into my wrists as they dragged me to the corner of the stairwell. I collapsed on the stone floor, but hairy fists hauled me upright and a truncheon jabbed into my face. I stood as best I could as they jabbered away to each other back down the corridor. I desperately wanted to lie down, but I didn't dare. The corridor that led to the street was right in front of me but I was too afraid even to look at it. My body was in shock and my mind was empty of everything except pain and fear.

I waited in a wilderness of time until a distant commotion roused me. A new shift was coming in and they were being told what I'd done. Their voices grew louder and louder, becoming hysterical outbursts that filled me with dread. A new group of cops clattered down the corridor towards me. I crouched as they yanked me from under the stairs and began hitting my back and arms. It was more than I could bear and I heard myself crying out in agony with each blow.

Strangely, somewhere in my head, a calm voice spoke. It said, 'This is okay. It's just a beating. If they stop soon, you'll recover and be all right.' But they didn't stop. I could feel my arms turning to pulp and my spine cracking. The blows exploded in my mind; I had a vision of how I'd draw the pain if I got out alive. It was a complex partition of boxes packed with jagged machines, snapped cables and mechanical medieval weapons. The voice came back: 'Now this is doing some harm, maybe permanent harm. You have to do something.' I jerked myself upright and shouted wildly, 'STOP IT! I'M ENGLISH!'

It was ridiculous, but for a moment they actually stopped. I glimpsed an old cleaner woman watching from halfway up the metal steps. Then they started to beat me again. Now it was weird. I could no longer pretend I was going to be okay: I was frightened for my life. I felt I was going to crap myself and actually smiled inside as they hit me, thinking, *It's true when they talk about beating the crap out of you*. But my dignity wouldn't let it happen. The cops must have known what they were doing because they stopped just as I began to black out. They shoved me back in the corner again. They wouldn't allow me fall, so I wedged myself into the stairwell, bent double like an old beggar. The cleaner lady started to walk up the stairs. I pleaded for her to make them stop but she just shrugged as if to say, 'You started it', and walked on. She thought I deserved it, and the worst thing was, I knew she was right.

Horror grew inside me like vomit as voices began to rise again. I looked up through my wet hair at a pair of black boots clacking down the corridor. They stopped beside me and a new officer pulled a nightstick out of his belt.

He went berserk on my back and arms. I twisted and turned, but there was no escape. I raised my leg to take some hits on my thigh, but the officer thought it was an attack and backed off. *You cowardly bastard*, I thought. He ordered me to stand in the corner, but I could hardly keep upright. I started to drift, so I propped myself up against the wall. I knew if they came back, it was going to kill me.

Consciousness drifted in and out like mist on the tide until muffled footsteps echoed out of the fog. I prepared myself for the final onslaught as their hands grabbed hold of me. But they didn't beat me. I was dragged down a corridor. A door opened and my handcuffs were taken off, then I was thrown onto a soft bed in a dark cell. My lips smeared on the rubbery texture of a bare foam mattress. It was absolute luxury. The door slammed me into darkness and nothing could have been more beautiful than the sweet oblivion that finally descended.

6

PIGSWILL

And ain't it just like a friend of mine To come and hit me from behind? James Taylor

I was woken by the ratchet of handcuffs biting into my skin. Two officers stumbled me out of the cell and pushed me towards a door. I was expecting to be beaten again, but instead my eyes were hit by brilliant sunlight. Heavy hands pushed me into a black van and I was driven away at speed.

We rocked and swerved through traffic as though we were being chased. It was only by bracing my feet on the floor that I managed to stay on the narrow wooden seat. I almost fell off when we screeched to a halt. Seconds later the doors crashed open and I was pulled out. My back was so stiff I couldn't stand upright, so all I saw were broad steps as they shoved me inside what must have been a large building.

I was taken into a back room where my captors told new officers what I'd done. They gave me a goodbye kick as I was

marched away. The officer ripped off my handcuffs in a toilet with a long line of stinking urinals. He kicked a bucket with some cleaning equipment in it and told me to get to work. I tried desperately to do a good job so they wouldn't beat me any more, but my arms refused to work properly. All I could think was, *I need a doctor*. *I need a doctor to look at my back*. After an age of scrubbing, the officer stalked back and jabbed me in front of him down an unlit stairway. We stopped in a subterranean corridor while he unlocked a door. It opened onto a flight of worn stone steps that led into darkness. I tensed, ready for a boot in my back, but thankfully he let me pick my own way down. The staircase led to a wide cellar, dimly lit by narrow grey windows set high in the walls.

I made out a dozen silent men lurking in the shadows. 'Does anybody here speak English?' I said. One of them came forward and I tried to point over my shoulder. 'Will you take a look at my back, please?' He had no idea what I was talking about and an argument broke out in rapid Spanish.

I needed someone to look at my injuries, but I couldn't get my jacket off. Some of the men saw what I was trying to do and helped me. They were surprisingly gentle. I unbuttoned my shirt as they continued to argue. As I eased it off my shoulders, I could just twist my neck enough to see the top of my arm. It was black and purple and puffed into lumps. The guys were still bickering, but when I showed them my back, they all fell silent. I turned to face them and the look on their faces nearly made me faint.

One by one we were taken out for questioning. Eventually the guard led me to a spacious, open-plan area that was separated from a large hall by a long counter. Clerks were working at desks or standing behind the counter to serve members of the public on the other side. I was taken to a chair in front of a desk and I lowered myself onto the seat opposite a thin, blond young man in glasses and a pale blue suit. His fingers hovered over a typewriter and he surprised me by speaking perfect English.

'Tell me your name, please.'

'William Stuart McLellan.'

He tapped away onto a form backed with carbon paper. 'Your age?'

'Twenty-two.'

'And where are you staying in Barcelona?' He spoke as though we were in a travel agents and I had to remind myself to lie.

'I can't remember the name of my hotel.'

He held out his hand. 'Do you have your passport with you?'

'It's at the hotel.' I knew it was a hopeless ruse, but it was all I could do to postpone the inevitable.

He withdrew his hand. 'So you don't have a passport?'

'I do, but... listen, I'm not feeling too good. Please, I need to see a doctor.'

'I'm not in a position to get you a doctor.'

'Can you get me a glass of water?'

'All I can do is take your statement. Please tell me exactly what happened.' I told him a rough version of events, as though I was a drunken tourist who couldn't remember the night before. He patiently typed it all in, then asked if there was anything I wished to add.

'Yeah. What do you think I'll get?'

The clerk looked up at the ceiling as though I'd asked him to guess my star sign. 'About a year'

That did it for me. I knew that when my passport and suitcase got handed in, the police would find the drugs and suss the reason I'd tried to fight my way out. There'd be ten years for dealing and God knows how long for kicking a cop in a police state. And, on top of that, I'd nicked a bike. It could be fifteen years. I'd be nearly forty before I got out. I couldn't do it. I rested my elbows on my knees and cradled my head in my hands. The pain in my back made me want to be sick. My life was over. I searched my mind for a way out.

Nothing.

Out of the blackness, a thought appeared. When we were kids, Mum used to read us Bible stories from an old picture book. We were so young that we believed the whole thing. We even said prayers. The only thing I could think of that might save me was Jesus. I buried my head deeper in my hands and pictured him in the book. He was dressed in blue and white robes with his arms held out in welcome, and his kindly head was surrounded by a halo of beams.

Painful taps on my shoulder broke my daydream. A hand pointed to someone on the other side of the counter, in the public area. The figure of a man with long dark hair slowly came into focus. His hands were resting on the counter with his arms apart, just like the picture of Jesus. It took me a moment to realise it was Michael. I staggered over and whispered, 'Get rid of the stuff!'

'Don't worry. It's gone.'

I couldn't believe it. 'It's all gone?'

'I've thrown it away and taken your suitcase and guitar to the British Consulate.'

Official people were walking towards us. I knew I shouldn't be talking to him, but there was so much I needed to say.

'How did you find me?'

'I took your passport round the police stations and one of them sent me here.' He suddenly looked concerned. 'Hey – are you okay?' There was only enough time for him to hand over my passport before they led me away. I didn't even have time to thank him. I knew he must have missed his ride to Morocco to look for me, but I was firmly guided back to my seat.

When the clerk saw my passport, his attitude changed. I was no longer a hippy vagrant; I was now a British tourist. I turned to look for Michael as the clerk typed in my details, but he'd had the sense to get out quick. I could hardly believe my luck. It was the only time I'd been in a public place since being arrested and Michael had walked in with my passport. It was an amazing coincidence.

Soon afterwards I was back in handcuffs, bouncing through Barcelona in another black van. I thought of what Michael had done for me as I tried to wipe the fingerprint ink off on my jeans. He had saved my life. There was no other way of looking at it.

We pulled up sharply behind the high walls of what looked like a medieval castle. The guard's boots echoed down a long, wide corridor of polished stone as he marched me through a series of steel-barred gates. We came to a giant round chamber with a circular office in the centre. Enormous galleries, each one the size of a church, branched off in all directions. The dull murmur I'd heard at the entrance began to build as we clattered up an iron stairway that crisscrossed the grey walls. The voices rose to a deafening clamour when we reached the top and began to walk along a high gantry. Each cell we passed was packed with criminals, caged behind bars like animals.

My guard stopped and unlocked a gate. He swung it open and glared at me until I walked into the tiny cell. There was just enough light to make out two double bunks with a narrow gap between them. Two men were stretched out on the left hand beds. A small sink and a toilet were in the corner. As the guard slammed the metal door shut, I remembered to ask for a doctor, but he just turned the key and marched away.

It didn't take long for the euphoria of Michael's visit to wear off and for reality to hit home. The men were hostile and silent, the place stank, the bedding was filthy and there was no way I was going to take a crap in front of everybody. I sat down on the empty bunk to try to figure out what to do. I needed food, water and a doctor. But how could I get anything if nobody spoke English? Besides, trying to think with all the noise going on exhausted me. I lowered myself down onto the rough blanket to rest. When my eyes closed I was overcome by the mad babble of a thousand foreign voices echoing in my head.

I must have drifted off because the rattling of the cell lock woke me. A small uniformed sailor who looked about fifteen was let in. He was desperately trying to get the guard to let his ship know where he was, but he span round in shock when I spoke.

'Forget it. They don't speak English.'

The sailor walked towards me, relief all over his face. 'So good to hear your voice, man.' He stuck out his hand. 'Sam Willis, US Navy.'

I tried to pull up my legs to make space for him on the bunk, but he was too jumpy to sit down.

'I just can't get *through* to these guys. I'm AWOL, but they don't understand what that means!'

'Same here. I got arrested last night.'

The two Spaniards shifted on their bunks, watching Sam march around the cell in his sailor suit. 'Me too. And I'm in *big* trouble. We were drinking in a bar and one of the guys gets out this joint and we all had a toke. I mean, it's like

nothing, but then the cops turned up and I'm holding this reefer and they're all over me.' He dropped onto the end of my bunk. 'My CO said there's only one thing we can't do – and that's miss the sail date...'

Sam ran a claw of white fingers through his short black hair. I couldn't tell if he was too upset to speak or if he couldn't think for all the noise. The place was like a mad house. He shoved his hands over his ears and spoke to the floor.

'I've got to get a message to the ship or I'm done for.'

'I'm trying to get hold of a doctor, but they don't even listen.' Sam managed a brief look up. 'So what happened to you?'

I told Sam my story and although his head was bowed I knew he was listening to every word. At the end he turned to me with a look of firm confidence.

'You know what? I think they're gonna let us go.'

Ever since Michael told me he'd got rid of my drugs, I'd been hoping the same thing.

Sam stood up and looked out over the noisy gallery. 'I bet this is just a shock tactic to teach us a lesson.'

I slowly pulled myself up from the bunk to join him. Could he be right? There was so much howling and shouting going on, it was like being in a horror movie. Most of the screaming was coming from the prostitutes on the opposite row below us. A tall blonde in a white leather miniskirt and piled-up hairdo waved at the guards through the bars. It was only when I saw how hairy her arms were that I realised they were all blokes in make-up and wigs. It reminded me of Fellini's *Satyricon* down there.

Things quietened down when night came, and even the pain in my back couldn't stop me falling asleep. It didn't last. Sam and I were both out of our beds in the early hours, tearing at our skin. When dawn finally broke, our pale flesh was covered in hundreds of angry red lumps that screamed to be scratched.

Our dark-skinned cellmates found this amusing. '*Chinches*!' they said, and laughed.

It must have been lunchtime, but instead of the guy who sold sandwiches we got a visit from an official who actually spoke English. Sam jumped up to the bars.

'Is there any chance I can get out of here before my ship sails?'

The official pushed some forms through the gate and told us there was a space to make a plea to the governor. If we showed enough remorse, he might grant us a pardon. He looked at me with surprise when I asked if I could see a doctor. 'There are no doctors in the prison. If you want to see one, you must also ask the governor.'

We took the pens he gave us and spent the rest of the day writing letters of abject apology while our Spanish cellmates took turns to crap into the bog in the corner.

It was impossible to sleep. Whatever position I tried, my back still killed me. I got up and stood at the bars with my hands gripping the cold iron. Rows of dark cells became visible as I stared across the silent gallery. It made me think of the zoo and how I used to run around having fun while all the animals were stuck inside their cages.

I suddenly realised that my speaking with the tigers was a load of bollocks. I knew it was wrong to keep animals locked up, but I never gave a thought about how they really felt. Now it was all too clear. When I cut the grass around Guy the Gorilla's cage, I never realised that the little patch of green was the only territory Guy had. One time, my shoulders had brushed against the mesh of his cage as I clipped the lawn with my edging shears. It was such a Zen occupation I didn't see it coming: the sky went black as Guy's giant body slammed into the wires right next to me. His roar was stupendous, curved yellow teeth in a hot red hole, inches from my face. My whole being went into shock and my joints turned to water. Now I knew what he felt like, and it made me feel sick with remorse.

Bed springs creaked behind me and Sam appeared by my side. I could barely hear his hoarse whisper.

'What do you really think's going to happen to us?'

I whispered back, 'I don't know. But I read in a book once that if you imagined something strongly enough, it could become a reality.'

Sam turned towards me in the half-light and I told him how it had worked for me when I pictured Jesus and my mate turned up. We devised a mental image of freedom and a chant to go with it: 'We will be free, we will be free, I do believe we will be free.' Sam and I clung to the bars in the dark cell repeating it in unison through every minute of the night, while we imagined ourselves walking out of the gates into the warm sunlight.

Morning came and went in a cacophony of confusion. Nobody told us anything. We'd been chanting since dawn, but now we were running out of steam. It was hard to hear ourselves above the howls and screams of what our cellmates called the *Maricons*. When the *Maricons* caught sight of us they started miming sex in our direction. They booed and whistled when we backed into the shadows of the cell, horrified at the thought of them getting their hairy hands on us.

My back had stiffened even more and my limbs felt weird, like something was wrong with my coordination. Not just that – I couldn't face going to the toilet – it felt like the cop's final kick had ruptured something inside me. Eventually I unbuckled my belt and walked to the corner of the cell. My jeans dropped to the floor and I sat on the cold porcelain with my head in my hands to hide my shame. I didn't even know if I could stand another day, let alone a year.

Unless something happened that day, Sam's ship would sail without him. Amazingly, something did. The official returned and threw the gate wide open. We followed him down the twisting iron stairway towards the circular building in the centre of the prison. Silently, we mouthed our chant, ignoring the *Maricons'* passionate farewells.

The official led us across the wide gallery floor towards the round stone office. Golden daylight cast long shadows down the shiny perspective of the exit corridor, as two guards stepped out of the office to meet us. Our official handed them some papers with a flurry of rapid Spanish. We couldn't understand a word, but there was a hopeful feeling of conclusion to the exchange. One of the guards turned abruptly and led Sam away towards the light. He didn't look over his shoulder, and I knew why. I didn't blame him.

Then it was my turn. The official ordered me to follow the other guard. But he was walking in the opposite direction, away from the light. I looked behind me. Sam was already going through one of the gates. This was too cruel to bear. No disappointment had ever torn the guts out of me like that. I thought Sam and I were going to leave together.

I followed the guard deep into the prison interior. He stopped at a dark doorway, spun round and barked an order at me. In a small, distempered room, a rough-looking man stood next to a solitary chair. A bare light bulb hung above it. Horror descended on me. Torture. I'd been freaking out about this ever since arriving in the prison. The man motioned for me to sit. I barely managed to reach the chair. I couldn't take any more. He turned to a shelf on the wall and picked up something shiny and metallic. It wasn't until he grabbed my hair and started cutting that I realised I was in a crude barber's shop. I was too numb to even feel relief. All I felt were the blunt scissors hacking away at my head as my sun-bleached hair fell to the floor. There could be no pretending any more. I really was a prisoner now.

I stumbled behind my guard like a zombie towards a wooden counter that was set back from the corridor. A fat, sullen man gave me a giant bedroll, a blanket, a spoon and a battered aluminium dish that looked like an old hubcap. The guard's boot heels rang around the prison as I climbed behind them up another giant metal staircase. I struggled to keep hold of the gear in my aching arms, and the sick feeling of disappointment was almost too much to bear. I had really believed I was going to be ordering a cold beer in a bar with Sam.

Our footsteps clunked across a narrow walkway at the top of a silent gallery. The cells we passed weren't like the cages we'd been in before. They had solid metal doors instead of bars. Suddenly the guard stopped, rattled open a lock and shouted an order at me. I shuffled into the cell and dropped the bedroll. The guard thrust some official-looking papers into my hands and the heavy door swung shut. I studied them as the snick of metal told me he'd opened the spyhole. It was my plea to the governor. Everything I'd written had been slashed through with red ink.

I was heartbroken, but I turned my back so the guard wouldn't have the satisfaction of seeing it. The spyhole closed and I looked around the cell. It was about six feet wide and ten feet long. The lower half of the walls was covered with cracked plaster over solid grey stone. A pair of double bunks were bolted to terracotta tiles on either side of the cell. They were separated by a flimsy wooden box that had once held oranges. Now it stood on its end to make a table. High above it was an arched window with bars instead of glass. Its long, sloping sill looked like something out of a medieval dungeon. I turned to face the studded door. In the left corner was a grey, seatless toilet with a bucket beside it. Next to that was a small stone sink with a blackened tap sticking out of the wall like a gibbet.

I unrolled my mattress on the top bunk over a few crisscrossed wires attached to short, rusty springs. Then I spread my matted blanket over the bed and put my bowl and spoon on it. It wasn't much in the way of possessions. I knew from Michael that the consulate had my suitcase and my name was in my wallet. *Surely they'll contact me*, I thought. Then it struck me that they had no way of knowing I was here; Michael hadn't known where I was when he'd given them my stuff.

Confused thoughts circled around my head until the monastic quiet was disturbed by a distant metallic thunder. The sound grew louder by the second, accompanied by hoarse shouting. I realised it was the hammering of the cell bolts and doors being slammed back, one after the other in quick succession. There were other noises too: metal scraping on stone and rapid footsteps.

Suddenly, my door crashed open.

Outside, a scruffy prisoner was dragging a huge metal soup tureen by a leather strap while another sank a ladle into it. He shouted angrily and I realised I should have been holding my bowl out already. I grabbed it in time to have it slopped full of lumpy grey soup. The door slammed shut and the mechanical Mexican wave echoed away down the gallery. I stared at the contents of my hubcap. It smelled rancid. Floating in the sludge were thick white squares of hairy fat that looked like the top of someone's skull. I guessed they must have been cut from a pig's back. The thought of eating it made me gag. I placed the bowl on the orange-box and climbed carefully up to the top bunk, so no strain went on my spine. I was asleep in seconds.

I woke up hungry and looked over the edge of the bed. The food in my bowl had congealed into a small island, circled by a wide moat of yellow oil. I couldn't bring myself to eat it. Then I understood what had woken me. The bolts were slamming back again. I tried to get off the bed before the door opened, but my back had seized up. One by one, three silent prisoners trooped into the cell. We nodded at each other. I slowly pushed myself up into a sitting position. Something pricked my hand through the mattress, which turned out to be a canvas bag stuffed with straw. I leant back on the iron rungs of the bunk and rested my head on the rough stone. A cold wind blew through the bars and I looked around the cell. It was as if I'd travelled back in time to the Middle Ages.

I dozed off again. It was dark outside when I woke up. The cell was lit by a dim yellow light bulb. It couldn't have been more than ten watts. I scanned the room without moving my head. My back didn't feel right. I suddenly thought, *Fuck*, *I can't move*. I grabbed hold of the sides of the bunk, frantically pulling myself forwards and backwards, trying to get some movement in my spine.

I tried to control the terror of being paralysed by talking to myself. 'This is no good... you've got to get a grip.' Feeling slowly returned, and I listened to the sounds of the other prisoners getting ready to turn in. I tried to find a sleeping position that wouldn't hurt my back, but the wires beneath the mattress had worked their way through the straw and I hadn't the strength to get up to rearrange it.

Wind howled overhead as dark seas rose and fell around the tiny boat. I was sprawled across its wooden ribs, rocked from side to side by the storm. It was like being on the rack and the pain woke me up to find the bed wires cutting into my back.

I cursed myself in the moonlit cell for the idiot that I was.

I stopped throwing stones and looked around the prison yard. That was it. I'd gone through everything. There had been so many opportunities when I could've turned back or jacked it in, but however I looked at it, it was all my own fault. I couldn't blame Daisy for pulling out and I couldn't blame Michael for letting me ride off on the bike. He did everything in his power to stop me, but I just didn't listen.

I threw a few more stones, and finally managed to look up. The yard looked different now. The sun had disappeared behind a white sky and the hard reality of prison life was staring me in the face. It was almost a week since my arrest and I'd heard nothing. The guards just yelled at us in Spanish and none of them spoke English. There was no chance of seeing a doctor and Spain was a law unto itself. Mario had warned us about Franco's police state, but I took no notice. The simple truth was inescapable. I really was an idiot.

7

GUTEN MORGEN

Oh! To start the morning. The warden bawling Get up out of bed, you! And clean out your cell! The Dubliners

The familiar sound of the bugle woke me. I got moving as fast as I could, working my stiff jeans over my flea-bitten legs in time to leave for the yard. Reaching down to put on my socks and shoes took even longer. It wasn't only the pain that bothered me. I was worried that the pressure of bending might harm my spine. The cold early morning didn't help either. A grey wind was blowing through the bars, so I knew there'd be no sun outside.

I took a leak before leaving the cell. There was no toilet outside, just a dark alley with prisoners' piss streaming off the blistered walls. The day before I'd held my breath and kept my head down so I didn't see what the shapes in the shadows were up to. I was filling the bucket to flush the bog when a guard stormed in. He shouted something that I realised was my name. I guessed from his pointing that I was to roll up my bed. I stuffed my bowl and spoon into the bundle and followed him out of the cell. For a brief moment I had the madly beautiful thought that I was being released, but it died quickly when we passed the big metal stairway. We clattered through a maze of high walkways then stopped halfway down another long gallery while he unbolted a cell door.

I stepped inside, and immediately saw that this cell was different. It was the same size as the one I'd just left and had the same medieval window, but there was only one pair of bunks on the right, with a single bed facing them on the other side. There were even photos from magazines stuck on the wall. One showed a lush, green valley. It reminded me so much of the fields around the farm where I grew up that I stood staring at it long after the guard had locked me in. Opposite the bog and sink was a homemade chair tucked under a small table. There were writing materials on the worn wooden surface, and I recognised the blue chevrons of American airmail envelopes. I got the feeling that whoever lived there had been inside for some time.

I unrolled my mattress on the thin wires of the top bunk and gazed around. On the grey, wooden lintel above the door someone had written '*GUTEN MORGEN*' in green letters with a black outline in the style of the Paris Metro. It was well done, but the best thing about being there was that I didn't have to sit in the cold shadows of the yard while my back grew stiff. I climbed onto my bunk and fell gratefully to sleep.

Slamming doors jolted me awake. The babble of voices and footsteps told me the prisoners were returning from the

yard. It took some effort to get down off the bed, but I wanted to meet my new cellmate standing up. I watched the long line of Spaniards parade past the open door until a slight man in his late twenties with floppy blond hair walked in. His fine features lit up in a warm smile as soon as he saw me.

'Hi. I'm Mike "El Motherfucker" Pearson. Pleased to meet you,' he said in a soft Southern drawl.

He smiled at the nickname he'd obviously given himself. Nobody could have been less of a motherfucker than this mild-mannered American hippy. I shook his hand and almost felt like smiling myself.

'My name's William. Just William.'

Mike swung his arm as though indicating a grand hotel. "Welcome to Modelo, William. Make yourself at home."

I pointed to the '*GUTEN MORGEN*' above the door. 'Did you write that?'

'Oh yeah. It's an early attempt at art nouveau.'

'It's far-out, man. What did you do it with?'

'One of these.' Mike reached for a jar and pulled out a maroon Rapidograph that looked like an earlier version of mine. My eyes opened wide. A Rapidograph was the last thing I'd expected to find in a Spanish jail. Mike grinned at my amazement.

'It's all dried up now, but it worked great while the ink lasted.'

When I told him about my black Rapidographs, we fell into an impassioned conversation about drawing and artists and Underground Comix. I almost forgot where I was until the lunch bucket scraped past. We made it to the door just in time to catch a ladle of slop in our bowls. Mike sat at the table and I ducked under the bunk bar to sit on the lower bed. I could feel him watching me poke my spoon around the murky soup. It turned over a bruised tentacle, covered in suckers. My nose wrinkled in disgust. Mike gave me a wry smile.

'You can buy food from the *economarto* if you've got the cash. It's a kind of supermarket.'

'What? They have a *supermarket* here?'

'Yep. And a factory. It's called a talleres.'

I tried some soup. It was like eating slime. 'You can live off this stuff?'

'Sort of. I reckon I've lost a tooth every six months through malnutrition.'

I noticed that Mike wasn't just thin; he was actually stooped. He ran his finger round his gums revealing black gaps between his teeth.

'Fuck, man! That's awful. How long have you been here?'

'Coming on for two years now.'

'Jesus! When do you get out?'

Even through a spoonful of soup Mike sounded matter of fact. 'Don't know. I haven't had a trial yet.'

A sickening wave of shock passed through me. The idea of being sentenced for a year had been bad enough, but waiting two years before you even got a trial was too much. Mike explained that in Franco's penal system foreigners weren't tried and sentenced in the normal way. Instead they were given a *fianza*, or bail. The idea was that you paid it, left the country and they kept the cash.

'What if you can't pay? What happens then?'

Mike looked serious for the first time. 'Then they get cheap foreign labour for the *talleres*. That's why I won't work for Franco. I'm not playing the system.'

'But you must get a trial eventually?'

'Eventually. But there's one thing you've got to learn in Modelo: it's always mañana, mañana en España'.

It was hard to get a hold on this new situation. I thought I'd be tried then let out after a year. The clerk hadn't said anything about a *fianza*.

'I wonder what my bail will be?' I said.

Mike shuffled to the sink with his bowl. His jeans were so frayed at the bottom that the hems were falling off.

'That depends on what you've done.'

Mike washed his bowl, then settled down on his bunk. I told him my whole story, absolutely as it happened. When I'd finished, he didn't say anything about how stupid I'd been. He just considered it from the Spanish perspective.

'The good news is, they didn't find the drugs, so your *fianza* shouldn't be too high.'

He didn't tell me what the bad news was and I didn't want to know. But I was curious to hear how he'd got arrested. He seemed such an open guy that I decided to ask him straight out.

Mike leant forward on the bunk and clasped his hands between his knees. He calmly described how he'd been travelling around Europe in an old VW Bug belonging to his friend, Jerry. They had a stash of dope under the passenger seat and sold it to get by. I had a sudden image of Jerry and a long-haired El Motherfucker cruising around with the sunroof down like the Fabulous Furry Freak Brothers.

They'd been pulled over and searched in Spain. The cops had found the stash and they were arrested, separated and interrogated. In the hope of avoiding the statutory dealer sentence, Mike stuck by their story that the hash was only for their personal use. Then he got a shock. The cops told him that Jerry had claimed he'd picked up Mike as a hitchhiker and as the dope was under his seat, Mike must have put it there. The cell had grown dark while Mike was telling his story. He looked up at the end with a weary smile.

'Until that little karmic problem is sorted out, I have to wait for a trial.'

Moments later the doors flew open. The sound of a TV on full volume blared up from below. Mike gave me another wry smile.

'It's social hour.'

I walked over to the open door and paused. After a week of being locked up, it felt strange to be allowed out on my own. I stepped onto the stone balcony and looked over the rail at the tiny prisoners wandering around below. The raucous squabbling of a lunatic asylum rose to my ears. It was like being in the gods of a weird theatre. An unexpected attack of vertigo made me grip the rail with both hands. Mike smiled at my ashen face when I stumbled back inside.

'We never go down there,' he said. 'That's the Spanish scene. This section of the top gallery is mainly foreigners... Talking of foreigners, look who's here!'

A short, round man in his mid-thirties walked in. '*Bonsoir*, Mike. *Comment ça va*? Who eez your friend?'

'This is William, my new partner in crime. William, this is Robert the French.'

Robert smiled. There was a twinkle in his brown eyes. 'Ow is Mike treating you? Better than the pigs, eh?' Before I could reply, a thickset Italian with dark sideburns entered. He introduced himself as Luigi in a deep warm voice. For the first time in more than a week, life approached some kind of normality as we talked together. An hour later the TV was turned off and the noise of a badly played trumpet began to echo loudly through the gallery. Robert jumped to his feet. 'Hi yi yi! He is pissed again,' he sneered. 'Typical Spic! They play trumpet like they fuck – *useless*!'

Luigi and Robert began to leave, but I asked them to give me a quick opinion on my back. I struggled out of my shirt, faced the wall and waited. But as before, there was only silence. I turned around and their faces said it all.

Robert spoke softly. 'Who did zis - Guardia Civil?'

'No. Just ordinary cops.'

'No, zey were hanimals'.

'Do you think they'll let me see a doctor?'

Mike shook his head. 'They don't have a doctor in the prison. There's a couple of *practicantes* – they're like male nurses – but they don't seem to know much.' He sighed and shook his head. 'But somebody's got to take a look at that.'

Robert and Luigi left and we got ready for bed before the light went out. Mike had a bit of soap and I managed to wash a little in the cold water. The tap was set high in the wall so that you could fit a bucket underneath it to flush the toilet. I cculdn't raise my arms or I'd have washed my cropped hair. I really wanted to brush my teeth too, but all I could do was rub them with my finger.

The trustees dragged their metal tureen round again. It screeched to a halt outside the cell door. Mike passed me a tin can and I was given a ladle of lukewarm milky coffee and three soft round biscuits. Mike called them *galletas*. He spelt it out when he saw my quizzical expression, and told me that the double Ls sounded like a mix of L and Y.

The biscuits were pretty stale, but they gave some comfort. I slowly peeled off my jeans, then climbed under my blanket in my shirt and underwear. For once I fell asleep without the Spanish Inquisition going on inside my skull.

8

INSIDE OUT

Oh, I'm bein' followed by a moonshadow, moonshadow, moonshadow Cat Stevens

I must have slept deeply because Mike had to wake me even though the trumpet was blaring and the bolts were already slamming back. He quickly showed me the ropes. Our beds had to be made neatly and the cell must be tidy. Mike cleaned the sink, toilet and terracotta tiles with a damp grey cloth while the trustees pulled large oval baskets along the balconies. I followed Mike to the door and copied him as he grabbed an orange from one. A sharp pain shot through my back as I stretched out for a fat baguette with pointed ends. I was surprised to find it was still warm.

Mike laughed as he put his orange in a bowl that was halffull of them. 'Enjoy it while you can. It'll be like iron by lunchtime.' He had another surprise.

'Would you like some tea?'

'Tea?'

'You didn't expect an American to be without every mod con, did you?'

Mike turned round the tall orange-box that had been acting as a table for the fruit bowl. Inside was a hidden shelf with a tin can neatly set into it. I knelt for a better look. The can was held in place by flaps cut out of the metal. These had been folded over the shelf like petals. Shorter flaps with holes punched in them had been bent inwards and string wicks hung through them into what smelt like cooking oil. I was impressed.

Mike lit the wicks with a Zippo lighter, then placed his metal bowl full of water over the flames.

'Stoves are illegal, by the way. They'll rip them off if they find them.'

I watched Mike drop a single tea bag in the pan. 'Is that all they do?'

'Pretty much. If they catch you too often, you get sent to the *Quinta*.' Mike caught my worried glance. '*Quinta* means "fifth". It's the punishment gallery.'

I didn't like the sound of that. I wanted to know if they were going to beat me again, but I wasn't ready to ask about it yet. I was only just holding myself together as it was.

Mike poured black tea into a can, then passed me a sticky packet of greaseproof paper.

'It's made from quince. They call it *membrillo* – it's the closest you're gonna get to marmalade.'

I spread some on my bread with the end of the spoon. It made all the difference in the world.

We cleaned up and put the stove away. Harsh shouts erupted outside. Mike quickly stood on one side of the door and told me to stand on the other. I looked over the canyon to see a stiff guard in a Gestapo grey uniform marching between the open cell doors. The prisoners stood to attention, their wet floors gleaming as the guard stopped to inspect each cell. Standing next to him was a trustee who yelled out numbers, then wrote them in a register.

My heart began to pound as the guard's jackboots got nearer. I focused on a distant wall and clenched my fists. It was like being in a war movie. The guard strode into view with the arrogance of a storm trooper and stamped to a standstill in front of our cell. He looked me up and down while the trustee shouted out what I imagined were details about me. I wondered if he was telling him what I'd done. I held my glazed stare until they marched off.

Mike didn't move, but he rolled his eyes and whispered, 'You get used to it.'

The whole gallery trooped down the iron staircases and crossed the stone floor towards a massive arched doorway. Its heavy, reinforced doors swung slowly open and we followed the line of men as it fanned out into the yard. Mike squinted in the low sunlight as he pointed out the geometry of the prison. It was designed like a wheel: the circular central office was the hub and the galleries were the spokes. Twin outer walls formed a rectangular rim around the circle, which was why the big yard we were in was roughly triangular.

Mike walked me through delicious drifts of black tobacco that floated from groups of prisoners slouching in the morning sun. We stopped close to the disintegrating outer wall and I looked up at the long cloak of a Guardia Civil officer. His automatic weapon was slung over his shoulder and the sun glanced off his spooky black plastic helmet. The image was so mesmerising that it took me a while to realise this was where the chess players hung out. They sat on tiny stools with groups of onlookers surrounding them like statues. One suddenly came to life and lurched towards us. He had uneven blond stubble and wild hair that made him resemble a pirate. His voice rasped like a file on steel.

'Hey, cocksucker. Who's your new boyfriend?'

Mike smiled and gave him a wave. 'Hi, Sven. How's it going?'

'Nowhere,' Sven barked. 'Give me a fuckin' cigarette.'

I stared at him, holding down my anger as Mike pulled out a cheap pack of Celtas. Sven snarled. 'Don't give me that shit!' Then he squinted at me with a bright blue eye. 'Hey, cocksucker. What have you got?'

'Nothing.'

Sven eyeballed Mike with disgust. 'Where did you find him?'

'He's English.'

'God help us!' He staggered off and I turned to Mike.

'Who the hell is that?'

'That's Sven Svenson. He's a crazy sailor, but I'm sure he's a regular guy after a few beers and a smoke.'

I didn't have the nerve to ask Mike for a cigarette, but I didn't need to. He offered me a Celtas, then flipped open his Zippo. I breathed in the comforting smell of burning petrol as my hands cupped the yellow flame. The rough, black tobacco burned into my chest like a bonfire, sending my brain dizzy and my legs weak. It was just what I needed.

We strolled across the yard towards two stocky young Spaniards playing a ball game against a shaded outhouse wall. Mike stopped and took a long drag on his cigarette. 'It's called *pelota*.' He blew smoke into the sun as one of the men dragged a line in the dust with his toe. 'They use a wooden ball wrapped in leather.'

I could almost feel the pain as the guy hit it with his bare fist. There was a ricochet of dust each time the ball bounced off the uneven yard, then it was smacked back against the wall with the force of a boxer's punch. The game stopped and one of the guys laid his swollen hand on the stone path while the other stood on it with his whole weight. Mike winced and turned away.

'They do that to reduce the swelling.'

Just looking at it made my back ache. 'Jesus, they must be nuts,' I muttered to myself.

Mike led me to the middle of the yard, where another ball game was going on. He called it *petanca* but it looked pretty much like boules, only with larger wooden balls wrapped in padded leather. Mike stopped and tucked his thumbs in his jeans, cowboy-style.

'That's pretty much it as far as entertainment goes. You can either come and watch me play chess, or check out these guys. I warn you, though – it's a great way to lose money!'

I decided to stay put. A bunch of old lags with wizened faces were watching a wiry young guy squat in the dust to measure the distance between the lumpy balls. He dragged his sharp thumbnails along a taut length of string until they locked precisely between one of the balls and the jack. Then he held the measure rigid and swung it over the contested gap. It looked like a close call. The players argued in rough, aggressive tones until one of them stalked back to a line drawn in the dust. He swung his arm viciously in a wide arc and his shot bounced over the bumpy ground like a cannonball. It smashed the other balls away from the jack and he walked over to collect his winnings. Mike was right. It did lock like a great way to lose money. If only I'd had some to lose.

A while later I found Mike hunched over a chessboard. He was so still, it was like watching somebody staring at a sundial. You could almost see the shadows of the pieces moving across the board. I wished I had my sketchbook. Mike had a great face to draw: sharp, fine features with a lock of blond hair falling over his high forehead. It dawned on me that, thanks to him, I was reaching a level of normality where I could actually function.

I walked to the corner of the yard to find a quiet spot to think. First, I took off my shirt to get some sun on my back. It took ages to peel it over my arms, but it was worth it. The fresh air felt good as I sat on the kerb and scraped up a handful of pebbles from the warm dust. I threw a pebble to emphasise each point in my plan. The first thing was to ask Mike if he could help me see the *practicantes* and maybe even get an X-ray. Bang! The stone hit the dust, right by the rock I'd aimed at. Next, I had to find out if the consul had contacted the prison authorities. Bang! Almost got it. I was desperate for the clean clothes and the money in my suitcase, and I wanted to buy vitamins so my teeth wouldn't fall out. Bang! Close again. It would be great to get my book back so I could draw all the stuff that was happening...

I was so deep in thought I hadn't noticed the pair of shiny black boots that suddenly stepped in front of me. A hoarse voice shouted:

'Ponte la camisa! Ahora!'

I shrugged my shoulders apologetically and the guard went crazy.

'Arriba! Arriba! Ahora mismo!'

A Spanish guy nearby leant over and hissed, 'Stand up quickly!'

I stood up as quick as I could as the guard shouted again. 'Ponte la camisa!'

'Put on your shirt!'

I picked up my shirt and began to put it on. The guard turned on his heel and stormed off. It was only when I was trying to push the buttons through the holes that I realised my fingers were trembling uncontrollably. I thought I was going to get hammered again, but I had no idea what I'd done wrong. Maybe they didn't want people to see I'd been beaten up.

Mike laughed at my shirt story. Apparently it was an offence for men to show their nipples in ultra-Catholic Spain, as it might incite bestial acts. They called the crazy guard Don Juan. He hung his coat over his shoulders like a cape in an attempt to look dramatic. I called him Zorro.

In the middle of the night I found myself awake, but I didn't know why. I propped myself up on my elbows and stared into space. My top bunk was close to the window and the chilly night wind blew over my face. I had no idea it could get so cold in Spain. The ice blue moonlight was bright enough to read Mike's *GUTEN MORGEN* above the door, but I couldn't stop looking at the stark shadow of the bars on the cell wall. I knew it was a movie cliché, but it freaked me out. It told me that however much I wanted to get out, I couldn't.

I closed my eyes to block out the bars and cursed myself for stealing the bike. I thought: *If I hadn't done that, everything would be okay.* But I was only kidding myself. I could just as easily have been arrested at the border or the zoo or for walking over the cars in the street. I had to face it – I would have got into trouble sooner or later.

Trouble seemed to follow me around. Like when I'd had a summer job in Butlin's holiday camp. That had been in '67, so I would have been seventeen. It was weird – we'd joked that Butlin's was like being in prison because we were locked in a barbed wire compound patrolled by the camp guards. We'd even had metal bunks and I was up on top.

On the first night, I was woken by the whole bed shaking. I'd thought there was an earthquake until the squeaking stopped and my room-mate whispered to a girl, 'That was the first – now for the second!'

I didn't even make it to first base. The next night the guards caught me chasing a girl through the moonlit camp, hammering out a riff on my guitar. They threw me out. What had made me wreck what could have been a great summer? Was it just because I was drunk and stupid? Or was there more to it?

A red-hot *chinche* bite was burning my thigh. I knew that if I started to scratch it I wouldn't be able to stop. I stuck my knee into the cool air and moved the straw around, trying to get my back comfortable.

Now that I was forced to think about it, my problem seemed to be obvious: I never learnt from my mistakes. That was because I lived for the moment. And if I didn't like what was happening, I just moved on. But what could you do when the moment wasn't worth living for and there was nowhere to go?

I turned away from the moon shadows of the bars and tried to ignore the stinging in my leg, but there was nowhere to hide from my thoughts. For the first time I understood something serious. If I didn't learn from this experience and figure out what was wrong with me, I'd keep doing the same idiotic things over and over until I got myself killed. I couldn't stand the itching any longer. My ragged nails attacked the *chinche* bite in an ecstasy of scratching, until my leg was slippery with blood.

9

OUTSIDE IN

I think I'm returning to The days when I was young enough to know the truth Dusty Springfield

The morning bugle worked its way into my dream and I woke up in confusion. I thought I'd overslept and scrambled off my bunk in a panic. The movement wrenched the bruised muscles I'd been nursing so carefully and I cried out in pain. Mike made my bed for me. If he hadn't helped me get dressed, I wouldn't have been ready in time for inspection.

Mike leaned out of the queue as we waited to go into the yard. He spoke softly to the guard, who grudgingly allowed us to visit the *oficina*. As we waited outside the door, I tried to remember the few words of Spanish that Mike had taught me. I mustn't use the familiar *tu*; I must use *usted* or they'll think I was being disrespectful.

I repeated '*usted*' to myself over and over until a harsh command called us in. We stood with our heads bowed respectfully in front of two guards seated behind a heavy wooden desk.

'Qué quieres?'

Shit, I thought. It's Zorro. His pressed uniform and polished straps made me feel even more dishevelled than I was. As soon as Mike began to talk, Zorro reached back to a cabinet and pulled out a file. That was just what I didn't want to happen. If he read my charge sheet, he'd find out what I'd done, then he'd really have it in for me. Mike finished his speech and I threw in a humble, '*Gracias, por favor*.'

Zorro paused for effect, then rattled off something incomprehensible as he filled in a form. He signed it with an absurd flourish, so that his signature ended up heavily underlined and surrounded by a massive circle. Then he handed Mike the *instancia* and dismissed us with a contemptuous flick of his wrist.

Mike led me down a dingy corridor to a badly whitewashed cell. They hadn't bothered to work the paint into the uneven surface so it was patchy and pitted – a perfect match for the grubby white coats worn by the *practicantes*. The larger of the two medics looked with disdain as Mike helped me out of my shirt. From what I could see of my shoulders, it looked like I'd been run over by a steamroller, but they were unimpressed. The smaller man listened impassively to Mike, but although he addressed him as *Senor*, it was usually followed by the word '*No*'.

It was hard to tell whether the *practicantes* didn't know what an X-ray was or if they didn't think I needed one. Mike tried to explain my lack of coordination, but their faces remained blank. When he resorted to mime, they looked like Laurel and Hardy trying to grasp the theory of relativity. In the end they bundled us out into the yard with some dubious-looking pills. Mike offered me a cigarette as an apology.

'Sorry about that. You'd have to be in a coffin before they'd let vou see a doctor.'

I finished buttoning up my shirt before the cold got to me.

'It's not your fault. I don't think those two were even medics. They looked like the blokes who drag the soup around.'

Mike lit my cigarette, then snapped his Zippo shut. 'Don't let it get to you... Chess?'

'No thanks. I'm going to sit down.'

The weather had turned again. It was a grey, late November mcrning and my denim jacket did nothing against the wind. Blankets weren't allowed outside, so all I could do was sit and freeze. I'd imagined there'd be long stretches of time in prison to examine my past and work out what was wrong with me, but there was no way I was going to figure out anything in that cold, bleak yard. I couldn't even work out how to keep warm.

The lunch bucket scraped down the gallery as I huddled in my bunk to thaw out. I tried to find a painless angle for my back, then began to pick the chickpeas out of my slop. They didn't look much different from the pills the *practicantes* had given me. I'd decided not to take them; they looked like they could knock out a horse.

A steady stream of prisoners shuffled past our open door. I asked Mike why they were all carrying tin cans.

He grinned. 'Ah! Para el vino.'

'Para what?'

'For the wine.'

'Wine! You get wine in prison?'

'It's traditional to drink wine before siesta. I think it's foul, but hey – you might like it.' I borrowed a can from Mike and plodded down the fire-escape steps towards a bustling queue on the ground floor. A trustee poured a small ladle of dark liquid from an oil drum into my tin and I nursed it back to my bunk.

Mike was right. It tasted like battery acid, but it was alcohol. The bed began to warm up and I sank into a doze as the wine took effect. I didn't want to fall asleep, though. This seemed the perfect time to examine my life. I decided to start right at the beginning.

The first place I could remember was the farm. Except for staring at a boring tree for hours in a pram, my earliest memory was of Jeremy. I didn't know if it was the wine or my state of mind, but my vision of him was incredibly clear. It was as though I was two years old again, looking across our old red shale farmyard.

Jeremy was standing at the corner of the farmhouse. His thick hair stuck up and the collar of his white shirt curled over a V-necked sweater. His grey shorts were crumpled and bulky. Jeremy steadied himself on the wall with his hand, then walked towards me like a robot, his leather and metal callipers scraping across the farmyard.

I'd forgotten that Jeremy had had rickets. I couldn't remember what happened after that, but the strange thing was that I could turn around in the yard and see the view from the house as clearly as when I was a child. Nettles were blowing in the wind by the dry-stone wall, and beyond the rusty bars of the gate was the meadow that led down to the stream. The stillness was beautiful. In the far distance, cloud shadows slowly passed over patchwork fields on the rolling hillside. I could almost feel the summer breeze in my hair.

I am tiny. I hold my mother's finger as she guides me through the soft poppies and the feathery grass that tickles my face. Cotton-wool clouds float in the high blue sky as we walk down the gentle slope towards the low stone wall. Mummy lets me climb the wall by myself. Its yellow moss feels warm under my fingers, like an animal's back. I turn to climb down but my foot swings into empty space. I'm frightened until I feel the firm earth of the field.

Grasshoppers spring away from us and cling to tall stalks of grass that bend with their weight. I hold the finger tight as my feet roll on crab apples that have fallen from the crooked little trees. The corner of the field is my favourite place, where the stream widens into a silent pool. Mummy lets me crouch down with my sandals in the sun-dappled shallows.

I watch the clear water ripple over shiny brown stones, reflecting the lilacs that curve above us. The thick summer air is full of birdsong and poppy seeds, and the warmth of the sun mixes with my mother's love and I know that I am happy.

The memory faded and was replaced by another. Pansies bobbed in the black witches cauldron that stood by the brick arch leading to the garden. I kneeled by the stone border that ran around the flowerbeds, following the trail of a snail with my fingers. Mummy lifted a slab of stone and I reached into the cold, dark earth beneath it. A spider ran out and the stone dropped like a guillotine. I pulled my hand away from the pain with my fingertip dangling on a shred of skin.

The bugle called me back to the cold reality of the cell. I sat up and examined the neat way they'd stitched the tip back on. You'd think I would have learned to look after my fingers after that, but I didn't. Not long afterwards I grabbed the orange bar of an electric fire and burnt them all. It was the colour that drew me to it; it was so bright and beautiful that I hadn't noticed the heat.

Siesta was over and the castle doors swung open. We shuffled out, blinking at the cold white sky. Mike went straight towards the lookout tower, but I hung back. The miserable bastard who watched the chess games through his fingers was already there. He always coughed when somebody made a bad move and it pissed me off. Sven Svenson lurched up to the group of players with his hands waving, probably trying to bum a Marlboro from some poor cocksucker.

I turned away and weaved through the crowd, avoiding the scary bloke from Transylvania. He had an overhanging forehead and looked like he ought to have a bolt through his neck. Raoul, another of Mike's pals, was standing by the outhouse wall with the group of hard cases playing *pelota*. It was hard to tell if he was smoking or if his breath was turning to mist in the cold. Anyway, I didn't know him well enough to ask for a cigarette, so I kept walking to keep warm.

I stopped to watch the stony-faced old boy who was always playing boules. He put such a heavy backspin on the ball that it dropped dead where it landed, right next to the jack. Except for his scruffy clothes, he reminded me of the pensioners Daisy and I used to see playing bowls on Woodhouse Moor. I used to admire the way their slow, curving balls rolled over the green then bellied up next to the small white jack. I wondered what state Daisy was in and where he was. He probably thought I was still living it up in Paris with Sylvie.

Somehow the old boy always managed to end up with his ball so close to the jack, the other guys were forced to waste their turns trying to knock it out of the way. I tried to concentrate on the game, but I kept wondering what would happen to me. I had no idea how a police state worked. For all I knew, they could hold me for years without trial – and not tell a soul I was here.

A shout from the game made me look up. Someone had managed to knock the old boy's ball away, but the jack had rolled off into open space and he'd got the last throw. He cupped the ball in his hand with his knuckles facing forward so he could snap the backspin on at the last moment.

Had Michael known I'd been arrested when he took my suitcase to the consulate? If he hadn't told them, how could they possibly know where I was?

The old boy's ball curved through the air in a high arc and dropped next to the jack with a little puff of dust. There was only the slightest change in his expression as he walked over to pick up his winnings. It could have been a smile or just the line of his mouth setting itself against the cold. You couldn't tell.

Going down for wine became a routine. I stood in the long queue with my shoulders hunched, slowly doing the forward shuffle. All eyes were fixed on the thin black ladle as it dipped into the oil drum. It looked like a tiny tin can stuck on the end of a long metal rod. It barely held more than a few mouthfuls. I was shivering. All week the yard had been getting colder and colder, but I managed to hold my can steady so the trustee wouldn't spill any of the precious wine.

Mike was in a deep siesta snooze when I got back to the cell, so I quietly climbed onto my bunk and got under the blanket. I took a small sip and snuggled into the straw, waiting for the alcohol to spread down my body and warm up my feet. It was so vile it had to be drunk slowly, like medicine. But I didn't care, as long as it took me where I wanted to go.

When it was cold at the farm we used to chalk pictures on the flagstones on the kitchen floor. I could almost feel the warmth of the blazing coals in the black-and-chrome range. That was where I first started drawing. Mum would chalk a few circles and lines, and suddenly a steam train would appear. The magic of that always thrilled me. I filled stone after stone, trying to draw like she did until the floor looked like a giant comic book. Mum sang along to the radio as I drew. It was the kitchen where I learned my first song, 'The Black Hills of Dakota'. I used to think they were the dark peaks of coal slag that glistened on the edge of our wood. Mum sang the song to Dad when he came home from work:

> Take me back to the black hills The black hills of Dakota To the beautiful Indian country That I love...

I'd hang off the end of the black piano as Dad worked out the melody and the chords. He'd turn and smile when his hand came crashing down towards me on the bass notes because he knew I liked the sound of their deep rusty echo.

A sudden, desperate ache to be back there made me move on – to the time Mum walked us over the black hills to climb trees in the gipsy wood. The more scared she got, the higher we'd go. I didn't see Jeremy fall, but I heard the branches snapping and the thump as he hit the earth. He lay still with a white bone sticking out of his arm. Mum gathered him up and ran across the dark hills, leaving me crying, 'I'm lost! I'm lost! I'll never be found!'

It became a family joke. I was the little boy who cried wolf. It only took the wind howling down the bedroom chimney to have me calling for help. Everything scared me. When Dick Barton shot a giant spider in his radio play, its gruesome body seemed to land with a sickening thump on our kitchen table. It filled me with such horror that I screamed until Mum came running. She always said the same thing: 'One day you'll cry wolf when you really need help, and nobody will come.' The creak of Mike's bedsprings told me he was getting up. I hated that sound. It meant that the warm siesta was over and we had to go out in the cold December wind again.

Mike offered me his chess stool so I wouldn't freeze to the kerbstone. I tucked it under my arm and we shuffled into the long line of prisoners on the high walkway. Every day was the same in Modelo, so it was hard to keep a sense of time. Three weeks had passed since my arrest and I still hadn't heard from the consulate. Maybe the fascist police didn't want them to know they'd beaten up a British citizen. I looked over the iron railings at the anonymous crowd filling the distant floor. The prison felt like a giant grey tomb hiding me from the world and I couldn't help saying to myself, 'I'm lost. I'm lost. I'll never be found.'

Zorro strutted up and down with his cloak flying as we queued up by the doors. You could tell he loved the sound of his voice ringing around the giant gallery. It was like being back in church, listening to the vicar droning on. Suddenly I realised Zorro was pointing at me with his arm outstretched, hissing like a goose with every flap of his hand.

'Oyeh! Venga! Ssss! Ssss! Ssss!'

Mike nudged me in the back.

Zorro barked like a dog as I walked towards him. 'Por qué tiene esto?'

Mike had taught me to say, 'I don't understand', and to put 'please' in front of everything. '*Por favor, no entiendo*.'

Zorro pointed to Mike's stool and rattled off a sermon. There was obviously a problem with it. I didn't know what – other people had little chairs. He gestured towards the floor and shouted, so I put the stool down and got sent back to the queue.

I asked Mike what it was all about when we got outside. He laughed. 'Apparently the stool was above regulation height, so it's been confiscated.'

'I'm sorry, Mike. I had no idea.'

'Me neither.' Mike laughed again. 'No wonder I got it cheap!'

'Jesus, I'm freezing. This wind goes right through me.'

'Maybe you're ready for some exercise. That'll keep you warm.'

I fancied having a crack at *petanca*, but Mike thought it would mess up my hands and make my back worse. Instead, he steered me through sparse groups of prisoners towards a game of basketball. We watched the ball bounce around in a haze of dust until there was a break in play. Mike crossed a line scored into the earth to chat to Raoul, then jogged back, grinning. 'You're in luck. He wants you on his team.'

I looked over at Raoul who was waving me over. 'But he hasn't seen me play yet!'

'He doesn't care. You're the tallest guy in the yard!'

The ball was thrown to me as soon as I jogged onto the pitch. I caught it, bounced and ran, but something was wrong. I couldn't do it. I couldn't run and bounce the ball at the same time. It was ridiculous. Basketball was easy. They kept passing to me, but it was no good. My coordination was shot to pieces. I held up crossed arms to signal defeat and joined Mike on the sidelines.

'Jesus, man! There's something wrong with me. I can't fuckin do it.'

Mike tried not to look concerned. 'You're bound to be rusty after a beating like that. And the ground's uneven, so the bounce is going to be unpredictable.'

He was trying to give me something to cling to, but it didn't help. I kicked stones across the yard as we headed over to the chess area. Furious thoughts exploded in my mind. I couldn't believe the bastards hadn't let me see a doctor. I might have a cracked vertebra. I hated Zorro. He'd only ripped off Mike's seat because I had it. And I was sick of freezing. If the consulate sent me my suitcase, I could at least be warm.

I turned to Mike when we reached the chess wall. 'How can I get in touch with the British Consulate?'

Mike frowned. 'First you have to get a form. That's a job in itself. Then you have to fill it in. Then you wait. Like they say, it's always *mañana, mañana en España*.'

I hated waiting. I just couldn't understand how a smart guy like Mike could calmly hang around for a trial while his teeth fell out one by one. I watched him amble off to play chess and thought: *I need to see the consul and get the fuck out* of here before I start to fall apart.

The lengthening shadow of the wall herded everybody into the corner to get the last of the winter rays. I huddled in the crowd, longing for the warm clothes and money in my suitcase. It was impossible to do anything in Modelo without cash. Mike had some soap, but it didn't lather in the cold water, and you had to pay for a hot shower or to get your laundry done. I was pretty sure my *chinche* bites weren't healing because my clothes were so filthy.

The toasted aroma of a Bisonte brought me back to the yard. I moved in closer and inhaled the mellow smoke. Bisonte was the nearest you could get to Golden Virginia, and it made me realise how much I missed my roll-ups. The sun quickly sank below the wall and the Bisonte drifted away with it.

At last we trudged up the iron walkways back to the cells. I noticed how Mike had to drag himself up on the rail and I couldn't bear the thought of ending up like that. He turned round as though he'd heard my thoughts, and called over his shoulder between breaths.

'I've got an idea.'

I stared at his worn boot heels as he suggested we write directly to the consulate. I couldn't help smiling to myself. Mike had been walking up and down these stairs for two years, yet he seemed to be doing more to me get out than he ever did for himself.

Back in the cell, we got to work on the letter. The only interruption was the food tureen. It was pig's back soup with lentils, so I put the bowl up on my bunk to let the *lentejas* separate from the oil. Mike had stamps and envelopes, and he knew how to get hold of the consulate's address. It wasn't much of a letter, but at least they'd know who I was, where I was and roughly what I'd done.

Mike stretched out on his bunk and tapped a Celtas out of a hollow soft pack. He offered one to me, but I turned it down. The guy was doing more than enough without me taking the last of his fags. I stared at the hairy slabs of fat floating in my bowl. The thought of eating them made me feel sick, so I grabbed hold of the bunk bar and tried a few pull-ups, bending my knees to take the weight off my arms.

It didn't feel too bad, so I did a few more as the blare of the TV drifted up from the gallery floor. They seemed to play the same commercial over and over. Some kid was desperate for sweets and kept whining, '*Quiero caramelos! Quiero caramelos!*' in the world's most annoying voice. Still, the advert worked on me. I could have killed for a bag of Maltesers or a big, fat Mars Bar. Each time I dipped under the bunk I glimpsed Mike, slowly dragging on his fag as though it was a joint.

I called out, 'Hey, Mike! Remember getting the munchies

when you were stoned and you had to go out and buy a whole load of sweets?'

Mike laid his book down with a smile. 'Oh, yeah. Did you see that Freak Brothers story? The one where Fat Freddy trips out on a bong full of dope, then runs into a store with an axe and rips off a whole load of candy and stuff?'

'Yes! And Freewheelin' Franklin tells the shopkeeper he's just about to be on Candid Camera.'

Mike grinned. 'Those drawings are so far out, man. The way Fat Freddy hacks through the store like a maniac, but always has one beady eye fixed on the next thing he's gonna munch'

I smiled too. 'That's exactly how I feel right now.'

Robert the French bounced in, looking not a million miles away from Fat Freddy himself.

"Ow is your back today, young William?"

'A lot better, thanks.'

'Soon you will be strong, like an 'orse!'

'Not on this crap, I won't.'

I picked up my half-congealed bowl and poured it down the bog. Robert's eyes blazed.

'Je sais! In France we give chickpeas to the pigs because we know they make people crazy. But the Spanish eat them every day. No wonder zey are so stupid!' He was almost shouting.

I poured the bucket of water into the toilet from chest height. Thankfully, the hairy slop disappeared. 'I just can't eat this stuff. It makes me sick.'

'Zen you buy food - simple!'

Mike took out his chess box. He'd drawn a beautiful label for it in art nouveau letters. I asked him where the *economato* was. 'It's in another gallery. You have to queue for ages or pay a runner to go for you.' Robert sat on the bunk opposite Mike and looked at me with interest. 'You 'ave money?'

'Not really.'

'Zen you can buy nozzing!'

'I know. I'm thinking about working in the *talleres*, but I need to get back into shape first. What do they make there, anyway?'

Mike looked up from arranging the chess pieces. 'You know all that tourist crap you see in the shops?' I didn't, but I nodded anyway. 'It's all made in Spanish prisons. Anyone for tea?'

I quoted Fat Freddy as Mike got up to light the stove. 'Is the bear Catholic? Does the Pope shit in the woods?'

Robert frowned at me, waving a bunch of pawns in his fist. 'Why you say ze Pope shit in the woods?'

Mike stepped in. 'It's from an underground comic...'

'Pah! American hippy shit!'

I wanted to steer the conversation back to the *talleres*. 'I don't mind making crap for tourists if the pay is okay.'

Robert smacked the pieces onto the board. '*Putain de merde*! I would rather die than work for Franco!' Like a fool, I asked why. 'Because Franco is the son of a whore! Picasso is dying but he don't come back in Spain while Franco is alive. Franco has a duty to die first!'

Mike gave Robert a sly grin. 'So you do like some Spaniards?'

Certainement. Picasso is a great artist. But only because he live in *la belle France*?

Mike winked at me. 'Picasso's okay, but he's not as funny as the guy who draws Fat Freddy. Maybe Pablo needs to smoke a bit more weed.'

Robert waved a handful of pawns at him.

'Who needs hippy drugs when you have French wine? I tell

you somesing funny. Picasso makes more money with one scribble than all your hippy comics will make in a lifetime!'

Mike held up his finger and put his hand on his heart to quote Free Wheelin' Franklin. 'Maybe, but dope will get you through times of no money, better than money will get you through times of no dope!'

I went to bed feeling okay, but a few hours later I surfaced from an uneasy sleep into the moonlit cell. My heart was racing. Perhaps it was nicotine withdrawal symptoms. I should have taken that fag when Mike offered it. Still, at least he'd got hold of the Consulate's address after beating Robert at chess. I hadn't known Picasso was dying. No wonder he wanted to go home. So did I. Christmas was coming and the thought of it gave me a wild yearning to be back in England.

My head was heavy with tiredness, but whenever I drifted off another *chinche* bite started to burn and the wires kept cutting into my back through the straw. Memories of my arrest crept into my mind. I tried to think of happy days on the farm to keep them away, but the stupid fact that I'd kicked a cop's head in a police state kept coming back to haunt me. I was sure that was why they wouldn't let me see a doctor. And it was why they were going to keep me waiting years for a trial that would never come.

The urge to rip the flesh off my burning bites was giving me a headache that gripped my skull like a vice. I wanted to get up and go out into the street and find a cigarette machine. I wanted to go somewhere, do something, be anywhere other than where I was.

I sat up quickly to stop the wave of horror and stared round the cell. The moon had risen and the bastard bars were back on the wall. It was checkmate. There was nowhere to go and nothing I could do. And I had the whole night to get through.

My eyes screwed up as my fingernails dug deep into my temples. I thought: *If I hadn't given up crying back in Leeds, I would sob myself to sleep*.

10

ONCE BITTEN

Spanish is the loving tongue. Soft as music, light as spray. Bob Dylan

The moment the bugle blew I got out of bed and began to wash the dried blood off my body. Mike swung his legs out of his bunk and winced at my scratched-up bites.

'Woh! Those guys have gone for you in a big way.'

I wanted to tell him how I was feeling, but it would have been an admission of failure. It wasn't just the prison that was getting me down. The Freak kept coming back on me and it was getting harder to hold it at bay. Mike watched me ease my filthy jeans over my bug-bitten legs.

'If you want, I'll show you how to get rid of chinches at siesta.'

'I can hardly wait,' I said sarcastically, then felt bad. He was only trying to help.

The bolts slammed back and we stood to attention at the

cell door. It wasn't like standing still in school assembly – even the toughest prisoners were ramrod stiff and totally silent, and when the guard had moved on, the prisoners didn't budge.

The guard stopped outside our door and looked up and down our disheveled clothes with a supercilious sneer. How things had changed. Not long ago I'd been strolling around the zoo, looking in all the cages. At the time I'd believed I understood the animals' pain, but now I knew I'd had no idea what they were going through.

The baskets scraped along the walkway and we rushed to the door to grab our bread and oranges. I peeled mine straight away, but Mike arranged his artistically in the fruit bowl. I looked at his skinny frame and thought, *No wonder his teeth fall out*.

'It's weird that I worked in a zoo right before I landed up in here,' I said.

Mike nodded. 'That's karma for you.'

I wandered around the patio like a dead man. I felt worse than I had since my arrest, and on top of everything I was dying for a fag and some clean clothes. I sat on the kerbstone and started drawing shapes in the sand with a stick. I'd considered writing home, but after what had happened in London, I wanted to deal with it on my own. Anyway, what could Mum do from there?

I'd even thought about writing to Hanna, but that would have been weird. The last time I'd seen her she was crying her heart out on the wall outside my new girlfriend's flat. Hanna was so suicidal that I'd run down the road to the fire station to ask if they could help. A big Yorkshire fireman had lumbered up in all his gear and said to her, 'Come on now, love. Don't take on so.'

Hanna threw back her head and wailed into the night

sky. The fireman was bewildered, but I knew why she was screaming. If I was heartless enough to think the fire brigade could help her, then it really was over.

I leaned back to look at the mandala I'd scratched in the dust and thought, *The whole thing was my fault. I can't ask her for help.* The symmetrical pattern looked like a mystical sign; it seemed to be saying something. In a way it was. It was the first drawing I'd done for more than a month, and it reminded me that I always felt terrible when I stopped drawing. I decided to ask Mike for some paper and a pen so I could draw his portrait.

All thoughts of drawing left my mind when I went inside for siesta. El Motherfucker was grinning at me from the middle of the cell with his Zippo clenched in his fist.

'Okay, *muchacho*. Clear the decks!' I rolled the mattress off my bunk, revealing the crisscrossed wires. Mike pointed meaningfully at the short, metal springs. 'Right, this is where the little motherfuckers live. Watch this.' Mike unhooked a bedspring from the rusty frame, then flicked his Zippo open and alight with two quick snaps of his fingers.

He held the bedspring over the smoky yellow flame with a grim smile. Nothing happened. *It won't be long before his fingers start to burn*, I thought.

'Come on out, you little vampires! I can stand this longer than you can.'

Suddenly a fat black bug jumped out of the spring and landed on the floor. Mike yelled, 'Kill it!'

I stamped on the bug, dragging my foot backwards to make sure it was dead. A long smear of blood trailed from my shoe. It was unbelievable that one tiny insect could hold so much. Mike was still cooking the spring.

'Hang on, there's gonna be more!'

He was right. Two more *chinches* abandoned ship and I stomped them into red blobs. Mike was gleeful.

'Just think - that's your blood down there.'

I bent down for a closer look, then drew back quickly, 'Jesus, it stinks!' I unhooked a spring of my own and chanted Arthur Brown's lyrics as I roasted it over a match: 'I am the god of hellfire and you are gonna *burn*!'

After a few seconds an absolute hippo of a bed bug plopped onto the floor. I quickly burst its bellyful of blood before it had a chance to hop away.

'Revenge is sweet!'

Mike had another spring on the go and his eyes were on fire. 'Burn, baby, *burn*!'

Bloodlust overtook us and I quoted Mike the classic Hancock line as we stamped a sticky red pool all over the terracotta tiles: 'That's very nearly an armful!'

We spent the whole of siesta making up stupid jokes as we roasted every last bedspring. It wasn't just the fun that made me feel good; it was the fact I was doing something at last.

There was almost a feeling of peace when the blaring TV was switched off and the doors slammed at the end of social hour. The twilight sky glowed through the bars as Mike poured tea into our beakers.

'I love the whole English tea thing. Back home, I'd always warm the pot and use tea leaves – never bags.' His nose wrinkled as he took a sip from his green plastic cup.

'I always had English bone china too. One finds the taste is faaar superior.'

I laughed at Mike's Dick Van Dyke attempt at a posh accent. 'That's funny, because I always wanted to be a cowboy. I had the whole costume when I was a kid. The boots were the best bit – red rubber with curved tops and embossed patterns all over like tooled leather.

Mike turned up his nose again. 'I never went for the Western thing: too darn redneck for me.'

I suddenly remembered I'd been planning to draw his portrait.

'Could you let me have a piece of paper and a pencil?'

Mike carefully tore a page from his writing pad. He smiled as he placed it on his chessboard with a blunt stub of a pencil. 'Sorry – they don't trust us with knives.' He watched me sharpen the point by sanding it down on the rough cell wall. 'What are you going to draw?'

I sat on the bottom bunk under the dim yellow light bulb and smiled. 'You,' I said.

The shadows from the bare bulb accentuated Mike's sharp features. I couldn't wait to get them on paper, but I hesitated before making a line. I'd been terrified that my poor coordination would affect my drawing. There was only one way to find out.

I drew a bold line, indicating the angle of Mike's forehead. I was just about to curve around the back of his head when the light went out. It really pissed me off, but Mike laughed in the blackness.

'What?' I said.

'Didn't you know we're being watched?'

I fumbled my way into my bunk and sank into the straw mattress. The quiet of the night was the best time to examine my past, but I was too tired to go back to the days of crying wolf. I stared into the black cell, remembering how scared I used to be of the dark. I always slept with my bear. Benjamin wasn't like a toy. His soft fur gave me something comforting to hold onto when the wind howled down the chimney. I closed my eyes and for the first time, a pleasant wave of exhaustion passed over me. I knew I was going to sleep well. Not only had we killed every fat *chinche* that had sucked my blood, I'd also done twenty pull-ups on the top bar using my legs to help, and twenty low angle press-ups on the bottom bar using only my arms. I closed my eyes and thought: *Tomorrow I'll do twenty-five*.

I woke from a nightmare in the early light and checked my watch, forgetting it was broken. It was my turn to mop out, so I got up to stop the freaky feelings taking over my mind. The cold of the tiles seeped into my feet as I took a leak. The dream was always the same: insane policemen chasing me through underground dungeons but I couldn't run because my legs were made of lead. There was no chance of escape and I always woke sweating with fear. I flushed the bog with the bucket and splashed my face from the tap as it filled up again. The chilly water woke me fully. It was another bleak day and my jeans felt as stiff as cardboard as I forced my legs into them. The bunks were bolted to the floor, so I held onto an upright with one hand and braced my feet against the base. Then I swung around in a wide arc, wiping the tiles with the other hand. My arms and back held up, so I guessed my exercise regime must be working.

I'd almost finished when the bugle woke Mike. He squinted at me quizzically.

'You're up early. Still being bitten?'

I wanted to tell Mike what had really got me out of bed: My nightmares filled me with a dread that could last half the day. But it would have been weak to admit that in prison, so I just said, 'No, we must have killed the lot.' I added, '*Quieres* tea?' as a sort of thank-you for his help. Mike replied in Spanish, speaking slowly as he always did to help me to learn. '*Sí, hombre. Gracias*'.

Mike pronounced *gracias* like *grathias*. It made me wonder why as I lit the stove. 'When I first arrived here, I thought everybody had a speech defect.'

'Por qué?'

'You know - the lisp on all the words like grathias and Barthelona'.

Mike really drawled when he was sleepy. 'A looong time ago there was a king who was really loved by the people. He was one of the Philips... the third, I think. Anyhoo, he had a lisp, so everybody just took to talking like him in his honour.'

'Bollocks!'

Mike got up on one elbow, looking as sincere as a halfasleep hippy could.

'It sounds crazy, but it's true. In South America they still pronounce the "c" in *gracias*. When they come to Spain, they find *Castellano* really funny.

'So a whole nation speaks with a lisp because of one bloke? Mike grabbed his jeans as the doors started flying back along the gallery. 'Maybe the same thing happened with Franco. All the poor farmers admired his uniform and gun so he gave them what they wanted. No wonder they ended up with a police state.' He finished buckling up just in time. 'Look out, here they come...'

The door crashed open and the trustees dragged their baskets past at high speed. I began to ask Mike why he never ate his orange, but he held up a hand. He was listening intently to the official calling out names from below like a town crier. The list ended with a big shout of '*Correo*!' and Mike said, 'Nope. Nothing for you.' 'What's that?'

'It's the mail call. You'd better listen out in case you get a reply to your letter.'

That was a downer. I'd forgotten about the letter. It seemed like everybody had forgotten about me too.

Mike led me to the basketball pitch and waved to Raoul. I felt too tired to play, but Mike's friendly pats on my back ended in a push and I was propelled into the game. Almost every time the ball came to me I fumbled it, but at least I was running around and getting warm. Mike grinned from the sideline for a while, then went off to play chess. I ran around a bit more, then drew my finger across my throat to let Raoul know I'd had enough. My head was pounding as I walked towards my corner of the yard. It was the most I'd ever played, and I sat down to rest my aching back.

When I leant forward to scrape up some pebbles, my dusty clothes stuck to my wet skin. I hated being dirty and I hated being in limbo. Mike was right. *España* really was the land of *mañana*, where nothing ever happens. Nothing had happened for Mike and he'd been banged up for years.

I threw down my handful of grit and got up to walk around the yard. I avoided the chess players. Even the sight of them bored me rigid. The usual group of hard cases was standing by the *petanca* wall. I kept my head down, but as I passed by Sven Svensson broke away and leered up in front of me. His blond hair stuck out all over the place and his blue eyes were surrounded by yellow, bloodshot whites. He barked at me like an old sea dog.

'Hey cocksucker, what's happening?'

'Nothing. Nothing ever happens in this dump.'

'Could be worse: you could be in a storm at sea, den you'd

give anything to be right here.' Sven stabbed his finger at the ground as if I didn't know where 'here' was.

'I don't think so. Right now I'd give anything *not* to be here.' 'Oh yeah? Well how about giving me a cigarette?'

'I haven't got any.'

'C'mon, cocksucker. Gimme a fuckin' cigarette!' His mouth hung open expectantly, all yellow teeth and blond stubble.

Hot adrenaline flooded my veins and I pulled my fists out of my pockets. 'I just told you. I haven't got any. *All right?*' Sven held my stare for a few seconds, then lurched off. I stood in the middle of the yard, waiting for my blood to stop pumping. The guards would have come down on me like a ton of bricks if I'd got into a fight. A light breeze ruffled my hair and reminded me to breathe again.

Something above me made me look up, and I squinted at a jet pushing its way slowly through the grey sky. It was a rare sign of people in the outside world. I'd never been on a plane, but I could imagine the tourists looking out of the windows, thinking how beautiful Barcelona was. That depended on where you were. Down in the yard the guards walked the same walls that threw the same shadows across the same yard. Even the same clouds seem to drift by each day.

The bell rang and I joined the ragged line drifting towards the doors. I stared at my shoes to avoid catching the eyes of the guards. The trudge of our footsteps echoed off the stairs like the tread of monks in a monastery. The acoustics always gave me an irresistible urge to sing sad songs.

As I walked out in the streets of Laredo As I walked out in Laredo one day...

The long stream of prisoners filed past my slow footsteps

towards the high gantry. They stared at me, but I didn't care. Singing in the prison was like singing in the church choir – I never noticed the congregation.

I saw a young cowboy all wrapped in white linen All wrapped in white linen as cold as the clay...

I stopped on the top bridge to finish the song. Weak sunbeams shone through the big circular window, casting long shadows from the tiny figures below. The childhood memory of singing in my church choir rose so strongly that I only just managed to get to the last line before my throat choked up with the sorrow of the song.

For I'm a young cowboy and I know I've done wrong.

Mike beamed at me as soon as I walked through the cell door. Immediately I saw why: a suitcase was sitting on his table. It was mine all right: scuffed white, compressed cardboard with a ridge of light brown plastic trim stitched round the edge. Mike seemed as thrilled as me and we couldn't stop smiling. I snapped open the rusty locks. It was full! I checked the hidden pocket. It was reassuringly empty. I thought: *One day I'm going to find Michael Schneider and thank him for saving my life*.

I slipped my hand down the side for my wallet. Nothing. 'Shit! My money's gone.'

Mike nodded. 'I think they keep all your bread and give it back when you leave.' That was terrible news. I knew I wasn't going to get my guitar back either.

Just then the metallic scrape of the lunch bucket triggered a Pavlovian response. I grabbed my hubcap and joined Mike at the door. 'I'm sorry, Mike. I wanted to pay you back. There was over fifty dollars in that wallet.'

'Forget about it. We'll get by.'

I held out my bowl for the slop and carried it back inside. It looked like puke.

'That's it. I'll have to get a job. I've got to get some decent food.'

Mike sounded like he'd been expecting my question for weeks. 'I can hook you up with Louis if you want. He's the *talleres* foreman and he's on this gallery.'

I didn't reply. I'd remembered I hadn't checked in my case for my book. Mike looked worried as I scrabbled frantically through my clothes. Finally my fingertips found the hardback cover.

'Thank God! And ... yes, here are my Rapidographs.'

Mike examined the pens with professional interest. They'd dried up, but he was sure they'd work again if I soaked them in soapy water. He asked to see my book and I picked the lentils out of my soup while Mike studied each page. He laughed when he got to my cartoon of Crumb's Mr Natural.

'You didn't tell me you could draw.'

'I did.'

'Yeah, but you didn't tell me you could *really* draw. You've got to meet Patrick. He's an amazing artist. He uses a ballpoint pen.'

'Far out! I knew a guy who used to draw with a Biro. He taught me how to write copperplate script with one.' I paused in the middle of washing out my hubcap. 'I've just remembered – he's in prison too. His name's Tim Daly. He was a pacifist and a poet and he set fire to the Imperial War Museum in London. Caused half a million dollars' worth of damage.' Mike grinned. 'That's your pacifist poet for you!'

I laughed as I filled my bowl with water.

'I was in a pub with him just before he bombed the museum. He got into a fight with a bunch of blokes and we got separated.' I knelt down to light the burners on the stove. 'The problem was, he hadn't paid back the fifteen quid he owed me, so I had to hitch home to Leeds.' Circular ripples shook in the water as I placed my aluminium bowl on the yellow flames. 'Meanwhile, Tim went to a garage in London and filled a couple of milk bottles with petrol. Then he hid in the museum.' I pictured Tim, crouching among the shop-window dummies that were dressed as soldiers. It was a spooky image. 'Then, when everybody had gone home, he chucked his Molotovs and ran.'

'How did they catch him?'

'I don't know. The next day the police came round looking for him. I tried to put them off by saying I wanted to find him to get my money back.'

Mike pushed his bowl away from him. 'It's lucky they didn't arrest you for funding terrorism!'

I laid my clothes out on my bunk, thinking about Tim. He got four years in Wormwood Scrubs. I still didn't know what I was going to get, but I tried to look on the bright side. I had a clean T shirt, socks, jeans, a scarf, my sleeping bag and, best of all, a pullover.

I stuffed paper into the plughole and poured hot water into the sink. Then I peeled off the filthy, stiff clothes that I'd lived in for the past month and dumped them in a heap. Mike wrote studiously at his desk while I washed. I finished up by shaving the few bits of fuzz off my face before the siesta bugle blew us back to the yard.

It was great to step outside in clean, warm clothes and a

scarf. For once I lasted out the session without getting backache from hunching my shoulders against the cold.

Back in the cell, my fringe nearly touched the tiles each time I dipped. My aim was to do thirty-five press-ups before social hour. Robert the French stumbled over me as he came through the door, but I didn't mind. It was impossible not to like him. I loved the way his eyes popped when he said, 'An-kwy-arbluh' instead of 'incredible'.

Robert did a comedy double-take when he noticed how clean and smart I looked.

'You ave your trial?'

'No. I just got my suitcase back. But they kept all my money.'

'Putain de merde! And they say we are the criminals.'

'Mike says I should get it back okay.'

'Your back is okay?'

I couldn't tell if he'd misheard me or made a joke. I smiled anyway. 'It's a lot better, thanks.'

'See how useless the Spanish are? Fifty cops and zey can't kill one English hippy.'

Mike laughed as he fired up the stove. 'It wasn't for lack of trying!'

Robert tapped a cigarette from a soft-pack of Spanish Celtas. 'Pah! Zey try to make a French cigarette, but zey fill it with horseshit instead of tobacco.' He jabbed the pack towards me. 'Here – tell me if I'm wrong?'

I pulled a bent Celtas out of the crumpled packet, grateful for the covert kindness. Mike threw me his Zippo and I snapped it open and alight with two clicks of my fingers.

Robert's eyes popped. '*Incroyable*! He is one of us already.' Mike grinned. 'Yeah, I'm teaching him everything I know.' Robert winked at me. 'Well, zat won't take long!' Luigi strolled in and began to set up the board while Mike slipped out to find Louis, the *talleres* boss. Robert watched him go, then pointed a stubby finger at me.

'Forget everything zat old hippy has told you and do as I do.' I smiled and he went on. 'Every night I pray for two things. *One* – zat Franco drops dead. And *two* – zat Spain has a visit from the Pope.'

I didn't get it. 'Why?'

Robert looked at me as though I was an idiot. 'Because zen there will be an amnesty and we'll all go free.'

A dark shadow filled the room as a giant in a massive donkey jacket ducked under the doorway. He looked like someone out of the Addams family. Mike introduced him as Louis, the *talleres* boss. His voice was big too; it fell out of his long, bony head with a heavy French accent.

'Allo. So you want to work?'

'Yeah. What kind of jobs have you got?'

He gave me a hard stare. 'What can you do?' It was crazy. I couldn't think of anything I could do that would be of any use in a prison. Mike told him I was an artist, and Louis coughed out a short, joyless laugh.

'Oh yeah? Well, come in on Monday and we'll fix you up with somezing... artistic.'

I could tell by Mike's suppressed smile that I wouldn't be painting in oils. 'Thanks. Where do I go?'

'Mike will tell you.'

My interview was obviously over because Louis swung his huge head towards the door. I noticed that he had to duck under Mike's *Guten Morgen* as he left. Louis didn't seem like the kind of guy you'd ask what he was in for. You'd rather not know.

Robert and Mike settled into an intense game while I

unscrewed the parts of my Rapidographs to soak them overnight. I wished that the pens were working right there and then. Mike's calm, focussed face was just begging to be drawn.

*

The moon wasn't up, so the awful shadows hadn't started to creep across the wall. I used the time to go through the events of the day in peace. It was bad that they'd kept my money, but now that the consulate knew where I was, maybe they'd let me know what was going to happen to me. And I'd found a job. I wondered what it would be like in the *talleres*. I'd been feeling safe among the hippies and tourists in the foreigners' gallery, but I was nervous about the real criminals. Would they all be like Big Louis and Mad Sven Svenson? One fight, and I knew I'd be thrown in the *Quinta* and beaten to a pulp again. My heart pounded and the long night yawned ahead of me like horror movie. I whispered over the edge of my bunk. 'Mike, are you awake?'

There was a long pause before I heard a sleepy, 'Yeah.'

'I just wanted to ask you something... What happens in the Quinta?'

I thought Mike had nodded off because he didn't speak for a while. 'Depends who you are. It's mainly the political prisoners who... who have a rough time. Did you know there's a garrotte in Modelo?'

I didn't. In fact, I didn't even know what a garrotte was.

'It looks like an electric chair... only it has a metal band that tightens round the prisoner's neck when they wind a crank.'

'Jesus! Do they still use it?'

'Yeah, but not on foreigners. Hey, I just remembered – you got your suitcase back!'

'I can't wait to start drawing again.'

Mike yawned. 'Draw a picture of me, okay?' 'Sure. What's your best side?' 'Outside.' I smiled. 'Goodnight.' 'Mind the bugs don't bite.'

You couldn't miss Crazy Bob in the yard. He always wore a flame-red shirt that made his skin look even blacker than it was. His energy was amazing. When he described the harvester he used to drive in the Congo, he bounced up and down and made engine noises that gave you a vivid picture of him rattling over rough ground on the big red machine. Mike and I watched him whipping up a whirlwind on the basketball court, and before I knew it, Mike had shoved me across the line to join him.

The ball came straight at me, right out of the sun, but I managed to time my jump and catch it. I turned and bounced the ball, searching for a familiar face for a pass. Bob's long black arms waved through a cloud of dust, and I threw on tiptoe to avoid the other team's block. It wasn't a great pass, but for the first time I'd completed a manoeuvre without messing up. Bob's shot rattled off the backboard and span through the rusty hoop. I grinned at Mike and he smiled back from the sideline. He'd been right to force me to keep trying. I was definitely getting better.

Back in the cell I began to clean my 0.5 pen, gently easing the wire up and down the tubular nib to work out the dried ink. It was a nerve-wracking job. If the wire kinked, the whole pen would be useless.

I rinsed it out, then squeezed ink into the cartridge. After drawing endless circles on scrap paper to get it going, all I got was a thin, watery trail. It gradually turned grey, then finally flowed in a smooth, black line. The clean white page of my book invited me to plunge into it like a pool.

I was desperate to draw the vision I'd had of my head exploding when the police were beating me up, but first I had to record my conversation with Canadian Michael and my drunken joyride on the scooter. I lost myself in the mindless pleasure of drawing and the distant memory of Veronica's beautiful love beads. She had given them to me just before I was arrested. I should have taken more notice of the look in her eyes when she'd told me to take care. It was almost as if she knew I was heading into trouble.

The bugle brought me back to the cell. Siesta was over and it was time to go out into the yard again. I shuffled around the dusty compound thinking what a drag it was having to spend the whole afternoon outside when I could be getting all this stuff out of my head and onto paper. But at least I was warm.

As soon as we returned to the cell I got out my pen again. I'd decided before leaving England never to make a guide sketch in pencil so that I'd have the freedom to draw whatever came into my head. It meant I had to incorporate any mistakes into the design, but it was worth it.

The first image that came into my mind was dark clouds rolling over my handcuffed arms. I was so occupied with drawing that I didn't notice Mike go out. When he came back he was with a young Chinese-looking guy. He had curvy black hair and round glasses over large, sensitive eyes. He looked like a mixture of John and Yoko, and I instantly liked him. Mike held out his arm and smiled. 'This is Patrick, the artist I told you about.'

I shook his slender hand. He had even less hair on his face than me.

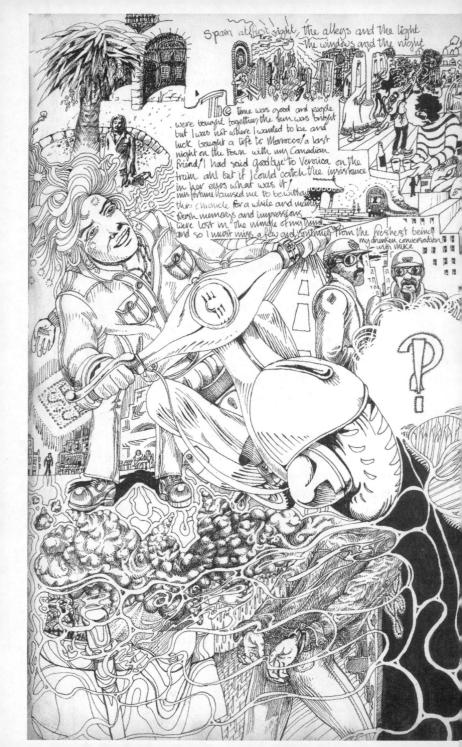

Mike said, 'Can he have a look at your book?'

'Sure. I've only just started it really ...'

Patrick made appreciative noises as he pored over the pages while Mike pulled out the stove. When Patrick reached the end he told me in perfect English that he liked the way I'd combined the drawings to make an overall composition on the page. I was glad he noticed that. It was something I'd been working on.

I asked to see some of his work and he took out a small book from inside his long, dark blue coat. Each page had a delicate portrait or a fantasy picture that made my drawings look like crude cartoons. The subtle gradations in tone he got were almost photographic.

'They're amazing. How can you do that with a Biro?'

Patrick held an imaginary pen. His hand was almost as delicate as his drawings. 'I hold the point at different angles, depending how strong I want the texture to be, but you have to keep cleaning the ball or it leaves a blot. You should give it a try.'

There was no way I was going to do that. His stuff had really blown me away. I knew I'd have to bump up the standard of my book with him around.

When I found out Patrick was French Vietnamese, I told him his drawings reminded me of Seurat. We launched into a deep discussion about the Impressionists and if it hadn't been for the drunken bugler, we could have talked of painters and painting all night.

I stared at the wall above the sink while I brushed my teeth. I'd been the best artist in my senior school, so it was a shock to meet somebody who could draw that well. The dim light went out as I climbed into my bed. I wasn't just shocked by Patrick's drawings. My feelings were beyond jealousy. My first acid trip had given me a terrifying view of myself – it stripped me down to my meager possessions, the little knowledge I had and the hollow pile of atoms that was my body. The sum of these parts were so insignificant that I felt totally and utterly worthless. In the desperate months that followed, I had to completely rebuild myself. When it came down to it, the only thing I really possessed was the ability to draw. From the isolation of the prison, it seemed as though this was the only constant thing I'd ever had in life. Drawing meant much more to me than making art or being able to represent something. It was what I was.

11

WORK SHY

More than workin' for the rich man Hey! I'll change that scene one day The Easybeats

I was marched through a series of underground corridors where even my small guard had to duck for cobwebs. We turned a corner and I was surprised to glimpse a vaulted cellar. I half-expected to see the garrotte Mike had told me about, but instead there were rusting bedsteads and rotting mattresses lying in drifts of brick dust.

I started to get nervous when we stopped outside a wooden cage covered with chicken wire. Was this the *Quinta*? I was ordered inside, locked up and left alone with my thoughts spinning. What had I done now?

Minutes later a tall man with a black beard was locked in with me. A pale hand stretched out of his dark blue suit and he introduced himself as Mr Bradley, my consul. I shook his hand, more relieved than he could possibly have imagined. Maybe it was the way I looked, or where we were, but he seemed as nervous as I was.

'Please tell me everything. Right from the start,' he said.

Bradley listened patiently as I told him about my arrest, from walking on the cars to trying to escape. I left out the drugs, but even so, he must have thought I was an idiot. I dropped my shirt to show him my back and arms. From the little I could see, the bruising had faded to yellow and lilac blotches, but I could tell from the tone of his voice, he'd got the message.

'So how are you bearing up?'

'Not too bad. I've been doing some exercises to get back into shape.'

'No, I mean, in yourself?'

I wasn't going to tell him that, so I just said, 'I'm worried about a few things.'

'Anything in particular?'

'I've heard you can wait ages for a trial. Like ... years?'

'That is possible in some of the more complicated cases.' He coughed nervously. 'However, as your situation is reasonably straightforward, I'm hopeful that a date for your trial can be arrived at in a relatively short time.'

I didn't quite get what he meant. 'What, like a couple of weeks?'

'It's too early to say at this point.'

It was hard to read him. I didn't feel much wiser until he told me my bail had been set at 50,000 pesetas.

'Fifty thousand! How much is that?'

'In sterling, around £350. But hopefully that figure will fall.'

I did a quick calculation in my head. It would take two years' solid work to pay that kind of money back, even if I managed to find someone rich enough to lend it to me. It *had* to come down.

'If it does fall and I pay it, will they let me out?'

'Well, yes... There is, however, a possibility that your *fianza* may not be reduced. The officer you attacked was in hospital for nine days, which is presumably why they're asking for a two-year sentence.'

It had doubled! And I was confused about the cop. He'd recovered enough to beat me just as hard as his colleagues had. Mr Bradley assured me he would appoint a good lawyer who would argue for the bail to be lowered. A key rattled in the cage door lock. I remembered to ask him to bring some multivitamins as the guard ordered me out.

'Is there anyone you'd like to be advised of your situation?' Bradley asked. I was about to give him my mother's address, then recalled how the last time I saw her she'd hit my head. I called, 'No!' over my shoulder as I was led away. On the march back to the gallery, I cursed myself for not asking if he'd got any fags on him.

The air in the cell was heavy with the smell of garlic. Mike sat on his bunk pounding a yellow paste with his mortar and pestle. His face lit up when he heard I'd seen the consul. He wanted to know every little detail. When I was done, he stopped grinding.

'Sounds like you've got a good guy there.'

'You think so?'

'Yep. And if his lawyer can fix a low *fianza*, that's got to be a good thing.'

'But what about the cop being in hospital? That's not so good in a police state, is it?' The smell of garlic increased as Mike got back to grinding it.

'No. But the consul has seen what they did to you and he can use that as leverage.'

'Maybe, but they want to give me two years now.'

'Don't worry. They always ask for more than they get. You don't want to know how long they want to put me away for!' Mike was right. I didn't. He stopped grinding when I told him I didn't think I'd be going home for Christmas either.

'C'mon man! Christmas in Modelo is far out. Roast chicken and a double hit of vino!'

'Wow. I can't wait'. I regretted my petulant tone immediately.

Mike began to grind like a maniac with the pestle. I waited for him to slow down, then tried to sound friendly to make up for my tactlessness.

'What is that stuff, anyway?'

'Aioli. A kind of Spanish mayonnaise.'

'What's in it?'

'Olive oil, garlic, salt, lemon, egg yolk. Get a bit of bread and give it a try.'

I snapped a crust from my rock-hard loaf and dipped it in the yellow paste. The taste blew me away.

'That's amazing! You've got to teach me how to make it.'

'Sure. You've just got to remember to grind it in an anti-clockwise direction.'

'Por que?'

'Otherwise it separates and you have to throw it away.' Mike looked up seriously. 'Course, you only go anti-clockwise in the Northern Hemisphere.'

'What if you're in the Southern Hemisphere?'

'If I was in the Southern Hemisphere, the last thing I'd be doing is making mayonnaise!'

I looked at Mike grinning away, and realised I didn't know what I'd do without him.

I couldn't sleep that night, trying to make sense of my meeting with the consul. He didn't give much away, but he

must have wondered why I attacked a policeman when all I'd done beforehand was a bit of drunken joyriding. So much had happened recently, I'd forgotten that I was supposed to be asking myself the same question. I went back to examining my past. One memory had always been a mystery to me. It was the day Jeremy took me down to the river.

We had to be careful because the bulrushes were high and the ground was soggy. I dipped one of my red cowboy boots in the water. They were made of rubber, but they were too short to touch the bottom. I told Jeremy that it was too deep to paddle and he held out his hand.

'Give me your boot.'

'Why?'

'It's a game. Here, let me have it.'

I pulled it off and handed it over. Jeremy held my boot behind his head. I didn't understand the game. Then he threw it. I saw a red colour spinning over the rushes until it splashed far away in the deep water. Then I understood. It wasn't a game. My boot had gone forever. I limped home crying. It wasn't just that I'd lost my beautiful cowboy boot, now the other one had to go or it would always remind me of my loss.

The loss didn't make me angry or violent, just sad that it was my own brother who threw it away. If I was going to find out what made me land up in prison, I was going to have to dig a lot deeper.

The tiles shone in sweeping arcs as I swung around the bunk bars in the pale morning light. I'd been woken up early by a violent nightmare about my arrest. I rinsed out the rag, then splashed a handful of cold water on my pounding head, hoping to wash away the image of the beaten-up cop. But it didn't silence the voice in my head. What if he drops dead from a brain haemorrhage? I'd be done for murder! I quickly wiped the rag around the toilet. A murderer! I had to find out what it was that made me do such stupid things, before it was too late.

* * *

Mike and I finished making our beds just before Zorro began his strut across the gallery. It was Monday morning and starting work only added to my nervous state. I could never understand what the guards meant when they shouted orders at me. At every moment I expected them to find out what I'd done and drag me off to the *Quinta*. The closer Zorro got, the worse I felt. I put on my blank face and stared at the opposite wall as he stopped to inspect us. I hated feeling his eyes on my scruffy clothes and the pit I was forced to live in. Now I knew exactly what the animals felt like in the zoo. Humiliated.

I turned to Mike as Zorro's goose-steps faded away. 'So, how do I get to the *talleres*?'

'I'll tell you when it's time to leave. Then all you have to do is follow the line.'

I did some press-ups to calm my nerves until the bugle cued in the town crier.

'Alto ... Primero ... trabajo!'

Mike listened by the door-frame. '*Trabajo* means work. Wait for it – the next one's yours.'

'Segundo... trabajo!'

Mike put on a sugary smile and fluttered his fingers. 'Have a nice day, dear.'

I told him to fuck off, and I was still grinning as I followed the line of Spanish workers along the balcony. We clattered down the stairways and gathered on the gallery floor. I ducked below the line to blend in as the guard yelled like a sergeant major. He marched us off and we filed through a dismal gallery the mirror image of ours. I gazed around hungrily. The fact that it was interesting made me realise how visually starved I was. Modelo's walls blocked out everything. No streets, buildings, cars, birds, trees, shops... No women. Nothing.

Our ragged line shambled through a large double door that led into a yard. It was smaller and scruffier than the one I was used to, with tufts of grass growing between bits of old machinery, slung out from the *talleres*. The guard left us to join a rough queue of workers alongside the factory wall. With the guard gone, some of the men broke off to talk and smoke.

It was the first time I'd been alone with real prisoners. Shifty eyes studied me under dark brows. I thought: *Shit, they look like desperadoes in a Spaghetti Western.*

I walked away from the line and wandered around, inspecting the rusting junk that littered the yard. At a slight angle a short way from the path was a blacksmith's anvil. It gave me an idea. I walked over to size it up. It was bigger than I'd first thought and seemed to be rusted to the ground. I did a few casual stretches and flexed my muscles. There was no pain from my back, so I decided to have a go. I secretly took a few deep breaths while mentally rehearsing the weight-lifting moves I'd learnt in the youth club.

The eyes of the queue were on me as I grabbed the horns of the anvil. I gave it a heave to loosen it from the ground. It rocked free, and I knew the lift was on. I bent my knees and curved my hands under the cold metal. The grip felt solid, so I straightened my arms and back, then pushed up hard with my legs. Thankfully, it came away from the ground. It was heavy, but I'd got it up to my thighs. I didn't want to hang around, so I went straight for the jerk, dipping my knees while yanking it up to my chest. Suddenly it was there, dirty and rusty under my chin. I thought: *This is a nice thing to lift*.

My knees were trembling and I hoped my back could take it. There was only one way to find out. I took a deep breath, dropped my legs and pushed my arms up with all I had. It's a great trick. You're using your arms, but you're also dropping underneath it so your legs can do the rest. My thighs strained and a line of sweat tickled my cheek as I slowly rose upright. Dust from the anvil dropped over my head. I locked my arms and steadied my shivering legs. Then I looked at the queue slowly from one end to the other, just to say, 'Don't fuck with me'.

I dropped the anvil from overhead for greater impact. The ground shook as it sank into the receiving earth with a satisfying thump. I slapped the rust off my hands and strolled casually back to the line, vowing to lift it every morning from then on.

The tall *talleres* doors creaked open and the line started to move. As I entered the shady interior, I realised this block had a different layout to ours. We shuffled up a broad staircase of grey wood, which turned into a wide, windowless hall. It was full of tables, each big enough for ping-pong and covered in speckled blankets like carpet underlay. An armed guard watched as everyone settled onto benches, so I found a space and squeezed in. Workers were already passing around stacks of cardboard shapes while strong hands twisted open pots of glue. The giant figure of Louis in a dirty brown work coat lurched through the tables towards me. In one huge hand he gripped a model of a vintage motorcar, covered in red, yellow and black felt. '*Hola*. Zis is what we make here. You take the board and stick on the felt wis glue. Miguel will show you 'ow.'

The car looked tatty and misshapen. The aluminium wire bent around it to look like chrome was all wobbly. I didn't think I was going to have any problems with quality control.

'What do I do when I've done that?'

Louis shrugged. 'Zey will give you more.' Then he bawled across the table, '*Oye, Miguel! Ven, aquí*.'

A stocky, middle-aged man in a checked shirt struggled out of his bench as Louis pulled the roof off the car. My eyes opened wide with anticipation as Louis's thick fingers took a cellophane packet of sweets out of his coat and shoved them inside.

'And after, we put in ze dulces. Voilà!'

I groaned inwardly as Louis walked away, stuffing the shiny bag back into his pocket.

Miguel showed me how to make a door. His fingers fascinated me. They were short, stubby and grubby, with almost non-existent nails – just little strips with the fingertips curling over them like mushrooms. Even so, he managed to paste the cardboard door panel and fold over the felt with great dexterity.

It looked easy and I thanked him in *Castellano*. It was a nice feeling. I'd been in Spain for more than a month and this was the first time I'd been alone with ordinary Spanish people. I'd thought it was going to be scary, but it felt easy and friendly.

I wrenched the top off my glue pot and quickly turned away. *Wow*, I thought. *This is high-octane stuff*. By the time I'd got halfway through my pile of felt doors, I was totally stoned. There were no windows and everybody had a glue pot. There was no radio either, just a low buzz of conversation, so I sang Dylan's 'Everybody Must Get Stoned' as I pasted away. It was a million times better than being stuck out in the freezing yard.

I was working through my second pile of felt when a door slammed open. Two guys wearing long white aprons burst in like actors on a stage. One had a tray of cakes on his head like a Dickensian pieman, while the other held out his arm and shouted with the hoarse voice of a street vendor:

'Pasta calentita, calentita, calentita!'

I quickly worked out that *pasta* meant pastry and *calentita* meant hot. It was terrible. He had a whole tray of cakes and I had no money. The warm, honeyed smell drew workers from their benches. Once they'd bought the sweet, sticky pastries, they all hurried off towards a crowded corner. Steam rose over their shoulders and I guessed they must be making hot drinks. I had a mad case of the munchies, but I was too out of it to care. Time slipped by easily as I sang Stones songs to myself through the fumes of the glue.

I was still singing as we filed back through the gallery for lunch. Mike was crouched over his steaming hubcap on the stove when I got in the cell. He looked up with a gap-toothed smile.

'Hey! How did it go?'

'Great. I've been sniffing glue all morning and I'm stoned out of my head! What are you cooking?'

'Tinned soup. Hungry?'

'Oh yeah. They had these hot cakes back there. I could've killed for one.'

'Well, let's see what you think of this ...'

Mike cracked a couple of eggs into the soup and stirred them around. I grabbed my bowl and bread. Mike must have been to the *economarto*. We hardly ever had eggs.

I leafed through my book while I ate, mentally comparing the sketchy faces I'd drawn with Patrick's delicate portraits. When I reached the drawing of me on the scooter, I stopped eating in a moment of realisation. That drunken expression on my face showed exactly what was wrong with me. The moment I got a mad idea I just did it without thinking. It was like lifting the anvil that morning. It could easily have damaged my back, so why had I done it?

I didn't know, but I knew what I wanted to draw. I turned to a blank page and visualised the image I'd had of my exploding head. First I drew the curved levels of my skull, leaving breaks in the lines where intersections for the partitions would occur. Then I drew the details of the machinery, working quickly to finish the drawing before siesta ended. When it was done I collapsed on the mattress. I could have slept for a week, but the bugle blew for work before I'd even closed my eyes.

When I got back from the factory I was exhausted. The work wasn't that hard, so it was probably the glue that was knocking me out. As I crashed out on my bunk, all the thoughts I'd blocked during the day came rushing in. *When will I hear about my* fianza? *When will I get a trial? What if the policeman gets a bloodclot on his brain?* I pressed my head into the comforting straw mattress. Straw had been a constant presence on the farm. Jeremy and I used to climb the high bales stacked in the barn and drop from the top onto a pile of soft straw that the farmhands had laid out for us. When we were too tired to climb anymore, we'd lie on the warm yellow stalks in our blue dungarees and soak up the sunshine.

The next thing I knew, it was morning. I was still fully dressed, and covered with a blanket that Mike must have thrown over me. I looked down at his sleeping figure and thought of the lunch he'd made for me after my first day at work. It wouldn't be the same in Modelo without Mike, and I didn't know how I would ever be able to thank him.

12

JOINT EFFORT

And it stoned me to my soul, stoned me just like jelly roll. Van Morrison

There was a Friday night feeling in the wages queue. Eager shoulders brushed against the flaky wall, picking up dusty streaks of whitewash as we shuffled towards the pay-desk. Behind the rusty grill, Louis's massive fist pushed a small stack of scruffy blue-and-red cards towards me. I fanned them out to see what I'd got. It looked like ancient Monopoly money and was probably worth about as much. Louis frowned through the wires: 'Is *bali* – yes?'

I didn't know what *bali* meant, so I just said, '*Gracias*,' and joined the line heading back to the cells.

It was great to see Mike's gappy grin as we toasted my first week working for Franco with sweet black tea. He gave me another Spanish lesson when I asked him what *bali* meant. 'It means okay. It's spelt v-a-l-e but you pronounce the v like a soft b.'

I held up my cup with a smile: 'Vale'.

I had a whole weekend of drawing to look forward to. Mike turned from the letter he was writing as I took my book and pen from my suitcase.

'You're a changed man since you got your case back.'

I shook my Rapidograph to clear the nib. 'Yeah – it's the second time my suitcase has saved me. If Michael hadn't taken it away from the hotel, they would have thrown away the key.'

'I've got a stamp if you want to write to him?'

My book fell open at a fresh page, inviting me to draw.

'I don't have his address. All I know is his name: Michael Schneider.'

I began to write the story of Michael and Jesus in my book to make sure I wouldn't forget it. It was probably the longest thing I'd written since leaving school. Then I drew a picture while Michael's face was fresh in my mind. Other memories came back that I wanted to hold on to, like an old political prisoner who'd been kind to me when I came in. I was trying to draw his portrait from memory when Patrick came round in his navy blue greatcoat. I liked it. It was the kind of military thing students had worn in Leeds.

We sat on the bunk below mine to look through my latest pictures. He praised the exploding head, but he didn't think the cartoon cops I'd drawn matched the inventiveness of the skull. He was right.

I winced when Patrick turned the page and saw Michael and my vision of Jesus. I viewed it through his exacting eyes. Even in the fading light he must have noticed how badly the hands were drawn. He was too polite to criticise, but when he showed me his recent work, the attention he gave to hands was obvious.

He treated them as though they were figures in themselves. I made a silent vow to improve my drawing.

I wasn't the only one with room for improvement. Down below in the *Primero* gallery, the drunken bugler searched vainly for a melody, but all he found were farts. Patrick got up to leave with a roll of his eyes. He'd only been gone a second when his head popped back round the door.

'One thing, William - don't write too much in your book. They don't allow you to make descriptions of the prison. If they find it, they'll take it away – and you with it!'

Losing the book didn't bear thinking about. I decided to improve my drawing by working from life right there and then. Mike was still writing at his table, so I climbed on top of my bunk to be as near as possible to the dim bulb. I tried to get the perspective right and keep the lines clean, indicating the worn paint on the bunk bar with a single wavy line. The bad light meant I couldn't crosshatch the shadows, but the figure drawing looked more authentic and the composition was stronger than on the page before. I put my pen away and called down from my bunk.

'Who are you writing to?'

A slow smile creased his face as he looked up. 'I'm organising a drugs deal.'

'You're kidding?'

'Sort of. I'm writing my *amigo* in California. We had this plan to rent a farm and sell stuff off the roadside with a handwritten sign. You know like "Fresh Eggs", but you write the *s* backwards so they think you're a hick and they'll get a good deal.'

I stretched my legs as I climbed down the cold metal bars on the end of the bunk.

I had no friend in Exercetona to help me I my composition of the previous nice Shadd now be stearning down to Morroco I whis could I turn to? my bush was making net feel sick - I put my head between my knees - 1 pictured Jerais. forus of the story book, and outstated heard slightly on one side halo and light so ounding him - That there a tap on my glandlor - and there was my friend! Hounding at the desk - a humied word and all was sofe - what unse can I say. to reason , mumores ast a her und une ne michiges mesent 1 liger test then seen wetowher Vwish stop and druw . tine Nes, I have taken a decision, I start brite all druning stall be fush us week old volumbes, 1 stude toute

It's hard work, looking after all the animals and stuff."

Mike leaned back against the table. 'Oh, we wouldn't do all that. The sign's just a front. We're gonna fill the fields with top-grade weed. He reckons we can make enough to retire on in three years.'

I started doing push-ups on the bunk bar and thought: *Mike really is one of the Fabulous Furry Freak Brothers*. Aloud I said, 'You're not *really* going to do that are you?'

He laughed. 'Who knows? But right now I'm just getting him to send me some hash brownies.'

'I thought they censored the mail?'

'They do, but all I'm asking for is some of those special cookies Grandma used to make. He'll know exactly what I mean.'

I kept pushing against the bunk bars, enjoying the exercise. 'God, it's ages since I've been stoned. Except for the glue.'

'Me too. It's been months.'

I stopped dead, halfway through a push-up. 'Months? But you've been here for years.'

Mike dropped his voice to a whisper.

'I've got a promise of a deal coming soon. We could be off our heads any day now.'

'That's crazy,' I whispered. 'What if we get caught?'

Mike turned back up to full volume. 'Instant six years and a day!' The phrase sent a chill through me.

'I don't like the sound of that.'

'It's okay. There's only enough for one joint. It'll be gone before they know I've got it.' Mike read my face like a comic book. 'Don't worry. I take full responsibility.' I knew he would, too. The light was about to go out, so we got ready for bed to save burning a candle. Mike's attitude was completely different to mine. I got arrested and worried myself sick. Mike

got busted and couldn't wait to do it again. I'd never spent time with an American before, but he was like the characters in Marvel comics: they were so powerful and bold that they made the English ones look weak and pathetic. Physically, I was much bigger and stronger than Mike, but compared to me, he was a superhero.

Mike walked me around the patio looking for the laundry guy. We found him by the arched doorway that reminded me of the church near my grandma's house in Cambridgeshire. The stone pillars around the wooden door were chipped and the flagstone steps were worn from the feet of countless prisoners. I recognised the laundry guy. He was the wizened old bloke I'd seen in the talleres. He stood out because of his yellow, haystack hair. It was a good job Mike was with me because I couldn't understand a word he said. It wasn't just the Spanish. He spoke in weird, explosive grunts with his lips squeezed together like he was playing a trumpet. It was only when he turned towards me that I saw he was actually talking through a hole in his scrawny neck. He took my money and scuttled away with my bag of dirty clothes. Then Mike tracked down a runner to go to the economarto for me. The guy looked shifty, but I gave him my cardboard cash and shopping list, and we walked off to find Patrick.

Patrick was leaning against the wall with his hands in his pockets, staring at a group of sun-baked Spanish prisoners, deep in serious conversation. Patrick looked so young and innocent next to their crumpled faces. It just didn't seem right that he was banged up for a possessing a bag of herbs.

Mike called, '*Hola, qué pasa*?' as we approached. Patrick answered him by pulling out of his pocket a drawing he'd secretly done of the Spanish guys. Just like Toulouse-Lautrec used to do in the Moulin Rouge. I didn't feel so bad when Patrick offered me a luxurious blond Bisonte. For once, I knew I'd be able to pay him back.

We leaned against the wall and talked as the weak beams of the winter sun shone through our cigarette smoke. There were no papers and no radio, so we didn't know if the world was about to blow itself up, let alone what was happening in the music scene. I didn't care. I was happy to be carried along by Patrick and Mike's stories of escape attempts. Apparently there'd been one guy who pretended to be a motorbike and drove everywhere holding his arms out like handlebars. He only spoke by sounding his horn and revving his engine. The idea was to convince the governor to send him to a mental hospital, from where it would be easier to escape.

I asked Patrick if it had worked.

'Sort of. One day they rang the patio bell. We all lined up to go in, but he didn't move. He just leant on the wall with his hands on the bars. The guards went crazy, but he wouldn't budge.'

'What was wrong with him?'

Patrick smiled. 'He'd run out of petrol. Two guards had to carry him back inside to fill his tank up. That was the last we saw of him. They drove him straight round to the loony bin after that.'

'Yeah, one in front, the other on the back!' Mike said.

Patrick continued. 'The problem was, he'd done the job too well. They say he's still in hospital and he still thinks he's a motorbike.'

At times like this Modelo almost seemed like a nice place to be. These were as good a bunch of friends as you'd meet anywhere in the world outside. If not better.

Mike and I jostled around each other to make our beds. We'd got up early and the breeze blowing through the bars was colder than usual. Now that I'd bought some food, I couldn't wait to fire up the stove. I heated olive oil in my hubcap and cracked a couple of eggs into it. While they cooked I did my Tarzan act with the damp rag. My back even felt good enough to hang off the doorframe and grab a baguette as the basket flew past. I ripped it in half and smeared butter over the warm bread. Mike did the same, then we dropped in the fried eggs and sprinkled them with salt. They tasted great. I mean, *really* great. Mike smiled through a bulging mouth.

'Qué bueno – me gusta!' He took another bite. 'In fact, me gusta mucho!' There was just enough time to cram it down before we had to stand to attention at the cell door to be counted. I fixed my stare rigidly into the distance. I didn't want any contact with the guard's eyes. If for any reason he stopped, he'd notice we'd been cooking and search for the stove.

I glanced over the chasm to see who was on duty. Shit, it was Zorro. I was convinced he'd got it in for me. Rumour had it he was a writer, and had only become a guard to get prison experience for a book. He stopped at our door for the count then clattered off in his jackboots with his long coat floating from his shoulders. But then his footsteps stopped. He marched back and looked into our cell. I could feel his eyes on me. I was taller than he was and I knew he must hate that. He paused dramatically then swept away like a musketeer.

Mike and I exchanged glances, Zorro knew we had a stove. He was just fucking with our heads. I hated being forced to fear the moron when we both knew that in a straight fight he wouldn't stand a chance.

I was still fuming when the bugle blew for work. Before I could leave, Mike handed me a twist of paper with something soft wrapped inside it. He smiled at my worried expression.

'It's only tea and sugar. So you can make yourself a cuppa in the break.'

I stuffed the wrap in my pocket and headed for the open door. I was so relieved it wasn't weed, I forgot to thank him for it.

The scruffy *talleres* queue swallowed me up, and I thought back to my time as an apprentice painter and decorator. I had to make my workmates hot drinks from the mixtures of tea and sugar they brought in their jam jars. I didn't mind doing it, but I didn't like the way they made fun of me just because I wanted to be an artist. One time they all started laughing at me as I stood by the portable gas ring that was boiling the kettle on the floor. I kept asking why, but they got so hysterical they couldn't have told me if they'd tried. It was only when a sheet of flame flared up my leg that I realised my paint-splattered overalls had caught fire.

For ages afterwards they kept describing the hilarious sight of me running around, trying to put it out. I got my own back, though. They always gave me money to buy milk, but by the end of the week I'd usually spent it. I found that a blob of white emulsion in their tea made it look just the right shade of brown. They never noticed.

We filed into the *talleres* yard and hung around in the pale sunlight for the doors to open. Every day I lifted the anvil. Nobody else had tried it yet and I liked that. Herro broke out of the queue as I walked back, dusting off my hands. Herro looked like a brigand: tight black jeans and waistcoat over a loose white shirt. He had a round unshaven chin, straggly raven hair and his voice rasped from a constant stream of black tobacco *Ducados*. He always smiled when he spoke and his teeth shone like his earring.

'Oye, coño. Qué pasa?'

I didn't know what *coño* meant, but I knew nothing much was happening. He grinned when I said: '*Hola, muchacho. No pasa nada*'.

Herro nodded at the anvil, then squinted his brown eyes at me. '*Té muy fuerte, eh*?'

I didn't understand, so I said, 'Qué?'

He grabbed my bicep and squeezed hard. '*Muy fuerte*!' I got it then and asked Herro if he was strong too. He said, '*No, señor*.' Then he tapped his head and smiled. '*Pero soy muy inteligente*.'

I actually understood him. He was saying no, but he was very clever. I asked him how come he was in prison if he was so smart, and he threw his head back and laughed like a Mexican bandit.

The heavy tread of worn-out shoes spread sand from the yard up the stairs. It seemed like the whole factory was covered in dust of some kind or another. Whitewash crumbled from the walls and the metalwork was powdered with a fine orange rust. We were in an old wing of the prison, and what I'd first thought were cupboards running down the walls had once been solitary cells. It was spooky to imagine being banged up for years in those narrow stone rooms. They didn't even have windows. Most of the doors had been taken off and the cells were now used as storerooms and workshops.

I took a seat on my usual table and reached across for a glue bottle. The solvent hit my nose as soon as I wrenched off the cap. Sticking felt over cardboard shapes was like being at primary school, but by the time the glue had got to my head I could have been anywhere. A husky voice cut through the haze of solvent and babble of conversation.

'Oye, Weeyaam! Canta! Canta para nosotros.'

It was Manuel, asking me to sing. He was a good-looking,

stocky teenager with thick black hair and a wide smile. I knew the poor kid had a big sentence hanging over him. I asked what he wanted me to sing and he handed me a tattered piece of paper. It had lines of phonetic English pencilled on it like a page of Chinese whispers. Manuel sang a line to the tune of 'Plaisir d'Amour' in a raspy voice much older than his age.

'I one two leaf. Is all I won todo. Sofly waitin summer send...'

I worked out what most of the words were and sung it back to him. He thanked me half-a-dozen times and we sang each other songs as we worked until the pastry guys crashed through the doors. They had to move like maniacs to sell the cakes before they turned cold and hard.

The pieman shouted his wares as though he was looking for a fight:

'Pasta calentita, calentita, calentita!'

He looked around with his hands on his hips, horrified at the lack of response. Then he roared, '*Pasta* calentita! *QUE ME VOY*!'

I laughed because that meant: 'Or I'll leave!'

The tray of pastries smelt irresistibly sweet. Each *pasta* cost as much as a whole pack of Celtas, but I had to have one. I threaded my way through the seats and paid for the sticky orange triangle. Then I joined the queue to get some hot water for my tea. It led to the blond laundry guy, who sat on a little bench holding some wires that straggled out of a dodgy electric socket hanging out of the decrepit plaster. Attached to the end of the wires were two metal plates separated by a little block of wood. He dipped this device into a cup of water and it boiled almost immediately. It looked lethal.

When I asked him when I'd get my washing back he circled his finger in the air and grunted what may have been

'*mañana*' out of his ugly hole. I carried my hot water back to the table and untwisted Mike's paper to sprinkle in some tea and sugar. The *talleres* buzzed with rapid *Español* as the workers ate and drank. I'd discovered a blissful oasis of pleasure: sweet tea and cake followed by a black tobacco Celtas.

It was my first tea break since leaving the zoo more than two months ago and I treasured every second of it.

The TV was off and the chess players had long gone. Night was falling earlier and earlier, and the dim yellow light had flickered on well before the door was locked. I was sitting on the lower bunk weighing up the drawings in my book. I'd got a great likeness of Luigi playing Mike at chess. It was obvious from his body language that he was on top in the game. Mike sat next to me and studied the portrait of Luigi.

'Yeah, he's a *mal hombre* - a bad guy... well, he plays a mean game of chess.'

'What's a *konyo*?'

'Coño?'

'Yeah, this guy called me a *coño* this morning.

Mike laughed. 'It means "cunt".

'He called me a cunt?'

'Yeah, but it's different here. It can be a form of endearment.' 'What, like when Sven calls everybody cocksucker?' 'Sort of.'

'They use it in a much better way than we do.'

Mike smiled as he stood up, 'True. But don't use it on the guards!' He reached into the frayed plectrum pocket of his jeans and gave me one of his special grins. 'Guess what?'

'Que?'

'Christmas has come early this year! 'Mike held up a little ball of silver paper between his thumb and index finger.

I felt I had to whisper. 'Is that what I think it is?'

Mike wheeled out his favourite phrase: 'Is the bear Catholic? Does the Pope shit in the woods?'

'Far out! Are you gonna smoke it tonight?'

'Sure we are. The guards never come round after lock-up, and even if they did, you'd hear their boots a mile off.'

Mike waited until the light went out and then snapped open his Zippo to light a candle. The grey cell looked softer in its warm, yellow glow. With the pictures on the wall, it could easily have been somebody's tiny flat. Mike put a book on his lap and ran his tongue along a Celtas. Then he snapped off the tip and stripped back the seam like opening a banana. Halfway through stripping another, he looked up in a casual sort of way and said, 'Hey, d'you fancy a joint?'

The tension was so high we couldn't help laughing. I watched the familiar routine with new fascination. Mike stuck three cigarette papers together in the classic style, then fluffed up the tobacco in a neat line down the middle. Instead of the smoky candle, he toasted the lump of dope on a needle over the clean flame of a wax match. Our excitement mounted as a sharp Moroccan aroma slowly began to fill the cell. Mike sniffed up stray wisps of blue smoke, his eyebrows raised and a half-smile on his mouth.

'Oh yes. This is the stuffy stuff stuff...'

I watched his delicate fingers crumble the precious dust across the tobacco. Then he carefully rolled the paper and ran the gummed edge along his waiting tongue. He finished the end in a neat little twist and held it up with a flourish.

'Voilà!'

'Very impressive. It's almost a shame to burn it.' Mike offered it to me but I refused. He was risking six years of his life so the honours were all his. The prison had assumed a monastic silence, and the lighting of the joint took on the

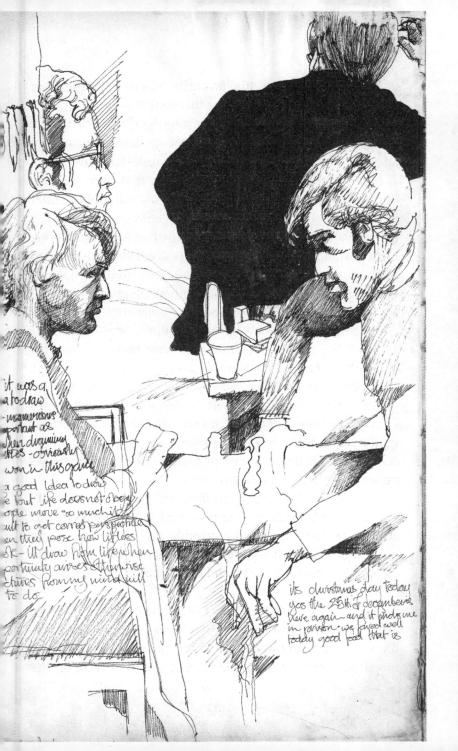

aura of a religious ceremony. The paper twist caught and the joint crackled into life as Mike took a long, deep toke. He held it in with his eyes closed and the hint of a smile on his upturned face. It was only when the smoke began to drift out of his nose that he passed the joint to me. The smell was so familiar. It took me back to my old flat in Kingston Terrace, album cover on my knees, listening to the Stones' *Let It Bleed*.

We passed the joint back and forth, occasionally adjusting an uneven burn with the touch of a wet fingertip. As soon as we hit the roach, Mike flushed the evidence down the bog.

Our heads were in a completely different place. The surroundings meant nothing. All that mattered was that we were stoned together. Mike reached for the fruit bowl in slow motion. So that's why Mike saved his oranges, I thought. He knew we'd get the munchies!

Mike peeled off the skin in one long spiral. It took a stone age to unravel. Then he split the orange in two and handed one half to me like a wine glass. He raised the other half to his nose to smell its bouquet.

'It's an impudent little vintage, but I think you'll be amused by its presumptuousness.'

Mike's voice rang like a Buddhist's bell in a blue Tibetan sky. I rolled a soft segment around my mouth until its skin burst in an ocean of juice.

'It greets the palate like an old friend's hullo ...'

We started to giggle. Everything we said was hysterical. The whole situation was so incongruously funny, our silent uncontrollable laughter was as delicious as the fruit. Slowly we calmed down and fell into a soporific daze. Mike looked up at me seriously.

'You know something?

If this orange was a woman, she'd be about thirtysomething. You know, not young, but still really delicious.

I bit into the soft flesh. It had a deep, ripe sweetness and I knew exactly what he meant.

'And she'd have a brass bed with a lace canopy hanging over it.'

Mike ate his final segment thoughtfully. 'Mmm... And the morning sun would shine through the lace to wake her...' He smiled and reached for the orange bowl. 'Excuse me while I undress another...'

We worked our way through the whole bowl, evaluating the age and charm of each fruit from teenage temptress to mumsy matron. We even compared eating one ancient orange to necrophilia, in a storm of breathless giggles. Nobody could touch us. It was our time, our moment. We floated to sleep in the early hours in beds on a different planet.

13

WARD X

How does it feel? To be on your own With no direction home? Bob Dylan

The handle of the blunt scissors had pressed a deep groove in the calluses that had formed on my finger and thumb. I'd been cutting cardboard shapes all week and the pain was killing me. I asked Manuel the time as I tried to massage it out.

'Diez, menos trenta-cinco'.

It wouldn't be long before the *pasta* guys came round, so I squeezed through the crowded benches to get some hot water from old Turtle-Neck before the tea-break rush. He dangled his wires in my cup and I stared at the manic bubbles to avoid looking at his hole. It worked until he started grunting at me. I had no idea what he was saying until he reached under his sink and held up a plastic bag.

My laundry!

I checked it out as I sipped sweet black tea and lit up a Celtas.

The stuff was amazingly clean. The Levi's I'd been arrested in had come up sky-blue with snow-white threads where they were faded. I couldn't wait to put them on. They kicked off an exciting train of thought. If my lawyer could get me a low *fianza*, I could be stepping out in them by Christmas. There was over thirty quid in my wallet, my guitar was worth at least forty and maybe Jeremy would be able to lend me some cash if I needed more. The door slammed open and the sweet smell of cakes filled the workshop. I still had the munchies from last night. I didn't have the money to buy one, but it didn't bother me too much because I knew there was bread and *membrillo* back at the cell.

Suddenly the door of the cell opened. I looked up from my book and thought, *Fuck! It's Zorro!*

Mike jumped up off his bunk. My skin was cold and damp against my shirt. I felt the blood drain from my face. What was going on? I knew Mike had thrown away the evidence, but had somebody told on us? I couldn't follow Zorro's rapid Spanish, but I heard my name and the words '*con todo*' – 'with everything'.

Mike looked at me. 'It's okay. You're being moved. Grab your stuff and follow him.'

'Is that all?'

'That's about it.'

I'd never seen Mike look worried before, and it had nearly made me pass out. I hid my book in my case and rolled up my bedding. Zorro escorted me along the balcony and barked at me to stop at a gloomy cell. He turned abruptly on his heel as soon as I stepped inside. The cell had a double bunk on the left, a single on the right and not much else. A chunky blond guy rested on the single bunk. He looked okay, a bit like Fred Flintstone's pal, Barney Rubble. He sat up and tapped his chest. 'Peter. Alleman.'

I thought: *What does he mean? He's all man?* I asked him, and a voice behind me boomed out.

'German. Peter is German und so am I.'

A meaty hand reached down from the top bunk and a broad face loomed out of the darkness. He introduced himself as Gunter, as though he owned the place. Then he gripped my hand with his pudgy fist and pumped too hard and too long. Straight away I didn't like him.

I rolled out my mattress on the wires below him and eased myself onto it. I was still in shock. It wasn't just the dope scare. I'd thought I was going to be with Mike throughout my sentence, or at least over Christmas. I could have coped with that. Now a cold wind of change blew through me as I lay in the shadow of Gunter's bunk, full of hatred for Zorro.

The afternoon shift passed in a daze of fumes and I shuffled back to my new cell. I was in a sullen mood. The Germans were already in from the yard and lying on their beds. I waved silently to Peter and carefully climbed onto my bottom bunk so Gunter wouldn't have any reason to bother me.

I kept my head down until the doors opened for social hour, then ran down the gantry to Mike's cell. He looked up from his table as I charged in.

'Shit, man! That was awful.' I said.

'Yeah. He had me worried for a while. I guess they move us around in case we're planning a jailbreak or something.'

'I thought for a minute...'

'I know. So did I.' We both fell silent, imagining what might have happened. I couldn't help moaning.

'Man, I was hoping we'd have our double vino together.'

Mike pulled out a pack of Celtas. 'Me too. I guess I'll have to pull my cracker all by myself this Christmas!' Mike

grinned as he lit two cigarettes at the same time. I managed a slight smile as he passed one to me, but I wasn't happy.

'The prison keeps reminding me of the zoo.'

'How so?'

'When it rained at the zoo, we were allowed to take shelter inside. I went into the tropical bird house once. I stood there with the rain pounding on the glass roof, watching this small bird pecking up seeds on the ground. Suddenly it flew up towards the sky and crashed into the top of its cage. Then it fell to the floor.' I pulled the rough smoke deep into my lungs and blew it out. 'After a while, it went back to pecking at the seeds, then it forgot what it had just done and crashed into the roof again.'

I took another long drag and looked around Mike's cosy cell.

'Sometimes you forget you're locked up. Then, when it hits you, you come down to earth with a bang.'

I thought Mike was going to say something about karma, but he just pulled out the stove and quietly started lighting the wicks. It was only when he'd put on the water and carefully turned the stove back to the wall that he spoke.

'It's hard to know why we end up where we are. Some say that by the time you go out into the world, your path's already made. That may be true... Most of us are heading for a fall the minute we leave home.' Mike laughed. 'I know I was!'

He reached over to pull a tea-bag from the wooden box on his table.

'There's forces inside us that makes us do things we regret. So why do we do them? Maybe when you hit the bars of your cage, that's telling you something.' I kept quiet as Mike set up two pale green, plastic beakers. 'I guess each person has to find out what that something is.' I nodded. 'Did I ever show you my shark bite?' I pulled up the leg of my jeans and Mike stared in horror at the deep ugly scar that ran from my knee to my ankle. I laughed. 'I'm only kidding – it was an operation that went wrong. The stitches split when my leg swelled and then they had to re-do the whole thing. They kept me in hospital so long I read Freud and Jung to find out what was going on. Freud said there was no such thing as an accident.'

I rolled down my jeans, pleased with the effect my scar had made. 'The thing was, I knew he was right. Almost everybody in the ward had done something stupid to hospitalise themselves, including me. I'd told the doctor that my leg hurt from pushing heavy lawn mowers, but really it was just an excuse not to work.

I didn't tell Mike that the horror of my first acid trip meant that I couldn't face life and I wanted everything to stop, but that was the truth of it. Mike smiled as he set up two plastic beakers.

'Well if you're looking for a little tea and sympathy, you've come to the right place!'

I looked at the warm yellow glow from the stove and thought, *Jesus*, *I'm going to miss all this*. All the other cells were identical, but Mike's had a chair and a table with books and papers and pictures on the wall. The Germans' cell was like a cold, grey tomb.

* * *

The only good thing about having the bunk below Gunter was that I couldn't see the moon-shadow of the bars on the wall.

But everything else was shit. What the fuck had I been doing getting myself locked up? Maybe Freud was right and I'd got myself arrested on purpose? The sudden realisation brought an old memory into sharp relief. I'd done the same thing before. I was bouncing on the sofa in the farm when one of Mum's knitting needles stuck right through my knee. I was only three, but it could have been my subconscious making me do it to get a reaction from her. She pretended there was nothing wrong to stop me crying wolf, but the needle had gone in so deep it took her three goes before she managed to pull it out.

Could I still be trying to get a reaction from her? After a while I gave up thinking about it. I had no idea what was wrong with me. All I knew was I'd had enough and I wanted to get out.

It was strange to wake up in the lower bunk and see Peter's sleeping face. We fumbled through the morning ritual. There was no stove, which meant I'd have to wait till I got to the *talleres* for a cup of tea. Peter was first to mop out the floor. He had a nice vibe, but he didn't speak English or Spanish. Gunter knew some Spanish and a bit of English, but he was a pompous straight and I didn't want anything to do with him. That was one of the few good things about taking acid. It taught you to suss out people like him a mile off.

We stood to attention while the guard struggled through his round. Something was up and they kept getting the count wrong. I couldn't imagine that anyone had escaped. There were double walls around the prison with armed guards on every lookout tower.

The guard finally strode past with a face like fury. It pissed him off every time someone in a cell yelled, '*Uno en cama*!' That meant: 'One in bed.' There must have been so many sick prisoners it was messing up the numbers.

In the talleres Louis started bawling at us before we'd even

sat down. I could see why. The car he was holding looked like it had been made by a drunk. It wasn't far off the truth. I twisted open the dreaded glue jar. The fumes were still as potent as ever, but they didn't get me stoned any more. They just gave me a headache. I grabbed a cardboard shape and started pasting. Everyone was chatting and Manuel was singing, but it wasn't the same without Mike to go back to.

I tried to keep my mind occupied, but I couldn't help wondering why I hadn't heard from the consul. I guessed he'd gone home for Christmas. I would have to give up on the idea of getting out by then. I thought, *He could at least have got me those vitamin pills*. I felt lousy. I took out the first Celtas of the day and studied the pack. On the front was a Viking with his sword held above his head. *That's how I've got to be*, I thought. '*Strong – like the tobacco*.

There was a twig sticking through the cigarette paper halfway down, so I pulled it out and smeared a blob of glue over the hole. Then I fired it up with a small wax match and took a long drag. The combination of rough black tobacco and solvent almost made me pass out. I reached out for another stack of cardboard thinking, *Roll on, Christmas*.

Without the trimmings, Christmas was just another day. No cards, no presents – though Gunter had got hold of what looked like a big box of chocolates. He stood in the middle of the cell shovelling them in his mouth with the lid held under his chin. It turned out they were only fancy little *galletas* and he was catching the crumbs so he could pour them into his fat gob. He offered them around. They were basically compressed biscuit dust and totally tasteless. I turned down the offer of another, but Gunter insisted I try a particular one.

'Toma esta. Esta es mejor!'

I knew that toma meant take, but I didn't know what

mejor meant. Marzipan? I tried it. It wasn't marzipan. It was awful.

Gunter wanted my opinion. '*Es mejor, sí*?' I asked Gunter what *mejor* meant and he tried to mime it for me. This mainly consisted of him scoffing various biscuits and repeating the word *mejor* very loudly. It was the nearest we were going to get to charades and almost brought a festive flavour to the day.

I lay down on my bunk and rolled over to escape into the past. Christmas on the farm had been a time of absolute joy that seemed to last for ages. First, we were taken to see Santa at Lewis's department store in Leeds. We would queue for hours, slowly climbing the black-and-white steps that looked like a giant liquorice allsort. It was worth the wait. Every year there was a different display in Santa's grotto. One year they'd built a whole Spanish village and mountain range with a mechanism in the ceiling that made the Pelham puppets dance. Senoritas and bandits jiggled outside haciendas in a soft orange glow, while music played 'The Donkey Serenade'. No wonder I'd been disappointed that Spain looked so modern when I first arrived; I really had been expecting donkeys in sombreros.

Gunter broke me out of my thoughts by jumping clumsily off the bunk. He wanted to know if he could buy my double hit of vino off me so he could get drunk. I should have guessed why he'd been forcing his crappy biscuits on us. I didn't want to sell. I wanted to lie on my bunk and wallow in drunken nostalgia, knowing I didn't have to get up and work at the end of siesta. Gunter thought I was haggling and upped his price. He didn't know enough English to understand I wasn't interested in his money.

Christmas dinner was surprisingly good. I could actually recognise some of the ingredients. The meat tasted a lot

like chicken. Gunter started on at me for my wine before I'd even finished eating. I couldn't shut the fucker up and it was getting on my nerves. I guessed he'd nailed Peter already.

I came back from the queue with a tin half-full of Rioja. I was hoping that they'd given us a vintage and not the usual battery acid. As soon as I got through the door, Gunter started waving cash in my face.

'Veinte pesetas! Toma! Sí? Yes?

I dodged round him. 'No. No quiero dinero!'

Gunter stood between me and my bunk. He stuck another five into his fist.

'Veinticinco pesetas! Por favor! Take it, yes?

'No! No fucking *quiero*! Jesus! I don't want your money. I just want my fuckin' wine!' I was inches away from punching his fat head, but I couldn't let that happen. I shoved my can into his hand and shouted, '*Toma*!' just to shut him up.

He stared at me in amazement and tried to hand me the cash, but I wouldn't take it. I wanted him to know what a complete and utter *coño* I thought he was.

I lay fuming on my bunk, waiting for social hour, while Gunter bored the arse off Peter with stupid drunken jokes. He must have bored me to sleep because the unlocking of the doors woke me. I stamped down the gallery in a foul mood, while the TV blared out crappy carols for the mob below. As soon as I got into Mike's cell, I moaned on about the German ripping off my wine and stuffing his fat face with biscuits. Mike began to set up his chessboard in his usual calm fashion while I moved on to Gunter's stupid mime act. I ended up asking what the hell *mejor* meant. Mike said quietly, 'Better. Superior.'

'No wonder I didn't understand him. All the biscuits tasted the same. Like shit.'

Mike looked up from the chess set with a serious expression. 'Why don't you speak German – it's the only language you don't have to learn.'

I pulled my book out of my jacket and said: 'Bollocks.'

'Okay, ask me any word and I'll translate it.'

I said, 'Book.'

Mike grinned. 'Buchen'.

'Mother.'

He grinned again. 'Mutter'. I fought down a smile.

'Father.'

Mike laughed. 'Farter!'

As soon as Mike saw me smile he got up to put on the stove. I opened my book and wrote:

It's Christmas day today. Yes, the 25th of December's here again – and it finds me in prison. We fared well today – good food, that is.

I stared at the page and the writing slipped out of focus. I felt bad. It was the first Christmas I'd had without getting a card or a present. But I shouldn't have brought my bad vibes into Mike's cell, especially not on Christmas day. If anything, I should have been thanking him for getting me through this far. Then I realised I hadn't even drawn him a card. I looked around the cell for inspiration. My eyes landed on Mike's chess set and I got to work.

Minutes later I looked up in surprise when Mike handed me a cup of sweet white tea. He'd bought a tin of Nestlé evaporated milk as a Christmas treat. That only made me feel worse. He peered over my shoulder at the horse's head I'd drawn.

'It's going to be a chess version of the prison.' I said. 'Guess what you're going to be?'

Mike waved regally. 'Why, the king, of course!'

'I was thinking more along the lines of court jester. What about Zorro?'

'He should be the black knight. No, he'd like that... Maybe you should just draw him as he is. A pathetic *poseur*.'

'Yeah, with his coat like a cloak. What a prat!'

Patrick came in, his Lennon glasses peeking out of his turned-up collar.

'Feliz Navidad, muchachos!'

His smiling face helped lift my mood. 'Merry Christmas. I see you've shaved for the occasion.'

Patrick rubbed his chin. 'I'm surprised you noticed.'

'I hardly need to shave either... Hey, let's have a moustache-growing competition!'

Patrick sat down in front of the chess set with a serious smile. 'Sure, but you have to shave this evening.' Mike sat on the opposite bunk ready to do battle. This was the perfect opportunity to draw them as pieces on a chequered board. We were so intent on what we were doing that I forgot I no longer lived there. Christmas Day passed in silence until the drunken wail of a bugle cut through the fading light.

Patrick stood up with a smile. 'That guy's too drunk to stand, never mind play.'

I quickly showed them what I'd managed to get done. Patrick laughed at his Confucian portrait, but he thought drawing a guard was a big mistake. He turned the book to Mike. Suddenly I felt embarrassed that I'd portrayed him as a shepherd. It was the nearest I could get to thanking him for taking care of me. Mike made a joke about being a pawn in the game, but I knew he'd got the message and my face began to burn. I moved into the shadows of the doorway and said to Patrick, 'Would you draw a chess piece for me?' Patrick put his hands together with a Buddha's smile. 'It will be an honour!'

He walked away with my book and pen, then called out, 'Don't forget to shave this evening!' as I left for Colditz.

Lying in my cold bunk, it was easy to recall winter on the farm. Mum opened the front door to reveal a wall of snow higher than our heads. I plunged my hand in and pulled out a frozen bottle of milk. Jeremy and I dipped the end of teaspoons in and ate it as ice cream. The snow was so deep that we didn't have to go to school, but nothing could stop us. The whole countryside was a blanket of white and we highstepped in our wellingtons, pushing our balaclava'd heads into the wayside drifts to make cannonball holes.

I was too young for school, but I missed Jeremy so much when he started, they let me go a year early. I watched the chart on the classroom wall with envy and dismay. All the other boys had long lines of gold and silver stars, but I had none. Their glowing metallic luminance was so beautiful my heart ached for them. When the teacher eventually gave me some, I knew I didn't really deserve them, but I didn't care. I gazed up at my two silver and one gold star in infant nirvana. Beyond the cell bars, the real stars were shining. I couldn't see them, but I didn't want to. They always brought the moon, and the moon was the last thing I wanted to see.

* * *

Winter had moved into the bricks of the prison. It was so cold that I climbed into my bunk fully dressed as soon as I got back from the talleres. I was furious. When I'd crouched down that morning to mop the floor, my best Levis had ripped across both knees. Turtle-Neck hadn't washed my stuff; he'd just soaked it in bleach. I didn't even know what day it was.

It was hard to get a grip on time when every day was like *déjà vu*. New Year had been and gone without a word from the consulate. It seemed like madness to have ever thought I could just borrow some bread and get out quick.

Work ate up most of the daylight, so it took ages for me and Patrick to finish the chess drawing. I crosshatched the black characters so heavily they were almost obliterated, while Patrick shaded the white ones in delicate dots and threw in a smiling bishop. You could tell from the bishop's benign expression that prison was a bit of a joke to Patrick. I drew myself as the Viking on the Celtas packet, but instead of being strong I was sinking beneath the water, with only my sword held above the surface. That was pretty much how I felt at work – as if I was drowning in a sea of solvent.

I snuggled deeper into my bunk. The glue reminded me of when the hippy thing had started and we'd do anything to get stoned. Dennis Candy once grated a whole nutmeg into boiling water and was out of his head for three days. Then we all nearly puked from smoking baked banana skins after hearing Donovan's 'Mellow Yellow'. But the worst thing had been sniffing Thorpit Carpet Cleaner. If you took a massive snort and jumped off a table, it took ages for you to float to the floor. The stuff was lethal. You could almost hear your brain cells popping as the solvent ripped up your nose like an ice pick. It left you with a worse hangover than rough cider. I thought, *God, that's just how I feel now*.

I heaved my eyelids open and looked across the bits of broken biscuits on the orange-box bedside table. I'd only just got back from work, but it was already so dark I could hardly make out Peter's profile in the opposite bunk. A dull pain hung heavily on my forehead and forced my eyes to close again. It was weird. My brain weighed a ton, but my body felt light. I remembered feeling like that when I was sick on the farm. They'd taken me to have an X-ray. It wasn't like the one in the shoe shop that showed your skeleton toes through a pair of sandals. This machine was made of black metal bars and filled the whole room. The doctor turned on a light and a cross shone on my tummy like a bomb-sight. It frightened me because Daddy had one in his Lancaster for the bomber to aim at the target. The doctor told me to look at a wax model of Mickey Mouse that stood on the bars of the machine. Everybody stood back as the X-ray came down from the ceiling. The metal bars closed around Mickey and I was afraid we would both be crushed. I stared hard at Mickey as I'd been told to do, but I couldn't understand what he was doing there. I didn't even know why I was there.

I opened my eyes. The cell was completely dark. That was strange because I hadn't heard the bugle and the cell light had gone out. I wanted to brush my teeth, but I didn't feel like getting up. I screwed up my eyes and tried to remember what had happened after the X-ray, but all that came to mind was being dressed up smart and tucked into an armchair next to the farmhouse door. We were waiting for something, but I couldn't remember what. I held onto Benjamin Bear and listened hard as Mummy tried to teach me the farm address. Sometimes I grasped it, only for it to slip away again. My mind seemed to have holes in it.

The next thing I remembered was being in a hospital bed. The sheets were so stiff that I could hardly move. Mummy sat beside me. She was still trying to teach me my address, but the antiseptic smell of medicine filled my head with fear and I couldn't concentrate. When the Sister came, Mummy leaned over to whisper in my ear:

'I'll come and see you soon. I promise.'

I closed my eyes and breathed in the warm, flowery powder on her cheek as she kissed me, but when I opened my eyes she had gone.

The Sister sat beside me with a pen and a book. Her clothes looked like cardboard held together with pins. She asked me my name, like the school register. I said, 'William Stuart McLellan'.

'And what have you brought with you?'

'Benjamin. He's my bear.'

'How old are you, William?' She frowned while I tried to remember.

'Four... and three quarters.'

'Four. And where do you live?'

My mind fuzzed up and the words wouldn't come. She looked cross, like a teacher, but I couldn't remember the whole address.

'It's something, something, Blind Lane Farm, East something, then it's...'

The Sister stood up briskly before I had a chance to finish. 'Well, I'm sure you're very tired.' I was desperate to try again, but the missing words were lost. The Sister didn't seem to care, but it was really important. Mummy had gone, so if I couldn't remember my address, how would I get home?

Slowly I became aware of a voice in the cell and forced my eyes open. Peter's face was very close to mine.

'Villy, Villy, is morning'

He looked worried. He seemed to want me to do something, but I wasn't sure what. I felt as if I was set in concrete. Even my eyes wouldn't move. Gunter began shouting urgently in German. He sounded miles away. The bunk shook as Peter pushed away from it. Seconds later I heard heavy footsteps, followed by Gunter shouting in Spanish: '*Uno en cama*!' Then I understood. I was the one in bed. I thought how lovely it would be if I could just stay where I was. Time passed. Then the cell door slammed shut. I couldn't believe it. They were actually letting me sleep in. It was bliss, but the thing was – I just couldn't move.

That was how I'd felt in the hospital. They put me in the end bed in a ward with other children. Nobody told me I had polio, or that Mum wouldn't be able to visit because it was an isolation ward. Ward X was long and narrow with two lines of red-covered beds facing each other. At the far end of the ward was a tall, brown cupboard. I was hardly aware of them taking fluid from my spine and whatever else they did to me. All I knew was that there were toys in the cupboard because some of the children went up and got them. I couldn't go, but I didn't need to because I'd got Benjamin.

In the cell I was dying for a piss, but I couldn't get off my bunk. Sometimes I drifted off and dreamt I'd got up to take leak. It was terrible when I woke and realised I hadn't. The last thing I wanted to do was wet the bed in prison.

It made the Sister angry if I wet the bed on Ward X. One morning I woke up soaking wet to find her standing over me. She stripped back the covers with a look of disgust. I tried to hide what I'd done, but I couldn't move. She dragged me to the end of the bed and bent me over in front of the whole ward. Then she shouted to the children,

'Look what this naughty boy has done! He's wet the bed!'

She pulled down my wet pyjamas so they could see my bare bottom.

'Let this be a lesson to all of you. I want no more bedwetting on my ward!'

I didn't cry because she was slapping me. I cried because all the things I thought I was – the brave cowboy, the climber of trees, the drawer of pictures – had been taken away. I was just the crybaby who wet the bed.

Mum couldn't visit Ward X, so the only way she could track the state of my health was by reading the *Yorkshire Evening Post*. Brief medical reports were printed in code on the front page every day. When a child who had been on *Very Poorly* for a while disappeared without going on to *Improving*, she knew what had happened. Dad had lost his only sister to pneumonia when she was very young, so when I'd been on *Very Poorly* for a few days he feared the worst.

That must have been why Mum came to the hospital alone. I remembered her visit clearly.

They gathered around me in white coats, floating around my bed and making it move. It rolled down the long ward, hurting my head with each bounce of the wheels. We turned past the toy cupboard at the end of the ward and bumped painfully through the big doors like a ghost train in a fairground. We stopped in a small, dark room. In front of me were double doors with round windows at the top. Somebody told me where to look, and I saw the side of Mummy's face in one of the round windows. Her head was tipped up, but she was looking down at me. Her face was white and green. She could see me, but she didn't speak and I couldn't understand her expression. There was something about it that didn't look right. Then she was gone.

Peter came back to the cell. He held a beaker of ice-cold water to my dry lips and helped me to drink a little. I asked him to help me get to the bog, but he didn't have time. The cell doors were locked again, only this time I wasn't alone. I could hear somebody else breathing. It wasn't Peter, so I knew that Gunter must be sick too.

A period of time passed in Ward X when I didn't know anything at all. The first person I remembered seeing when I came back to reality was a kind boy who brought me a redand-yellow plastic harmonica from the toy cupboard. The fact that I could make real music on it like Daddy did on the piano was thrilling. I asked the boy to get it for me every day. One time I was playing the mouth organ when a nice doctor came to my bedside. He picked up Benjamin and told him he was going to teach me how to walk again.

I cranked my hot legs out of the rough, prison blankets and swung them onto the icy tiles. Then I pulled myself up on Gunter's bed rail, hoping I wouldn't wake him as I traversed towards the bog. My feet froze to the floor as I stood there with the heat leaking out of me. Somehow I managed to stagger back to the bed, where I lay in a trance listening to Gunter's heavy breathing.

Learning to walk again in the hospital was like mastering a huge radio- controlled robot. I'd never had such fun. It was weeks before I got anywhere near the toy cupboard, but one day I made it to within three beds. I leaned on the metal end rail to get my strength back, then I forced my plasticine legs forward one at a time. There was a wobbly moment when I was one step away, but I made a desperate lunge for the cupboard and held on. When I reached inside and picked up the beautiful red-and-yellow harmonica for myself, it was the best moment of my life.

The fever came back in a mechanical dream, filling my head full of steam in a boiler-room basement. My corroded joints burnt with friction as they creaked in the baking bedstead. I gripped the prison bunk in horror as it slowly sank, like a red-hot elevator, descending through layers of rib-caged radiators into the flaming shafts of hell.

Suddenly I was lucid. My head was clear and bright, like a child's. But something was weird. I was back on my old top bunk on the other side of the cell. It must be a dream, I thought. But no – I really was up by the cool window and I could hear Gunter breathing below me. I peered down into the shadows with a growing sense of fear. It wasn't Gunter down there. It was me.

* * *

At last, Mum came to take me home. She talked with the Sister while I went around the ward saying goodbye to my friends. I heard her calling my name, but I couldn't leave until I'd found Benjamin. A rising panic took over me as I ran between the long lines of red beds towards Sister.

'I can't find my bear!'

She bent down with her hands on her knees to explain: 'I'm sorry, William, but patients aren't allowed to take their toys home with them.'

I didn't understand. I *had* to take him home. Benjamin wasn't a toy – he was my bear. Mum stood in silence as the Sister bent closer.

'Your bear has got nasty germs that could make your brothers sick, so I'm afraid he has to be burnt'

I couldn't breathe. I wanted to tell her why Benjamin couldn't be burnt, because she didn't know him like I did, but the choking sorrow in my throat hurt too much to talk.

The Sister walked away to burn him while Mummy pulled me through the door.

'Don't worry,' she said. 'We'll buy you a new bear.'

She kept promising to buy a new bear all the way to the bus stop, but I knew I'd never want another. When I finally got my breath back, I told her that if she gave me one I'd throw it away.

I pulled myself up into a sitting position and looked

nothing whitten gives chirefmas and now the memory of new year has faded 1973 have we are I have little time to myself work takes all day and the few hours at night are gone with a single portaint togay I live in ked with only the for company fiver & like ating and these keds are like. the rack next day S thank God it to over only 3 days bit it was energh latt night was the longost night studt line still poin stous bue thing, there and no linete to set the only trouble is the is outing seen abler a words during the tost and unal is as the brink of hoplessness to the seems well 00 hurt the coldthere is a with the pale on with the adjustic of the pale on the the adjustic of the pale of the the adjustic of the offer of the filler with a streng with a day the book is loving its thou even the illuses is de fully ver no, its us good to chine have the 144 14 14 21 4 fear dounur 1 sam (1 smoons 1) mo timere me sur no pour l'interet anno ma ma son on or anno

around the empty cell. At last I'd found something. My first feelings of anger. Mum did buy me another bear, but the fur was harsh and new. It wasn't a real bear like Benjamin. I threw it out of the window every night until one day they didn't bring it back and that was the end of it.

I got up from my bunk and walked over the icy tiles. I'd planned to brush my teeth, but all I did was stare at the wall with my hands resting on the cold stone sink. That wasn't the end of it. It was only the beginning. I was angry back then. And I knew that deep down I was still angry now.

14

IN THE BAG

Oh, a storm is threat'ning my very life today If I don't get some shelter, Oh yeah, I'm gonna fade away. Rolling Stones

Louis held up a mangled car and bawled across the worktables like an ogre. Our spirits sank under an angry barrage of Español. I half-expected the guard to wake up and shoot someone, but he was probably too doped out on the fumes to bother. I glued on another bumper and stuffed my face deeper into my scarf to keep out the vapour and the cold.

As soon as the piemen came round I jumped up. I was out of money, but it gave me an excuse to visit Patrick and Paco at the back of the workshop. Their cell was narrow and had no window, but it looked like a design studio, with cardboard templates hanging from string on the grey-washed walls. I squeezed past their chairs, then stood in the shadows to watch them work.

It was like a scene from a Bruegel painting. Patrick was straddling a section of tree trunk, hammering holes in a leather pattern with a punch, while Paco huddled over a warped drawing board in his black poncho. Paco was paleskinned compared to the other Spaniards, and had short, cropped black hair and big, dark eyes like Picasso. He leant back to show me a drawing of a bag.

'How you think it look?'

I thought it looked awful, like a galleon with a strap stuck on each end, but I smiled.

'Not bad. What's that bit in the middle?'

'That is to close the lid, like a...' Paco asked Patrick the English word for *soga*.

'Noose,' said Patrick, and punched another hole.

Paco mimed being hung. 'Sure,' he said with a dark smile. 'Like a noose.'

Patrick stopped hammering and squinted at me through his round glasses. 'Hey, have you been shaving?'

I glared at his smooth cheeks indignantly. 'Have you?'

'Your illness must have stunted your hormones. How are you feeling?'

'The fever's gone, but last night was terrible.'

Paco rolled his eyes and turned back to his drawing board, but Patrick asked me what had happened.

'I had another nightmare. The Guardia Civil were chasing me through the streets. I was running in slow motion and the buildings kept getting closer and closer together until I could hardly squeeze through them. Then I got trapped in an alleyway. I couldn't breathe and my ribs started cracking.'

Patrick punched a few more holes. Probably to shut me up.

'You're run down,' he said. 'A friend of mine is having a party tonight. You should come.'

'He's having a *party*?' The idea of a party in Modelo seemed insane.

'It's his birthday. He's local so he's bound to have food from home.'

The sound of Louis bellowing signalled the end of the break. 'See you later.'

Paco raised a lazy hand and said, '*Ciao*.' I squeezed past him, feeling like I was leaving the cool place to pick oakum in the workhouse.

That evening, Patrick clattered down the metal stairs in front of me, taking me to the party. Spanish prisoners crowded around the TV on the gallery floor, and the raucous noise grew louder with each level we descended. It was my first time down in the Spanish scene and The Freak began to twist my stomach. We threaded through the bustling crowd and pushed our way into a smoky corner cell. It was packed with people, and the smell of chorizo and garlic mingled with sweat and smoke made me gag.

Patrick introduced me to the birthday boy, then pulled me over to a line of rickety orange-box tables and told me to grab some food. The only thing I recognised in the dim light was a bowl piled high with small cubes of bright pink ham. They were unpleasantly squishy, as if they'd been injected with soapy water. I knew I should try to build myself up, so I stood there pushing them into my mouth until I started feeling queasy. I wanted to leave, but it seemed rude to just eat and split, so I leant back against the wall. I was sweating. A small Spanish guy squeezed between the dark bodies to get close to me.

'You're English, yes? Are you political or criminal?'

'Er, criminal I suppose.'

'I'm political. You know what they did to me?'

'No.' I didn't want to know. I felt sick enough already.

'They put electricity on my testicles. You can't imagine the pain.' 'Why did they do that?' 'For information.'

'What, like torture?'

'Yes, they torture me for days. You know what else they do?'

I didn't want to be rude, but I had to get out. It was like an oven in there, with so many people crammed into a small space. He held up the backs of his hands. 'They burn me with cigarette. *Look*.'

His skin was so dark and rough it was hard to tell the burns from the wrinkles. I told him I wasn't feeling well and he grabbed my jacket as I moved away.

'When you go back to England, tell the newspapers what they do in Franco's prison.'

I said, 'Sure,' and dragged myself to the door, hoping I'd make it to the bog in time.

I lay on my bunk, vowing that I'd never eat ham again as long as I lived. When the bugle blew, Peter and Gunter came in, quickly followed by Patrick. He grabbed my book and ran off just as the bolts started slamming. I'd forgotten it was his turn to add a drawing to our collaboration. Our pictures were beginning to look as disturbed as I felt, and the thought of them only made me feel worse.

It was too early to sleep and it made me think that prison was the adult version of being sent to your room when you'd been naughty. That reminded me of the first time I'd drawn something I thought was any good. I tried to remember what I'd done wrong to be sent upstairs. Nothing came to mind, but as I sank into my Modelo mattress, I recalled how empty it felt to be in my bedroom while there was still daylight in the farmyard.

I sat down on my patchwork bedspread. Without Benjamin I felt completely alone. There was nothing to do, so I stared at the pattern of scratches on my flat wooden bed head. The varnish was deep brown and the marks were yellow with crinkly edges. Some of them looked like bows and arrows or seagulls flying in a dark and stormy sky.

I wanted to scratch at the varnish with the nail I used to lever stones out of the tyres of Dad's van, but I didn't dare, so I pulled my pillow away to reveal the polished bar of wood underneath it. It had gold writing in the middle like the lid on Dad's piano. I lay on the bed and slowly scratched a long wavy line in the dark varnish with the nail. The golden mark was so pleasurable to make, I gouged another curvy line, followed by more that crossed over the other ones.

When I sat back to look at what I'd done, I got a big surprise. In the middle, where all the lines crossed, was a beautiful speedboat sailing through the waves. The bow curved like a real boat and it had a cabin with a windscreen, like a drawing in a book. All it needed was a back and a steering wheel, so I carefully scratched them in. It was much better than anything I could have drawn on purpose.

I opened my eyes and looked around the dark cell. Mum never noticed the boat on the bed, but that wasn't surprising. She never noticed the mountains of fluff that piled up underneath it either. Did I draw because I was sad, or did I scratch the bedhead because I was angry? Was that how it all started? I wanted to think more about it but a faint click of metal came from the door. I'd heard it before, but never really thought about it. Suddenly I understood. It was the spyhole. The guards must have taken their boots off to creep round and check on the prisoners. Mike and I would never have heard them coming when we were smoking the joint. It had been sheer luck that they hadn't caught us. I was going to have to be a lot more careful in future.

162

There were no windows in the *talleres*, so I only saw the day for a brief moment the next morning. Even then there was nothing much to look at. The walls of the yard were so high that all you could see was the pale grey sky. It was months since I'd seen real life.

The babble of rapid Spanish and the fug of solvent and tobacco faded away as I cut out cardboard shapes of car parts. I tried to think of something nice that had happened after I left the hospital. It wasn't hard to do. I immediately thought of Jeremy, leading me through the warm, prickly straw-bale tunnels in the barn. I followed him on my hands and knees as he went ahead to warn me of the dark, square holes that fell away to the centre of the earth. He was always kind to me. When we came back from school along the hilly country roads, Jeremy carried my satchel and gabardine so I could run free in my beautiful blue dungarees. I'd sprint downhill with the wind in my hair as fast as my legs could carry me. It was the best feeling in the world – *ever*.

When I got back from work it was almost dark. There was just enough light to make out Gunter's teeth, stained purple from ripping off Peter's wine.

'Hey, Villy. You vork too hard!'

I wanted to say, 'Yeah, and you drink too much!' but I just told him I needed the *dinero* and crashed onto my bunk.

The trouble with being on the lower bunk was I could hardly see what Patrick had drawn in my book. I'd done a sequence of Louis bawling his head off in the workshop and Patrick had replied with mysterious soulful faces. I tried to match his inventiveness, but the straight lines of my crosshatching looked conventional in comparison with his undulating forms and pointillist shading.

When the dim light went out I got halfway into bed and

leant against the bunk bars. Patrick's drawings made me question my ability. The boat I'd scratched on the headboard of my bed was my first real drawing, but it felt like cheating because I'd done it by accident. I didn't learn to draw properly until I went back to school after leaving Ward X. The boys in my class were all a year older than me so there was a lot of catching up to do. One boy had worked out how to draw the way a chimney stack intersected with the roof. I copied his picture until I could draw it myself. Mum was delighted when I took my drawing home, so I kept trying hard to impress her.

I slipped further into my bunk. I'd stumbled on a hidden memory. At the end of term, the boy who had drawn the chimney had done a painting of an aeroplane. He'd drawn the complicated way that the rear wings and tail fitted into the fuselage perfectly. I knew that I'd soon learn how to do it myself, but I was so impatient for my mother's praise that I stole his picture and told Mum I'd painted it myself.

Could that have been how the whole stealing thing got started? Or was it ridiculous to think that trying to keep up with my older classmates could eventually lead to a prison sentence?

I opened my eyes and stared into the murky cell. What was the good of going over all this stuff? There were no excuses in the past. It was simple. I did stupid things because I was stupid. End of story.

As soon as the bugler began to murder the call for social hour I took my book round to Mike's cosy cell. Mike leaned on the bunk to look over my shoulder as I flipped through the pages. He laughed at the drunken expression I wore on the stolen scooter, and praised Patrick's delicate drawings. I wiped my nib on my jeans and got to work, determined to get my standard up to Patrick's.

The mail call started and I asked Mike if his *amigo* had sent him any of Grandma's special brownies yet. He shook his head as he poured the tea.

'Nope. But then again, the guards did look a bit dopey the other day.'

'Are you really going to grow dope when you get out?'

'Why not? Hey, you used to live on a farm. Maybe you can give me a few tips.'

I took a sip of sweet black tea and thought about harvest time. 'You won't need much land. Our farm only had one field for crops, but it gave the farmer tons of wheat. He rented a combine harvester and everybody got together to help. It was like a massive picnic.' I sipped my tea, enjoying the memory. 'At the end of the day, there was a small square of corn left in the middle of the field. It was packed full of rabbits and when they broke cover, the dogs went for them. It was really exciting.'

'So why did you leave?'

'I don't know. My dad bought a house in town.'

Mike turned the stove back to the wall and covered it with the fruit bowl. 'Did you miss the farm?'

'Not at first. We'd been given scooters for Christmas and they were useless on the bumpy country lane. Our new house had smooth pavements outside so they went like rockets. Only the first time I rode round the block, the handlebars snapped and I fell off.'

Mike laughed. 'You don't have much luck with scooters, do you?'

I was about to agree when Mike's smile froze on his face. There was a clatter of footsteps and Zorro strode into the cell, black cape flying from his shoulders. I stood to attention, folding my book behind me. Zorro yelled in my face and pointed to the door. I edged out quickly, shielding my book with my body.

When I got back to the cell Gunter said, 'Oh, you're back!' as though I'd been away on holiday. I ignored him. Mike had got me on to something, and I slipped into the shadows of my bunk to keep the train of thought going.

Mike was right about me having no luck with scooters. The broken handlebars had been a sign of things to come. The farm had been a secure home, but in the new house everything started to break up. Including Dad.

All I knew about his past was from the brief snippets Mum used to roll out. He'd flown forty-seven missions and been shot down three times. In winter, the burn marks on his forehead showed up blue from when he'd tried to rescue the rear-gunner from his burning plane. Dad was the only survivor of his original squadron. Mum said this was because he claimed to have an angel on his wingtip. That was about all I knew, except that he had perfect pitch and played jazz piano like Art Tatum.

As I thought about it in the cell, I realised he couldn't have been happy. He'd enjoyed flying Mosquitos and Lancasters, and playing piano in the officers' mess, but the only work he could get after the war was driving a delivery van and knocking out standards in the local pubs and clubs.

Maybe that was why he drank so much, and maybe that was why he ran off with a barmaid. Mum didn't tell us stuff like that until we were older. It was around that time that I found a bundle of Dad's letters in Mum's desk. Some of them were written from jail, asking Mum to send him some tobacco. It was no surprise that the mortgage didn't get paid.

I opened my eyes and stared up at Gunter's stained mattress. I'd completely forgotten that Dad's drinking had landed him in prison. Maybe it was true that apples don't fall far from the tree. As a kid I hadn't known any of this. I just hated taking Issy's pram to get off-cuts of wood from the furniture factory. It made me feel ashamed when I pushed it back, because everybody could tell that we couldn't afford coal.

When the house was repossessed we moved to a red brick terrace. Dad didn't come with us this time. It had a front door that opened right onto the pavement, which felt strange after the open fields that surrounded the farm. When we arrived there were newspapers on the floor instead of carpets. Mum scrunched them up and burnt them in the grate. From then on, the smell of burning newspaper would always take me back to the sad, bare floorboards of that room.

Peter climbed into his bunk opposite mine. His routine had taken the place of my watch, and it meant the cell light was about to go off. I ought to get up and brush my teeth, but I didn't want to stop thinking now that I seemed to be finally getting somewhere. Peter flicked me a salute before he lay back in the shadows.

'Good night, Villy.'

I didn't bother saying goodnight to Gunter, but I always said it to Peter. His few kind words stopped Colditz from turning into solitary confinement. It didn't seem possible that Peter could have done anything bad enough to be put in prison. But I was sure that whatever it was, Gunter had dragged him into it. Gunter heaved his bulk into the bunk above me, and seconds later the cell fell into darkness.

In the newspaper house that happened all the time: the light would suddenly go out. The first time it happened I felt guilty, as though I was to blame for using up the money in the meter. I searched through the empty bedrooms until I found a light switch left on without a bulb in the socket. I told Mum that the electricity must have leaked out, but she just shook her head like I was an idiot and angled the blackened stub of a candle into the flame of a match.

I'd opened floodgates. It wasn't just specific memories that were returning. There was a whole feeling that went with them. It seeped into me as though I'd left my cell in Modelo and travelled back in time. It wasn't exactly an emotion, more a sense of disorientation – like being cut adrift over a deep and disquieting ocean.

We moved often, never knowing where we were going to live next. One place was by a railway line, up lots of narrow stairs. The kitchen was like a greenhouse stuck on top of a building. Somebody sent us a huge tin of army surplus greengage jam. It was the size of a bucket and it took Mum ages to hack off the lid with a tin opener. By the time we moved on, we'd got so sick of greengage jam that we left it behind.

The next house was better. It had a small front garden and a rackety old piano, so Dad could play when he visited. He'd drive up in his van and show us the red lines that crisscrossed his hands from delivering heavy reams of paper. I could never understand how something so soft as paper could cause so many cuts. Instead of pocket money, he'd give us long strips of pink and blue cardboard to draw on.

I'd draw tall pictures of him with his pilot's moustache and shiny black hair swept back like a Teddy Boy. I always drew his arm bent with a triangular gap between it and his body so he could see it was a proper drawing, not a childish stick man.

Unexpected tears stung my eyes as I remembered those pictures. At the time, I'd thought I was just trying to please Dad with the drawings. Now, lying there in the dark of the cell, I understood. I was really trying to show him how good I was, so he wouldn't want to leave me. The next day I was put on the car production line again. Manuel was already pasting away, but I was back on the dreaded scissors. *Jesus*, I thought. *Henry Ford has got a lot to answer for*. The calluses on my finger and thumb looked like extra knuckles and needed a good, long rub before I could bear to start cutting. I saw Louis coming towards me and quickly reached for a batch of cardboard. His bony face fell into jowls as he looked down on me from a great height.

'Patrick showed me your book last night. You draw very good.' Louis rubbed the loose skin around his chin with his big hand. 'Maybe you should design some bags wis him?'

I could hardly believe my ears, but I managed to say, 'I'll give it a try.'

'Okay, you can start now. Make a *bolso*. If it's good, you make more.'

Manuel watched me gathering my stuff. His face lit up when I told him I was leaving. '*Tú libertad*?'

I shook my head and pointed to the back of the workshop. *No. Tengo trabajo con mis amigos*?

'Bueno, Weeyaam. Bueno!' He rubbed his thumb and fingers together with a wide grin. *'Más dinero*?'

Louis hadn't mentioned money, but I told Manuel that I hoped so in my clumsy Spanish. He smiled at my effort.

'Siempre esperanza, eh, Weeyaam?'

I nodded. He was right. You always have to hope.

I stepped over the bench. It seemed almost a shame to go. That was my first real conversation in Spanish and it meant a lot to me.

Paco and Patrick shuffled their stools apart so I could sit between them at the workbench. Patrick's oriental eyebrows rose over his big round glasses. 'So you've been promoted?' A grin of thanks spread across my face. 'Yeah – I wonder how that happened!'

Paco raised a pencil like the stem of a wineglass and assumed a pompous expression. 'Now all the artists are assembled. Let us begin.'

I took it in quickly. First, you made a drawing, then you broke it down into parts: the sides, the back, the front and the flap. Then you made the parts out of cardboard, using callipers to plot the holes around the edges. These were used to sew the bag together with string. If Louis thought it looked okay, you cut round the patterns in leather and punched in the holes. The moment of truth came when you cut thin strips of leather that Paco called *tiras* and stitched the whole bag together.

I started drawing straight away. I went for classic simplicity – nothing fancy, just a beautiful shape that widened into a curve like a pear with a flat base. I wanted to make the model in a single day to impress Louis.

Louis strolled over when the bell rang and considered my grey cardboard bag with his hands on his hips and his mouth dragged down like a high-court judge. At last he nodded his head slowly, like a donkey.

'Sí, está bien. Tomorrow you make in leather.'

We trudged back in a long ragged line over the high metal walkways. The last rays of sun coming through the big circular window always reminded me of my old church at evensong. I had only two rituals in Modelo: I lifted the anvil every morning and I sang every evening as we walked over the high gantries, shaping the guitar chords with my fingers so I wouldn't forget how to play.

> Dusk till dawn I'm walking Can you hear my guitar rocking?

While I stroll on down, on down the highway.

The song echoed down the gallery as a new guy shoved his giant bedroll through a cell door a short way down from mine. You could always tell the hippies: the rough prison haircut revealed an untanned neck and a ghostly white forehead. The other giveaway was the look of terror on their faces.

Peter nodded to me as I entered the cell. 'Gut day, ja?'

I smiled as I flopped onto my bunk. 'Yeah, and you?'

Peter smiled back. That was about all we could say to each other. I dozed until the rasp of the food bucket made me reach for my hubcap.

Gunter was already at the door, crouched down to get his bowlful of slop. He stood there, wolfing it down while I thought, '*Feeding time at the zoo*'.

I carried my loaded hubcap back to my bunk and opened *Balthazar*. There were so few books in Modelo that *The Alexandria Quartet* was being passed around the cells like a joint. Its trippy imagery painted surreal pictures in my head and I lost myself in reading until the orange filament in the dim bulb faded to black. I closed my eyes and imagined how Durrell would have described it – as a bulbous glow-worm, dying on its umbilical cord.

It was annoying being forced to go to sleep before you were ready. The light went off but my mind was still switched on. To keep darker thoughts at bay, I tried to imagine how the finished bag would fit together the next day. The leather was thicker than the cardboard – would the holes still line up on the curves? It had to be good. I couldn't bear to go back to the production line now. It wasn't just the work that was better. Patrick had told me the money was too.

Money. That word opened up a fresh seam of memories.

I was surprised how detailed my journeys into the past were becoming. I was getting so used to visiting that I could remember the address of the piano house we'd moved into – and my exact age. That was when money first began to fascinate me – maybe because we hardly ever had any. There was never enough for food, never enough for clothes and never enough for sweets.

I could even remember when I'd started to steal.

I was seven years old when we moved into 31 Delph Mount, Leeds 6. Except for the beds and bookshelves, it felt empty. I never found out what happened to our toys. They just disappeared somewhere along the way. Maybe it was while searching for them that I found what looked like a small red Bible hidden between the hardbacks. It was a metal moneybox with gold-edged leaves and a crest embossed on the front next to a keyhole. I shook it and heard money rattling around ir side. It was like discovering a pirate's treasure chest.

I got a knife from the kitchen and slid it into the slot. Then I shook the box until I felt a coin land on the blade. But when I pulled it out, a sprung metal flap scraped the coin off. I got another knife and used it to hold the flap open when I'd landed a coin on the other one. The sight of the coin's edge coming through the slot was absolutely thrilling.

I kept going back to the book until I had a small pile of coppers and even a golden thrupenny bit.

When Dad came to take us shopping, I slipped outside while he was deep in conversation with Mum. I ran down the street placing stolen pennies by lampposts and drains, then sneaked in the back door. As we got ready to leave I casually told them I'd heard about a man who'd lost some money near our house.

My money-laundering plan was doomed from the start.

I'd expected my parents to be pleased every time I found a coin, but there was only a silent exchange of glances that told me they knew of my guilt.

I felt terrible. I had become a thief. The weight of my crime hung constantly on my heart. But now, from my prison bunk, it no longer seemed like I'd been stealing. I'd lost my school, my toys, my friends, my bear, and I was losing my father who meant more to me than anything in the world. I was just trying to get something back.

A nasty sound abruptly ended my thoughts. The snick of metal across the spyhole, followed by the creepy sense of an eye roving around the cell. The image of Zorro standing out there in his socks made me want to shove a spike through it, just to hear him scream.

15

LAST NIGHT

Woke up this morning and my Mama was gone Middle Of The Road

Paco's black eyes looked up from his cluttered workbench. Buenos días. Cómo estás?'

'Muy mal. I couldn't sleep last night for thinking.'

To Paco, every problem had an easy answer: 'Then don't think!'

I dropped heavily into my seat. 'Yeah, but I can't stop things coming into my head.'

Paco flapped his hand around his temple. 'Then thrrrow out the mind! Thrrrow out the mind!'

If only it was that easy. Every night stuff jumped into my brain and wouldn't go away. It wasn't so bad during the day when I had things to do – and thankfully, that morning was going to be busy.

Patrick turned up in his long, dark coat and I checked out his chin. There was a hint of black hairs among the fluff, but

nothing to worry about. He glanced at my face for signs of stubble, then pointed to my desk.

'Get your templates and drawings and come with me.'

He led me through the workshop tables to a part of the *tall-eres* I hadn't known existed. The sense of freedom to wander was exciting. We entered a dingy storeroom that smelled like a cow shed. The walls were hidden by dark wooden shelves piled high with hides. Patrick stopped at a counter and showed my patterns to a stocky trustee who looked like a butcher. The man disappeared into the shadows.

Patrick motioned me on with a conspiratorial grin. 'Follow me.' He slipped round a corner and the smell of leather changed to sawdust as we reached a noisy workshop. It was as though we'd stumbled into the past. Dusty carpenters hacked away with spokeshaves and chisels at benches scarred with saw cuts.

Patrick waved over a guy in a long, leather apron. 'Rafa can make your fastener here.' He smiled as Rafa took my drawing. 'And lots of other things too.'

I looked round at the lathe and fretsaws, and realised that this was where the stoves were made. That was great, because I'd been meaning to have a spare one made for Mike in case Zorro ever ripped his off. We dodged back to the counter like school kids, and the silent trustee handed me a pale calfskin for my *bolso*.

Patrick cleared the workbench and showed me how to position the pattern around the nipples to get the most economical cut. You only got one go with the knife, so it had to be spot on. I took the same care cutting the curves as I did with drawing, and the finished leather shapes looked symmetrical and smooth.

Paco lent me a wooden tool. It resembled a tiny

two-pronged fork with one tine shorter than the other. It was fun to use: the long tine followed the edge of the leather while the shorter one scored a neat brown line in the surface, a short distance from the edge. This served as a guide when it came to punching the holes. I cut long strips of *tiras* using a heavy metal ruler, and by the end of the day my bag was stitched together and ready to be judged. It stood pristine and perfect on the battered bench surrounded by a mess of tools, patterns and off-cuts. It only needed a wooden toggle to complete it.

Louis came over and studied it from all sides, one hand on his elbow, the other spreading creases across his bony chin. Eventually he pronounced, '*Sí, es un bueno bolso*. Señor Vendrell will see it in the morning.'

Louis wasn't giving much away, but I felt good. I might have been mistaken, but it looked as if he was trying not to smile.

That night, when the light went out I fumbled in the dark to put *Balthazar* on my bedside box. The stones of the prison were so quiet at night that I could hear the rustle of individual straws in the mattress as I lay back in my bunk. It had been a good day. Being free to roam around the *talleres* was fun, and even here in the dark cell the smell of fresh leather and the carpenters' workshop still hung in my nose. Señor Vendrell would look at my bag in the morning and hopefully take me on full-time. That would mean more money and a move into the studio with Patrick and Paco. It was the first time in the prison that I was actually looking forward to the next day, but however hard I tried to savour the experience, my mind kept drifting back to the past.

There was a reason for that. I was finally getting somewhere. I'd always believed I'd had a happy childhood, and in a way I had. But that was because I'd pretended the painful things had never happened. Now that I couldn't hide them anymore, the bad memories kept coming back.

We were thrown out of the house where I'd stolen from the money box, and placed in a run-down Victorian building called South Lodge. Mum told us that the Lodge used to be a workhouse, but it was now a halfway house. I thought that was because it was halfway between a house and a shed. We only had two rooms in South Lodge. They had hardboard walls with a curtain between them instead of a door. I liked it because there was a huge heating pipe running through the partitions that you could lie on and cuddle like a giant hot-water bottle. What I didn't like was having to start at another new school. I couldn't remember exactly how long we'd stayed in the Lodge, but I clearly remembered moving out. And why it happened.

The year was 1958, so I'd have been eight years old. I woke up one morning, and everything seemed strange. It was quiet, like a Sunday, but I knew it was a school day. I swung my legs out of the warm bed and stepped onto the cold lino floor. Isobel was in her cot and I could tell Jack was asleep because his thumb was still jammed in his mouth. For some reason, that really annoyed me – if you pulled it out, he just kept poking his face till it stuck back in again. Jeremy's bed was empty, but I could hear someone in the other room. I drew back the pale flowery curtain to find Jeremy sitting on a chair by the kitchen table. His knee was tucked under his chin so he could tie his shoelace. He looked up when I asked where Mum was.

'I think she's gone.'

'Gone? Gone where?'

'Don't know. Gone' Jeremy pulled the bow tight and nodded to an envelope leaning on the teapot in the middle of the table. 'She left a letter for the caretaker, so I'm off to get him.'

He seemed so grown-up, but he wasn't even ten yet. I wanted to help too.

'What shall I do?'

'Get the others up. I'll be back in a minute.'

I pulled open the curtain and walked down the gap between the beds. It was strange. Mum had been here last night. We'd all been lying in bed while she pretended the curtain was a stage in a theatre, walking side to side from one end to the other, pulling a different funny face each time. I liked the Egyptian best, her neck moved like a duck and she held her arms flat like a drawing. We'd laughed our heads off. She was good at stuff like that.

I knew how to turn the metal clips to drop down the side of Isobel's cot. You had to be careful with the last one or it would slam down and trap your fingers. We called her Lulu back then because that's how she'd said Isobel when she was tiny. I liked lifting her out because she was lovely and warm. Mum had made up a song about her and I sang it in my head as I picked her up.

> If Lulu was a fairy She'd be too fat to fly She'd flap and flap and flap her wings And never reach the sky.

It was a good song except Isobel wasn't fat. Mum was fat. I'd seen her bottom once. Sometimes she let us take our Sunday morning sweets and comics into her big bed. Mum was sitting on the edge of the mattress and didn't know her nightdress had ridden up her back. When she stood up, her bottom was like a flat, white wall. It was so wide I could hardly believe it was part of a person. She was always on a diet, but it never made any difference. She stayed fat, only she called herself 'pleasingly plump' to make us laugh.

I helped Isobel into her dress and watched as she put on her glasses. She was only two-and-a-half, but she tilted her head to one side and twiddled the hooks round her ears like a grown up. They were those pink National Health specs that needed Elastoplasts round the joints to stop them falling apart. I burst out laughing when Isobel first got them and Mum slapped me around the head. But I wasn't being mean. I just couldn't help laughing because the lenses made her eyes look so big.

I woke up Jack. He was five, so he could sort of dress himself. He stuffed his shirt into his trousers even though it would soon come out again. Mine didn't. I'd got my red-andgreen elastic snake belt on. I loved the way the silver snake hooked into a circle to fasten. It meant that even though you were at school, you were still dressed as a cowboy.

Jeremy came back with the caretaker. I could tell from the way he walked that he was trying to act grown-up, except his hair was sticking up at the back. We all had the same hair. However much we plastered it down, it always stuck up. The caretaker read Mum's note and then left. We were hungry, but we didn't dare touch anything, and anyway there wasn't that much to touch.

Eventually the caretaker returned and told us to follow him. I felt excited because we were going on a journey, but it was also a strange feeling because I didn't know where. Nobody spoke as our footsteps echoed down the wide stone steps. I ran my hand along the cold, metal bannisters, wondering if we'd ever come back and what would happen to our things. The caretaker held the heavy door open and we walked out into the big tarmac yard. I looked into the kitchen annexe on our way to the gate. It was always freezing in there, with long lines of grey speckled gas cookers that stank of old fat.

There was a pale green car waiting outside the gates. The caretaker told us to get in and we all squeezed together in the back. It was so posh inside that we didn't dare talk. The grown-ups in front didn't say anything either, so the only sound apart from the engine was the ticking of the indicators as we turned corners. I sat by the window, which made it easy to lift my foot every time we passed a lamppost. The line of the post had to go under my foot like a skipping rope, but it didn't have to be lifted high because the line was invisible. Sometimes I only lifted my toes up inside my shoe so that no one knew I was doing it.

I could tell the journey was ending when the car bounced as it entered a drive. Some adults came from a large building made of red bricks to meet us. It looked a bit like a school, except it had a big garden with trees and bushes.

When we got out, a man in a tweed jacket started explaining things to us, but all I could take in was that Isobel had to be taken away by herself. She didn't want to go, so she clung onto Jeremy. Mum had always said that Isobel had to come with us wherever we went. Issy liked that because she wanted to learn how to be a boy, and we liked it because it was good fun teaching her. The grown-ups kept asking Issy to come with them until she started to cry. Then the ladies took hold of her and pulled her off Jeremy. Issy reached out to us through their arms as they dragged her away crying, 'Me bruvvers, me bruvvers!'

It was her glasses that made me want to cry. It didn't seem fair to do that to someone wearing those glasses.

When I arrived at the *talleres* the next day I was shocked to see a dark shade on Patrick's upper lip. But that was the least of my worries. Today was Judgement Day. Patrick joined me in clearing up the mess from yesterday's intense activity. It helped to calm me down until I saw Louis's stained brown work coat lurching between the glue tables. I scanned his face for a clue. It was hard to tell, but he appeared to be smiling.

'Señor Vendrell likes your *bolso* very much,' he said. He nodded at Paco as he handed him my bag. 'Zey will show you ow to make the master patterns and the fassner.'

Louis must have noticed my questioning expression. 'You work here now,' he said. '*Vale*?'

'Bvali'.

When Louis left, Patrick congratulated me and for the first time I really felt part of the prison scene. He showed me how to use the callipers to get the holes in exactly the right places and to make sure that they were level at the top where they met to be tied. I asked him why the master patterns had to be so accurate. He looked up from his work.

'They're going to be used on the production line, so they have to be good.' Patrick looked at my astonished face and added, 'Didn't you know?'

I was glad I hadn't known. I'd thought I was just making a single *bolso*. I would have been a bag of nerves if I'd known it was a blueprint for tons of them.

By lunchtime I had a pounding headache. It had been another bad night. First I'd been kept awake by my thoughts about the past; then, when I did sleep, nightmares had woken me up in a panic. Patrick offered to take me to see the *talleres practicantes*, who apparently were much better than the prison ones. Louis gave us permission, and the guard allowed us through the mysterious civilian doors. I felt a rush of excitement as we stepped unescorted up a whitewashed spiral staircase.

Halfway up, Patrick turned to me with his finger to his lips. Then he ran down a narrow corridor that led to a small landing. He braced himself under a high window and clasped his hands together to give me a leg up. I put my foot in and slowly pulled myself upwards until I could see over the ledge. Immediately below were the outside walls of the prison. I ducked as a Guardia Civil officer walked past. He was so close I could see every detail on his automatic rifle. For a crazy moment I thought Patrick expected me to escape, but then I looked beyond the prison walls and realised why he'd brought me there.

It was like seeing the Pyramids for the first time. My jaw dropped as I gazed on the golden city in the siesta sunshine. Cars cruised lazily past on the wide, circular road as if their drivers didn't have a care in the world. Just across the street, a lady in a long brown coat with a bag on her arm walked slowly towards a corner shop. I couldn't understand why she wasn't skipping with joy at being free. Instead, she casually pushed open the door, unaware how wonderful it was to be able to walk wherever she wanted. I could have stayed drinking in the scene forever, but Patrick lowered me to the floor and we went on to find the medics.

My head felt better after the tablets and the siesta. I took my bag to the carpenter's workshop to have the toggle made. Patrick's friend turned it on a lathe while I used his tin snips to cut a stove out of Gunter's old pineapple rings can. All I had to do to finish it off was jigsaw a hole in a bit of wood for a shelf.

Patrick lent me his punch to make wick holes in the tin, and at the end of the day I hid it in my Levi jacket to smuggle it back to my cell. I smiled once I'd safely passed the gallery guards. It was the best day I'd had since coming to Modelo.

The activity of the day had kept my thoughts hidden, but when night came they all returned.

I was back outside the children's home.

After they had taken Isobel, the man in the tweed jacket told us his name was Mr Smith. He bent down to talk to me with his hands on his knees and his head close to mine. He had a thin moustache along his top lip, but you could still see the dark bristles he'd shaved off. He smiled, but his voice was hard.

'And what's your name, young man?'

'William.'

'William, sir'.

I'd done something wrong already. I wanted to make up for it, so I said, 'William, sir.'

'Well, William. I'm going to ask you a question. Do you wet the bed?'

The man looked like someone who might get angry, so I said, 'No.'

'No, what?' he snapped.

'No, sir.' I knew I shouldn't have said no, but I was too shy to say yes.

All my life I'd been afraid to say things. The last time I'd seen Dad, he'd asked me to go to the shop for some milk chocolate. I hadn't dared to ask him if milk chocolate was a drink or a chocolate bar in case he thought I was stupid. All the way to the shop I tried to imagine what a bar of chocolate milk would look like.

When I got to the counter I was too embarrassed to ask for milk chocolate. I just pointed to one of the bars on the stand and gave the shopkeeper Dad's sixpence. When I brought the wrong bar back to South Lodge, Dad was annoyed. He told me all I had to do was ask for milk chocolate, but I kept bringing back different bars until he ran out of money and patience. He said he was going to stop my pocket money until all the sixpences had been paid back and I saw long, barren years stretching ahead of me. I should have had the courage to ask for milk chocolate, and I should have told Mr Smith that I wet the bed.

We followed his tight tweed jacket and sharply creased trousers through the imposing front door. It led us into a large hallway. In front of us, across the parquet floor, was a broad staircase with brass runners and a red flowery carpet. Mr Smith talked as he walked towards some blue-painted double doors, but I wasn't listening. I was worrying about what would happen if I wet the bed. Mr Smith held one of the doors open and the smell hit me before I took in the huge hall or the distant echo of children playing. It was a strange mixture of disinfectant and blancmange, and it filled my whole being with an overwhelming sense of dread, as though it was the smell of fear itself.

I spent the whole of Friday in the prison factory thinking about money. Not just because Louis might give me a raise. My mind kept going back to a talk I'd had with the Transylvanian guy about his time in Zürich. He wasn't as scary as he looked, and he'd given me an idea to pay off the *fianza*. I'd done all the sums. The Swiss were so rich that even menial jobs paid ten times more than you'd get in England. All I had to do was get Mum to arrange short-term loans from friends in Leeds and then, when I got bailed out, I'd work in Switzerland to pay them off. Jeremy always used to bang on about the Gnomes of Zürich. It gave me a mental picture of them shovelling gold in their underground tunnels. I didn't like to think about where the gold came from, but the Gnomes of Zürich couldn't be any worse than the Pigs of Franco.

There was no daylight in the *talleres*, so when the bell rang at the end of the day it always took me by surprise. I put down the new bag I was working on and ran to the pay queue. Louis grunted as he slid me a pack of pink and blue cards. I took them and joined the line of workers shuffling back to the Gallery. I wasn't going to count them until I'd got out of the *talleres*, but just by the thickness I could tell that I'd got a raise.

Saturday was cold in the yard, but after a week in the windowless workshop even the grey daylight was a welcome change. My shoes scuffed through the dust towards the far corner, beyond the noisy boules and Crazy Bob yelling for the basketball. I wanted to find a peaceful spot where I could think about what to do with my cash. As I lowered myself onto the granite kerbstone, I instinctively looked around. There was only one other prisoner up there with me. It was the new guy from our balcony. I recognised him by his hacked hair and white forehead. He just sat there, looking as vacant as I must have done when I first came in.

His open mouth reminded me of the crocodiles in the zoo. They would lie absolutely motionless on the rocks with their jaws wide open, like life-size replicas. When it rained, we used to take shelter in the reptile house and watch the school kids trying to work out if they were real or not. When they leaned in for a closer look, I'd flip a penny over the barrier. The croc's head would swing round and snap at it violently and the kids would scream their heads off.

It was hard to believe I'd once thought that was a funny thing to do. I looked down the yard at the new prisoner, who might easily have been mistaken for a statue himself. I thought about asking him what was on his mind, but my Spanish wasn't good enough.

I was still thinking about money that night when the light went off. First, I had to buy a stamp to write home. Next, a pack of Bisonte. They cost three times as much as Celtas, but the smooth blond tobacco was worth it. Or I could get some eggs and a slice of *membrillo*, so I could pig out with decent food. Or maybe I should splash out on another shower. The last one had been amazing. For the first time in months I'd felt clean, and for a brief moment, almost human.

The first shower in the children's home was awful. Jeremy, Jack and I were taken up the plush red stairway into a long, white-tiled bathroom by a couple of young 'Aunties'. They told us to strip. I didn't want to take my clothes off in front of them, but there was no escape. We were showered, inspected, disinfected and clothed. Then one by one we were sent downstairs.

It was pretty clear that we weren't going back to South Lodge. I didn't know where Jeremy and Jack were, so I walked into a small room off the lobby. There was a play on the radio about an unhappy black girl in a school full of white kids, but nobody was listening. Instead, half-a-dozen children were clustered around a boy who was pulling the legs off a spider. He offered a leg to me. It was still moving, as though it was trying to run away. I wanted to run away too, but I knew I mustn't let him see my fear or he'd chase me with its mangled body. I forced myself to take it, imagining that the leg was just a bit of bent wire as it twitched on my palm. Then as casually as I could, I said, 'Here, you can have it back.'

I left the room with deliberate slowness. When I saw a staircase, I escaped down it. The steps led to a basement

cloakroom with a row of small white sinks above a cream tiled floor. A long line of pegs with bags and coats hanging from them ran from one end of the room to the other. For the first time in my life I couldn't think of anything to do. There was nobody to talk to, no toys to play with and nowhere to go. But I knew I had to come to terms with this new situation. My parents had gone, so I would have to look after myself from now on. I began my new life by reading the names on the coat pegs out loud.

'Alan, Barry, Brian, Charles, David...'

A noise from the stairwell stopped me. I looked as a skinny, dark-haired boy clattered into the basement. Even before he spoke, I could tell that there was something wrong with him.

'What y'think y'doin?'

I felt guilty at being caught next to the bags. 'I'm reading out names. Fred, Gary, Gerald, um...'

I didn't read well at the best of times and got stuck on Ian. I didn't know how to pronounce it, so I tried it like the second half of Brian.

'I-yan'. It didn't sound right, so I said it again: 'Iyan?'

The boy broke in: 'That's MY name that is.'

I was confused. 'What, Iyan?'

'It's not IYAN, it's Ian – *EEEEAN*!' He waved his arms so wildly I thought he was going to hit me.

'That's a great name.'

'WELL, WHY CAN'T YOU READ IT?'

'I can now. See: *Ian.* My name's William, but your name's much better.'

'Ian's the BEST name.'

I circled Ian, trying to reach the stairs. 'It is. It's a great name. I wish I had a name like that.'

'Well, you CAN'T. It's MY name, Ian is.'

I raced up the steps and opened the first door I came to. It led outside onto a narrow concrete terrace that faced a huge garden the size of a football field. Along the top of the wall was a spiked green metal fence. I walked slowly down the terrace, dragging my fingers along the rough, red bricks of the building. A large yellow dog limped around the corner and stopped in front of me. Its right front paw was raised in pain. It looked at me as though asking for help. The prospect of starting my new life by curing it and making a friend really appealed to me.

I reached gently for its injured paw and examined a raw, dirty cut. I'd seen some toothpaste in the cloakroom and I ran to get it. But when I squeezed the paste into the cut the dog reared up onto my chest and began snapping weakly at my face. I gently pushed its head away but it started gnawing my sleeve. Its jaws clamped stronger and stronger, as though it was going to take a bite out of my arm. Suddenly everything was too much for me and I felt myself slipping towards tears. I wanted to shout for help, but there was no point. There was no one to help me anymore. I backed towards the lobby and scraped the dog off as I slipped through the gap in the door. I'd escaped from the dog, but I felt more sad than safe. My bid to make a friend for life had failed.

The Transylvanian guy came up to me in the yard on Sunday. I tried not to look at his huge forehead as we talked some more about making money in Switzerland. He didn't seem that happy and I felt bad about thinking of him as Frankenstein. When I got back into the cell I drew a picture of him looking sadly into the future. It wasn't a great likeness, but it was much better to draw than lie on my bunk looking sadly into my past. As soon as the doors opened for social hour, I trotted down the walkway towards Mike's cell.

He turned from his table as I stepped inside. 'Hello, stranger. I hear you're a big shot in the fashion scene now.'

I gave him a sarcastic grin, but I was secretly pleased. 'Not quite. Still, it's tons better than sniffing glue.'

'So what else have you been getting up to besides making crap for the tourists?

I didn't want to tell him what had really been on my mind, so I just said, 'I've been building a spare stove in case Zorro rips yours off.'

Mike put on a Hillbilly voice: 'My, that was right neighbourly of you, but I'm still accommodated.' Then, falling back to his usual, dry tones, he said, 'You better watch out with all this work you're doing for Franco. You're getting to be part of the furniture.'

'Not for long. I've got an idea to pay off my *fianza*.' I pulled out a five from my wages. 'Can you spare me an airmail letter and a stamp?'

Mike shuffled through the papers on his desk while I told him about my Switzerland plan.

When I finished, his grin was wide enough to show all his missing teeth. 'That's what I like to see – free enterprise! It's the American way!'

Mike tucked a stamp and a letter into a dog-eared copy of *A Clockwork Orange*. He quoted from it as he handed it over: 'Have a dobby time, my droog.'

I grabbed the book and called, '*Muchas gracias, muchacho!*' as I ran back to Colditz.

Thankfully Peter and the Wolf were out, so I sat on my bunk to get my letter written before the screeching TV came on. Mum didn't have any money, but she knew tons of people she could ask for a loan. The important thing was to make the letter sound cheerful so it wouldn't get stuck with the censor. By the time I'd finished, it could have been sent from a holiday camp.

As soon as I got back from the post-room, I dropped onto my bunk and dived into *A Clockwork Orange*. Each time a slang word came up, I said phrases out loud to commit them to memory, 'Viddy this moloko, my droogs... I'll tolchok you with my...'

Suddenly a horrendous scream descended from the balcony outside the cell, then cut dead with a sick thud. I rushed out and looked over the rail. On the stone floor was the twisted body of a man. A brief moment of silence was broken the sound of shouting voices from along our balcony. I realised who it was. It was the new guy.

Guards and trustees stampeded across the floor, shoving everybody back into their cells and slamming the doors like cannons. I stared transfixed at the figure on the floor. He didn't look dead. A guard ran over to him with four trustees. One of them lifted the man's head, but the guard shouted and gesticulated until they each grabbed an arm and a leg. It was criminal. They ran off with his body jiggling between them. I knew it was the wrong thing to do. Everybody knew you shouldn't move someone with a serious injury.

I looked across the balcony as the doors on our level began to bang shut. Prisoners stared grimly over the railings or shook their heads as they turned away to their cells. They knew it was wrong, but what could anybody do?

Before they slammed our doors I walked back to my bunk and took out my book from underneath the mattress. Drawing was the only way I was going to get the image of the prisoner's bloody head out of my mind.

For once it was a relief when the light went out. I'd

drawn a montage of the men running off with the body, their expressions matched by the stony-faced blokes staring down from the opposite gallery. The effort of concentrating in the weak light had given me a headache and all I wanted to do was rest, but the image of his cracked skull wouldn't let me sleep.

I turned over in my bunk and remembered my first night in the children's home. I was lying between stiff, white sheets in a nine-bed dormitory. Matron had warned us that there was to be strictly no talking – either before or after lights out. We could see Mr Smith's sinister silhouette through the half-open door. The sight of his shadowy head was frightening. It was as though he was waiting to see if I wet the bed. Only the night before I'd slept in a cosy bedroom with my brothers and sister. Now I was in a strange dormitory with kids I didn't know and a scary man outside in the dimly lit corridor.

The next morning I woke to the utter horror of soaking wet sheets. I waited until all the other children had got up before I dared to get out of bed. After breakfast, I went out to the garden. I was beginning to hope I might have got away with it, but Mr Smith found me.

At first his manner seemed so friendly that I thought I'd misjudged him. He cupped my head gently in his hands and smiled down at me.

'You told me that you didn't wet the bed, didn't you?'

I nodded as best I could. It was hard to form a look of apology with my cheeks creased against my mouth. Suddenly his hands flew away from my head then slammed back on my ears like bricks. For a moment the whole world went black, then he shouted at me, his face ugly with anger: 'DON'T YOU *EVER* LIE TO ME AGAIN!'

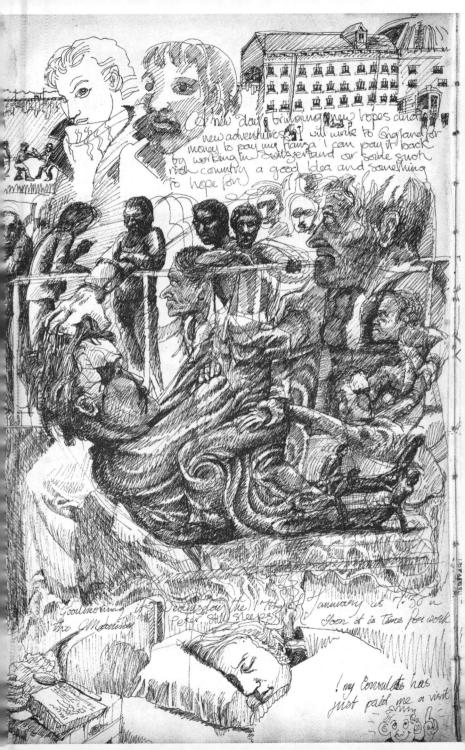

I didn't know when he left. I could hardly see or hear or anything. The experience left me in a state of shock for hours, even days.

I opened my eyes and looked around the gloomy cell, waiting for my breathing to calm down. That moment had always been there in my memory, like a milestone, but I'd never really thought about how it might have affected me. Now, from the distant isolation of a foreign jail, it began to be clear. Until then I'd been holding onto a memory of a life I'd enjoyed so much – my family, the farm, my friends and my toys. But now I could see how I'd been knocked into another world from which I could never return.

I woke up early and looked at Peter's peaceful face in the bunk opposite. I'd have given anything to sleep like that. I reached for my book, to take advantage of a still model. The likeness turned out to be pretty good, and I liked the way he appeared to be dreaming of the suicide guy in the drawing above his head. I drew a few squiggly lines to add to the effect, but Peter's face looked too calm and it wasn't convincing.

That morning in the *talleres* Patrick shook his head sadly as soon as he saw me. There was no need for words; there wasn't much we could have said anyway. We'd never even got to meet the guy. Paco had heard on the grapevine that he'd stayed alive for two hours, but that it had been four hours before a doctor got to the prison. That really made me angry.

'I drew a picture of them running away with him,' I said. 'That's what killed him.'

Patrick looked up from the bag he was stitching.

'I know. But if they see that picture, they'll take your book.'

'I can't help it. Drawing keeps me sane. I go mad if I can't draw.'

I thought of my exercise books at school. They were always packed with drawings. I could never concentrate on the lessons, so I just drew all the time. The teacher must have known I was from the children's home, and instead of being angry, she encouraged me.

Thinking out loud, I said, 'I had a great teacher. She let me draw in class.'

Patrick put his bag down. 'What?'

'Nothing. Just that my teacher was...' I got up quickly, and squeezed past Patrick. 'Listen, will you cover for me? I'm going to the workshop.'

There was no reason for me to go, but the conversation was getting too close to things I couldn't share with Patrick.

I couldn't share them with anybody.

Ten minutes later I was working my way back through the glue tables when Manuel gave me a furtive wave. I looked to where his jabbing finger was pointing. A guard was standing outside our studio, giving Patrick a hard time. He turned on my approach, rattling out words like a machine gun.

Patrick translated: 'You've got a visitor. It could be your consul.'

I followed the guard through the decaying cellars. The mysterious arches and corridors made me wonder where they kept the garrotte. The image of the band of steel crushing the victim's neck reminded me of the suicide's head. Thankfully, we soon arrived at the cage.

Mr Bradley and a small, round man with slick hair and glasses were waiting behind the wire, like animals caught in a trap. Mr Bradley explained that it was only a short meeting to give me my vitamin pills and to introduce me to Mr Juchau, my lawyer. He didn't talk much, but what he did say was mind-blowing. Paco and Patrick looked up when I returned, a big smile all over my face.

'Guess what? I just met my lawyer. He said I could be free in *seven days* if I can pay my *fianza*! And they're going to reduce it.'

Patrick stopped lacing. 'But I thought they wanted two years?'

'They do, but who cares? I've already written a letter home to borrow some money. They'll let me out of here once I've paid my bail, then I can just split across the border.'

Paco didn't seem impressed. 'Did he show you any papers?'

I sat down. Paco always managed to throw a downer on things. 'No. He just said I should hear something in the next few days.'

Paco leaned back and folded his arms under his poncho. 'Strange that they lower your *fianza* when you had so many *drogas*?'

'They didn't find the drugs. My mate got rid of them.'

Paco frowned. 'So why you have so much?'

I sighed. 'I was going to sell them in Morocco so I could become an artist.'

Paco did his eye-rolling thing and went back to cutting strips of *tiras*. There was no point in explaining it to him, and anyway, I wanted to concentrate on my plans. If the lawyer did manage to get me a really low bail, I could earn enough money in Switzerland to pay for a trip to Morocco, then everything would be back on track. My mind was racing. The other thing I had to do before I left Modelo was make a bag for my book. I'd missed so many good opportunities to draw in Paris, I wanted to make sure I had it with me all the time.

Patrick looked at me as he reached across for another of Paco's *tiras*.

'You've gone very quiet.'

'I need to make a bag for my book. How can I get hold of some leather?'

Patrick smiled. 'No problem. Just make up a pattern and the store-man will think it's another bag for Louis.'

I leant back and looked around the narrow, whitewashed cell. Suddenly it looked different, like somewhere I used to be. Things were working out better than I had planned. I'd asked Mum to raise £350, but even if she only got half that, the money I had in my wallet should make up the difference. Computations were still running round my head when the bell went for lunch. I was so deep in thought on the walk back to the cells that I forgot to check if they'd cleaned up the bloodstains on the gallery floor.

Gunter and Peter hit their bunks as soon as they'd forced down their lunchtime wine. There was no way I could sleep. I got out my book and started working on a full-page picture of me in a boat with 'Here is a boy just looking for the sun' written on the flag. The boat was called *Wonder Will*, and I drew myself standing at the prow, looking forward with a hopeful expression. It was the most optimistic drawing I'd done since being arrested, but for some reason I'd drawn the sun staring through its fingers at an approaching horror. It made me feel uneasy.

I crosshatched the shadows, thinking of something Mr Bradley had said. He'd asked me if I'd heard from my mother. I hadn't. Then he told me he'd sent a telegram to tell her about my arrest way back in November. That was more than two months ago. So why hadn't she written? I stopped drawing and thought: *She could at least have sent me a Christmas card or a bar of chocolate.*

* * *

I looked at the happy picture of me sailing away on the open sea, my guitar leaning on the mast behind me. Then the bugle blew and I shoved my book under my jacket so I could make a pattern for it in the *talleres*. For once, I was straight out of the door, itching to get back to work.

The weekend arrived quickly. Some of the morning coffee had splashed onto my book as I turned over a new page. I made the pale stain into a pattern and wrote some Spanish words on it:

Que Passa Hoy? Oh! Passa Nada.

The spelling was all wrong, but it sort of meant: *What's happening today?* Oh! Nothing. Even though it was only brown, it was still nice to see some colour in the book after all the black and white. I added a tint of pink from my box of crayons while we waited to go out into the yard. Then I got out my pen and wrote:

For how long can you ignore the existence of colour?

I kept writing until the bugle blew. It was too cold to draw outside, so I wrapped my scarf round my neck and shoved Mike's copy of *A Clockwork Orange* into my pocket. Then I followed Peter and Gunter into the flow of scruffy foreigners mooching down the walkway to join the queue for the patio.

I looked around the chilly yard, trying to spot Frankenstein. As usual, Sven Svenson was leaning at a crazy angle over the chess players. He looked up when I called his name and gave me a yellow-toothed grin.

'Hey, cocksucker! Where haf you bin hiding?'

'Some of us have to work for a living.'

'So you got money den?' His nose wrinkled when I offered him a black tobacco Celtas. 'You cheap English! When you gonna fuck off home?'

I smiled when he deigned to take one and gave him a light.

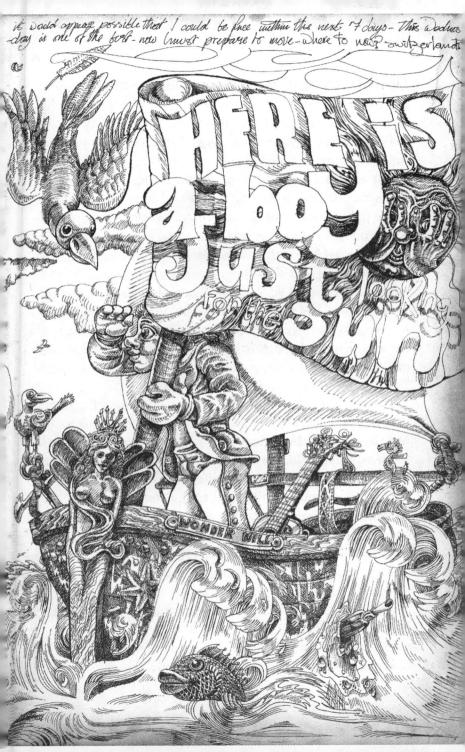

'Maybe sooner than you think. Hey, have you seen the guy from Transylvania?'

'Frankenstein? He's over dere.'

I walked in the direction of his tobacco-stained finger and called over my shoulder, 'Thanks, Sven. See you later.'

The whole yard must have heard him yelling out behind me.

'Hey, cocksucker! What d'you want him for? I'm much better lookin'!'

I crossed the yard wondering how we'd ever come close to having a fight. Maybe Mike was right – the rudeness and the insults were all an act and he was really a nice guy.

We trooped back to the cells and I got straight into my bunk to warm up. Frankenstein couldn't really tell me much more about Switzerland other than that Zürich was rich and clean, but he claimed he'd made ten times what he would have got in Barcelona just working in a kitchen. That's what I'd done in the holiday camp. It was easy.

I spent siesta snuggled into my bunk absorbing the slang in *A Clockwork Orange*. Some of it I already knew. We always used to call policemen 'rozzers' and in the book a cop was a 'rozz'. When the bugle blew again, I couldn't wait to get to the patio to try out its crazy language on Mike and the gang.

Mike was standing in the arched doorway and he got the first line in as I approached: 'Hey, my droog. Give me a cancer!'

I reached for my cigarettes and handed them around as Paco and Patrick strolled over. We'd all read the book and we looked around the yard in a haze of tobacco smoke thinking up lines. I went first:

'Hey, my droogs. Viddy the horrorshow pants on the mooge playing petanka.'

Patrick clocked the guy in striped trousers and laughed. 'You can almost viddy his yarbles!' I had to laugh, even though I could also viddy a cloud of black stubble growing on Patrick's chin. I surreptitiously ran my finger over the sparse hairs on my top lip as Mike said, 'Heard any dobby warbles lately?'

The sheer ridiculousness of the words and the casual way he said them gave us a fit of the giggles. I got my breath back and said, 'I'd listen to dobby warbles all day long if I had enough deng to get out of this stripey hole.'

Mike took a drag on his cancer and came back with, 'Don't blub, my droog. That's what you get when you tolchock a rozz.'

That night I quickly added a few dots of stubble to a picture I'd drawn of Patrick. Gunter had creaked his fat arse into the bunk above me, so I knew the dim light would soon be turned off. I'd made Patrick look cool, with his paisley shirt running into the cover of *A Clockwork Orange*. The light went out and the straw crunched around me as I lay back into the mattress. Patrick never made a big deal about being in prison, but he always listened to me when I'd had a bad night. It made me wish I'd told him more about my teacher in the *talleres*.

Maybe that was what was wrong with me. I couldn't tell anybody anything. The only person I'd ever confided in was Michael Schneider, and that was because I was far too drunk to care what I was saying. Michael had told me that he was so locked into his life that he could never be free. I was beginning to think that I'd never be free either. My life seemed to be hidden so deep inside me that it could never be unlocked.

It was lucky that my teacher had noticed that I needed to draw. Her praise made me think there might be something

* *

special about me when all I felt inside was a hollow hole. Suddenly I remembered the name of my school. Talbot Road. I wished I could remember my teacher's name too, so that one day I could go back to Leeds and thank her.

My teacher wasn't the only one who was nice to me. In the children's home they gave us tuppence pocket money, and the ancient janitor used to dole out little tufts of Duraglit so we could polish the dull, copper pennies. Our green fingers smelled of paraffin as we rubbed the Queen's head until she shone like gold. In the summer, the janitor cut tomahawk heads out of hardboard and nailed them onto bits of broom handles for us. When they broke off, we'd run over to his shed to get them fixed. He didn't say much, but kindness radiated out of his workshop like a warm fire. It was his kindness that had made me want to be a carpenter when I grew up.

The young Aunties in the home were nice too, especially Auntie Jean. She promised to give us a kiss if the numbers on our bus tickets added up to twenty-one. When they did, we'd run into her arms and push our faces into the curls of her dark hair as she kissed and cuddled us. I've never stopped counting the numbers on bus tickets. She must owe me hundreds of kisses by now.

But the kindnesses weren't enough to take away the fear of Mr Smith.

It only took one boy to breathe a word and the whole dormitory was marched down to his study. He'd lock the door and order us to form a circle facing away from him. Then we had to drop our pyjama bottoms and bend over to be beaten with a thick, multi-coloured rubber seaside spade. It was a slow process and the terror increased as you waited your turn. The sharp edges of the blade cut deep, red indentations into our bottoms. We could never understand why he beat us so badly for so little reason. And we were too young to understand why he dragged out the process for such a long, long time.

16

HEAD CASE

You better stop, look around, here it comes. Here it comes. Here comes your nineteenth nervous breakdown. Rolling Stones

Patrick wasn't in the *talleres* when I arrived at the workshop. I squeezed past Paco and felt my jacket brush flakes of whitewash off the wall.

'Donde esta Patrick?' I said.

Paco shrugged in his poncho, and his dark eyes watched me slip my book under my drawing board. He always spoke slowly, like Hitchcock, especially in the mornings.

'Any news from your lawyer?'

I shook my head. It was Tuesday and I'd almost given up hope of hearing from him. Not only that: after a week of listening to the mail calls, there'd been nothing from my mother. *Nunca, cero – no pasa nada*.

The flurry of Patrick's approaching footsteps broke me out of my thoughts. He sounded out of breath.

'Sorry, William. I'm going to have to call off the moustache growing competition.'

I wasn't surprised. It had been going on for more than a month and nobody had even noticed.

'Por qué?'

'My lawyer says I have to look smart for the judges.'

'What! You've got a trial?'

'They're sending me to Madrid any day now.'

Paco beamed as I shook Patrick's hand. 'That's great, man. Let's hope it happens'. I couldn't help thinking the *talleres* was going to be an empty place without him. Patrick picked up the bag he was working on, still smiling. I cleared my throat, then said,

'Have you got a drawing I could stick in my book as a memento?'

'Of course. It would be an honour.'

Patrick looked through his book while I sneaked off to get some glue from Manuel. When I got back, Patrick handed me a Biro drawing of a wistful little girl, his niece. It was almost too beautiful to accept.

'That's amazing ... but shouldn't you give it to her?'

Patrick laughed. 'I don't think her family will want it when they find out her uncle's a criminal!' I twisted off the glue cap and the stink hit my nose. I'd forgotten how strong the stuff was. My watercolour brush sank into the thick, toxic liquid and the fine bristles dragged as I pasted the back of the drawing.

'It's funny,' I said. 'When I bought these brushes, I thought I was going to be painting pictures with them.'

Patrick's oriental nose wrinkled, not just because of the smell.

'I never liked painting. They made us use powder paint at school and the colours were terrible.'

The glue fumes were going to my head, but I was secretly enjoying it.

'We had the same crappy stuff. I tried to paint a picture of a bonfire for my teacher. I had a vision of the firelight flickering on people's faces, but it all ended up looking like mud. She still wanted to keep it, but I screwed it up before she could take it home.'

I stuck Patrick's drawing next to the picture I'd done of him the day before.

'Look. You and your work together.'

He glanced at the little girl's face gazing sadly out of the page.

'She must have been disappointed,' he said.

'Who? My teacher? No. She was always nice to me. Sometimes she'd even bring me toys from cereal packets and let me play with them in class.'

Patrick looked surprised. 'I thought British teachers were really strict?'

'She wasn't. I was always late, every day, but she never told me off – not even when she caught me copying from the kid next to me.'

Patrick stopped threading *tiras* and looked at me. 'Maybe that's why you tried so hard to go to art college.'

I laughed. 'Why, because I was rubbish at school?'

'No. Because you wanted to please your teacher.'

That made me think. I pressed the heel of my hand on Patrick's drawing to make sure it was properly stuck. Maybe he was right. If it hadn't been for that teacher's kindness, I don't know how I'd have coped with Mr Smith and the home. I hated going back there after school.

If you didn't eat all your supper, you had to sit alone in the dining room until you'd forced down all the gristle or bony

herring. One morning I woke up in a stinking pool of vomit, piss and diarrhoea. I was really ill, but Matron ordered me to get up and carry my soiled bedclothes down to the laundry in the cellar. I stood naked on the freezing stone floor, scrubbing carrots and peas out of my slimy sheets, hoping the laundry ladies would see that I needed looking after – but they just turned away in disgust.

No wonder I can't talk about this stuff, I thought. Nobody would want to know.

Patrick said what he always did when I went off into my own world:

'You've gone very quiet.'

I looked at his pretty drawing next to my crappy cartoon of *A Clockwork Orange*.

'I was just thinking. No more scruffy sketches from now on. Just pure, analytical observation.'

That evening after social hour, Gunter was snoozing, and the only noise to disturb my concentration was the occasional turn of a page from Peter. I sat under the bare bulb and started to mark out my orange-box food cupboard hanging on the wall, drawing each line with meticulous care, just like Patrick did. I wanted the curve of the sugar bag to bulge with the weight of its contents. My eyes screwed up in the dim light as I drew each tiny bean on the tin's label, trying to imagine what the bloke who wrote the Lord's Prayer on a grain of rice must have felt like. I even managed to fit in the lady on the can of evaporated milk. The effort made my head ache, but it was worth it. It wasn't up to the standard of Patrick's work, but it was ten times better than the stuff I'd been drawing from my imagination.

My mind began to wander as I crayoned colour between the black lines. It was great that Patrick had got his trial, but I was going to miss the pictures we drew together and his gentle advice. Peter's bedsprings creaked as he got up to look over my shoulder. He watched for a while as I shaded the walls with a dove-grey crayon.

'Ja, Villy. Is gut, ver gut.'

Peter's praise made me want to draw more, but I couldn't. I didn't know if I was tired from trying to concentrate in the poor light or from lack of sleep, but it felt as though an iron band was tightening around my head like the garrotte. Even worse, I could feel the presence of The Freak. Shockwaves were passing through me as though I had permanent vertigo. I piled my clothes on top of me and curled up to rest for a while.

The bunk shook as Gunter rolled over. I tried to put my crayons back in the tin in the order they were packed before the light went out, but I gave up and shoved them in chaotically. The blackness was a welcome relief and the tension in my head relaxed enough for me to think again. I hadn't heard from Mum or my lawyer, but the day hadn't been a complete disaster. I'd done a decent drawing and it had felt good talking to Patrick about my teacher. I'd never mentioned any of that school stuff to anybody before. Not even to myself.

Back then, I walked just as slowly when I left school in the evening as I did on the way there in the morning. It was partly because I didn't want to go back to the children's home and partly to give me time to twist petrol caps off cars. I'd learned how to do it in one smooth move so nobody noticed. At the time I felt like a thief, but I only stole them because the solid feel of metal and the rich smell of petrol fumes reminded me of Dad's van.

The other thing I used to do was tuck the end of my tartan tie under my belt so it hung down like a sporran. It must have looked stupid, but whenever anybody asked, I said I was Scottish like my Dad. I wanted to keep the petrol caps, but I was scared of Mr Smith finding out, so I threw them into the thick bushes at the end of the giant garden.

I could do anything I liked down there. When I was alone, I'd invite passing boys to climb over the railings to play with me. Once they were inside I'd start a play fight, but it always ended with me punching them so hard that they ran away with their faces covered in tears and sometimes blood. It was a stupid thing to do, because after a while nobody came to play with me anymore.

Jeremy and Jack had been put in different dormitories and schools, so we only saw each occasionally. Once, Jeremy came down to find me at the end of the garden. He looked terrible. His face was pale and his eyes were red from crying. He told me that a boy from his dormitory had run away and for some reason Mr Smith thought Jeremy knew where he was hiding. He'd beaten Jeremy with a spade when he told him he didn't know anything, then sent him away to think about it some more.

It didn't make any difference how long he thought about it, Jeremy still had no idea where the boy was, so Mr Smith beat him again. My brother cried out that he would say anything Mr Smith wanted, but that he really didn't know where the boy was. Mr Smith sent him away to have another think. Jeremy had been in such a bad state when he got back to the dormitory that a boy who did know where the truant was told my brother to save him from a third beating.

I stared angrily into the shadows, breathing deeply until my muscles relaxed and my heart slowed down. Now I knew how Jeremy felt. Two beatings were bad enough, but the third was a killer. How had bastards like Smith ever been allowed to look after children? I imagined going back to Leeds to find out where Mr Smith lived. The fantasy was so real that I even heard the metallic click as I rapped the chrome letterbox on a red suburban door. When it opened, I said in a friendly voice, 'Oh hello. Are you Mr Smith?' Then, as soon as he'd answered, I punched him so hard that his face split open and he crumpled to the floor. I knew I should just turn and walk away at that point, but it wasn't enough...

I stopped myself. This was no good. I was back in the same vicious circle, with violent thoughts running around my head. But I was beginning to understand where those thoughts came from. My anger may have been born in a children's hospital, but it had never crossed my mind to hit someone until I was taken care of by the dreaded Mr Smith in Street Lane Children's Home.

Next morning, the prisoners shuffled into the yard in a ragged line, their misty breath billowing into the cold morning air. It would have made a great painting, but the image couldn't erase the nightmare that had woken me again in the early hours. It was always the same. However fast I ran, the cops always caught me and I'd wake feeling like I'd been beaten up all over again.

I flopped down at the workbench in the morning and started to tell Paco about my dream. I'd only got as far as 'Last night...' when he threw up his poncho in mock despair.

'La última noche! La última noche! Always la última noche!' Paco thought everything was a joke, but it wasn't funny to me.

My veins burned with adrenaline and I wanted to punch him, but thankfully Patrick chimed in before it got heavy.

'Hey, talking of *la última noche*, this is probably my last night in Modelo.'

That pulled me up short. 'Seguro?'

'Sure, droog. My trial is set for tomorrow in Madrid, so they have to take me away tonight. Listen out for me after mail call. I should be on the list.'

'That's incredible news.' There was so much more I wanted to say – I knew we might never see each other again – but I was useless at goodbyes and I just sat there tapping a chisel on the desk. Paco probably thought I was pissed off because Patrick was going and I wasn't. He held up his finger like a preacher.

'Don't worry. You will have your trial.'

I nodded. 'I still haven't heard from my lawyer or my mother, though.'

'She is bound to write soon,' said Patrick.

There didn't seem to be much chance of that. Mum had had nearly three months to write. Besides, I didn't want to talk about her. I wanted to say something meaningful about the drawings Patrick and I had done together, but I couldn't find the words, so all I came out with was, 'Yeah, maybe.'

I reached for the hammer to put the final touches to the leather bag I'd made for my book. I'd been planning a design with the pattern punches, but the thought of our drawings gave me an idea.

'Hey, guys – do you want to give me a hand decorating my bag?'

Patrick turned on his seat, like a smiling Buddha.

'With pleasure.'

We took it in turns to straddle the tree trunk and punched stars, flowers and leaves in a circular pattern all over the front and the flap. Patrick flipped it over when we'd filled every available space and said,

'Hey, take a look at this...'

The leather on the back of the bag had spiral indentations

from the surface of the tree after all our hammering. In some ways it looked better than our pretty shapes on the front. Paco and Patrick got back to work while I sat looking at the mysterious mandala. It said so much more than any conversation we might have had that I decided never to try saying goodbye again.

The trumpet for evening mail call sounded hollow and uncertain; the bugler wasn't completely pissed, but he was getting there. I rolled off my bunk and wandered over to lean against the doorframe, picking at the chipped paint as the hoarse voice floated up from below. It droned on above the clamour of the crowd, ending with the usual rapid flourish.

'JoseManuelLuizGonzalesVerdascooo... Correo!'

There was no mail for me, but after what the consul had told me about Stella, I wasn't surprised. I listened intently for the list of lucky men who were leaving. They all sounded distinctly Spanish until right at the end I heard:

'Jeannn Patreeek Beauuu.... Con todo!'

Con todo – with everything. The most beautiful words in the Spanish language. I raced to Mike's so we could watch Patrick leave together, but when I got there his cell was empty. Everything was gone. His pictures, his books, the table, the stove – everything. All that remained was the faded green *Guten Morgen* above the door.

I dashed outside and leaned over the balcony just in time to see Patrick heading towards the first set of gates. I stared at his long black coat, hoping that he'd turn and wave, but he didn't. Nobody ever did. They didn't want to do anything that might stop them walking down that long shiny corridor.

Peter and Gunter were reading in the dim light when I got back to Colditz. The cell never looked welcoming, but now it looked as bleak and as cold as my future. I'd miss Patrick, but life in the prison without Mike was unthinkable. I forced myself to open my book and got back to work on the drawing of the cell that Patrick had inspired me to start the night before.

I outlined the stove and the scrabble board tabletop I'd made, leaving space for the oranges in their basket above. It was almost too dark to make out the detail, and the effort began to pull the iron band tight around my head like the night before. I chose some soft browns from my crayon tin and wondered what the hell had happened to Mike as I coloured in the orange-box. I knew that sometimes the guards opened the cells in the middle of the night and took people away, but their boots and the bolts were so loud that we always heard them.

The sound of Gunter rolling around on his mattress stopped me drawing and I leant back to assess it. Gunter never looked at my stuff, but Peter came over and nodded in silent appreciation as he spoke.

'Ja, Villy. Is ver gut.'

I could see why he thought so. The colour and the fine detail had really improved my drawing. Peter's praise made me want to finish it, but I could hardly draw another line. The concentration was killing me. Every stroke I made seemed to tighten the band around my skull and I had to shut the book and give up. I crashed out into the shadows of my bunk like a corpse. I was so exhausted, I just crammed the crayons back in the tin and couldn't even close the lid.

It wasn't just The Freak. Everything was changing. Everybody was moving except me and I couldn't bear the thought of Mike leaving without saying goodbye. I had to find a way to turn off my thoughts or my head would implode. I didn't need to. When the light went out, I felt myself sink into an inky blackness, like a coffin being lowered into a grave.

Suddenly I was awake, but I wasn't myself. Something was

In the night of last night ! thought This moment innoosside and sake theight never adam, lowe ner santhe meno token and nay prairies Vier Derid ansarplied - also to to ration the who bolige have never encours en never before, wasthis paron needed an expleme satter value Keeping we col and poo the nove sensible and keep the Porson present the Edgesfilligeness 4005 adain weakedowns NEWVOUSS ! et quetter tear in life, but how Small ave all The others in gampar all are as me over to the ampart to well we are to the of lall formed only friend down below BR OCORRE Jos Maright going war WORS malphe the join setting meldrin I dent wighto 9 record this there is not voorson other 6 bod Wars that of a shouger personality advino as was sand legove acost OWF et. X THOM ave up lippits thor here was there have been cone the way there and have been and have been and have been and don't the about that one so really there is the so ett sufficier it unen to veither here ver there that and now ive is added were would appear to aunother a qual line is added have. Nor bide inthe to Margin toute I floor two him for an interest is work ins its Dativer Nes he !!

horribly wrong. Not only in my head – my whole body didn't feel right. I was cold with fear. I pulled my arms out of my sleeping bag and flexed my fingers, but they were thin and they bent like paper. My whole body was flat and my brain was compressed into a little ball of nutty, twisted panic. There was no room for thought in its shattered core – only horror.

I said the Lord's Prayer out loud. Really loud. I forced the thin words out of my mouth, trying to make them sound like real speech and not like things that had no meaning. I knew that if all meaning went then I would go too, and to let go meant to scream in a void of insanity. I sat up quickly, sweating and staring. Peter was sitting up too, saying, '*Was ist, Villy? Was ist?*'

Desperation made me reach for his hand and he took it. It was a lifeline to reality and I wouldn't let go. I gripped it as he said again, '*Was ist, Villy? Was ist?*' I couldn't tell him. I was in pure terror and it was only his hand that kept me from smashing my head against the wall.

The long night passed. Peter kept his grip on my desperate fingers, repeating, '*Was ist*, *Villy*? *Was ist*?'

My reply echoed off the walls. 'I don't know... I don't know...' It was true. I had no idea what was happening. It could be an acid flashback, or my damaged spine cracking up, or maybe I was having a nervous breakdown. All I knew was Peter's voice, patient and caring. And his hand, holding me in the real world and not letting me go. It wasn't until dawn broke that a part of my normal brain returned and told me that everything was going to be okay. Peter stayed up with me until I was finally able to lie back in my bed and slip into a kind of sleep.

When I awoke I could scarcely believe I was still sane. I got up tentatively, washed, dressed and cleaned the floor. It felt like I was walking an invisible plank that I could fall off at any moment. Peter and I stood to attention on either side of Gunter and waited to be counted. It was strange to be so formal after we'd held hands all night. Zorro strutted along, clicking his heels and swinging his cloak around. I couldn't look at him. I couldn't look at Peter either. I tried to focus on the far wall until Zorro's blurred figure pranced past.

It was almost time to leave for the *talleres* when I finally thanked Peter. He probably didn't understand a word, but I hoped he could tell from the tone of my voice and the look in my eyes that I couldn't have made it without him.

When Paco asked how I was, it seemed like he really wanted to know. I told him I was fine. I just wanted to forget that last night ever happened. Acid trips were bad enough, but this was the worst thing that had ever happened to me. It was as though the whole framework of my brain had broken down and whatever it was that was me had fallen apart with it.

I sat down to work in the doorless studio cell. It made me realise that if my cell door hadn't been locked last night, I might easily have joined our friend down below.

Paco hadn't heard Mike's name being called so he could be in the Quinta. That was bad, but at least he'd still be in Modelo. Without Patrick's playful conversation the day felt empty and unreal – especially when Louis brought me a big sheet of paper and asked me to draw him a giant clown. I didn't mind doing it, thinking that he must like my bags or he wouldn't ask. I drew a grinning red-nosed face wearing a bowler hat with a big flower in the lapel of its baggy, patched suit. It looked pretty freaky and I was glad when he took it away.

Just making it through the day was a major achievement. Peter smiled shyly from his bunk as I came into the cell. I gave him the thumbs-up to let him know I was okay. Then I leaned back against the bars of my bunk, listening to the spine of Gunter's book cracking above my head with each aggressive flick of a page. The sound marked time as I stared into space. My book was resting on my knee, just below the splits in my jeans, and, although my pen was in my hand, I felt too scared to draw. If the freaky feelings came back that night, I felt sure they would finish me off.

I began to write a stream-of-consciousness ramble about prison life that turned into a fairy story.

Once upon a time there was a farmhouse. It would have been happy to be just a farmhouse, but it was happier being a home for Jeremy, William and Jack. These were three boys who were so happy that they never noticed their parents were not...

By the time Peter followed Gunter out for social hour, the barrel of my pen was bending in the middle. I'd filled two pages with tightly packed writing. They ended with:

Dreams of life, a life of dreams, it seems I live a life of dreams.

That was it. There was nothing to look forward to in Modelo, so I always ended up sinking into a pit of nostalgia and self-pity to escape reality. No wonder I was falling apart. Suddenly soft footsteps made me look up and a familiar face came into focus. I couldn't disguise the delight in my voice.

'Mike!'

'Hola, my droog. Long time no viddy!'

'What happened? I thought they'd taken you away.'

'If only. I'm back on my ownsome lonesome down on *Primero*'. Mike grabbed the bunk bar and lowered himself onto the mattress beside me. 'They're moving me towards the gates by degrees. At this rate I should be out by 1984...'

I studied Mike as he read the spidery handwriting in my book. He looked different – not just thinner, but sort of

vulnerable. I pushed my pack of Celtas towards him, mainly to stop him reading my embarrassing drivel.

'You ought to eat more, Mike. You're wasting away.'

Mike flicked open his Zippo and squinted at me as he lit up.

'And you'd better cut down on the writing or they won't let you take your book out.'

I looked at my uneven scrawl, unable to meet his eyes.

'I know. I've been thinking too much about the past and it's doing my head in.'

It sounded so lame. I could feel Mike looking right through me to the freaked-out coward who couldn't hack it in prison.

He smiled as he blew out smoke, 'There's nothing wrong with self-examination. I spend most of my time contemplating my navel, wondering why we're here.'

'Here in Modelo?'

Mike laughed. 'No – I mean in the universe!'

I tried to smile, but my heart wasn't in it. 'I've been thinking the same thing, only about the prison. There's got to be another reason for my being here apart from being foolish.'

Mike stared into the distance as though the walls weren't there.

'I know what you mean. I always thought that when you got to a certain age, you'd learn from experience. But I never did.'

He took a long drag on his cigarette and talked through the smoke. 'Nobody could tell me anything. And even if they were right, I'd still go on ahead.' He paused for a moment. 'You can see where *that* line of thinking got me.'

I nodded to keep him talking.

'There's something to be said for taking a long hard look at yourself –'specially when you get the old calabazoo blues.' Mike took another drag and held it in as if it was a joint.

Duames. Steame dreams dreams of leathor bags and Dicesso - dreams of Rocks and Mouttoins dreams of life and dreams of dreams of dreams bogs will, if you to do athen util his of work out as growing fede bears or Callions and mobilike but the third is its all a folio its all so simple is all so spawish well I must admit I enjoy wertuin und would like to fill a whole book past with weiting reboold weite a story pysbully of my adventices and those of my prings write it would be after the bawer of dawane Scene of the word of a way thave wind with his word of paint of the bawer of the word scene of the bar of the bar of the bar of the second of the one of t Oh! I would just weill as I speak maybe on just as it hoppen take to Once upon a Times there are a formularise, it would have been happed to be just a formularise but it was happier being a home for Alex William and Jaok and hat i they were thrue baye sho were go hoppy that they were to the set they were thrue baye sho were go hoppy that they were noticed that there provents were not and ofter an years they because City boys and that is where the story begins ~ in the city wight core inflormed the light is overige and care are shing for a young bay its a wonderful place to be und there I was But I allurage had to come home and allucups it was late and everytime my motion was cross but that was the way it was in those days-new it became appeared that it was drawing to a close, and I should be optaving old hom ... it took some time for I enjoyed ing youth I still had the streets at might which walkad, there while gives to go to and buys to leave alow, it was all in the winter and in summer if was worus, thard were words and deed and actions to leaver and I will them all one by one, The City of Leeds has two prosts of town, and I call up The other is down, I jured in the up part where people abound who go, for theer pleasure in the class pilet of have The part that I livest in was deven and bright and every one new what was wrong or was right and all there were young and were happy and gay, what was wearing for is fine and high minded a few wood's exchanged on a library floor and a fight in a quitter 1 saw - 1saw some things that wade we sad and sadetnes is just tog the sachy I believed some things that norde

I leave my story and return for a while to the place then of and it wakes we smile, to think sourcey I'll read this and think of these days ch. What of these clays it recall these days part as 100 new Dreams of Mataing bags Dreams of Prasso incomes of dreams of life Lang well is the best verenge cays The species say in the is allow the title of al food in private is praces & others Rudolph Valuntue to but I never dream Juy weat to continue my trong which is written andly for Au pleasure of making navels on paper with a black pen - the big citiz obound on I breav up and the class people became dime and those that were an the top of the palaer became heavy care the ladder cank no the epong I walked part and spid now that the ladder is on opioned livel why not got of and join us but they suid WD-better to have a small lorder than no lorder at all - I wayf to lot for a ladder to eline and faind many an the holling of yoing lodys becaul an agail many man half abaid of heights and tughts but forced to cland so I was not left behind - quadros privades I have settled down I wish I wish I will get with but I did wish cine I to blew up the balloon and the skin strected and the weiting on the balloon became fainter and langer and could and be seen from a great distance of war lang over and that to go home but Type was posed - your is where they heart is - where is the heart? - look and you shall find und no I went to look - I lost a silver buckle. I lost it from my close so now I only have the are when I should have The two and looking bort the buckle, I knew what it was like, I chanced to fund something else - and so what do 1 do? do I put it ou my shoe? on maybe I should stop and think and shart the search anew Decounts, Oneouns, Decount, decounts of life a life of dreams, it seems I live a life of dreams C 600 - 2

'I guess what I try to do now is go with the flow instead of going against the grain.' He blew out a long line of smoke that sounded like a sigh. 'Take Franco, for instance. Right now he's a big boulder in the stream of my life.' Mike looked up at me with a weary smile. 'So I just do my best to flow around him.'

Sparks flew as Mike ground out the cigarette on the sole of his boot.

'Does that make any sense?' he asked.

I nodded. 'It makes a lot of sense, actually.'

Mike grinned as he threw his stub into the bog. 'Well, so much for being heavy. Never more than once a week, as my old grandma used to say!'

I was happy to change the subject. 'Talking about being heavy – look what I've done to my pen.'

I showed Mike the fine cracks in the barrel. He unscrewed the nib section and examined the damage.

'Yep, that's gonna go soon. I'll see if I can find something to fit it.'

The drunken wail of the bugle sounded more like a trombone than a trumpet. Mike pulled himself up on the bunk bars and walked to the balcony. He turned round at the doorway with his finger held up like Freewheelin' Franklin.

'Don't give up on the past – it forms the present. Just don't write it in your book!'

The doors started slamming and my smile faded as I stared up at the bulging mattress that would soon expand with Gunter's fat backside. Mike always made me smile, but, even better, he made me think. He wasn't afraid to look into the past, but he also looked for a way to change. I'd never thought about flowing around my problems before. I just slammed straight into them – usually with my fists.

Gunter lumbered into the cell and clambered onto the

bunk. I hardly noticed him. The chorus of an Incredible String Band song was spinning around my head as though it was on my old turntable in Leeds. Hanna and I had lain awake many a night, listening to their album in the dark.

'Water, water... Heaven's daughter... wizard of changes, teach me the lesson of flowing.'

I woke in the early morning from a mystical dream and reached for my book before it faded. I still wasn't ready to draw, but the pale winter sky gave just enough light to write:

> at the wave of my hand mountains crumble at the blink of my eye volcanoes erupt my very breath makes rivers run dry and seas crash and sway with words from my mouth my future is nothing my past is condemned my time is forever my self has no end

I knew I shouldn't write in the book, but it felt so good. By the time the morning bugle sounded, I'd crammed two more pages with words. It looked like something a crazy person had scrawled on a wall so I wrote: 'My name is Bill and I'm a head case.' Then I thought: *Who knows? I probably am*.

Gunter's thick legs swung over the bunk above me. I jumped out of bed to take a piss before he got in there first. The grey wall tried to stare me out, but I glared back, think-ing: *Another day in Modelo*...

Late that afternoon I was punching holes in leather when a harsh blast of Spanish announced the arrival of a guard. I tried not to get my hopes up as I followed his clean, pressed uniform through the dusty labyrinth.

There was no reason to get excited. The solemn faces of my lawyer and the consulate through the chicken wire told me everything. By the time we'd finished talking, the *talleres* was closed, so the guard escorted me straight back to the gallery. I got out my pen and found a corner of the closely written pages of my book to add my latest news:

What do you know... The consulate and my lawyer told me today that I will not be free on lowered bail. Oh well. Still, I was told that in a month or less I will stand trial and that is a good thing.

Just above it I'd written, *words are lies* over and over again. It seemed light years ago when Daisy had told me that in London. I hadn't really understood him at the time, but I was beginning to now. The barrel of my pen creaked as I screwed the top back on. If my trial really was going to be in a month's time, I had to get the bail money from Mum so I could get out before they hit me with a heavy sentence. But it had been ages since I wrote to her, and I was worried that she wasn't going to reply in time.

I leaned back on my bunk. It wasn't the first time I'd been left waiting for Mum. She didn't have a great history of coming back for her kids. She'd left her first daughter with her parents and there were dark rumours of others. We waited so long for her to come and take us out of the Home that we began to forget her.

After the summer holidays we settled into Street Lane Home for good. I was moved to another school where the art teacher inspired me to paint something decent. She gave us all a huge sheet of paper and told us she wanted to see an exciting picture of an animal from a circus. The white expanse covered my desk, pulling my imagination onto the page. Suddenly a vision appeared of a black panther leaping diagonally across the blank sheet. I painted its long body jet-black with shiny highlights and its roaring mouth blood-red, showing curved white teeth as sharp as its outstretched claws. The teacher pinned it up on the wall and explained to the class how the bold position of the animal on the page was as important as the drawing itself. From that moment on the other boys talked to me about drawing and I actually made some friends. It was almost as if I had begun to exist again.

At some point the waiting ended and Mum visited us in the home. My ninth birthday had already been and gone. There was something strange and distant about her; she was more like an aunt than a mother. She must have said lots of things, but I only remembered one. Dad wasn't coming back.

I didn't believe her. I thought: *He will come back. He'll come back in a big car and take us all away.*

But he didn't. Instead she brought a new man, Barrington, in his big, posh shooting-brake. It was white and had a timber-framed back that sloped like a motor launch. We drove out into the countryside and filled the floor full of conkers for the kids in the home.

Bonfire Night came and went in a blaze of glory. There were boxes and boxes of fireworks, and we ran around the smoky field with Roman candles fizzing in our outstretched hands like jet fighters on a raid.

It was nearly Christmas when Jeremy heard that if Mum couldn't find a place for us to live, we'd be split up. He called us together at the bottom of the field for a meeting. Jeremy was now eleven and pretty much a grown-up. I was nine, Jack was six and Issy was three.

dt the well of the well of the shirt poole din at the well of the shirt well of the shirt poole din at the well of the shirt well of the shirt of the shirt of the of well at the set the shirt and a state of the shirt of the sh of We when we we we we we we we we we have a construction of the we were we were the or when the were were were were the or were were the or were the or were were the or were WW butu ea ave winds ane hers and ave over words haster wakes Me hude 2 words View Part even foste a hine 0 Sal with a 2 aug NO a violate startit NON All work Show how and in the source of Woldo Will Way R NONUC 1

10Al la vavina wo the NOW tina 0 nees 1011 KAUNA letters adaer and anna SH nue a bu D ennes filase nada which ·is 6711 and 400 conversations SUL 000 le open all of ne Where wan came Gere e stin so soft the in ster o for un bot out In Stin so RELEASES WEAR THEY TOUR THE ETTHOSE EVEN THEY WAR DUED HUD ROLAND THEY WAR DEED HUD ROLAND PAND RUG FOR METHEY SMILLS RUG work would FOR METHEL SMILLED Tea mon only me will the mon only me will we she is we will pretty yours aner Jus 08/1 CA a walk her do ONT 0 hear Sm hand upideus helier 14 ma NO 185900 12 Not da Soh LAND KISSEDME Not wear bia perc U MAN can ved MSELF J WIL HE WAS SO K MASHIS and a lamb RINDANDGOOD HE MADE EVERY THE WHS SO-RUNDANDOROD HE MANDE EVER BOOM REACT TO KIM ONE DOLY HE WEITHE MEN WHO WIDE BY FOOLING FEDDLE WHET THEY CAME TO GETHER. THEY LOOKED HAT EARCH STARE IN THE EYES FOR NOT COME HAD NO LOOKD WHS SPOREN PRESENTLY HE SAME TO THEM Kon 20 we when white a heart W Jun tell tall but write today I read a bot will alts, it made we sime from this was true as I head long lit of it mus the monoral long lit of it ALD A -here or 814 nothing good brock by ad Miwat LOV - time but mo man cat said 2 Tuhat Wat The good My self life hung all the Time the monuent a word m as wall words are his aul - lies the concert is starting MP.an and. CS · hatt the

The meeting didn't last long and the verdict was unanimous.

We stood in a circle as Jeremy pronounced in a solemn voice: 'Okay, that's agreed. If we're going to be split up, we're going to run away together.'

17

WHAT'S IN A NAME?

Mailman pass and he did not leave no news. Snooks Eaglin

The babble of conversation from the Primero gallery was so loud that it was hard to understand what the mail guy called out. I leaned over the rusty railings, watching the tiny prisoners below until I heard:

'Weeeyaaam... Aystuwarrrr... Murcleeeyaaan.... Correo!'

The mailman was obviously drunk and his words slurred, but that was definitely me. My shoes rang as I zigzagged down the metal steps and crossed the crowded floor to the mailroom. A bored trustee gave me not one, but two beautiful airmail letters. One of them had a hand-drawn aeroplane on the front. My heart leapt. *At last! Something from Daisy*, I thought.

The letters had been opened so I guessed the initials on the corner must be the censor's. I checked the addresses on the back as I scooted upstairs, then slowed to a walk when I saw they were both from Hanna. It was disappointing that Mum hadn't sent news of the money, but the downer didn't last. There were still three weeks to go before my trial, and it was great to hear from people I'd actually known in my life before Modelo.

Hanna's kind words made me feel like a part of my old life had come into the grey prison to colour the walls of my cell. She had mostly written chitchat about friends, but that was just what I wanted to hear. Daisy had turned up in Leeds. He'd been sleeping on Dennis Candy's floor and they'd hatched plans to open some kind of art shop together. I couldn't see that working out: Daisy would use up all the materials before Dennis got a chance to sell them. Hanna didn't say what happened to Daisy in Paris, and he hadn't sent me a message. I still felt angry with him, but part of me was relieved to hear that he was okay.

At the end of the letter, I suddenly missed Hanna's tenderness and warmth. I wanted to sink into her arms. I closed my eyes, hoping that our years together would come flooding back, but all I saw was the long line of Russian books Hanna had stacked on my mantelpiece the day she moved in. I looked through the titles, as I had done back then. *War and Peace, Diary of a Madman, The Idiot.* They pretty much summed up the story of our relationship.

I opened my book and found a corner of space to write:

I really do believe that in the world outside people still do what I once did, and the people I knew are still living and laughing and all else they did when I was among them, and that one day I will be there again and rejoice – hallelujah! I will be FREE! It was hard to imagine being free. At first my lawyer had thought I'd be free in a week, now he was saying there'd be a trial in a month. But there was no guarantee that was going to happen. Mike had been inside for years without a trial. I had to get used to the idea that tomorrow in Modelo never came.

I tried to recall the day we finally got out of the children's home, but my memory was blank. That was weird. You'd think that a day like that would be burnt into your brain forever. I sank into the soft shadows of the bunk to bring it back.

We must have been driven away in a car because I remembered my compulsion to lift my foot as we passed each lamp-post. The roads got darker and smaller, and the tall orange streetlights turned into the green glow of gas lamps. That seemed odd at the time, because the driver had said we were moving into a red light district.

We stopped at the end of a run-down terrace and piled out in front of the last house. Its dark windows were set in brickwork that was almost black with soot. Mum told us that we wouldn't be there long because it was soon to be pulled down for slum clearance. Cracked stone steps rose to a battered front door, but Mum stepped down into the tiny yard below them. She pointed out a sunken stairway that led to an underground toilet and we followed her to another door hidden beneath the main stairs that rose above our heads. The door's edge was worn to bare wood where the handle used to be. Mum shoved it open and we entered a dark lobby the size of a wardrobe. The electricity hadn't been turned on, and I suddenly remembered that Barrington had given us all little torches. We flashed our beams around a waterlogged coal cellar on one side and a door on the other. I followed Jeremy into a subterranean kitchen. Our yellow circles of light floated across a cooker, a square white sink and boxed into a corner with hardboard was a bathtub.

Mum lit candles in the kitchen while we swarmed up a stone staircase, sweeping our searchlights over peeling walls and rickety wooden steps. They took us past two rooms on top of each other, then curled up to the sloping ceiling of an attic. Our shoulders squashed into an alcove window and we aimed our weak beams over the main road, trying to reach the soot-blackened tower of a church. In the dark it looked like a moon rocket that had burnt up on a launch pad.

The evening ended with me hiding inside a cupboard, watching the coiled filament of my bulb fade to a feeble orange glow after an endless game of hide and seek. We tumbled downstairs into the candlelit kitchen. Mum had got a fire burning in the black metal range and it glowed through the bars like the one we'd had on the farm. I yanked open the heavy chrome handle of the oven to let the heat recharge our batteries and found a tray full of toasting crusts. We drank sweet tea around the fire and spread the fingers of toast with butter – a forgotten treat we hadn't had since the farmhouse days.

I looked around the cell and smiled to myself. That was what freedom was like. It made a slum feel like a palace and turned crusts into a feast.

When the dinner pail was dragged round, I threw my bowl of dried sausages down the toilet. They sank into the cracked bowl like ancient turds until I sluiced them away. Their gristly chunks of white fat always made me gag. I made a *membrillo* sandwich, and strolled out onto the walkway to eat it.

Leaning over the balcony for evening mail call had become a habit. It was hard to think above the noise of the crowd, but that wasn't a bad thing. Anything that could stop the constant conversation in my head had to be good. A movement caught my eye in the grey line of prisoners on the walkway. It was Mike, waving at me with a book in his hand. He looked weary, but he gave me his usual smile.

'Hola muchacho. Qué pasa?'

'Nada. What've you got?'

'Alan Watts. I've read this one a few times and I thought you might like to give it a go.' He gave me the dog-eared paperback and I smiled as I read out the title: '*The Wisdom of Insecurity*. That's a weird title.'

'It's based on the Zen principle of reversed effort. Y'know, like if you try to stay on the surface of the water, you sink – and if you try to sink, you float.'

'That's so true. It's like if you try to fall asleep, you can't. Then when you have to get up, you can hardly keep your eyes open.'

The bugle drowned out Mike's reply, so he leant towards my ear as the shouting began from below.

'Good luck with the mail. Let me know how you get on with the book.'

The hoarse voice rattled out a string of indecipherable Spanish names while I studied the cracked cover. It had a subtitle: *A Message for an Age of Anxiety*. I grinned as I watched Mike amble away: El Motherfucker could read me like a book.

I was halfway through the preface when I caught the Spanish version of my name. Surprised prisoners moved aside as I scrambled down the iron stairways to pick up my letter. The first thing I did was turn it over. Mum's name was typed on the back. That sent a strange feeling through me. It was the first contact I'd had from her since she'd thumped my head in London. Peter watched as I stood in the middle of the cell, skimming through the words on the thin, blue typewritten paper. I stopped when I got to where she'd written there was no chance of raising the money. I'd sort of expected it, but the blow was almost physical. I huddled into the cocoon of my bunk and pulled the blanket over my knees. I didn't know if I was shivering with cold or nerves. She said the reason I hadn't heard from her for so long was because she was too upset to write. How did she think I felt?

She went on to say that Christmas had been the usual pleasant family affair with Jeremy, Kathryn and the girls. *Pleasant*, I thought bitterly, and wondered who she'd punched this time.

I shut my eyes and tried to calm down. I knew that Peter was looking at me. He was probably wondering if it was going to be another long night. It probably was. Now that I knew I couldn't pay my *fianza*, all the freaky thoughts I'd been trying to suppress stormed back into my head. What if the cop starts getting headaches? What if he gets sick? What if he dies and they do me for murder? It always came down to the same thing. I should never have nicked that bike and I should never have kicked that cop.

I tipped my head back, closed my eyes and tried to calm down. It wasn't about stealing any more. The real question was: *Why was I so violent*? I realised it hadn't all come from Mr Smith. Mum was violent. She used to scream blue murder at the farmhands, and then take it out on us. One of her threats was that she'd knock you into the middle of next week, and she meant it.

It had got worse when she took us out of the children's home. Once we were making dinner in the slum house and I wiggled a pink sausage between my legs for a laugh. Jack and Issy giggled, then suddenly my head exploded. Bang! It was just her hand, that time. She moved on to shoes, spades, a cricket bat and worse.

The problem was, she was so big and powerful that I was too scared to stand up to her – even when I had grown up. It had already occurred to me that the real reason I'd attacked the policeman was to get revenge on her. He'd hit me just like she used to, without warning and when I was unable to defend myself.

I reached for Mike's book to stop the train of thought, but as I opened it, a strange question came to me: *why had I* found it easier to stand up to an armed fascist policeman than a fat old woman?

The next morning Paco's dark eyes looked up from his workbench as I approached. He smiled slowly.

'Buenos días. How was la última noche?'

Last night had been terrible, but Paco would only take the piss now that Patrick wasn't around. I smiled back at him.

'Bien, gracias. I finally got a letter from my mother. She can't get the money for my *fianza*.'

Paco shuffled his chair forward so I could get to my half of the bench. 'That's too bad. But it's good to hear from *tu madre*.'

'Sort of. She said she hadn't been able to write for months because she was too upset. And she signed the letter "from your affectionate mother, Stella McLellan". It was like she was writing to a bank or something.'

'You are lucky. My mother was too... *afectuosa*, and look at me now..'

Paco posed like the work-shy fop he was. 'I am thpoiled!' It was true, but he was funny too. I sat at the workbench and started to sketch out my latest idea. I'd learned a new way of fastening leather together with tassels and I was planning to design a hippy bag for straights. We worked through the morning in silence until the door around the corner burst open with a bang. The *pasta* guy's spit-and-sandpaper voice rattled on and on until he finally ran out of breath:

'Pasta calentita, calentita, calentita, calentita, calentita, calentita, calentita, calentita, calentita'

Everybody on the production line laughed and got up for coffee. Even Paco smiled as he offered me a Ducados while we waited for the crowd to die down. I was designing the hippy bag in my head when a huge cuddly clown sprang into my vision. It freaked me out. I felt as though I recognised it from a nightmare. Louis's bony head popped out from behind it.

'What you sink?'

Louis was actually grinning. The penny dropped. It was the clown I'd drawn ages ago. They'd made it into a toy.

Louis stood up and said, 'It's for Señor Vendrell's birthday. What you sink, eh?'

I thought, *I sink it's awful*. But I told him it was great. It was even better when he took it away.

That lunchtime I retreated to my bunk and watched Gunter and Peter wiping their bowls with bread before they joined the queue for wine. I'd decided not to get any more wine at siesta. It was supposed to make you sleep, but it only made me think. Since moving out of Mike's cell there wasn't much else to do. Peter and Gunter couldn't speak English, so the only conversations to be had were inside my head. Not only that, I still didn't dare draw in case it drove me mad. All I could do was go back to my past.

There was one room we hardly used in the slum house, partly because the ceiling had fallen in, leaving a big circle of gaping laths around the light bulb. Powdery white dust had fallen over the old piano that somebody had left in the house. It was out of tune, but I was glad it was there so Dad could play it if he ever came back. Most of the time I got along okay without Dad, but I never stopped thinking about him. Whenever a plane went over our house I'd think it was him, flying past to keep an eye on us. And when something good happened, like getting charity presents at Christmas, I'd think he'd secretly organised it to make sure we were okay. I missed him most at Christmas because they always played 'The Little Boy Who Santa Claus Forgot' on Uncle Mac's radio show. I'd hold back the tears for as long as I could, but I always ran out of the room crying when they sang, 'I'm so sorry for that laddie, he hasn't got a daddy ...'

I jerked upright on the bunk. I had to stop thinking about this stuff.

My hands scrabbled in my case for the book Mike had given me. Anything to stop me feeling sorry for myself. I opened it and began to read the first chapter. It couldn't have been more perfect. The first page was about the problem of making sense out of the chaos of life. The writer said it reminded him of how he'd tried to send someone a parcel of water in the post as a prank when he was a kid. The idea was that the poor guy who received it would untie the string and get soaked. The only problem was, it couldn't be done. I related to that straight away. It was like me when I went to buy a bar of milk chocolate for my dad, trying to picture how a liquid could be held in a wrapper.

Peter and Gunter trudged back into the cell with their wine, but I hardly noticed them. I was trying to get my head around the idea of reversed effort. It seemed to be like Alice Through the Looking Glass – you had to go in the opposite direction to get where you wanted to be. It was obvious that you had to lose your breath in order to breathe in, but understanding how you had to embrace anxiety to feel secure was another thing entirely.

The bugle for the *talleres* blew all too soon.

Work went by in a blur. I couldn't wait to get back to Mike's book. Deep below our balcony the squawking telly mixed with the frantic hubbub of the Spanish social hour, but it seemed quiet up in our cell as we burrowed into our bunks to escape the cold. I was even deeper into *The Wisdom of Insecurity*. It was easy to see why Mike had read this book a few times – there was a lot to take in. Watts used forces of nature to explain something about life that you'd kind of wondered about yourself but hadn't been able to make any sense of. I felt a sudden urge to draw, and I reached for my book.

I began by drawing cogs to show how the moon interconnected with life on earth. But after scribbling away for ages, all I ended up with was an inky picture of me in a dark pool surrounded by creeping plant people, while a giant rat crawled out of an arsehole in the sky. It was the first drawing I'd done since my breakdown and it really freaked me out. If that was the state of my mind, it was no wonder that Mike had given me a book called *The Wisdom of Insecurity*.

Peter watched with concern as I reached below my bunk and yanked Hanna's letters out of my case. I reread the endings, trying to absorb their love and comfort. Then I placed them on my blanket while I drew a picture of Hanna's face, her cheek resting on my shadowy head. It was only a bad drawing and a couple of letters, but they helped to calm my mind until the light went out.

Unwanted thoughts rushed into the vacuum of darkness – pointless images that had no place in the prison. Mum lying in a spreading pool of black blood, me running from her staring eyes... She would have died if I hadn't found her. The faded blue butterflies tattooed on the chauffeur's knees and the pile of silver coins that I had to hide from his wife... Mum again, painting her face until the mother we knew disappeared, night after night. I squeezed my eyes to shut out the image and the cries of, 'Your mum's a prostitute!' but I couldn't get rid of the long-forgotten feelings of loss and emptiness.

I got up early. It was Friday and from what I could see through the bars it looked like a sunny morning for a change. Peter began to clean the floor and I pulled out my book to draw him. He looked preoccupied, as though he too was working out some complex problem in his head. It was a shame we couldn't talk to each other. Gunter started hassling the poor guy in German while I jotted down a Modelo version of an old blues song as I waited for the bugle to blow.

When you wake up in the morning Hear the trumpet blow Don't lay watchin' the dawning Man, you gotta go....

The bugle sounded right on cue and the shout went up for the first and second galleries. I quickly scribbled out the rest of the song:

Let the Midnight Special Shine a lite on me Let the Midnight Special Shine an ever-lovin' lite on me. I jumped off my bunk and headed for the door as the call bellowed up:

'Segundo... Trabajo!'

Peter flicked me a salute and flashed a shy smile as I left. For the first time I noticed that his eyes were pale blue, like Hanna's. I joined the line down the gallery thinking how strange it was to be friends with someone you'd never really spoken to. Language didn't seem to matter, just the smile and the funny salute were enough to tell me he was still there if I needed him.

Suddenly I remembered I'd left my book out so that the ink could dry. I'd forgotten to hide it in my jeans. It was too late to do anything, so I kept marching towards the dark archway, hoping there wouldn't be any searches while I was at work.

As we lined up to cross the *talleres* yard, I realised something weird was happening in the atmosphere around us. Pink candyfloss clouds were floating over a chalky blue sky that seemed close enough to plunge my hand into it. I looked down as a liquid yellow light rippled over the sandy ground. For a moment I thought I was having an acid flashback, but surprised heads were turning all around me, so I knew it must be real. It was like standing inside a moving rainbow: the *talleres* buildings changed from ochre to indigo whenever the effect touched a window or a wall. The phenomenon slowly faded as we walked across the yard and entered the deep purple interior of the factory. Nobody seemed to know what it was, but I secretly felt that the Midnight Special had shone its ever-lovin' light on me. My trial was only a couple of weeks away, so I took it as a sign of good things to come.

Paco didn't seem surprised when I told him what I'd seen.

'You don't have in England?' he said.

'No. I've spent most of my life outside and I've never seen anything like that before.'

Paco punched a few holes in his leather pattern then stopped. 'Why you stay outside so much?'

I laid the heavy steel ruler over a sheet of leather to cut some *tiras*.

'I used to be a gardener. I worked in a zoo before I came here.' Paco turned away and started punching again.

'I don't like zoos.'

'Neither do I. Sometimes I think I'm only in here because of the zoo.'

Paco put down his tools and looked at me. 'Why?'

'I don't know. Karma, I guess. I'd only been working there for a few days and I saw this big, beautiful eagle crammed into a tiny little cage. It was baking hot and he had to hold his wings out all day so he didn't cook like a turkey. I should have walked out, but I stayed on for the money.'

Paco picked up his tools and gave me a sly smile.

'So the reason you are in Modelo is karma?' He started punching again. 'Nothing to do with drinking, stealing, fighting, *drogas..*'

I shook my head and got back to cutting strips of *tiras*. There was no point having a serious conversation with Paco – everything turned into a joke.

After a while, a dark shadow on the whitewashed wall made me look up. Louis's giant donkey jacket filled the doorway. It was hard to tell, but it looked like he was grinning again.

'Señor Vendrell likes your present very well,' he said. 'And he want to see your book.'

'No problem. I'll bring it in tomorrow.' Louis frowned and his voice dropped an octave. 'Today.'

I nodded. 'I'll bring it back after siesta.'

Louis turned away. The cell brightened up when he left, but I didn't.

'What do you think that's all about?

Paco rubbed his chin and frowned. 'I don't know, but I hope Señor Vendrell don't show your drawings to an official.'

I made a *membrillo* sandwich for lunch and ate it as I flipped through my book. There were pictures of the cops beating me up and quite a few cell interiors. On top of that were drawings of the suicide guy and one of Zorro. Looking at the stuff I'd done in Paris and the drawings of Mike and Patrick made me realise how much the book meant to me – especially the drawing of my exploding head. I couldn't bear to lose that. To distract myself I started to draw the morning's colourful experience while it was still fresh in my mind.

Louis was waiting for me in the *talleres* when I came back from siesta. He took my book with a silent nod and headed for the guarded door that led to the civilian world of Señor Vendrell.

I turned to Paco. 'Well, that's the last I'll see of that.'

Paco's reply was typical. 'That is why Patrick only drew fantasy pictures. If you draw the prison they will take them away.' He must have seen the look on my face, because he added with a smile. 'Don't worry. You still have enough time left in Modelo to draw another book.'

I was deep into Mike's book when the metallic squeal of the evening dinner pail roused me. I was out of *economarto* food, so I jumped down from my warm bunk and shivered in the doorway next to Peter and Gunter. I caught a bowlful of slop and then slipped back into my sleeping bag to continue reading. It was so absorbing that I finished the bowl without

that ambe us black without white says The men I am set in wind vight was of those winter english marings, the day is frelay warking another wask at modello. yosteday on leaven the prison toulding to an the courty and to work we supresed tor see the day, now light, we calcured an a uncaning because the dands were deep pink, we and flufty behind them the people dudter the the trindings in one a and fluffy behind them have been charten the full for any the buildings were a rever before, all different that such that the first states with tight yell some grey but bright, some ever charten as we want this states gradult of home but most of all I was there always as we want built states from a soundy wellow floor the some between the built of the findne on the stars it had a set it some to that it is the build but it soeme on the sky it had a find the start of the abed but it soeme meents of its cante and assumed another stid from the owner Morning Finols me moving Cells In in another place again Jutside moves the cells within at a faster pace my friend called m and so we go to another constituer day, another stores unthen day or hopes ous and ears and Mettle fested! Onward! onwand! Attonet Unward III Warth down ill have a style of my own West can I when der sain of that I have nussel how com 1 Thear a his lund re why your ba really good day / was Fold I Laked berything and when I die will look into this and The color is cours on 1 do This! renther - slowly, it's Attives now Cann uch - its time to sleep acres I unirept be in Mikes bella avorduich - averi changes-so fu

noticing what I'd eaten. Watts was explaining that sometimes you don't need to change the world around you to be happy. The world is what it is and, if you want to find happiness, it's your attitude to the world that you have to change.

I closed the book and crossed the cold tiles to rinse out my bowl. The granite wall stood before me like a monolith as I brushed my teeth. There was no way to change my situation, so how could I see it for anything other than what it was? The squeaky tap coughed icy water into my mouth, freezing my teeth as I rinsed. I spat into the cold stone sink. *Reading's one thing*, I thought, *doing's another*.

Back in my bunk I stared at the grey walls. In the half-light the cell looked as grim as the slum house we had moved into. But after the horrors of Mr Smith and the children's home, we were happy to be there. That was the point Watts was making. It was our attitude to the situation, rather than the situation itself that mattered.

Although I liked the slum house, I wasn't keen on starting another new school mid-term. By that time everybody had made friends and I would always be an outsider. The first morning always scared me. I dawdled along the pavement towards Roundhay Road County Primary, looking into gardens and through lace curtains in the same way that had made me late for all my other schools.

I stopped at the end of Tramway Street to inhale the warm smell of freshly baked bread drifting through the cold air. It led me to a wall surrounding a low building, and I climbed up to investigate. I looked down through a flour-dusted skylight into an underground bakery. Men dressed completely in white were pummelling pastry with such force that their tall white hats waved around the room like mushrooms in a hurricane. Clanking away behind them was an enormous metal mixing machine, churning up enough bread to feed a giant. The scene reminded me of the card in our Sergeant Bilko game that read:

'Send us your dough - we knead it!'

It made me smile until I turned the corner into Roundhay Road and saw the tall red-brick school with its soot- blackened pediments. Just the sight of 'Boys' and 'Girls' carved in stone sent a chill of fear through me, but when I got into the playground it wasn't so bad. The yard was full of kids thwacking coloured tops around with leather whips. I wandered among them, fascinated by the kaleidoscope of colours chalked onto their spinning surfaces. Suddenly the school bell began to clang like a fire engine.

The other children quickly formed into lines, while I ran around in a panic until a teacher pointed me towards a queue trooping through the entrance. We trudged up dark stairs and filed into a classroom where a big bald man in a shiny blue suit was standing on a raised stage like an actor.

Mr Freedman bore a strong resemblance to Sergeant Bilko. Even down to the thick black glasses that looked as though they'd been drawn onto an egg. He stuck me at the front of the class next to a kid called Shepherd, and his foghorn voice ordered us to copy what he wrote on the blackboard.

Shepherd's blue-and-gold fountain pen filled line after line with neat, round writing while the prongs of my school pen caught on the paper, spitting flecks of ink over the page. I wrote as fast as I could, but by the time Freedman had filled the board I was miles behind. He glared around the class, flipping his chalk impatiently. I mentally pleaded for him to wait, but he started rubbing it off so he could write more. To make it worse, Shepherd curled a stocky arm round his book when he saw me trying to copy from him.

The only thing I'd learned by home time was Mr Freedman's favourite phrase: 'You'll thank me for this when you're older.' Every time he said it, I thought: *No I won't*.

Back in my bunk, I tossed uneasily. I knew I had to get to sleep or I'd feel terrible in the morning. Yet part of the reason for my obsession with the past was to stop me from falling asleep. I was scared of what was waiting for me when I dropped off. My nightmares had become so violent that it was almost better to stay awake all night than to wake up sweating in fear with the moonlight sliding through the bars like blocks of blue ice. I started to compose a letter in my head to my mother, urging her to try and raise the *fianza* again. When every sentence was committed to memory, I promised myself I'd post it the next day. It was my only hope.

My head rested against the rough doorframe while I waited for the call to work. It was Monday morning. I was so tired that I could have fallen back to sleep right there and then. The harsh words from below cut through the cold morning air and jerked open my eyes.

'Segundo... Trabajo!'

I shuffled out into the dishevelled queue, wishing I was sick so I could stay in bed. I needed to talk to someone about my nightmares, but I couldn't bear to admit my failings to Mike. Last night's was a hyper-real version of my arrest, except the cops were super-zombies who could walk through walls to kill me. Peter would have been sympathetic, but he didn't understand English and I wasn't going to tell Gunter.

Paco looked at my haggard face when I got into the *tall-eres* and asked me how last night was. I knew he didn't really

want to know and anyway, my main concern was getting my book back. I scanned the workshop for the familiar mustard coloured coat:

'Bueno, gracias... Have you seen Louis?'

Paco flapped his black poncho like a giant crow. 'No, but I've heard him shouting.'

That didn't sound good. It wasn't just my book that was getting me down. Every time I worked on a new bag I was worried that Louis wouldn't like it and he'd put me back on the production line. My latest idea was to make a handbag that would fit snugly under your arm, like a half- moon shape with a short strap coming from the points. You'd hold onto the strap like you did with a rucksack, making it hard for anyone to grab it off you. I got back to work on the cardboard prototype. Designing bags was exciting – there was always a chance one of your designs would sweep the nation. Then my job would be safe. By lunchtime I'd stitched the patterns together, and even though it was made of stiff cardboard it fitted under my arm perfectly.

Siesta was a welcome break. I wanted to sleep before I wrote my letter, but the thought of a nightmare in the daytime was too much to bear. Peter had settled down quietly, but Gunter was snoring above me after wangling Peter's wine off him.

Gunter reminded me of Mr Freedman. Freedman was always snorting into his hanky like a pig. I could remember exactly what he was like, but I couldn't remember much of the lessons I was now supposed to be thanking him for. Only one of his art lessons had stuck in my memory. He'd tried to teach us how foreshortening enlarged parts of the objects that were nearer to you.

One kid got his head round the idea brilliantly. He was from the year below me so he must have been about ten. We'd both drawn a plane, but I got a shock when I looked at his. The bomb hanging under the wing ballooned into the foreground while its tiny fins sloped away in distant perspective. I'd tried to get my head round the idea, but my drawing just looked like a normal plane with huge propellers. Freedman had made a big deal of how a kid who was a year younger than me had done a better drawing.

He was always telling me I didn't try. And to be fair, he was right. I did my best in the drawing and singing lessons, but whenever he started to teach us something else, my thoughts just drifted out of the window. At the end of term he asked me to come out and write a complicated sentence on the blackboard. I decided to do it perfectly just to prove that I wasn't as stupid as he thought I was. I knew I'd done it correctly – the grammar and the punctuation and the spelling. I'd even written it in neat, joined-up writing.

When I'd finished, Freedman blew his nose like a trumpet, then turned to the class.

'What's wrong with that?' he asked. His shiny head scanned the silent classroom. 'I'll tell you what's wrong with it...' He paused for effect, then yelled. 'It's PERFECT! *That's* what's wrong with it!'

Freedman turned on me. I'd never seen him so angry. 'See what you can do if you try? You just don't try! That's what's wrong with you. You. Just. Don't. TRY!'

What he didn't know – and what I didn't know back then either – was that I had nobody to try for. I was waiting for my Dad to come back in a big shiny car, and until he did, I didn't really care much about anything.

That evening I finally forced myself to write another letter to my mother. Spanish pop music blared from the *Planta* gallery telly. It was so loud I could hardly hear my pen scratching on the paper. I meant to say more, but all I could manage was a repeat request to raise my bail money. I made up for the lack of news by drawing a pattern around the envelope to show it wasn't just a begging letter. The wall of sound hit me as I stepped out onto the walkway and headed for the unknown depths of the *Primero* level.

Mike spotted the decorated letter as soon as I walked through his open door.

'How did you know it was my birthday?' he said.

Mike always made me smile. 'It's for my mother. Can you spare another stamp?'

I looked round the cell as Mike rummaged through the papers on his desk. Without all the pictures it seemed bare. Mike's voice echoed off the walls.

'Give it to me. I'll post it with mine.' He studied the pattern on the envelope. 'So what do you think of Watts?'

'He's great. I like all the reversed effort stuff. You know, if you can't change the world, change your attitude towards it.'

'I think that comes from a Lao-Tzu story...'

Mike flicked his Zippo into a smoky flame and put on a Disney voice as he knelt down to light the wicks of the stove. 'Long, long ago, in the days when men wore skins instead of clothes, there lived a powerful ruler. He was unhappy, because wherever he walked in his kingdom his feet hurt from the rocky ground.' I passed Mike his bowlful of water and he put it on the circle of fire. 'So the king asked his tribe leaders to slaughter all their sheep and cover his land with their soft hides so he could walk over the stones in comfort. The wise elders talked into the night, then came back to him with an answer.'

Mike held up a finger and laid his other hand on his heart.

'Sire, would it not be better to kill but one sheep and fix a piece of its hide to each of your feet?'

I laughed. The story was good, and I loved Mike's Bronze

Age version of Freewheelin' Franklin. Mike unfolded the chessboard and I reached for the box. Holding the familiar pieces made me want to start playing again, but what I really wanted was to find out how all these Zen stories worked in practice. Before I could form a sentence, the heavy frame of Luigi lumbered into the cell, his eyes full of intent. Mike called, '*Ciao, Luigi*!' like a Sicilian gangster, and the big Italian smiled grimly as he sat down in front of the board. This was too good a drawing opportunity to miss, so I headed back up to Colditz for my book.

The moment I entered the cell it was obvious that something was wrong. Peter and Gunter were standing next to each other between the bunks and all the beds were messed up.

I looked at Gunter. 'What's happening? Where's the stove?' Gunter didn't look as pompous as usual. 'The guard took it.'

A feeling of horror swept through me and I dived under my mattress. 'My book! Did he take my book?'

Gunter stammered, 'I don't know... He vill be coming back soon.'

I almost grabbed hold of him, then I remembered. Senor Vendrell had my book. The sudden click-clack of boots made us stand to attention. Zorro strode straight towards me. He did his point-and-shout routine at my bunk and I quickly rolled up my mattress. Then he stormed off as I tried to follow him along the walkway holding my massive bedroll in front of me. I could hardly see where I was going, but I knew where Zorro was taking me. Crazy Bob had shown me the rips in his red shirt from when Zorro had watched through the *Quinta* spyhole as the guards beat him up.

All I could think was: *He's a fuckin' madman, but at least he didn't get my book.*

Halfway along the corridor I almost collided into Zorro's cloak as he stamped to a halt outside a cell door. He pointed inside and did an about-turn. It took me a while to realise I wasn't going to the punishment gallery.

I heaved my mattress through the door and saw an ageing hippy sitting on the lower left bunk. He looked up from a small black tabletop balanced on his knees and examined me through a jeweller's monocle, wedged in his eye socket. He didn't speak, but a voice I recognised called from underneath the opposite bunk:

'Incroyable! C'est William!'

Robert the French sprung off the bed with his hand extended towards me. I shoved my bedroll onto the empty bunk above him and grabbed his hand with pleasure. Robert introduced me as an artist to the hippy, who was called Boris, and to Larry, a tall American stretched out on the lower bunk. I unrolled my mattress, thinking how great it was to be with friends again.

After the light went out I lay in my sleeping bag and reviewed the events of the day in darkness. It was great to escape from Colditz and even better to be in a cell with people I could actually talk to. Larry was around my age. He didn't say much, but I guessed he'd just got in and was going through the shellshock period, which was probably why his head was stuck in a book. I was still doing the same thing, except my head was stuck in the past.

There'd always been a shellshock period whenever I went to a new school. Roundhay Road was the seventh we'd been to in five years. I didn't like Mr Freedman and I hated having to make friends all over again.

I remembered how at the end of my first day, we'd all tumbled out into the yard, and I'd bumped into a kid who kept bragging that his dad was Billy Two Rivers. I didn't believe such a famous wrestler could live in a dump like Chapeltown, so I ignored him.

I headed across the playground, but was stopped at the gate by an oily-faced kid covered in blackheads. His name was Smiggy. He grabbed my collar with black-nailed fingers.

'Oy, thingy... d'you wanna fight?'

I turned away, but his mate, Stevens, started picking on me. They followed me up the street all the way to the lollipop lady, punching my shoulders with their pointy fists. I kept my head down and thought to myself: *Just keep walking, just keep walking...*

The next day, they were waiting for me by the green metal gate. As I got closer I realised they didn't look as hard as the kids I'd used to beat up at the home, so I put my head down and pushed past them. I'd made up my mind what to do if they started anything. As soon as a fist hit my shoulder, I spun round and thumped Stevens really hard in his face. He went down clutching his nose with blood oozing between his fingers. Smiggy backed away, but I kept swinging until I landed a heavy punch on his cheek. The unpleasant memory of my fist sinking into his ugly flesh took ages to fade, but by the next day the three of us were mates.

After school, Smiggy and Stevens took me down a deadend street. We climbed over an old red-brick wall with triangular coping stones and dropped into an overgrown scrubland. It led to a wide, shallow beck flowing between high tenements that rose out of the water on either side of it. Except for the rusting prams and stuff, it looked like the watercolour my granddad had painted of Venice. I loved the place. We stepped from stone to stone, picking up bits of junk thrown out of the tenement windows. I called out to my new friends when I found a submerged doll. Her eyes were staring out of the water and long green weeds snaked downstream from her head like the hair of a mermaid. I was in heaven.

Even in my Modelo bunk I could feel the pleasure of the cool, rippling water on my hand. I loved the way the mysterious reflections could suddenly reveal a hidden treasure. Maybe that was why I'd liked going down there so much – because it reminded me of the stream at the farm where I'd spent so many happy hours with my mother.

18

PIGS WILL FLY

We gotta get out of this place If it's the last thing we ever do The Animals

Normally, the dragging of the metal coffee churn grated on my nerves in the morning, but a beautiful day was dawning behind the bars, and I didn't care. Nobody had a stove in the cell, so I grabbed my beaker and followed Boris and Larry to get a lukewarm ladleful of the pale coffee-like liquid. It was the first time I'd drunk the stuff for ages. It tasted slightly better out of plastic than a tin can, but it was still weird.

I leaned on the end of the bunk while I waited for the bugle and asked Robert why he didn't drink it. He spat out his reply as though it was a mouthful of coffee grounds:

'Because it's full of crazy Spanish chemicals!'

'Oh yeah. Like what?' Robert stuck his finger up and then made it droop with a comical downturn of his mouth. I got the message, but I swigged it down anyway. Nobody else moved when the *talleres* call went up, so I joined the queue alone. I missed my morning cup of tea. By the time the coffee reached our level it was too cold to warm you up. I decided it was worth risking the *Quinta* by making another stove. But that all depended on whether Senor Vendrell had shown my book to the officials.

There was no sign of Louis or my book when I arrived at the *talleres*. I looked nervously at the guard while Paco shifted his stool so I could squeeze into the narrow cell. Paco was used to me looking worried.

'Bad sleep?'

'Do you get food sent from home?'

Paco raised a single black eyebrow like Dracula.

'Why?'

'Don Juan ripped off my stove and I need a big can to make another.'

'What size you want?'

I circled my hands to the size of a grapefruit and he raised both eyebrows together.

'So big! You want to cook a chicken?

I smiled at the thought and told him about the gangster in our gallery who often had big red lobsters sent in on a pile of rice.

Paco turned back to his board. 'Look busy. He's coming.'

I grabbed a pencil, then looked up with fake surprise at Louis's heavy tones. '*Hola. Qué pasa*?'

Paco and I droned like schoolboys: 'No pasa nada.'

Then I saw a black shape under Louis's arm and thought: *Pasa mucho – I've got my book back*! Louis was also carrying a rolled-up sheet of cream-coloured leather. Paco leant back as Louis passed it across to me with a deep frown.

'Is possible to draw a picture on piel?' he said.

I unrolled the pale leather on my drawing board and ran my hand over it. It was smooth and shiny, like soft glass.

Louis grunted. 'Well?'

'What do you want me to draw?'

'An old ship, wis cannons. Is possible?'

I said, 'Yeah,' without even thinking. Any chance to draw was worth going for. Louis gave my book to Paco, but he was looking at me.

'Is for Señor Vendrell, so make it good, eh?'

Paco opened my book as Louis walked away. 'Let's hope he pays you for it.'

Paco flipped through the pages while I imagined the galleon in a stormy ocean, its torn sails billowing as it listed over from the broadside blast of its cannons. I was lost at sea until I realised Paco was speaking to me. 'Did you always draw?'

'Yeah. It was the only thing I was good at in school.' I suddenly remembered Freedman's bald head. 'My teacher didn't think much of it, though.'

Paco closed my book and handed it over. 'Who cares what the teachers think? Only what you think is important.'

It was great to feel my book back in my hands again. And a big relief to know that Senor Vendrel hadn't shown it around. Paco was staring at me. The black dots of his eyes framed by the twin arches of his short dark hair.

'It doesn't matter how good I think I am. It's still not going to get me into art school.'

Paco turned back to work with a shake of his head and we worked silently on our bags until the bell rang for siesta.

When I got back to my new cell I took out my 0.5 Rapidograph and a new plastic ink bottle from my case. Paco was right: he was spoiled. His affectionate mother had probably sent him to a posh school like Jeremy's, where they'd told him he could be whatever he wanted to be. Mine was different. The last thing we'd had to do before leaving Mr Freedman's junior school was stand up in alphabetical order and say what we wanted to be when we grew up. I hated standing up in class, and fear built up inside me as my turn approached.

Freedman pointed to a kid behind me.

'Lake, what are you going to do if you ever grow up?'

Lake shoved his chair back noisily as he lumbered to his feet.

'I'm going to work in a shop, sir.'

'And what kind of a shop would that be?'

'Don't know, sir. Me Mam works in a grocer's and I thought I would an' all.'

Freedman flapped his handkerchief open and got ready to blow.

'That's a good choice. The benefit of being in a shop is that you're working with people, and that's always rewarding. Remember that, all of you.'

Freedman blew his nose and studied his handkerchief before looking down at the register. That really disgusted me. He folded his hanky and looked up.

'McLellan, you're next. What, in your infinite wisdom, have you chosen to be?'

I stood up and suddenly realised I didn't know what to do with my arms.

'I want to be a commercial artist, sir.'

Freedman frowned. 'Why?'

'Because I really like drawing and you can earn more money doing commercial art.'

Freedman's bald head glistened as he tilted it to one side. 'Who told you that?'

'My mother, sir.'

'Did she now... And did she tell you what a commercial artist does?'

I clasped my hands behind my back to stop them flapping around. 'Yes, sir. They draw adverts and pictures in the papers.'

'And what makes you think you can do that?'

'I like drawing and if I work hard, I think I could learn to do it.'

Freedman looked around the class the way he always did before he made a pronouncement.

'Well, I'm sorry to disappoint you and your mother, but I've seen a lot better than you that didn't make the grade. Next up is...'

It wasn't fair. Mum and I had spent ages thinking about what I was going to do.

'But I'd try my best, sir, and...'

Freedman silenced me with a withering stare. 'Yes, and pigs will fly. Now – Morrison!'

I sank down onto my chair while Morrison droned on about some boring job. I was mortified. My whole future had been written off just like that. All I could do was draw. If I didn't do that, what else was there for me?

When I told Mum, she quoted: 'Sticks and stones may break my bones, but words will never hurt me.' But I thought the opposite was true. I didn't mind Freedman caning me – lots of teachers did that. It was the way he blew his nose afterwards and said, 'You'll thank me for that when you're older.' In the long run, his words cut deeper than his stick.

I imagined calling on Mr Freedman after I'd beaten up Mr Smith. *Knock! Knock!* Freedman opens the door and as soon as I see his big shiny head I punch him hard. Bang! I wait until he looks up at me from the floor, then I say to him,

'You'll thank me for that when you're older.'

When I returned to work after the siesta, Paco watched as I carefully took my Rapidograph apart to clean it. I was moving the wire gently up and down the nib when it occurred to me that if Canadian Michael hadn't taken my suitcase to the consulate after I got arrested, I'd never have got all my art equipment. I'd still be sticking cars together, stoned on glue. Forget Mr Freedman, if there was one person I ought to thank when I'm older – and for the rest of my life – it was Michael Schneider.

I started drawing straight onto the leather with no pencil outline, enjoying the feel of the clean nib gliding over the smooth surface. I did all the foreground stuff first, leaving gaps in the rigging for spray and smoke from the cannons. Except for the *pasta* guys, the only interruption was when Manuel sneaked in to give me a Ducados.

Canta, Weeyaam. Canta para nosotros, he whispered huskily, before ducking back to the production line.

I sang 'Plaisir d'Amour' while I drew, because I knew he liked it. Then he sang a sad Spanish song back to me. It floated into our narrow cell as though it was coming from a church. If you didn't know it was a young boy singing, you'd have thought you were listening to some craggy old gypsy leaning over a flamenco guitar.

We swapped songs throughout the afternoon while I was lost in drawing. I knew it was only another present for the boss, but it was a welcome break from making bags and a far cry from the dreaded worktables. When the bell rang I'd pretty much mapped out the whole thing. The crosses I'd drawn on the sails followed the curve of the bulging canvas, and I could hardly wait until tomorrow to add in the detail.

Social hour was even noisier than usual. Fanatical football commentators whipped the Spanish prisoners into a frenzy. The chaotic clamour reminded me of the mad babble I'd heard in the caged cells when I first came in. It was loud, but it didn't drown out Robert sneezing or Boris moaning about it. Nobody said *Gesundheit* any more, after Robert had kept us awake most of the night. Our bunk rocked with another sneeze and I stopped reading to think about what Alan Watts had written about words.

I'd been thinking a lot about words. I didn't trust them. Watts didn't seem to trust them either. He thought that by splitting things into boxes to classify them, the free-flowing unity of the world had been broken up and man had separated himself from it. I got that. Animals didn't have words so they fitted into nature without thinking about it, but we saw ourselves as above nature and tried to control it. That's what words were used for – control. That's what the zoo was all about too. Each creature was labelled and shoved into a controlled environment. A false one. Daisy was right when he said all words are lies.

The bed shook with another sneeze. Boris tutted and Robert went mad.

'You should give thanks to God for zis epidemic. Maybe it will kill Franco – zen we can all go home!'

Boris didn't look up from the table on his knees.

'Or maybe it will kill you – then we can all have some peace!'

Robert's string of obscenities clashed with the hysterical celebrations for a goal from downstairs. I smiled. Once this would have seemed like living in a cage full of chimps, but after Colditz it seemed like one big, happy family. I looked down at Boris. He was perched on Larry's bunk with the tiny cogs of a watch sparkling on the black patch of velvet that covered the tray on his knees. His thick hair had streaks of grey, but with his embroidered waistcoat and tatty bell-bottoms it was easy to imagine him cross-legged on a street corner, braiding beads into hippy girls' hair.

I climbed down to look at the tiny silver tool in his strong hand.

'Is that a pin?' I said.

He didn't look up. 'No. Pins are too soft. It's a needle. I filed the point on stone to make it into a screwdriver.' His English was so good that I couldn't make out his accent. It could be German or maybe Dutch. I leaned forward to get a closer look. He was turning what looked like the smallest screw in the world. I couldn't help saying,

'Wow! That's amazing.'

Boris was like a statue. His head didn't move a fraction, even when he spoke.

'When I was in the *Quinta* they took away all my tools so I filed down my fingernails and still fixed watches.'

I was trying to picture his screwdriver fingernails when he added, 'You're in my light.'

I leant back on my bunk to watch him work. I wanted to know if they'd beaten him up in the *Quinta*, but I just asked if he was a jeweller. He still didn't look up.

'No. I can do anything. There are no walls for me, only horizons.'

'Do you work in the talleres?'

I thought he hadn't heard me above the roar of the football crowd, but eventually he said, 'I'd rather have my thumbs screwed than contribute to the corrupt regime of Franco.'

I was about to change the subject when Boris looked up

at me. It was hard to tell if he was pissed off or if he was only frowning to hold the monocle thing in his eye.

'Do you work in the talleres?'

I sensed a bit of aggro and tried to sound off-hand. 'Yeah. I need the money for food.'

Boris licked the end of his screwdriver and touched it delicately on a tiny cog. It stuck on long enough for him to place it in the watch.

'That's why I'm fixing this reloj. I run my own talleres.'

Robert called out from behind his paperback. 'And that's why they keep throwing him in the *Quinta*.'

I jumped as Boris shouted, 'Viva la revolution!'

Robert responded with, 'Franco a morte!' then burst into a fit of sneezing.

The football match was roaring to a climax so there was no point trying to carry on the conversation. I climbed back up to my bunk. It was too noisy to read and I couldn't draw because my book was still in the studio. As usual, the only place to go was the past.

As soon as the summer holidays started I forgot all about Mr Freedman. I filled my pockets with coloured chalks and began drawing pictures on the pavement outside our house. It was soon filled with drawings like the flagstones of the farmhouse kitchen. I began to work my way down Tramway Street, developing a simple way of drawing an old-fashioned car outside each house I passed.

When I reached the corner I crossed Roundhay Road at the zebra and settled down on the warm paving stones by the railings of the school I'd just left. I looked through the bars at one of the low pillars that supported the railings. The granite had been worn into smooth shapes by thousands of feet playing tig-off-ground. I used to love sitting next to it, pushing my Matchbox cars slowly over the rolling hills of stone. I liked the playground and the games we played, but I hated Freedman. It wasn't just because he'd told me pigs would fly before I became an artist. He'd also thrown me out of the school play.

The first line I had to say was, 'A ventriloquist?' But I said it wrong because I didn't know what a ventriloquist was, and he replaced me before I had a chance to get it right. I watched the play from the back of the dark audience, silently mouthing every line, aching to be on the bright and beautiful stage.

I could still feel the hurt of that rejection, but back then there was a much worse pain inside me. One I couldn't even name. It felt heavy in my body and ran through my bones like lead.

I took a stub of crumbling chalk out of my pocket and wrote in large capitals on one of the flagstones:

LEARN THESE WORDS

BASTARD CUNT FUCK

SHIT HATE BOLLOCKS

Underneath I filled another stone with:

DON T LEARN THESE

NICE LOVE SWEET

PLEASE GOOD

Then I walked away. I can't remember how I felt after that, but I know I was confused, as though I didn't know quite what I was doing.

The next morning Paco asked how I was, but I didn't tell him. I'd woken from a nightmare that wouldn't leave me, and I felt terrible. I hated Modelo. The incessant slamming of steel on steel, the unnecessary shouting of the guards and the complete absence of any glimpse of the outside world. Just the unrelenting, unending, long grey tunnel of being held without trial. I'd been blocking an image from the zoo that had been coming into my mind for some time. Now I couldn't escape it. It was the cheetah's cage. It was about 50 feet long and just wide enough for the beast to turn around. The idea was to give the fastest animal on earth a place to run. All it ever did was walk up and down in abject misery. The designers couldn't have thought up a crueller punishment if they'd tried. I loved cheetahs and I felt I deserved every second of my time in Modelo for standing by and doing nothing when I worked at that zoo.

I kept having to wipe my pen nib across my jeans before I could get a smooth line out of it. The lawyer that Bradley had got me was full of shit. The only reason he'd said there would be a trial in a month was to soften the blow of not getting me a lower *fianza*. My excitement had made me forget that all words were lies. That was what Mike had been trying to tell me all along, but I wouldn't listen. It made me want to shout out like the pasta guys, '*España*! *Mañana, mañana, mana, mana, maxa a m*

Instead I worked on the galleon in silence. I didn't care if it was only a present for the boss. I was going to make it look as good as I possibly could. Anyway, the mood I was in was perfect for cross-hatching the stormy sky. By the time the pasta guys' arrival shocked me out of my concentration, the clouds behind the tattered sails looked thick, dark and turbulent.

At the end of the day I was pleased with the drawing.

Even Paco murmured something complimentary about it before making a stupid joke. I felt a bit more cheerful, and admired his bulbous bag in return. Hopefully I would have a restful weekend. The torments of the night before had been inked into the ripped rigging of the storm-tossed galleon, and I felt strangely becalmed. Louis came round to pick up the drawing. He didn't say much, just stood there nodding thoughtfully in Gallic contemplation. For a moment I was worried that he didn't like it, but the gentle way his big hands rolled up the leather before he placed it under his arm made it seem like he thought it was precious.

Sunday felt like the boring day it had been when I was a kid. I lay on my bunk in the quiet of siesta with my book propped up on my knees. I was too tired to draw after running around in the yard so I wrote a poem instead:

> Patio, playing basketball, the sun is strong Sitting, watching chess games, talking some Nothing, nothing new to fill an eager mind Turning, turning to memories of places left behind.

That was pretty much all there was to do. I knew the dictionary defined nostalgia as a sick yearning for the past, that was why I'd never looked back. But as memories of the slum house began to return, I could feel the sickness taking a hold of me.

Mum was always getting sick. Mostly it was from abortions that went wrong. A shiver ran through my body. Even now, I couldn't bear to think of the time I'd found her lying there in a pool of blood, looking like a corpse. I'd never run so fast in my life. Her glamorous friends who lived in the run-down terraces looked like prostitutes – they all dressed like the one who'd been murdered in the house opposite us – but we never knew for sure. We were usually sent away to foster homes when Mum went to hospital, except sometimes I went to Laura's on my own.

Laura's house was down our cobbled sidestreet. It stood back-to-back with the Chapeltown Road shops and her front room was almost as dismal as our sunken kitchen. Laura sang all the time like Mum did, only her voice was beautiful and so was she. Her daughter Joanna was nice, but her son Jonathan always spoke in baby talk, even if you threatened to thump him. I didn't like him because one Easter he brought a massive chocolate egg round to our house and sat scoffing it at the table without offering us a single piece.

Sometimes Laura asked me what I wanted her to sing. I mostly chose 'Are You Lonesome Tonight?' and she'd wander around the room, tidying up as she sang. I liked the way Laura stopped in front of the mirror when she got to the line, 'Do you gaze at your doorstep and picture me there?' For ages afterwards I could see her standing there in her pink silk dressing gown. With the soft light from the window falling on her cheekbones, she looked like a film star.

Jonathan wasn't very bright so it was easy to steal his watch and hide it under the carpet beneath the table. I thought that was a clever idea. When Laura asked me if I'd got it, I could honestly say no. I left it there for days before I smuggled it out and hid it in the dusty fluff above our copper boiler along with all the other stuff I'd nicked.

All my past sins started to crowd into my head. I stole – and I knew it was wrong. I shouldn't have stolen from Mum's purse when I knew the shops wouldn't give her any more credit. I shouldn't have taken her jewellery to give to my girlfriends. I shouldn't have nicked a quid from Mum's best friend. God only knew why I'd done that to Maureen. A pound note was a huge amount of money back then. I didn't even enjoy spending it. The sweets I bought tasted like stones in my mouth and I deliberately dropped a shilling on the pavement in front of a woman to show how little I cared for it. She stood there with her jaw hanging down like her shopping bags and said, 'Hey lad, you've dropped some money.' I tossed my head like a bored millionaire and strolled away as though it was too much effort to pick it up.

Why did I do it? We were always being sent to someone else's house after school. Maureen, Mrs Borowitz, Mrs Shupinski, Laura – and Mum's queer communist friends, Frank Fyffe and his mate Paddy, with the milk-bottle dick. Mum was far too busy with her own life to guess what they were doing to us, and Jack was only eight or nine. It messed him up far more than it did me.

It was no excuse for stealing, though. By then I'd already been doing that for years.

The moment I woke up the following morning, I knew I was ill, even though I'd been secretly taking my vitamin pills. I needed an idea for a new bag, but I just couldn't face going into work. As we queued up to cross the yard I asked the guard if I could go into the *oficina*. He pointed to the door and I stood beside it rehearsing *dolor de cabeza* for head-ache and *muy cansado*, which was the best I could do for exhaustion.

'*Dentro*!' was yelled from inside and thankfully it wasn't Zorro sitting behind the big desk. I struggled through a list of my ailments in broken Spanish and finished by pleading to be allowed to stay in my cell. Amazingly, the official agreed.

I tramped back up the steel steps, staring dully at my

ragged Levi's as they flopped over my worn-out shoes. I should've climbed into my bed to sleep, but instead I sat on Robert's bunk with my head in my hands. All I wanted to do was to get out. They weren't going to give me a trial and Mum hadn't replied to my second letter. I kept thinking that the reason I hadn't heard from the lawyer was because the cop I'd kicked was back in hospital. If he was sick, they were going to keep me inside for years.

I stared at the flaking distemper on the wall. It stood for everything that was wrong with my life and seemed to say, 'Whatever you do, you can't get out of here.' It was right. I couldn't. There was something I wasn't getting. I knew there was a force within me that made me do stupid things and I had a weird thought that I'd get out if I understood what it was, but thinking about it left me feeling more confused than when I started.

I leant forwards with my elbows on my knees and squeezed my hands together in front of me. I felt like I was right back to when I got arrested, sitting in the Palace of Justice with only the picture of Jesus to help me. There was a time when we'd used to pray when we were kids. For a while I really believed that there was an all-seeing God who watched everything I did and listened to all my problems. Sometimes I'd be in the middle of explaining a complicated situation and I'd say, 'Well anyway you know what happened, because you know everything.' Now the thick stone walls mocked me with their strength. I closed my eyes and talked in my head in complete and absolute honesty, 'Listen God, if you're testing me for something you want me to do, then you've got the wrong man. I give in. I can't take any more. I'm not that strong.'

Somewhere inside, a part of me felt better just for admitting my weakness. I climbed up onto my brown, matted blanket and drifted off to sleep as soon as I lay down my head.

Feeling a little stronger the next day, I returned to the talleres and worked like a demon. At one point, Paco leant back from his drawing board to light a Ducados. He blew out a cloud of smoke and waved it away with a lazy hand.

'Did you work this hard at the zoo?'

I was trying to make up for the day I'd lost being sick in case Louis put me back on the production line. 'Not really,' I said, and kept on working.

Paco blew another cloud of smoke and asked, 'Why?'

I sighed. 'Because I liked watching the animals.' It was obvious from Paco's expectant expression that resistance was useless, so I told him about the old man of the forest as I cut my pattern out of leather.

'He was the oldest orang-utan in the zoo, and he always had a crowd around him. You could see the thoughts flickering over his face as he sat there, smiling like a big hairy Buddha. Anyway, somebody threw him a boiled sweet, the size of a golf ball, but it landed too far from his cage for him to reach it. He strolled off and we all waited until he came back, carrying a long twig. He used it to drag the gobstopper close enough to the cage so he could get hold of it.'

Paco smiled. 'Did he enjoy the dulce?'

I smiled back. 'It was too big to fit through the gap in the wires. The crowd groaned in disappointment, but the old man of the forest stuck out his elbows and hooked his index fingers through the wires like this' – I mimed for Paco's benefit – 'then he rolled his eyes upwards and went, "*Uh*!" as he pulled the wires apart. Man, his strength was phenomenal! His hands were all leathery, like big black bananas, but he delicately rolled the sweet up the outside of the wires and pulled it neatly through the hole. But the best bit was, before he ate it, he held it up for everybody to see with a big smile of satisfaction. I swear his little finger was stuck out! Then he popped the sweet in his gob and sat there sucking it with a grin all over his face.'

It was a great story, but when I got back to cutting out the pattern, I couldn't stop thinking how terrible it was that the orang was still banged up for life – and he hadn't even done anything wrong.

We worked on in the silence of our own thoughts until the broad body of a guard blocked my light. He shouted his message so loudly that the whole *talleres* must have heard that I'd got a visit from my consul. I got up, my heart pounding, and Paco whispered, 'Good luck!' as I squeezed past his chair.

I followed the guard into the grim underbelly of the dungeons, trying to hold back a tingle of excitement.

I'd expected to see Mr Bradley smiling through the wires of the cage like the old man of the forest. But it was all too easy to read his expression. There hardly seemed to be any point going inside to talk to him, but I nodded my way politely through the reasons why the trial had been postponed.

At the end of the excuses, Mr Bradley asked, 'Are you happy to wait until May for a trial?'

'Mum can't get the bail money together, so I suppose I'll have to.'

His parting words were the only crumb of comfort. 'At least you can be sure it will happen this time.'

And pigs will fly, I thought as I headed back to the talleres.

Paco looked up expectantly as I returned, but he could see from my face it wasn't great news. I slumped down on my chair and tried to sound casual.

'I didn't really believe it was going to happen anyway.' Paco nodded. 'So what will you do now?' 'Nothing. My mother couldn't raise the *fianza* so I told him I'd have to hang on till May.'

'That's too bad. You are like the monkey who cannot get the *dulce*'

Typical Paco, but he was right.

'I know. Except I can't pull the bars open. It's like I'm paying for working at the zoo by being locked up in here.'

Paco rolled his eyes and asked if I wanted some tea. I didn't. I had a headache but I didn't want to see the *practicantes*. I wouldn't be able to resist jumping up to look out of the window, and the sight of all the free people in the street would only make me feel worse.

Paco came back from old Turkey-Neck with a steaming cup of water. He spooned some instant coffee into it.

'You are berry quiet?'

I didn't look up from my work as he sipped noisily at his coffee.

'I'm thinking.'

'Maybe you think too much.'

'I know, but there's a lot of stuff I need to work out.'

I gave Paco a hard stare, but he kept on talking. 'When I was a boy my mother always say to me, *Si quieres ser feliz, como me dices, no analices, hijo. No analices.*' He waved his pale hand like a poet as he translated. 'If you want to be happy, like you tell me, don't analyse, my son. Don't analyse.'

I'd had an idea it would be something like that. 'But if I don't work out what's going on, I'm going to keep doing the same stupid things over and over again!'

Paco smiled again and shook his head. 'You always look for a reason for everything – and it's always a disaster if you don't find it!'

I stared at him, smirking as he sucked up his coffee. The most annoying thing was that he was right.

The guys looked up in surprise as I came back into the cell at siesta with rancid wine sloshing around the bottom of my beaker. I didn't care. I hadn't slept well for ages and all I wanted to do was crash out. I read Alan Watts as I waited for the red vinegar to take effect, but instead of getting sleepy, I got interested. Watts was spot on: you can only live in the present. The past has gone and the future is up for grabs, but everybody who has ever lived has only existed in one moment – the present.

I sat back and stared at the pitted wall through the metal bars of my bunk and thought: *This is it – this is* always *it*. It was pretty obvious really, but that was why Watts thought it was important to come to terms with whatever reality surrounds you. *There was nowhere else to go*. But what could I do? There was no future without a trial, and the present stank, so the only place to go was the past.

Paco greeted me with a questioning smile as I dropped groggily into my seat. I gave him a 'don't ask' look and searched through the tools for the punch. Wine and siesta didn't go together well and my head hurt every time I hammered a hole through the leather. The tree trunk was scored with thousands of indentations, so I always had to make sure there was a flat space directly beneath where the hammer fell. One bad hole would ruin the bag, and Louis was always moaning about how expensive leather was. I was lost in concentration when a deep, '*Voilà*!' made me look up.

I'd forgotten all about the galleon picture, but there it was, dangling before me in Louis's big mitts. It was completely different from the pristine one I drew. They'd used a sepia dye to make it look at least a hundred years old and the leather was cracked with age and burnt round the edges like a pirate's map.

This time there was no mistake – Louis was definitely smiling. 'What you sink? *Es bueno*, eh?' It did look good. You wouldn't believe it had only been drawn a week ago. I asked Louis who it was for and his face dropped back into its familiar serious folds.

'Señor Vendrell will sell them in America. He want you to stop working on the bags and do more drawings.'

I tried to raise a single eyebrow like Paco, but they both shot upwards.

'What? More ships?'

'No. Anysing you like. But zey must be old. From the past, you understand?'

My mind ran away with me. I could do all the Greek heroes. Perseus rescuing Andromeda, Odysseus blinding the Cyclops, Jason stealing the Golden Fleece.

Paco interrupted my thoughts by asking Louis if I'd get more money. Louis shrugged his huge shoulders as he turned to leave.

'I will speak wis Señor Vendrell.'

Paco folded his arms under his poncho and gave me a long, hard look.

'Now you are happy? Yes?'

I smiled as I looked at the rusty tools and dusty patterns hanging from the pale grey walls.

'Yeah, I am. But it's weird to think that my first job as an artist is forging antiques in a Spanish prison.'

Paco gave me another look, harder this time.

'Is more strange you can be an artist in a Spanish prison but not in an English art school.'

I picked up the hammer to punch the holes in my last

bag. I couldn't wait to start drawing the Greek myths, but how was I meant to live in the present when everything kept taking me back to the past? 19

MIDNIGHT SPECIAL

Well I dreamed I saw the silver space ships flying In the yellow haze of the sun Neil Young

The cell light went off and the bunk shook as Robert slammed his book down on the orange-box table. I put Mike's book under my sleeping bag and thought about what I'd just read.

Watts said there were two ways of looking at life. Tao explains that the reality that surrounds you is all there is and you have to make the best of it. The Christian view is that life is just a trial and happiness only comes when you're dead.

Mike was definitely in the Tao camp: he always made the best of whatever situation he was in. Robert was always at war with the world and, judging by the way he defended the Pope, he probably thought he was going to spend eternity in a Spaniard-free heaven.

I didn't know much about Tao, but I sort of knew what the yin-yang sign meant. The two fish shapes showed how the opposite sides of life flow together, meaning you couldn't have one without the other. Opposites worked that way in drawing too. You couldn't make something look bright unless you put something dark behind it.

Watts made the real meaning of this crystal clear. It was impossible to have an eternal happiness in Heaven because without the contrast of sorrow it wouldn't be happiness. It wouldn't be anything.

According to the Tao view, life was an ever-moving mixture of everything. You couldn't fix any part of it in one place – that would be like trying to hold a river in a bucket. All you'd have would be still water, and that would be dead.

The cell walls lost focus as I leant back on the bunk bars to think. I pictured a river flowing to the sea and the sun evaporating the water into clouds. Then the clouds rained on the mountains and completed the circle by filling the rivers. I supposed that was why the yin-yang sign always seemed to be moving – like the cycle of life – but the cross always looked still and dead, like the sign of a grave.

I shuffled towards the metal grille in the straggling line of workers, nervously watching as rough hands slid beneath it to grab the dog-eared, cardboard banknotes. The week had been spent drawing a dramatic picture of a medieval battle. I'd overlaid crossed swords and thrusting spears to give depth to the swelling scene and I was hoping that Señor Vendrell was going to give me some extra cash for it.

Louis gave me a nod and a grunt, then he shoved a thick pink and blue pile towards me. It was so big that I had to press it down to get it under the bar. It made me grin inside like a Monopoly millionaire. It was thrilling to have finally earned hard cash from drawing. As I walked back to the cells, I wondered if it was the best thing that had happened to me in the prison. By the time I crossed the bridge over the gallery, I'd decided it was the best thing that had *ever* happened to me.

Larry lowered his book and Robert looked over his boots as I crashed into the cell. Now I was grinning on the outside, and I couldn't resist fanning out my stash to show them. Boris forgot all about Franco's blood money and was on to me in an instant:

'There's a *reloj* for sale that I know you'd like. I could get it on trial if you want.'

Boris was a sly wheeler-dealer. He must have spotted that my watch was broken. I did want another, so I agreed. I also asked if he could get me a needle and thread to stitch up my tattered clothes. I'd never seen Boris move so fast. He was out of the cell like a rocket. I climbed onto my bunk and lay back with my eyes closed and a smile on my face.

A poem about Freedman had been forming in my mind on the long walk back from the *talleres*:

What will you be? said the teacher to me A commercial artist, said I I've seen better than you that did not make the grade But you will when the piggies can fly Oh, where are your piggies, you silly old man? Say I with my eye to the sky They're still on the ground with your nose-blowing sound But a commercial artist am I, a commercial artist am I

The bugle announced mail call. A string of Spanish names floated up through the open cell door. It hardly seemed worth climbing off my bunk to hang over the railings. I didn't hold out much hope that Mum was going to write to say she'd managed to raise the bail money.

Boris slipped back into the cell and walked up to my bunk. His head was on the same level as mine and I could see little beads of perspiration on his forehead. He dipped his fingers into his waistcoat pocket and silently handed me a chrome watch with a black strap. It looked boring, like my granddad's Timex.

I strapped it onto my wrist, while Boris placed a matchbox on my bunk.

'There's brown and white cotton in there,' he said. 'And a few needles. He wants thirty for the watch, but just give me a five for the sewing stuff.'

Boris watched hungrily as I dealt him a five from my scruffy pack of money. He stuffed it into his pocket and turned away. I found myself thinking: *It's Friday night, I've just been paid and the only thing to do is sew up the holes in my jeans.* The light was too poor to thread the needle, so I lay back in my bunk and tapped a Celtas out of my softpack. Blue smoke rose to the ceiling, as cloudy and twisted as the thoughts in my head. I started thinking about the slum house, but I threw the image out of my mind. I was fed up with all that crap. It wasn't getting me anywhere. I decided I wasn't going to think about it again. Ever.

On Saturday, the big black doors slowly opened and the mild breath of spring seeped into my lungs. The week had been so intense that just stepping out into the yard was like going on holiday.

The wad of pesetas in my pocket pressed comfortingly against my thigh as I walked off in search of a runner to go to the *economarto*.

I scanned the faces in the yard. They were so familiar that

I couldn't help feeling a strange sense of belonging. Mike and Sven were chatting alongside the usual chess crew, and there were guys I recognised from the *talleres* among the sparse groups of smokers. I'd finally accepted that I was a prisoner waiting for a trial, just like everybody else. In fact, I was probably better off than most of the guys around me. So many had lived in the shadow of the garrotte or had been tortured in the *Quinta* by Franco's pigs. It wasn't great being held without trial, but at least I had a chance of buying myself out.

I gave up on finding a runner and sat down with my back resting against the solid Modelo wall. The sky was white, but it wasn't cold. It wasn't anything much. Just me and a bunch of friends hanging around a yard.

I closed my eyes and thought back to the dream I'd had last night. It was so achingly beautiful that I'd woken close to tears.

I was lying in a gutter in the shadows of a cobbled street. It was growing dark and I was young, cold and lost. There were no stars in the twilight sky, but I could see something bright coming towards me over the silhouetted rooftops. As it got closer, I saw it was a round sphere of clear glass with a shiny metal base. It was a small spaceship, and standing inside like figures in a snowdome, were a man and a woman. I instinctively knew that these were my real parents and that they were coming back to find me. What made me feel like crying was that I knew they loved me and that they would rescue and look after me. It was the most beautiful experience I'd ever had, and the feeling stayed with me, giving me peace and comfort as I sat in the grey yard.

I picked up a single stone and threw it into the dust. What had the dream meant? The emotion was so strong that I desperately wanted to believe it was somehow true. I'd never felt love from my mother since the farm, and my father had taken away his love without a word of goodbye, never to return. The previous night I'd vowed never to look into my childhood again, but now I had to. My past was as much a prison as Modelo. The walls were just as strong and I didn't have a key. It was hard enough getting out of jail, but how did you escape from yourself?

Back in the cell, it was hard to draw a picture of myself without a mirror. It was even harder with Robert in the bunk below. He shook with anger if he read something that annoyed him, and I had to incorporate the squiggle it made into my drawing.

Thankfully my pen was off the page when Robert bounced off his bunk yelling, '*Bonsoir, mon ami*!'

Mike had arrived in the cell. Boris's eyes flicked up for a moment, then dropped back to his worktable. *Sly bastard*, I thought. I knew he was pretending he hadn't seen him so he didn't have to offer to make tea. I was struggling with my self-portrait, so I got up and put the stove on.

Mike whistled appreciatively as I pulled out the orangebox to light the wicks.

'Where did you get a can that size?' he said, throwing me his Zippo.

I checked my reflection in the chrome surface of the lighter. 'It's a pie-tin. Paco got it from home.'

Mike unfolded his chessboard and tipped out the pieces on the tabletop.

'It's amazing what you can do with an old pie-tin. That's how the whole frisbee thing got started.'

I wasn't too sure what a frisbee was, so I just lit the wicks and said, 'I built my first guitar with a Fray Bentos pie-tin when I was a kid.'

'No kidding?'

'Yeah. I made the neck on the grinding wheel in my granddad's shed and drilled holes in it for the tuning pegs.'

Boris looked up from the table balanced on his knees.

'What did you use for strings?'

'Different weights of fishing line. It made it easy to play because each one was a different colour. The first tune I got out of it was "D'Ye Ken John Peel?"

Boris's eyes burned.

'You should make a guitar in the *talleres*. I could get you a *Gran Corona* cigar box for the body.'

Robert stopped lining up his chess pieces. 'No way! We 'ave enough noise in here wis you.' Boris jumped to his feet with his fists clenched. For a moment I thought he was going to smash up the chessboard, but he just gave Robert a stare and stalked out through the door.

Peace descended and we drank our tea. The only sounds were the occasional flick of a page, the slow, uncertain slide of a chess piece and the scratch of my nib as I crosshatched the shadows on my face.

It still wasn't going well because my reflection in the side of Mike's Zippo was blurred. I'd drawn my calloused hand squeezing a giant pair of scissors to cut a hole in the fabric of reality. Floating inside it were sepia photographs of past memories. Some were hidden, like corpses in a lake, but I knew that they had to surface sometime.

I got out my brown crayons and started to colour in the stoned photo Hanna had taken of me just before we broke up. Suddenly a huge explosion lit up the night outside our window. A rapid burst of gunfire followed.

We clambered up onto the top bunks and stared through the bars. Seconds later the black sky was streaked with rocket trails and multicoloured starbursts. They looked beautiful, but it was a big let-down that there was no revolution. We were slowly dropping back to the floor when Robert started jumping around the cell. He was yelling his head off:

'Franco est mort! FRANCO EST MORT!'

Larry joined in, a huge smile across his face. I didn't get what the fuss was about, then I realised there was bound to be a huge amnesty if Franco died. That meant we might all be free. A rush of elation flooded my body as I stared into Robert's wild eyes.

It didn't last. Mike held up his hands and shook his head.

'Sorry to disappoint you guys, but they do this festival every year.'

He lowered himself back onto the bunk with a sigh. 'I had exactly the same thought the first time I heard it.' We all shut up. None of us had been in Modelo long enough to have heard it twice. I got back to my self-portrait. A white coffin hung from my withered wrist with a pair of eyes peeping through a window in the lid. The image was supposed to symbolise being held without trial. It was a bit obscure, but I was pretty sure Mike would get it.

The bugle blew before I could show him and Mike got up to leave. He frowned at the half-finished chess game and held up a finger to Robert.

'I'll know if anything's moved.'

'Putain de merde! What do you take me for? A criminal?'

Mike left with a grin as the doors began to slam in the distance. ' $O\dot{u}$ est Boris?' asked Robert. We stared at the door as the metal wave came down the gallery towards us. At the last second Boris swung around the corner, just before the steel door crashed into the frame behind him.

'*Mon dieu*!' whispered Robert as Boris flattened himself against the wall. I looked at his heaving chest and thought it was no wonder they kept sending him to the *Quinta*.

Boris slowly opened his eyes and walked unsteadily towards my bunk. He reached inside his shirt and brought out a decent-sized cigar box.

Well! here we asserthen! 9 This, Braying backet ball, the sun is stong sitting, watching churs grains, talking lowe ver wind Thes new, Fo To memories turning a new week Santino cvect gin buon dimon a nele e eu & This bids us away

'This,' he said, 'is for free.' His steely eyes looked into mine as he handed me the wooden box.

'Let's see what you can do with it.'

The green numbers on my new Timex glowed in the dark cell. The watch kept lousy time, but for a moment the luminous circle brought back the magical pleasure of my first watch. It didn't last. The thoughts I'd managed to suppress during the day crept back into my mind like shapes coming out of the forest. That's what my self-portrait was about: the huge scissors cutting open the past, releasing the memories that I'd hidden for years. Now I couldn't stop them.

I turned on my mattress towards the dark corner of the cell, and was back in the shadows of the chauffeur's sunken kitchen. I didn't like the blotchy blue butterflies he had tattooed on his knees. And I didn't like the wheezy way he breathed when he did it, or the long, messy cleaning up of the Vaseline. But the real reason I didn't like it was because it was all my fault. I'd really thought he was going to kill me when he started it in his car, but it didn't stop me going back. I was eleven years old and I really wanted the money. I didn't care what he wanted to do. What I liked was the silver tower of coins hidden in the corner of his piano stool. At the base were heavy half-crowns, embossed with royal heads and heraldry. Stacked above them were the knurled edges of florins, with a slim pile of shillings on top.

Every morning on the way to school, I bought a sixpenny double-pack of Cadbury's Bourneville chocolate. The two thin bars were wrapped separately in gold foil and lasted almost the entire walk to Harehills School.

I ate well for the best part of a year before we got found out.

I rolled onto my back, keeping my eyes shut to block out the shadow of the bars.

When the chauffeur story came out, I lost all my friends. One of them kicked me in the balls and the rest never spoke to me again. What did it mean? Maybe it showed that I needed a father figure. Or maybe it just meant that I would do anything for money. Like selling drugs.

I turned to the wall again and thought, *No wonder I got arrested*.

I started to feel sleepy and I hoped I would be taken back to my beautiful space parents. The lovely feeling was still there. In fact, it was so strong that I knew it would stay with me forever. It was strange to think that a dream could be more real than life itself.

It was Wednesday morning. Paco looked pale and pastyfaced as he shuffled his chair forward. I pressed against his black poncho so my Levi jacket wouldn't scrape whitewash from the disintegrating wall. All the clothes I owned were either patched, frayed, streaked with ink or covered with dust from the yard and the *talleres*.

Paco perked up as I slipped the large cigar box out of my jacket.

'You have a parcel from home?'

'No. I'm going to make a guitar.'

Paco's question made me realise that none of my family had sent me anything. Mum had given Jeremy my address, but he hadn't even sent me a postcard – and I'd spent months looking after his kids just before my arrest. I didn't care. There was work to be done.

I set up my drawing board and took out my pen in case Louis came round, then reached for a pair of compasses. There was a pattern of tobacco leaves burnt into the lid of the cigar box and I drew a circle for the sound-hole in the centre of it. Then I made a mental checklist. I needed a piece of wood to strengthen the body, nails to secure the strings and a length of wood for the neck. I also needed dowel for the tuning pegs and a few bits of hard olive-wood for the nut and the bridge.

There was no sign of Louis. I hid the box in my jacket and rehearsed the Spanish for 'piece of wood' as I walked over to the carpenters.

'Un pedazo de Madera, por favor'.

The carpenters had everything I needed except strings. Rafa gave me an ancient fret saw that looked like a lyre. It had a string tourniquet on the frame that pulled the blade taut. I twisted the wooden ratchet to decrease the tension so I could slip out the blade. Then I pushed it through the hole I'd drilled in the cigar box lid and hooked the blade back into the frame. I kept checking my watch as I sawed out the sound-hole so I could time my return to the *talleres* with the arrival of the *pasta* guys, but either they were early or the watch was late, because the distant cry of '*Pasta*!' took me by surprise.

I stuffed the box inside my jacket and sneaked back just as the rush for hot water was easing off. It was a risk to stray from my post for too long in case a guard came to take me to my lawyer, but that didn't seem too likely. I'd heard nothing to confirm my trial in May and, judging from past experience, that particular carrot was dangling from a very long stick.

Boris looked up from his worktable as I came into the cell at siesta.

'How did it go?'

'I made a good start. The problem is the strings. There's no nylon line in the *talleres*'.

Cogs ticked in Boris's brain as he frowned into his monocle. 'I'll see what I can do.' Larry offered to make tea and Boris wheeled out his usual response: 'If there's any left over, I'll finish it off.' Boris was a lazy git. He only said that so he wouldn't have to make tea in return.

I watched Larry drop teabags into the pan. He didn't look like a New Yorker – he was tall and bony, with frizzy hair that looked like a perm. His lips curled too; they stuck out under his long nose like a Roman statue. I'd been dying to find out if he'd ever run into the New York gangs, but when I finally asked him, he shook his head.

'Not really, there were some gangs around, but we knew where they hung out so we didn't go there.'

I was disappointed. I'd expected him to have scars and scary stories. 'So what did you do before you came to Spain?'

Larry neatly lined up the beakers. 'Not much. I worked in a bookstore to get the bread together for the trip over here.'

'Sounds better than working in a zoo. So how did you end up in Modelo?'

Larry smiled ruefully as he poured out the tea. 'Man, it was so dumb. I'd been living with this bunch of guys just off Las Ramblas for a couple of months. We were off our heads most of the time and we just got careless. The cops busted the flat in the middle of the night and they found my stash.' He passed me a beaker of tea like it was a full stop to the conversation. 'So how was life in the zoo?'

'Pretty good. But it was shit for the animals. They were just like us. All they wanted to do was get out.'

Boris interrupted me.

'Many animals prefer being in zoos. They have no stress from predators and no fear of starvation.'

I'd heard that crap before and it really pissed me off.

'You might think that if you just went for a day. When I first

worked at the zoo it seemed like a happy place with all the mums and kids and everything, but after a while I noticed the strange behaviour of the animals. They all had nervous tics, or they acted weird, or just paced up and down their cages. It was only when you got to know them that you realised how miserable they were.

'But how do you *know* they don't prefer it to the wild if they can't talk?'

"Course they can talk! They just don't use words. Listen. Once I watched this orang-utan use a stick to scrape out the cement between the concrete blocks on the floor of his cage. They were so big that it took him days to get one loose. A whole crowd of people stood there watching him pull it out. Then he rolled it towards the fence like you do with a heavy box." I was finding it hard to keep the emotion out of my voice, but I carried on. 'He picked it up and threw it so hard it made a huge dent in the wire. I wanted him to smash open the cage and swing away through the trees, but the keepers rushed in with sticks and shoved him back into the lock-up.'

Boris was fiddling with a watch, but I knew he was listening. So were the others.

'The thing is, he didn't *need* to talk. It was obvious he wanted to escape. He knew how strong the fence was – that meant he had to find a powerful tool to break it. He sussed out that the concrete blocks were stuck together, so he used another tool to get one out. Then he used the block to get himself out. If that doesn't tell you he'd rather be free, *nothing* will!'

My outburst had surprised me, and my fingers trembled as I undid the crappy watch from my wrist. I was going to give it back to Boris, but I didn't trust my voice to speak. I took my tea to the doorway so I could listen out for mail call. The whole zoo thing had been going around my head for weeks. Dad had never taken us to zoos because he hated them. I admired him for that and it was one of the reasons I felt guilty for working there.

I was so deep in thought that I almost missed the town crier calling out his weird version of my name. My tea splashed onto the stairway as I rushed down to the mailroom, wondering what karma had in store for me.

The blue airmail letter had 'Stella McLellan' typed on the back and the postmark was 8 March. My nervous fingers unfolded it as I walked back up the iron steps. I nearly fainted when I read the first line:

Delighted to be able to tell you that we can raise the \pounds 350 for your bail...

It was followed by a *BUT* in capital letters, but there was no obstacle in the world big enough to stop me going for bail. She wrote that the consul advised waiting for the trial in May in the hope that they might free me; it was up to me to decide. I'd spent so many nights worrying that the cop I'd kicked was going to get a brain haemorrhage. I didn't want to hang around a second longer than I had to.

I stopped at the top of the staircase and looked down on the crowd of prisoners in the gallery below. It seemed madness not to take the chance of freedom now that I'd got it. I turned and headed back to the cell.

Larry glanced up as I hauled my suitcase from under Robert's bunk and yanked out my notebook. He said, 'Good news?' as I perched on the bog with my case on my knees. I thought it would tempt fate to build it up, so I just said, 'Sort of...' and left it hanging.

I scribbled a simple note, asking Mum to send the money to the consulate as soon as possible. Then I took my letter straight down to the mailroom.

Larry didn't look up from his book when I came back into the cell. I climbed quietly up onto my bunk, feeling bad for not sharing my news. But rereading the first line of Mum's airmail letter sent all other thoughts right out of my mind.

Delighted to be able to tell you that we can raise the £350 for your bail.

After the disastrous plans I'd made with Daisy, it was great to have one that looked like it might actually work.

I flipped to the end of the page. She'd signed it: *Your affec. Mother Stella McLellan*. It just seemed so cold. She had never been able to tell us she loved us when we were kids, and she couldn't bring herself to write it now.

A flash of luminous green in the dark cell reminded me that I had to give Boris his useless watch back. I needed all my money for more important stuff now. Alan Watts was right when he said that life was an ever-changing mixture of everything. Everything was changing, and now that paying my bail was a reality, three hundred and fifty quid suddenly seemed like a huge amount of cash to pay back. There was enough money in my wallet to get me set up in Switzerland – unless the bastards had ripped it off – but I could always hitch and busk if all else failed. The main thing was to find out if I'd be allowed through the border under bail or if I'd have to go through the mountains. By the time the moon was up, I'd been through every option I could think of, but I was still too wired to sleep.

Thoughts of my childhood began to creep back into my head, but I didn't need to go there anymore. As far as I was concerned, the past was history.

The next morning, I spotted Boris in the yard and gave him his watch back. He didn't look happy about it.

'Señor Ferrer thinks you are going to buy it.'

'I don't want it.'

Boris pulled a face. 'But you kept it a long time.'

I looked around the sunlit yard. 'Where is he?'

Boris led me to a respectable-looking man standing in the gallery doors like a vicar waiting to greet his congregation. When we arrived, he started rattling away in Spanish.

I said to Boris, 'Tell him I only held onto the watch to see if it kept time. It didn't, so I don't want to buy it.'

Señor Ferrer's face hardened as he listened to Boris's explanation. At the end he looked more Mafia than minister.

His voice had hardened too. 'No, señor'.

Boris said, 'Sí, señor'.

'No, señor,' came the immediate response.

'Sí, señor'.

'No, señor'.

Prisoners watched as they constantly repeated themselves. It might have been funny, but I couldn't afford to spend money on a watch now. Eventually I tapped Boris's shoulder and said, 'Look, the watch is useless. Just give it back to him.'

Boris pulled the Timex out of his waistcoat pocket, but Señor Ferrer held up his hand, '*No, señor*!

Boris said, '*Sí, señor*!' and the whole thing started to get heavy. I had to fight down the desire to grab the watch and shove it into the bloke's pocket, he was being so stupid.

'No, señor!' 'Sí, señor!' 'No, señor!' A crowd began to form

and somebody behind me grabbed my arm. I turned round. It was Mike.

'Hey, you're wanted on the basketball court.'

I reached into my Levi's pocket for my pack of Celtas as Mike dragged me away. It was a relief to be rescued. I offered him a cigarette and Mike stopped to flick open his chrome Zippo. I liked that: Celtas always tasted better when they were lit by the oily flame. Mike's face creased like a cowboy's as he drew in the burning black tobacco.

'So how's the new apartment? That's quite a team you've got in there.

'It's like being in a cage full of monkeys, but like Alan Watts says, you have to accept the reality that surrounds you – there's nowhere else to go!'

Mike smiled as he blew a cloud of smoke into the sun.

'Yessiree. There's no time like the present.'

'You know all that writing I was doing about the past? I've stopped it now. It wasn't getting me anywhere.' That wasn't strictly true. I'd only stopped thinking about the past because I had a chance to get out. Mike's dry tones broke into my thoughts.

'Yep, the past is a tough territory – but that's what shapes the future.'

My mind had been fixed on the future ever since being promised the bail money. I should have told Mike about that right there and then, but I didn't want to jinx it, so I just said, 'The problem is, the past is such a mess. It doesn't make any sense.'

Mike nodded as he took a slow drag on his cigarette. He stared into the distance for a moment, then continued walking, with me following in the trail of his smoke.

We reached the sideline of the basketball game. Mike finished his cigarette, then ground out the stub with a twist of his shoe. He pointed to a group of players running around in a tornado of dust. 'That's the past right there,' he said.

'How do you mean?'

"That's where you were when you first came in. You couldn't play a lick!"

I smiled at the memory of how weak and useless I'd been. Mike continued: 'But you kept right on trying, and look at you now – you're a star!'

I certainly wasn't a star, but at least I could play. Mike patted me on the back.

'The thing is, the shape you're in now is due to what happened in the past.' I was about to tell Mike that it wasn't that simple when I noticed Raoul beckoning me over. Mike put his hand on my shoulder.

'Sometimes you have to go backwards if you want to go forwards. That's what the old reversed effort is all about.'

Mike's pat on my back turned into a push and I found myself in the basketball game.

Crazy Bob was running all over the bumpy yard, waving for the ball. Somebody threw it to him and his red shirt billowed in the breeze as he bounced the ball through the hazy crowd of players.

I suddenly realised what was different about the day. It was warm. The mild spring sunshine felt pleasant on my skin and the thought of leaving Modelo as summer was beginning was so enticing that I almost gave in to it. I quickly thought: *Wrong*! *Wrong*!

Mike was right about the reversed effort thing – it was a game of opposites. Gardening was a bit like that. If you wanted something to grow, you had to cut it back. I waved to Bob for the ball, as though playing basketball in prison was the only thing I wanted to do in the whole wide world. Monday morning came and went. I'd heard nothing from Mum or the Consulate about the bail money and the days were slipping by.

It didn't bother me too much in the morning. The moment I sat down at my drawing board I entered my own world. I'd started to draw Samson pulling apart the pillars with his chains. I grew absorbed in shading the crumbling masonry as it fell onto the fleeing crowd and didn't look up until I heard the familiar husky shout:

'Pasta... calentita, calentita, calentita!'

The pieman took my blue five and handed me a sugary pastry from his tray. I glanced past the guard, through the wire grill of the *oficina*. Louis had his head down over his books so I headed for the coffee corner – but instead of stopping, I kept on walking to the carpenter's workshop.

Rafa mimed playing a guitar when he saw me pull the cigar box out of my jacket.

'Is berry good!'

I held up my pastry and worked out the Spanish for Yes, but this is better: 'Sí, pero esto is mejor!'

We both smiled. At least I'd learnt something from Gunter.

I clamped the guitar neck in the vice and borrowed a spokeshave to shape the curve into the headstock. It reminded me of making the neck for my first guitar in my granddad's shed. I loved being alone in its quiet atmosphere, among the neatly arranged and oiled tools. A soft light shone in through the dusty window, illuminating the hand-cranked sanding wheel. The first thing I'd made on it was a boat, grinding a smooth, pointed bow and a round stern on the ends of a piece of firewood. It was the janitor at the children's home who'd kindled my interest in woodwork, but reading Bernard Malamud's *The Fixer* had taken it a stage further. It was about a handyman who'd been wrongly put in jail, but still managed to look back on his life and work out his problems.

I'd set the blade so only a fine curl of wood came off with each stroke. I didn't want to carve away too much in case the neck warped under the tension of the strings.

Malamud's book had inspired me. It showed that fixing things was as much about mending a part of yourself as making a repair. Only that wasn't working for me. Whenever I tried to work out my problems, it seemed as if I was looking for an excuse for the way I behaved.

I undid the vice and began to sand down the neck. First with rough paper, then with fine, like we'd used to do at school. It was funny – if I'd shown the same interest in exams as I had in woodwork, art and music, I probably would have gone straight to art college.

I went to find a drill bit to fit the dowel Rafa had given me for the tuning pegs. The thing was, I'd never liked senior school. I was the same height as Jack, who was three years younger, and the big boys picked on me. That was part of the reason I'd started to nick off school. Was that an excuse too? Probably. The swots got bullied, but they didn't play truant. They came top of the class.

I drilled four holes in the headstock, then decided I should head back before Louis noticed I was AWOL. A final thought occurred to me as I sneaked into the busy workshop. I hadn't liked going to school because I was scared of being beaten. The problem was, I didn't like going home for the same reason.

Back in the cell my wrist almost gave way as the ladle

slopped a heavy lump of *lentejas* into my hubcap. The lukewarm sludge was as grey as the metal, but at least it was edible.

I climbed up the cold bars of my bunk, still thinking about school. Jack had once told me he'd tried to break his leg on the steel bed frame at home because he hated school so much. That had really shocked me – because I'd deliberately jumped across the gap between our beds trying to do exactly the same thing. It wasn't surprising that the long shadow of Harehills County Secondary School seemed to hang over everything. It even hung over the summer holidays.

I could still picture Mum in her armchair, tearing four purple sugar-paper tickets from a fat roll. They looked like tickets for the pictures, but they were for free dinners at the old Annexe building – enough for the whole summer. It was like having to go back to school every day

Jeremy held out his hand and Mum counted out eightpence from her purse for our bus fares. Then we left. But we didn't go to the Annexe. We'd been there once and that was enough. It was a Victorian block set in sloping waste ground a few bus stops past the boarded-up Gaiety Kinema on Roundhay Road.

The Annexe was packed full of hard kids. They could tell we were different and continually picked fights with us. We couldn't run away because we had to look after Issy, so instead we vowed never to go back there again.

One thing was certain: Mum must *never* know. Not only would we be in big trouble, but we'd also be forced to go back to the Annexe and get beaten up there too. We worked out a plan to spend our bus fares on lunch and find somewhere to hide during the day. We'd just have to agree in advance what we'd had for dinner at the Annexe, in case she asked. I suggested the abandoned workshops at the wood yard because nobody would be able to see us from the road. We bought four narrow bags of KP Nuts from a corner shop and scoffed them as we picked our way across the rubble of the bombed-out houses.

One by one we squeezed ourselves between the huge, sagging, rusty blue gates. Then I led the way through the jungle of tall weeds that grew out of the cracked concrete in the junked-up yard. Issy caught dandelion fairies while I pointed out a door right at the top of the high factory wall. Smiggy had told me that a kid had run through it to get away from a gang, thinking it led to another room. Miles below it was the smashed skylight he'd fallen through to his death.

Unseen pigeons fluttered above us as we entered the ground-floor workshop. Most of the machines had been taken away, leaving big rusty bolts sticking out of the floorboards. We padded up a wide wooden staircase, soft as a carpet with years of dust. The next floor was almost identical except for an open trapdoor in the middle of the huge space.

Issy stopped.

'I don't like it here. It's scary.'

Jack held her hand.

'No it's not. Wait till you get to the top. There's a surprise.'

We walked past partitioned offices, crunching over the glass from their smashed-out windows, half-hidden under layers of ancient pigeon shit. Each level had an open trapdoor in the middle, but when we got to the final floor there was a huge mechanical winch next to the square hole, its thick rope coiled around a cast iron wheel. You could tell it still worked because parts of the rusty metal were shiny. Issy eyed it with disgust. 'Is that the surprise?'

I told her to wait and see what it did. Not that I knew exactly. Smiggy had told me you could drop down it on the rope and that it had a brake, but he had no idea how to use it.

We shuffled closer to the trapdoor and peered over the edge. The drop through the doors made me feel sick. It was like one of those films where the goodie and the baddie roll around it fighting. Jack was all for going down, but Jeremy studied the gears and put on his posh school voice:

'Theoretically you could, but if it slips into freewheel, you'd go at a hell of a speed.'

Jack pumped a lever with his foot.

'Yeah, but you just put the brake on.'

'True. But if it jammed, the rope would stop and you'd keep going.'

I imagined my hands burning as I tried to grip the rope, then falling, hitting all the trapdoors on the way down. Issy turned her nose up. 'You're not getting me on that thing.'

'The best thing to do is to test it with a heavy weight,' said Jeremy. We were about to search the workshops when Jeremy stopped, his head on one side.

'Can you hear something?'

'No.'

'Hang on... No - it's only the pigeons.'

We felt okay for a while, until there was another noise like distant footsteps. Issy gave Jack a worried look, her brown eyes magnified by her glasses.

'There's somebody in here,' she whispered.

She was right. Now we could hear low voices and people banging about. I looked around the empty factory. There was nowhere to hide and the only other way out was a single door – and we all knew where *that* went. The voices grew

louder and deeper. It was a gang of big kids, and they were coming up the stairs.

It seemed stupid just to stand there by the winch, but there was nothing else we could do. We stared helplessly as their heads appeared over the stairwell. They didn't clock us until they got right to the top. Then they went quiet.

There were about seven of them. A big lad with dark hair walked towards us, cocking his head as he spoke.

'What you doing here?'

'Nothing,' I stammered. 'We were just going ...'

The lad got closer and the gang followed him. He shook his head. 'No you're not. This is our place, this is.'

Jeremy said quietly, 'We were only looking. We didn't know...'

Somebody shouted, 'Shut it!' Then they all started talking at once. We bunched into a tight group. It was pointless running for it with Isobel. The big lad shouted at the others to shut up. Then he turned to us.

'Right. You're going down winch. Who's fust?'

We looked at Jeremy. He'd turned pale and his voice had gone really polite.

'Look, we're really sorry. We didn't mean any harm. Can't we just...'

The big lad butted in,

'What've you got?'

'Sorry?'

'How much have you got on you?'

Jeremy looked close to tears. We'd just spent all we had. 'Nothing.' The lad looked around in disgust and then turned back to us.

'I'll tell you what – if your young 'un can beat our kid, we'll let you off. If he can't, you're all going down. Right?' We looked at Jack. The kid was much bigger than him, but Jack just shrugged. 'Okay.'

The kid lumbered across the wide floorboards with a halfsmile on his face. He planted his legs apart and put up his fists up.

'Cum on then.'

Jack let go of Issy's hand and walked towards him. His arms were by his side, but his fists were clenched. I hadn't noticed until then just how thick Jack's wrists were. The gang leader stuck his arm in the air.

'No kicking or biting, all right? Go on!'

Jack immediately waded in with his arms pumping. We were as surprised as the kid, who staggered backwards under the barrage. He started punching back, but it didn't make any difference to Jack. He just ploughed into him, thumping the kid's head from side to side.

Somebody yelled, 'Get hold of him!' and the kid grabbed Jack in an attempt to stop the blows. Jack wrestled him to the ground and kept punching him as they rolled over the floor. We got glimpses of the kid's squashed face, dust sticking to the blood.

The leader strode in and pulled Jack off before he killed him.

'All right, lad. You've done enough.' Then he glared at us. 'And you can fuck off, the lot off you!'

We scuttled away before they changed their minds, and didn't start giggling until we were well out of the gates. By the time we got home, we'd rehearsed the day's menu until it was word-perfect.

The memory made me feel good. Jack was magnificent, like a hero. But I'd never told him that at the time. He was my younger brother, so I always had to be better than him. I made a mental note to tell him when I got out. I made a note of something else that had just occurred to me. Jack had fought because he was brave. I fought because I was stupid.

20

UNDERGROUND

I'm a joker, I'm a smoker I'm a midnight toker Steve Miller Band

Boris was perched up on his bunk when I stepped into the cell from the *talleres*. Usually he remained aloof, but this time he looked down from his toadstool mattress as though nothing had never happened.

'How is the Stradivarius coming on?'

'It's nearly done, but I can't try it out till I get some strings.' Boris swung a tatty nylon shopping bag over his bunk bars and held it before my puzzled gaze. He shook it impatiently.

'It's for the guitar. For the strings!'

I looked more closely at the frayed edges. The bag was made up of fine nylon fibres, like fishing line. I thought, *He may be mad, but he's a genius.*

Boris bubbled with enthusiasm.

'You can plait them into different weights. Strip them out and I'll show you how.'

I sat on the edge of Larry's bed, twining the fibres together while I listened to the mail call. Boris's enthusiasm had ccst me 10 pesetas, but it was worth it. A twinge of paranoia twisted my stomach when the call ended abruptly with nothing from Mum. I brushed the feeling away by thinking, *Mañana, mañana en España*. That was true of everything in Modelo – I was still waiting for Mike to fix the cracked barrel of my pen. Minutes later, El Motherfucker himself appeared in the doorway.

Instead of coming in, he beckoned down the gallery. We watched as two newly-shorn hippies shuffled inside. They looked around our cell in their colourful shirts as though they'd just entered the Underworld.

Mike followed them in with an unshaven smile.

'Hi, fellas. I'd like you to meet Pete and Jake. They're from my part of the world. This is William, Larry and Boris up-top. And that's Robert the French holed up in the bunk under there.'

Robert waved his paperback at them and Larry stood up with his hand held out.

'Good to meet you. Would you like some tea?'

Larry took the fruit bowl off the orange-box to light the stove. Mike grinned as the hippies watched in mystification, then he came straight out with the big question:

'So what did you guys do to get yourselves busted?'

Pete shrugged his shoulders. 'We was ballin' on the train.'

Robert snorted from behind his book, and even Mike was surprised. 'Say what?'

Jake shook his head as though he couldn't believe it himself. 'That's all we were doing, man. Ballin' on the train.'

Jake leaned on the bunk with a sigh. 'We'd been picking grapes in France and when we got paid they gave us a bunch of free wine.' He smiled ruefully. 'Then we got on a train to Barcelona and found these two chicks in a compartment all by themselves.'

Pete chipped in from the doorway.

'Jake offered to share our wine if we could share their carriage. It was so cool. There we were, drinking the best wine in the world with two great-looking chicks!'

Mike asked Pete where the girls were from. I was interested too. I'd almost forgotten what girls were like. Pete shook his head with a half-smile.

'They were West Coast, man. They were far out.'

I imagined two blonde California girls like the ones in the Beach Boys song while Jake continued the story.

'By the time we'd crossed the border, we were getting on real well. Pete pulled down the blinds and we started getting it on.'

The cell rang as Pete stamped his foot. He was actually wearing cowboy boots. The heels sloped right back like Freewheelin' Franklin's.

'The guard came in to check our tickets and he totally freaked out. Jake told him to cool it and come back later.'

'But he was really pissed,' said Jake. 'I mean, we didn't know we were doing anything wrong. We were just having a good time.'

Pete took over. 'When we got into Barcelona there were cops all over the train. It was really heavy. They dragged us away in handcuffs like we was criminals.'

Larry asked Pete what happened to the girls.

'They got them too, man.' Pete shook his head. 'They treated them like they was hookers – they're in a women's prison right now.'

I stopped plaiting the strings and asked what was going to happen next. Pete shook his head and said, 'We have to go back.'

'Back where?'

'To the place of penetration.'

Robert laughed into his book and even Mike couldn't hold back a smile. 'To *where*?'

'I kid you not. We have to be tried at the actual place of penetration. They kept trying to find out the nearest town the train was passing through when the crime was committed. When they work that out, we'll be taken back there to stand trial.'

Mike grinned at Robert.

'They seem to be showing a very unhealthy interest in the circumstantial evidence. Still, that's Catholics for you!'

Robert swore in French.

'What do you think we'll get?' said Jake. Mike tipped his chin up and scratched the blond stubble on his neck. 'Not long. It's lucky you were only drinking wine. They took your wages, right?'

'Yeah - what's gonna happen to all our bread?'

I knew exactly what would happen to it. 'They took my money too. The idea is, they hold us without trial so we'll use it to bail ourselves out.'

Jake looked puzzled. 'So how come y'all still here?

Mike laughed. 'Because we don't have enough money.'

'Fuck - that's evil, man.'

Larry nodded. 'Yeah, life is like a shit sandwich – the more bread you've got, the less shit you have to eat.'

Everybody went quiet. I felt bad because I hadn't told anybody about my bail money, but it was too late to bring it up now. The silence was broken by Mike as he passed a beaker of tea to Jake.

'Don't worry. They'll probably fix your bail at the same amount as your wages, then you'll be out of here.'

'You really think so?'

Mike smiled back. 'Is the bear Catholic ...?'

The bed springs echoed as Robert kicked his bunk. '*Putain de merde*! Stupid hippy shit!'

The next day I stood by the doorframe, listening intently to every word the town crier bawled out. You got a good view from the top gallery. The bright shirts of Jake and Pete stood out as their cowboy boots clanked down the grey zigzag stairway, probably heading for Mike's. I would have joined them, only I was desperate to find out if my bail money had been paid.

The day had been good so far. My drawing was getting faster and better, so it was easier to find time to sneak into the workshop to finish off the guitar. I'd fixed on the bridge and was only waiting for the varnish to dry so I could attach the strings and try it out.

Suddenly I heard my name being called. My stomach knotted up as I rattled down the steel staircase into the noisy Spanish scene. The trustee handed me a single airmail envelope. It had Mum's name on it, and I ran back up to the cell, almost tripping over Larry who was lighting up the stove.

He leaned back as I vaulted onto my bunk.

'D'you wanna coffee?'

I could hardly speak. 'No... no thanks.' My fingers were trembling so much that I would have torn the thin blue paper to shreds if it hadn't already been opened by the censor. I scanned the closely typed page to see if she'd got my letter. She had, but then I read: *I* don't know quite how to tell you this, but *I* am not sure if *I* can raise the money again.

What did she mean – *again*? She'd had the money two weeks ago; why didn't she have it now?

I read on. She'd phoned the Foreign Office to tell them she'd raised the bail money and asked if she should send it. They'd called back to inform her that they'd had a telex from the consul – apparently I'd decided to wait for trial.

But I'd only decided that when I'd heard she *couldn't* raise the money. Why hadn't she waited to hear from me?

The letter shook in my hands as I read on. She'd given everyone their money back. I stared into space in disbelief. Either there'd been a communication breakdown, or my mother just didn't want me to get out.

It was like the time I'd moved into a flat with Daisy, on my sixteenth birthday. I was desperate to leave home, but she didn't want me to go – probably because she could claim benefit if I stayed. One day I came back to paint the outside of her upstairs window. When I'd finished, an idiot friend of hers wouldn't let me back inside. I tried to pull up the window, but he slammed it down on my fingers and I fell backwards, landing on the railing stumps on the low front wall.

I hadn't been able to work for months with a broken arm and damaged hip. Mum had filled in my sickness benefit form. Instead of putting my new address, which meant they would have paid me full sick pay, she put her own address, which meant that only a small maintenance allowance was paid to her. So I had to move back home. She knew exactly what she was doing, because she spent every day helping single mothers claim complicated welfare benefits. I couldn't believe she was still controlling me, even when I was in a different country.

The doors started slamming through the gallery, sending shockwaves through my nerves with each metallic crash. I looked up as the cell walls closed in on me and the horror began all over again.

* * *

I was in a part of the prison I'd never been to before. I shouldn't have been there at all, but Zorro had found Mike's stove and claimed it was mine. I knew he was just looking for an excuse to beat me up, so I slipped away down a dark stairway instead of following his flowing cloak to the *Quinta*.

The stairs led to a huge old dungeon. The walls were dripping with moisture and crusty chains hung overhead. It dawned on me that this must be the old moat, so I must be close to the outside of the prison. It was a long, curving corridor of stone with gaping sluice gates set in the walls. Damp green weeds were draped over the rusty bars, but they offered no way of escape.

The distant clatter of jackboots started me running, only the floor was so slimy that my shoes wouldn't grip. The cries of the guards echoed around the curving chasm like baying hounds as I pumped my aching muscles, but the damp air was so thick that my legs felt as if they were running in treacle. I realised too late that the footsteps weren't behind me – it had been a trick of the circular moat. The Guardia Civil stomped round the curve in front of me, their wild, glassy eyes bulging under their black plastic hats. I froze in terror. There was no way of escape and I knew they were going to kill me.

I woke up sweating. It was early. A cool breeze was blowing

through the bars and I sucked the fresh air deep into my lungs to slow my pounding heart. What had made the nightmare so horrifying was how real it was – as though I'd been there before. In a way I *had* been there before.

I remembered it well, just as vividly as in the dream. The day after Jack had the fight in the wood yard, we went back to the same newsagent's to buy our packets of KP Nuts. Jeremy shoved the purple sugar-paper tickets down a drain and stamped on them to make sure they were really gone. We looked at the old factories that lined the road as we chewed our salty peanuts, wondering where we were going to hide.

Jack strolled towards the railings on the other side of the road and we followed. Above them was a hoarding on a factory wall with our favourite poster on it. It said:

For coughs and colds take Aspros – you couldn't take anything better.

Jack read it out properly:

'Fuck offs and colds take Arse-pros – you cunt take anything better!'

Even Issy laughed at that one. We grabbed hold of the rusty green railings and looked down. Fifteen feet below us, an industrial sewer ran parallel to the road. It looked like a miniature canal built out of curved York stone. It even had pavements on either side.

The decision was made without a word being spoken. We lifted Issy over the railings onto a grassy bank, then dropped her down the high wall onto the pathway. The water was clear enough to see the curved stones at the bottom of the sewer, but they were lined with dark green slime that you just knew was deadly poisonous.

The sewer was the perfect hiding place. The walls were so high that nobody could see us from the street. We went there every day, and spent the whole summer exploring its mysterious twists and turns. Normally we travelled downstream, our voices echoing through the tunnels we'd discovered and named: Cannonball, Giant's Coffin, Half Mile, the Twins and the Eggs and Bacon. There were tons of them, but one day we got bored and went upstream, towards a low, sinister tunnel we'd christened the Slants.

Of all the tunnels we'd been through, the Slants was the most frightening. It didn't have a path, just slimy cobbles that sloped at a steep angle into the dark water. The bright eyes of big rats shone in the shadows until an echoing splash told you they'd dived in. Then you'd see their V-shaped ripples coming towards you. The water must have been at flood height recently because the uneven cobbles were slippy with mud. We took it slowly, leaning at an angle with one hand on the cold stones of the wall. Going through wasn't too bad. It was the return journey that turned into a nightmare.

We were in the next tunnel along, which had the usual flat paths. When we came round a bend we saw the silhouettes of heads bobbing up and down against the white circle of light at the other end of the tunnel.

We ducked back along the towpath, but the gang had spotted us and began shouting like maniacs. Jack and Jeremy held Issy's hands while I dragged the tricycle that I'd pulled out of the water for her. It was just like the prison dream, with the gang's footsteps and shouts echoing louder and louder behind us. We shot out of the tunnel and sprinted between the high factories. There was no way out so we hit the Slants at speed, slithering along the cobbles with the gang right behind us.

Every now and then our shoes slipped down the slimy bricks into the water, but the screams of the gang were so close that we didn't dare slow down.

Jeremy yelled over his shoulder, 'Leave the bike!'

But it was far too good to abandon, so I kept pulling it through the water beside me. We made it into the daylight and scrabbled up the high wall that led to the railings. Jack stayed back to shove Issy up the bars while Jeremy and I heaved her over from the other side. At that moment the gang burst out of the tunnel.

Jack was halfway up the railings when two big lads grabbed his ankles and tried to pull him down. Jeremy and I held onto his arms, with Jack stretched out like a rope in a tug of war. The rest of the gang were climbing up the wall so I shouted, 'Kick! Kick the bastards!'

Jack started booting out like a maniac and they let go long enough for us to scramble him over and run away.

We'd walked home rehearsing what we'd had for dinner at the Annexe. Our stories had to match or we'd be done for. Issy was amazing. She'd been dragged through a rat-infested sewer, almost beaten up and nearly drowned – but she stood in front of Mum, calm as you like, saying, 'I didn't like the gravy. It was too slimy.'

The smile faded from my face as bunks began to creak around the cell. I wasn't ready to get up. Something had dawned on me and I had to put it into words or I would forget.

It wasn't right for children to spend the whole summer holiday hiding down the sewers from their mother. I wanted to remember just how scared of Mum we were.

21

HASTA LA VISTA

Help, I need somebody. Help, not just anybody. The Beatles

The morning bugle was still blowing as my feet hit the tiles. I lit the wicks of the stove and then carefully placed my bowl of water over the greasy flames. There didn't seem to be a floor-cleaning rota in my new cell and I guessed why – Boris hardly ever did it. In fact, he hardly did anything.

I swung from the bunk bars, mopping the floor while he lay in his pit. He got up just before the guard's footsteps were upon us and swayed next to Larry at the cell door, looking half-asleep. I was angry. If he gave the guard an excuse to come inside, he'd smell the stove and I'd be in the *Quinta*.

As soon as the guard passed by, Boris started pissing into the bog like a waterfall. When I asked who wanted tea, he yawned over his shoulder,

'I'll have some if there's any left over.'

I wasn't having that and asked him again pointedly, but he just yanked up his zip and said, 'Only if you're making some.'

That really pissed me off.

'I'm asking if you want some tea. *Do you want some tea*? Yes or no?'

He sounded sharp, like an old woman. 'All I'm saying is, if there's any left over, I'll have some.'

Something snapped. I was shaking my fist in his face and shouting, 'Last chance! Do you want some fuckin' tea or don't you?'

'There's no need to talk ...'

'I'll talk how I like, you lazy piece of shit!'

The hint of a sneer crossed his lips and I banged him up against the wall with his shirt around his ears.

'You never do *anything*, you lazy fucker. You never clean up and you never make tea. All you do is fuck around while we do all the work!'

One more sneer and I would have smacked his head against the bricks. Only the fear in his eyes saved him. My fists relaxed and he sagged back into his shoes, buttons dropping to the floor. Nobody said anything for the next five minutes. We just mooched around until the bugle blew for the *talleres*. I headed out, then stopped at the cell doorway with my hand on the frame. Mum always said you had to apologise when you'd done something wrong and I believed she was right.

I took a deep breath and forced myself to turn around. Boris was slumped on Larry's bunk.

'I'm sorry, Boris. I shouldn't have done that. I'm really sorry.

Normally Boris was all cocky, but the quiet way he said, 'It's okay' made it sound like he was sorry too. I slipped into the trail of workers on the narrow balcony. It looked even higher than usual and as I crossed the walkway over the gallery floor, it seemed to sway like a rope bridge across a chasm. I held onto the handrail feeling dizzy. Losing my temper had been stupid. It might have sent my chances of freedom right out of the window, bail or no bail.

I clung to one thought: Maybe Mum will get the money together before I do something really stupid.

I knew she wouldn't, but I had to have something to hold on to. Paco must have read my expression as I edged between the workshop tables.

'La última noche...?'

'Sort of. And I nearly punched Boris this morning.'

'Why you do this?'

'Because he gets on my nerves.'

Paco held up his bag. It was huge.

'What you think of my bolso?'

I told him what Louis always said about mine.

'Sí, es un buen bolso'.

Paco gave me a weak smile. 'I think it is a monstrosity.'

He was right. It was awful. It looked more like a cello than a handbag, and probably weighed as much. I couldn't help feeling sorry for him as I unscrewed the top of my Rapidograph.

'It's not that bad.'

Paco shook his head, woefully. 'It is.'

I shook the pen from side to side, until the weighted wire inside the nib began to slide backwards and forwards. Then I wiped the tip on my jeans, adding lumps of dried-up ink to the black lines that were already there. The Rapidograph had done so much work that it was beginning to show the strain. So was I, but as soon as the ink started flowing, I was lost in a bygone age of jousting knights. The outline was the hardest part of the drawing. I couldn't make a pencil sketch on leather, so everything in the foreground had to be drawn without a mistake. I loved the idea that the picture was going to look old and mysterious, as though I was some long-dead artist from the past. I never doubted that a rich American would buy it, and the thought that someone would want to own one of my drawings made me try even harder to make every line sublime and every curve superb.

I strung the guitar in the hubbub of tea break so the guards wouldn't hear me plucking the strings. At the end of the day, Paco watched with a bemused expression as I stuffed it under my jacket. With the cigar-box lid, it looked like it had fallen out of a Cubist painting. I didn't sing on the walk back to the gallery in case it attracted attention to my bulging chest.

What worried me most, though, was how Boris would react after the events of that morning. I was hoping things would go easier with him when he saw what I'd done with his cigar box.

My fingers were on the guitar neck as I stepped into the cell, ready to pull it out and surprise Boris. But he wasn't there. I asked Robert if he'd gone to meet his lawyer. Robert looked over his tatty copy of *Papillon*.

'It is too late for a lawyer because he is back where he belong – in the *Quinta*'.

'No! What happened?'

Robert shrugged his round shoulders.

'Maybe he sold your broken watch to a guard.'

I climbed up onto my bunk feeling it must have had something to do with our fight that morning. I hoped it hadn't turned Larry against me. I was still feeling bad for not telling him about the bail thing. Robert huffed and puffed as I tuned the guitar, using a triangle of plastic from the *talleres* vacuum form machine as a plectrum. There was a sudden creak of bunk springs, then Larry's head popped up over my bunk, a wide smile stretched over his crooked teeth.

'Far out! That looks *so* cool, man.' I smiled back, more out of relief than anything else.

'I've been dying to play it all day. I'm tuning it like the top four strings of a guitar.'

'It sounds great. What you gonna play?'

Robert shouted from below. 'How about something quiet? Like a game of chess?'

'Don't worry,' I shouted back. 'I'm taking it to Mike's!' I ducked out with the guitar under my jacket and threaded my way towards *Primero* gallery. It was only when I got outside Mike's cell that I realised I should've invited Larry along.

Mike looked up from his book as I stepped inside. He'd stuck his picture of the Irish countryside on the wall, and with the books stacked up on an orange-box, the place didn't look too bad. He smiled when I pulled out the guitar with a flourish.

'Ta-da!'

Mike turned it over in his hands and squinted down the neck like an expert.

'It looks like a Spanish version of Bo Diddley's guitar. How does it play?'

I sat on the bunk opposite and started strumming. It sounded like an out-of-tune ukulele, but I managed to get through a verse of 'Blowin' in the Wind' before I dried up.

Mike gave me a grin and a round of applause.

'That was great! It's the first real music I've heard for years. Play some more.' I played 'The Streets of Laredo' because the lonely echo of the Modelo walls seemed to suit the song. Mike listened all the way through with his head bowed. When I got to the end line, 'For I'm a young cowboy and I know I've done wrong', he looked up slowly.

'They used to play that song all the time back home.'

Mike had never talked about home before. I knew it was in Arizona, but that was about it. I strummed a slow chord and tuned one of the strings.

'What was it called, where you lived?'

Mike smiled into the distance. 'Wickenburg. It's an old cowboy town pretty close to Phoenix.'

'Did you have rattlesnakes?'

'Oh yeah. Snakes, coyotes, eagles. We even had an old gold mine. You ever see that film *To Kill a Mockingbird*?'

'Yeah. Gregory Peck was a great Atticus Finch. I loved it when he shot the mad dog.'

'Well, it was sort of like that. All small-town stuff, but it was a great place to grow up.'

Mike tailed off so I pitched in.

'It sounds like Wisbech, my grandma's town. That was really small, but it had a lovely little railway station. We used to go there in a steam train till some idiot closed the line down.'

Mike settled back into his creaky bunk.

'Ours got closed down too. It was a real shame. When I couldn't sleep on a summer's night, I'd hear the whistle blowin' in the distance and wonder what exciting places the train was goin' to.'

'Same here. I could hear the sound of wheels on the tracks coming from miles away and I'd picture the long line of tiny yellow lights speeding through the dark countryside'. The light in the cell was fading fast and the bugle was about to blow. Mike looked up from the shadows.

'Do you know that song that goes "In the summertime when all the trees and leaves are green and the redbird sings"?'

I finished it off: "Then I'll be blue 'cause you don't want my love."

We sang through it together as the cell darkened around us. The song reminded me of *The Black Hills of Dakota* and I thought how homesick Mike must be for his Arizona mountains. We stopped singing when running footsteps outside told us that social hour was about to end.

Mike hurried over to the books on his orange-box table and asked how I was getting on with *The Wisdom of Insecurity*. I watched him rummage through his library as I tried to think of an answer. There was so much I wanted to tell him about how it had helped me, but all I came up with was: 'It's amazing. I can't stop reading it. Especially...'

Mike turned round with a book in his hand. 'If you liked that one, this'll blow your mind.'

The bugle blew as I looked at the cover. It was another Alan Watts: *The Way of Zen*. I felt bad taking it – the books were Mike's bibles. I asked if he wanted the other one back. I was halfway through the door when he replied, 'Not really. I may be leaving soon.'

I tried to stop, but the stream of rushing prisoners carried me down the walkway. Mike leaned out of his cell door and called over their heads.

'They're sending me to the penitentiary!'

Bustling shoulders brushed against me as I headed back up to the *Alto* gallery. That was amazing news, but it was strange too. The penitentiary was where you went to finish your sentence, but Mike hadn't even had a trial. It didn't matter. The penitentiary was more relaxed and it even had gardens.

I climbed straight onto my bunk when I got into the cell. The thought that I might have just spent my last evening with Mike really got to me. I wished I hadn't played 'Blowin' in the Wind'. I'd really wanted to play a verse from 'Chimes of Freedom' – the one with the line: 'And for each unharmful, gentle soul misplaced inside a jail' – but I probably would have ruined it by blushing.

I took out the book Mike had given me. It looked more serious than the last one; there was a chart at the beginning to tell you how to pronounce Chinese words. Out of pure laziness I chose the shortest chapter and began to read. Watts wrote that Zen could only be defined by saying what it wasn't – like the sculptor who takes away pieces of marble to reveal the form within. I liked the analogy. It was how Michelangelo had found his figures in Carrara marble. I tried to read on, but I was too tired to concentrate. I flipped through the pages, guiltily picking out the short poems like sweets. One of them made me stop and think:

The wild geese do not intend to cast their reflection The water has no mind to receive their image

The poem only had two lines, but I got stuck on it for ages, turning it over in my mind like a coin with three sides. The image was both empty and full at the same time. It was so different from anything I'd been taught by teachers or priests or *anybody* that I didn't really know what to do with it. But what I really liked was the complete absence of self. This wasn't trying to tell me about how great some god was or whether something was good or bad, it was telling me something about life, but from no perspective at all. The freedom of thought was as pure and as fresh as the image it evoked.

The next morning Zorro strutted across the opposite walkway as Boris, Larry, Robert and I stood motionless in the doorway like dummies in a shop window. I hadn't seen Franco's little puppet for a while and had been hoping he'd buggered off to write his book about tormenting prisoners. As we waited to be counted, I tried to make sense of the acidtrip dream I'd had last night. It had been like a Technicolor cartoon, set in a Disney jungle, with Mike in a canoe being chased by pygmies.

The sound of Zorro's approaching jackboots jogged me into my seven-mile stare. He stopped dead in front of me and I could feel his eyes on my tatty clothes. I wondered if he knew about my book. He'd freak out if he saw the picture I'd done of him and probably burn it on a bonfire like the Nazis used to do. I decided to take the book into work every day from then on.

The narrow workshop studio looked grey and empty without Patrick's welcoming face. Paco stuck his hand out of his warm poncho when he saw me pull my book from my jacket. He flipped through it like a teacher reading a pupil's essay while I tried to get my pen to work. The cracked barrel clicked as I shook the internal weight. It would be a disaster if it broke down. My job would end, and so would my book.

Paco stopped leafing through its pages when he got to the picture of the suicide guy. He threw up his poncho in despair.

'You have drawn the dead man! They will take your book if they see that.'

'I know – Patrick told me. That's why I brought it here.'

I angled my drawing board under the cardboard lampshade

that I'd made to reflect more light from the dim bulb. The picture of the knights was only half-finished, so I had to work fast. Senor Vendrell wanted to send it to America at the end of the week, and it took a few days to add the antique effect.

The smell of the smooth leather and its soft feel under my pen drew me into the Arthurian legend of chivalry. I'd always loved drawing horses. They were so beautiful and you could tell by their expressions that they were aware of what was going on. I'd drawn one of the knight's lances splintering on the other's shield, and got straight into drawing the little shards of wood exploding over his armour.

I didn't look up until Paco brought me a beaker of hot water when the pasta guys came round. He leaned over to check out my picture.

'This belongs in a museum.'

I smiled and pointed out the yin-yang symbol I'd hidden in the knothole of a tree. Paco stirred his coffee and frowned at me.

'Why you do this?'

'To show that they're forgeries. I've put Tao and peace signs in all of them.'

Paco held up a pompous finger.

'Ah, because you feel... cómo se dice, culpable - guilty?'

'No, I like doing forgeries. Michelangelo started off by faking Greek sculptures, so I'm in pretty good company.'

Paco slurped his coffee and smiled knowingly. 'So *that's* why you want to go to art school: to be the next Michelangelo.'

I couldn't talk to Paco like I could with Patrick. 'No. I just want to learn how to draw.' I rattled my pen and got straight back to my picture.

It wasn't Michelangelo who'd made me want to go to art school. If anybody had, it was Gerry Keon, a guy I used to babysit for in Leeds when I was a teenager. He'd been at Hornsey Art School where they'd had the famous Sit-In of '68. He made it sound so cool that I yearned to go there. Gerry gave me a big book on art that became my bible for years, and he'd also turned me onto some great writers – Baldwin, Salinger, Malamud...

I stopped drawing when Manuel started singing on the production line. Conversation dropped as the other workers listened. Gerry used to say that you should have music playing while you painted because it occupied the conscious part of your brain and let whatever was inside you come out to play. He always asked what bands I was into. When I told him I loved The Byrds' 'Mr Tambourine Man', Gerry pulled a record out of its sleeve. He gave me a knowing smile and said, 'If you liked that version, this'll blow your mind.'

As soon as Dylan sang the first line, I'd had to breathe in deeply to make space for the sudden rush of emotion to my heart.

Somewhere inside me a new door opened and Dylan's vision and poetry flooded in.

When Manuel stopped singing, I sang 'Mr Tambourine Man' as I drew, but it was a weak imitation and I longed to hear the real thing.

The bell rang at the end of the day and the guard watched us shamble out. I hid my book under my drawing board, hoping the workshop wouldn't be searched after we'd gone.

Drawing medieval scenes had pushed my worries out of my mind, but the long trudge back to hard reality soon had them creeping in again. I looked over the high walkway at the spot where the suicide guy had landed. The patch of blood had long gone, but the memory of his fall and the night of insanity that followed sent a wave of The Freak shuddering through me.

I stopped halfway along the bridge and held onto the railings. Now that I'd lost the bail money, everything depended on the mythical trial in May, and I hadn't heard anything about that for ages. If I knew how long my sentence was, I could just do the time and go. But I couldn't bear the idea of waiting years for a trial. The strain had even been getting to Mike. He was fraying at the edges. And that was another thing: Patrick had already gone. If Mike was going too, I didn't know how long I could hold on without punching somebody. Then who knew what would happen to me.

Robert leaned out of his bunk when I came into the cell. 'Did you hear? Mike is leaving any day now.'

I climbed above him, knowing I had to go and see Mike that evening, before it was too late.

The soup bucket scraped along the balcony, setting my nerves on edge. I even hated the sound of rustling straw as I pushed my head into my mattress to block out the squealing metal.

Mike's story about the ruler who wanted to cover his kingdom with fleeces brought back Watts' phrase: The world is what it is and you can't change it. All you *could* do is change your attitude towards it. But even if I could change my attitude, what good would that really do me? I'd still be stuck inside waiting for a trial. Like Watts said: *The present is what surrounds you – there's nowhere else to go*. That was my problem.

As soon as the drunken bugler started to blow, Robert bounced out of his bunk below me. He shouted, 'I have to beat Mike before he goes!' and slipped out of the door.

That was a blow. I'd missed my chance to have a real talk with Mike. I climbed down into the quiet cell. Boris was in the *Quinta* and Larry was stretched out on his mattress reading *Balthazar*.

I wished I'd got off to a better start with Larry. Now that I needed someone to talk to, I didn't know how to begin. I sat down on Robert's bunk and pulled my suitcase from under it. Instead of opening the lid, I read the dust jacket held in Larry's long fingers: '*Balthazar*, a novel by Lawrence Durrell'.

'I had this trippy dream about Mike last night,' I said to Larry. 'He was being chased through a weird jungle by pygmies with blowpipes and spears.' I wasn't sure if Larry was listening, but I rambled on anyway. 'They kept aiming at him, but he never got hit. In the end he jumped into a canoe and paddled away through a river full of crocodiles...'

Larry looked up slowly from his book when I asked what he thought it meant.

'Well, he's going on a journey, that's obvious. I guess the jungle symbolises the penitentiary and the pygmies are the guards who he feels are too insignificant to harm him. The canoe probably represents his psychological capacity to deal with any danger that may be lurking in the future.'

I was impressed.

'That's amazing. I thought the whole thing was just like a bad acid trip.'

Larry put his book down and shook his head slowly. 'Man, I used to get so fucked up on acid.'

That was the first time I'd heard anybody admit that; it was just the opening I'd been hoping for.

'Same here. I'm still so freaked out from my last trip, sometimes I don't know if I can keep my head together...'

Larry interrupted me. 'No. I mean I was fucked up out of my head, man – it was amazing!'

Helle! I've not finished the ducting backpage but I must write much is happening but what I cannot say ~ I will not rack my prain, but again I have my pen, but owhy the wit from the oviginal remains, the verst is from Wike, like so ONE AND A WELCOME NUMBE

I rummaged through my suitcase to hide my burning face while Larry stuck his head back in his book.

It was only when footsteps clattered into the doorway that I dared to look up. It was Mike, grinning like a madman.

'Hey guys - guess what?'

'What?' we chorused.

'I just found out, I'm leaving Modelo ... tonight!'

I could hardly speak. 'Wha ...?'

'They're gonna call my name any minute now...' Mike dug his hand into his jeans pocket. 'Here – I've got something for you.'

He dropped a short length of carved wood into my hand. It had a hole running through the centre and for a mad moment I thought it was a pygmy blowpipe. Mike explained.

'It's a barrel for your pen. Louis let me carve it on the lathe.'

I unscrewed the nib section from my Rapidograph and pushed the cartridge end into the hole while Mike told me its history.

'It's made from an old olive-wood chisel handle. It's probably been in the *talleres* for a hundred years, so I thought it would be a happy reminder of the time you spent in Modelo.'

I smiled as I squeezed the plastic tube deeper into the hole, but I was really trying to work out how to thank Mike for all he'd done for me. Larry got up from his bunk and shook Mike's hand. He knew exactly what he wanted to say.

'It's been a real pleasure to know you, man. I've never been so happy to see anybody leave before!'

Mike looked totally different. His eyes were shining and he seemed to be floating above the floor.

'They haven't given me a trial, but at least it's a step in the right direction. Oh, I nearly forgot...'

Mike handed me a piece of paper with the penitentiary address on it. I folded it up and put it in the plectrum pocket of my Levi's while my mind fumbled for words. Mike held out his hand with the same smile he had when he first introduced himself as 'El Motherfucker' Pearson. His blue eyes looked into mine and his voice went quiet.

'Drop me a line.'

At least I managed to smile back this time.

'I will.'

He turned and walked away and I realised that was all we needed to say. We both knew we'd have all the time in the world to talk when we met again, and when that day came we'd both be free.

The cell light went off and I sank into the body-shaped mould of my mattress. I closed my eyes and strained to hear the far-off sounds of the city. I thought of Mike, handcuffed to a Guardia Civil officer, then pictured the train he was travelling on, a long line of yellow lights, snaking through the dark, mysterious countryside.

Larry's voice interrupted my daydream. 'It was great to see Mike go'.

'Yeah,' I said, remembering Mike walking towards the magical corridor of freedom. 'But he's going to find it tough going to a new place after being here so long.'

A match scraped in the darkness and I caught a flickering glimpse of Larry's face as he lit a cigarette.

'Mmm. Change can play strange tricks with your mind.' Larry blew smoke into the dim cell. 'I spent my whole life surrounded by big shiny skyscrapers before I came to Spain. When I arrived, I got a massive culture shock. All the narrow little alleyways and tiny ancient buildings freaked me out big time.' The red glow of Larry's cigarette lit up his features as he took another drag.

'I went straight back to the airport and got on the first plane to Germany.' Larry blew the smoke out slowly. 'Then I spent a whole week hanging around the office blocks of Munich until I got my head back together.'

'You're kidding!'

'No shit, man. I had to get out. My head was totally fucked up?

I laid back into my bunk. We'd been talking about Mike, but it seemed like Larry was trying to make me feel better after the blunder I'd made about the acid.

'I guess Mike's going to be okay,' I said.

Larry stubbed out his cigarette in his tin-can ashtray. 'Sure, Mike's gonna be fine.'

I pictured him working in the penitentiary gardens. He was dressed in a prison outfit with arrows on it and he was smiling. Knowing Mike, he'd get his *amigo* to send him some seeds in a brownie and he'd soon be growing himself a plot of weed.

22

INK SPOTS

Couldn't bear it without you Don't get around much any more Ink Spots

Paco was hammering *tiras* holes in a bag on the tree trunk, making it impossible to concentrate. I leaned back against the flaky wall to study my picture of the Argonauts until the pounding stopped. The landscape looked a bit weird. There were no windows in the *talleres*, so the trees, plants and landscape of ancient Greece had come from my imagination. So had the figures. I could see the broad outline of Manuel's shoulders as he worked on the glue tables. He would have been a great model for Jason, but the guard would have had a fit if he'd disrobed and exposed his nipples.

Mike's pen barrel was beautiful to draw with. He'd sanded the wood to a smoothness that was almost soft, and holding ancient olive-wood to draw on leather made me feel closer to the mythical scene I was creating. I was pretty close to it anyway. Modelo was like a giant's castle. Its stone walls echoed with drunken trumpets, town criers and tolling bells. There was no heating and the inmates huddled on strawfilled mattresses under iron-barred holes in the walls. They used ancient tools to make oil stoves and ate peasant gruel with dry bread. Modelo even had torture chambers and a garrotte. There were no radios, newspapers or telephones. Cars, cinemas and shops were a distant memory.

Paco finally laid down his hammer on the tree trunk and I got back to work, thinking that I wasn't just drawing the past – I was living it.

I must have remained deep in thought for some time because Paco turned to me with a raised eyebrow.

'You are berry quiet. Have you seen your lawyer?'

'I'm not expecting to. He'll let me know about the trial in due course.'

'Is in May... yes?'

I nodded.

'Is due course now,' Paco said.

I got back to drawing the twisted branches of an olive tree, carving out the bark as though my pen was a chisel. Drawing always calmed me down. It didn't take long to realise that Paco was right. If my lawyer knew I was going to have a trial, why didn't he visit me?

When I stepped back into the cell from the *talleres*, I almost stopped in shock. Boris was perched like a gargoyle on the end of Larry's bunk. As usual, his eyes were fixed on a tray of watch parts balanced on the neatly patched knees of his jeans.

He looked up at me, as though our bust-up had never happened.

'Ah, William! Can I see the guitar? Does it play well?'

Larry unwrapped it from the jeans in his bag and passed it over. Boris held the cigar-box sound-hole to his ear as he plucked each string, saying, 'Excellent!' after each note. He passed it back to me and asked if I'd play a few bars. I sat down on Robert's bunk and started strumming. Boris listened intently as I picked out some individual notes, then asked me which I liked best between art and music. It was strange. Boris almost seemed a different person – chatty and friendly instead of his old prickly self.

'Drawing, I guess,' I said. 'It makes me forget everything and before I know it half the day has gone.'

The *Quinta* couldn't have changed Boris that much because his eyes started to burn with his old passion as he spoke.

'It's the same with me when I make things. Sometimes I work all day without a break.'

'Yeah, I used to do that, and when I finally stopped working I'd realise it was dark and I was starving.'

Boris's eyes blazed.

'Yes! Yes! That's when you're truly happy. *When you forget to eat*!'

Larry tilted his book down and asked Boris if he managed tc do any work in the *Quinta*. Boris shrugged his shoulders and turned back to his watch.

'A little, but it was dark and there was no window, just a light bulb – and that was never on for long.'

'I guess you slept a lot.'

Boris squinted at his work in silence before he spoke. 'Not this time. They didn't give me a bed and the floor was cold.'

Larry leaned up on one elbow.

'So how did you pass the time?'

'I made things when I had the light.' Still transfixed by his work, Boris took a miniature pipe from his waistcoat pocket with his left hand. He passed it silently to Larry and I leaned over to look. The slender stem was smoothly carved in dark wood and it had pale calfskin stretched over the bowl. The tiny stitching on the seam was so precise that it could have been done by an elf. Larry turned it over to reveal the word 'Quinta' written in small, neat capitals on the smooth leather.

Boris answered my question before I could ask it.

'I wrote *Quinta* on it so that when I am released it will remind me that if I can make this in a dark prison cell, just imagine what I can do with my freedom.'

Boris slipped the pipe back in his pocket without acknowledging our praise. I thought to myself: *That's what I should be doing – thinking about the future*. I'd given up trying to make sense of the past, though I still knew Mike was right. The past was why I was here. I pulled out the stove and asked if anyone wanted a cup of tea. Boris was the first to answer.

'Only if you're making some.'

It was the weekend, so I brought my book back to the cell. I wanted to do a picture of my own for a change. It felt good to be holding Mike's wooden barrel while I drew him paddling through the crocodile-infested river of my dream. In the background I drew a smiling Paco, running away through the jungle.

I was wondering what Larry would say about Paco's significance when a small fat guy in a smart black suit and clean white shirt wandered into our cell. His casino image was so incongruous next to the old stone sink and cracked porcelain bog that we just stared at him.

The soft-faced man had to strain his delicate American tones to be heard above the husky babble of social hour.

'Do any of you good people speak English?'

'Yeah,' we all said, and he looked at us imploringly. 'Listen – my name's Mel Goodman and I need to know to whom I have to speak to make a phone call.'

I told him I'd never seen a phone in the prison, and even if they had one, they'd never let us use it. Mel's head sank to his chest and his black hair flopped as he shook it from side to side.

'Oh God. My boys will be killing each other.'

Robert asked what happened and he raised his pale hands in despair.

'I was robbed at my hotel. They took *everything*. All I have is the clothes I'm standing up in.'

On closer inspection his suit looked crumpled, like he'd slept in it.

'The police asked me for my passport, and when I told them it'd been stolen, they arrested me for not having one.'

'What?'

'Yeah. They threw me in here and, if I don't get to a phone soon, I'm gonna be looking for a new career.'

I started making some tea while Mel told us he was the manager of the Ink Spots. His main worry was that they'd tear each other apart without him to keep the peace. Mum used to have old 78 records of the Ink Spots. They were great singers, but I'd thought they were all dead. Larry offered to speak with the officer in charge tomorrow, and Mel's voice brightened up.

'You're an American – thank *God* for that. They gotta give you a phone call, don't they?'

Mel rolled his eyes around our medieval cell in horror as Larry explained the finer details of Modelo law.

When the drunken bugle blew, Mel's dark suit drifted out onto the walkway like a lost soul in Hell.

Boris slipped into the cell seconds after Mel disappeared. His long yellow teeth grinned in my direction.

'Hey!' he said. 'Have I found a reloj for you!'

I smiled inside. I'd been wondering why he was being so nice to me.

The cell light had gone out some time ago, so I knew it was getting late. Soon the moon would appear and the bars would begin their sinister journey across the cell wall. I needed a watch, but I didn't trust Boris after what happened with the last one.

A cold wind blew through the bars. It took me back to the broken window in our freezing attic bedroom in the slum house. I'd moved the rickety bedside table into the middle of the room to practice throwing my tomahawk. I was doing well: the blade had two steel points which made it easier to stick into the wood than a knife. Unfortunately, my final throw was too hard and the axe cartwheeled off the tabletop, smashed through the attic window and landed in the street. The tomahawk wasn't broken, but the window never got fixed in all the years we were there.

I stayed out late almost every night at the slum house. Mum didn't work, but the place was always so filthy that none of us brought our school friends back. It got so I couldn't bear to go home. Sometimes I'd wash the dried-up porridge from the breakfast bowls and tidy up the room. I'd always leave a note on the tablecloth that said: *The fairies have been*. Then I'd hide on the dirty floor under the table to hear her happy surprise when she came back. But I was never sure if she was really happy, or if she was just pretending.

The night had been so familiar to me back then. I'd been able to tell that the pubs had shut when the orange streetlights flickered into a pomegranate purple before turning into a dull orange. And I knew it must be really late when there were no more drunks lurching about under the ghostly green glow of the gas lamps.

My favourite place to go after school was the Brickyard. It was way off our patch, but it was well worth the risk. In the centre of the Brickyard was a massive oval kiln the size of a church. The inside looked pretty much like a one-storey version of Modelo. It even had a shoulder-high walkway that ran around the big, hollow gallery. It didn't have a railing, but the hundreds of arched ovens that circled the walkway looked just like miniature prison cells.

Some mad genius had tied a thick, grey, elasticated rope from a beam. It hung down in the middle of the building with a knot as big as a football on the end of it. You took hold of the spongy rope and ran around the walkway at full speed, then jumped onto the knot just before the path curved away from you at the oval end. The thick elastic stretched to the floor as your legs wrapped around it, then you bounced up and down as you swung around the vast interior, wider and faster than any other swing in the world. It lasted for ages, but when you finally began to slow down, you could hit the floor running and then leap off again, spinning and bouncing through the air like Tarzan. There were no windows in the kiln, just a few low entrance arches, so I'd swing around till it was too dark to see, and then go out into the yard.

The yard was littered with bricks of all types and shapes. I used them to build palaces and forts under the distant glow of the streetlights. Eventually I'd get so scared of being alone in the dark that I'd have to go home. Then I'd stand for ages under the shadowy shrubs that overhung St Clement's church wall, just staring at our house because I didn't dare to go in. It was stupid because that only made me later than I already was – which meant I'd get an even bigger beating.

At first Mum used to grab my collar and we'd sort of spin round together with me trying to get away and her trying to get a good run of smacks on my legs. Then it got to be a slipper or a shoe, and then the little white cricket bat with the red plastic handle, which stung like hell. But the curtain wire was the worst.

I'd taken my Irish mate, Dominic, to the Brickyard. It was so dark when we got back that Dom didn't want to go home on his own. As soon as I knocked on the door, his dad flew out. He was furious and swung a punch at me as though I was a bloke. I ran through the streets with him so close behind me that I could feel his fingers grappling for my jacket. But there was no way he could follow my zigzag down our yard steps, and I crashed through our door and ran upstairs, thanking God that the door had no catch.

Mum was waiting in the bedroom for me. Jack was huddled under the covers with only his eyes showing, but Jeremy was out of bed in his red striped pyjamas. Mum's face was already red and she was wrapping a curtain wire around her fist.

'Where on *earth* have you been? I've been worried *sick* all night!

'I was out with Dom. His dad nearly ...'

'Get undressed for bed right now!'

I didn't like the look of the curtain wire. Neither did Jeremy, who was looking more scared than me. He kept saying, 'Don't do it. I don't want you to do it!'

When I got down to my underpants, Jeremy tried to stand between us.

'Look, you can beat me to within an inch of my life, but I'm not going to let you hit William with that!' I was surprised at his dramatic language, but much more surprised at his bravery. Jack started crying, but Mum ignored them both.

[•]Put your hands on the bed!'

Jeremy shouted, 'No!' as I turned to grab the end of the bed and a white-hot streak of pain whipped across my back. It was followed by another and another.

The room exploded in screams, with Jeremy yelling, 'STOP IT! STOP IT! STOP IT!' and Mum screaming, 'NEVER! NEVER! EVER!' as a frenzy of lashes crisscrossed my back. She almost slammed the door out of its frame when she stormed out. I crept into the cold bed and curled up like a question mark so the sheets wouldn't stick to the blood.

The cell slowly came into focus as I opened my eyes. My body was stiff as a corpse. No wonder I was so scared of being beaten up in the prison. I'd lived with the fear of being hit for so long that it had become a part of my life. But maybe I was finally finding out what was wrong with me. I was a problem child and I'd learnt that violence was the only way to deal with problems.

The following evening, Mel stumbled into our cell the moment the doors swung back. His worried face was as creased as his suit. He stopped by the bog with his arms spread wide in disbelief.

'How do you guys live here?' He whined.

Boris looked up sharply, a tense vibe coming off him. I asked Mel what was wrong.

'All they give me to eat is pigswill. I'm gonna starve or get dysentery, and I shouldn't even *be* in this dump in the first place!'

Boris stood up and stalked towards the door. Mel had to sidestep quickly or Boris would have gone right into him. Larry's calming voice drifted from behind his book. 'Have you heard from the consul yet?'

Mel continued to whine: 'No. I've heard *nothing* and they *still* won't let me make a call.'

I almost told him I hadn't heard from my consul for weeks, but I changed my mind.

'It won't be much longer now,' I said. 'Would you like some tea and a *membrillo* sandwich?'

Mel gave a faint smile as he sank onto Larry's bunk. I fired up the stove as he moaned on about his temperamental singers. He made out his job was a nightmare, but I enjoyed hearing about the exotic world of stage clothes and sound checks.

Boris returned to the cell, interrupting Mel with a triumphant exclamation.

'Mira, senor! This is the reloj for you!'

He dangled a golden Spanish wristwatch under my nose. It was so huge and ornate, I just had to have it.

'Oh, man! That is *so* far out!' I held it over my wrist and asked how much it was. Boris held up seven fingers and I asked him to knock the guy down. He looked at me with his eyes on fire.

'I will try – but you've got to have that reloj!'

In the morning I lit the stove and put an egg to fry in olive oil while I washed and dressed. When they dragged the bread round, I tore an end off my loaf, ripped it open to smear it with butter then I dropped in the egg. Larry and the guys wondered what the hell I was doing as I stuck my head out of the cell with the sandwich hidden behind my back.

The orange basket was on its way towards us, but otherwise the coast was clear, so I slipped down the walkway to Mel's cell. His face lit up when he saw my present. I ducked down as I ran back so the guards wouldn't spot me. Larry and the guys thought I was mad when I told them I'd done it because Mel was so helpless. That was partly true, but I was also drawn towards the mystical world of music that surrounded him.

The guard yelled at us as we lined up outside the *talleres*. For a moment, I thought he'd seen me running down the balcony, but thankfully he spun on his heel and left us in the early morning sun.

I always waited until the guards went before I lifted the anvil. I didn't want to give them any reason to think I needed bringing down. I loved the feeling of power when my muscles locked with the big block of steel over my head. My arms and legs didn't shake any more and I held it up for even longer than usual before crashing it into the ground.

Herro, the brigand who'd admired my weightlifting on that first day, had gone a long time ago, so nobody talked to me as I rejoined the queue. People just disappeared from Modelo and you never got to say goodbye to them. Pete and Jake had been taken back to 'the place of penetration' in the middle of the night. I knew it was them because their cowboy boots had sounded even louder than the guards' heels.

Boris grabbed at my jeans jacket the minute I got back from the *talleres*.

'I can offer him sixty and I think you'll get it for sixty-five!'

It was a huge amount of money for a watch, but it was better than the asking price. I thought about it while Boris's wet lips twitched with excitement.

'Just give me ten for a deposit and I'll see what I can do. You've just *got* to have that *reloj*. It's magnificent!'

He was right. I gave him a ten and he shot out of the cell, even though social hour hadn't begun yet.

I slid my big Bushey sketchbook from my jacket and sat on

the end of Larry's bed. Mike had given me a book on Picasso and one of his quotes had been running around my head all day: 'You should have an idea of what you want to paint; but it should be a vague idea.' After all the tight pictures I'd been doing at the *talleres*, it was fun to let the pen go where it wanted. I drew away happily until Mel poked his round head into the cell.

'Thank you for the breakfast, William. I really appreciate it.'

'That's okay. How's it going?'

Mel looked uncomfortable. 'It's... er... going as expected... I have to go now.'

As soon as he disappeared, Robert bounced out of his bunk.

'All zat stolen passport talk is horseshit! He was up to no good in the hotel.'

He made a circle with one hand and vibrated his finger through it with a sly smile on his face. There was no point arguing with Robert, so I just grinned and got back to my drawing.

For some reason I'd drawn a picture of me as an old man in a theatre, writing in a book. The white coffin that I'd drawn in my previous self-portrait was hanging open on my wrist and I was wondering if that was a good or a bad sign when Boris came back from his wheeler-dealing. He reached into his waistcoat with a grin and pulled out the huge *reloj*. It dangled from his fingers like a pocket watch with straps on.

'He drove a hard bargain, but I got it for sixty-five.'

Boris's eyes suddenly flashed with anger as Robert murmured from behind his paperback. 'And what did you get for all your hard work?'

Boris spun round. 'Get back to your book, you filthy frog!' 'And you get back to the *Quinta*, you capitalist pig!'

While they argued, I climbed up onto my bunk and strapped on the big, beautiful watch. It was slim and golden, and I lay there staring in fascination as the fine hands moved slowly around the ornate silver design on the face. What made it all the more beautiful was the fact that I'd earned it by drawing.

23

GIRL OF THE NORTH COUNTRY

Like a beast with his horn, I have torn Everyone who reached out for me Leonard Cohen

Mail call echoed around the gallery as I leaned against the chipped doorframe. Boris was working on the end of Larry's bunk, and I was reading Mike's Picasso book. Picasso said that nothing could ever stop him being an artist. Even if he were tied up in a prison, he would still paint by licking patterns on the cell floor. I looked over at Boris and smiled. I could picture the two of them in the *Quinta* – Boris fixing a watch with his fingernail and Picasso licking a picture with his tongue.

The Spanish version of my name floated up from the *Planta* gallery. I was down the steps in a flash. I'd been secretly hoping that Mum had got the money back together. When I saw Hanna's name on the blue airmail envelope, I felt

let down. It seemed that my last chance had gone for good.

I read the letter in the vain hope of a message from Mum as I trudged back to the cell.

'Good news?' asked Larry.

It wasn't the news I'd wanted, but this time I shared it with him.

'Sort of. It's from my old girlfriend in Leeds.' I read on. 'Oh no – I don't believe it! She sent me a bar of chocolate *ages* ago.'

Larry stood up and smiled. 'Well, you can kiss that goodbye.'

The thought of the thick, sweet taste made me reach for my pack of Celtas. Larry took the cigarette I offered, and waited for more news.

'She's going to visit me! That'll be weird. I haven't seen her since we broke up.'

Larry gave me a light, then coughed as he lit his own.

'Get her to bring some more chocolate. And some decent cigarettes – these taste like shit.'

I wasn't really listening. Hanna said that Daisy was painting for an exhibition that his new girlfriend was organising in London. *What a conjo!* I thought. He was happily painting away without even bothering to write, let alone apologise for dropping me in the shit.

I flipped the letter over and checked the date. It had been sent weeks ago. That meant Hanna was going to be in Spain any day now.

The prison lights went out before the moon rose so it was a ways dark when we hit the sack. I couldn't see the time passing because my new watch wasn't luminous. The bunks weren't creaking so I guessed everybody was asleep. I should have been too, but I was going through the events of the day in my mind. Anything was better than pointlessly obsessing about my trial.

I'd finally got hold of some heavy-duty leather to make a pair of sandals before my shoes fell apart. They were going to look like the ones I'd drawn Odysseus wearing as he blinded the Cyclops. The act of drawing every day was saving my sanity. Today the hours had passed quickly, lost in the lines of sheepskin folding around muscular limbs and dark crosshatched caves in craggy escarpments. It had been a good day, but Hanna's intended visit had eclipsed everything.

I pictured her face – her pale eyes half-hidden in the wind by her long, fair hair. Even though we'd broken up, she still made me think of Dylan's 'Girl of the North Country':

Please see for me if her hair hangs long If it rolls and flows all down her breast

The image took me back to cold Saturday mornings at the back of Leeds market. We'd buy cheap vegetables and if we could afford it, a single piece of reject pottery. The Victorian transfers were slightly askew, but I loved the way they looked so French on the table by the window – like Impressionist paintings.

The sugar bowl had been the first to go. I'd stormed out of the front door after a row and a long streak of sugar and pottery had shot along the path in front of me. When I looked up, I saw the whole table tipping out of the window as cups, saucers, bowls and plates tumbled and crashed into the sunken cellar yard. But it wasn't Hanna's fault. She may have smashed our crockery, but it was my stupidity that broke our relationship.

When I left work the next evening I smuggled my book back, I should have left it in the *talleres* but my drawing was improving and I wanted to record the progress. Not only that: I'd missed so much of what was happening in my head. I quickly drew my watch, then started on a picture of Boris while I listened to mail call. I didn't know why I kept listening. I just did. The dark shape of Mel's increasingly crumpled suit lumbered in front of me. When he saw I was drawing Boris, he apclogised and tiptoed around to look over my shoulder.

Robert shouted from the depths of his pit.

'Bonjour Mel - how do you like our Picasso?'

Mel studied my drawing of Boris's jowly face and cooed like a dove. 'It's a very good likeness.'

Robert shouted back, 'Zen it must be a very ugly picture!'

Mel asked if I'd draw his portrait too. I got him to sit on Larry's bunk with a book in his hands to keep him still. He didn't move, but it didn't stop him talking. 'What part of England are you from?' he asked.

Robert swore as I lowered myself onto the end of his precious bunk.

'Yorkshire. It's sort of in the middle.'

Mel stared rigidly at his book as he spoke. 'Yes, I'm familiar with Yorkshire.'

'The bunk shook as I adjusted my position and Robert exploded. '*Putain de merde*!' He jumped up and strode between us to the bog. Mel carried on asking questions, talking like a ventriloquist so his face didn't move while I was drawing him.

'Whereagouts in Yorkshire do you gum from?

I raised my voice as a stream of French piss thundered into the bog behind me.

'Leeds. But I live in London now.'

I was getting a good likeness of Mel. It was easy, like drawing a waxwork.

'Leeds is a nice place,' he said. 'I worked there in the Sixties.'

I was amazed. What would the manager of the Ink Spots have been doing in a dump like Leeds?

The torrent of urine continued as Mel told me.

'I was the manager of the Rollarena on Kirkstall Road.'

My pen stopped drawing in shock. 'You're kidding! I used to skate there all the time with my girlfriend.'

Mel's mouth stayed as still as a doll's.

Then we must have rubbed shoulders before.'

My mind flew back to the leathery smell of the wonky roller skates and the empty echo of the PA as it pumped out cheesy pop songs. It seemed a lifetime away. Robert squeezed out a few final jets, then farted his disapproval of me for sitting on his stupid bunk. I just kept shading Mel's plump features and thought, *The longer I stay here, the crazier it gets.*

Saturday morning didn't seem so cold, so I decided to sneak my book out into the yard. I slid it into its brown leather bag and waited by the cell door for the bugle to blow. Then I joined the line of prisoners on the high walkway with the bag slung over my shoulder. It felt great.

Minutes later, a crack of light split the dark doors in two and the queue moved eagerly forward. As soon as we stepped out of the shadows, the blinding white sky took me by surprise. I hardly noticed the weather in the windowless *talleres*, but out in the open there was a definite scent of springtime in the warm breeze. It brought back memories of planting wallflowers in the bus station flowerbeds and stabbing a spade through the soft turf to turn over the thick, black earth. The thought of an English park made the dry, dusty yard look foreign again, as it had done when I first arrived.

I sat on the kerb to draw a group of prisoners who looked as though they were waiting for a bus that would never come. That was exactly how I felt. I hadn't heard from my mother or my lawyer or consulate for ages, and the springtime atmosphere was re-awakening the dreaded desire to be free. I closed my book and walked off to sketch the chess-players before the longing could get a grip on me.

By the time we got back to the cells for siesta, the sun had

burnt through the thin clouds. It wasn't long before Boris and Robert were snoozing on their bunks. Larry was reading, but he put his book down and asked to see what I'd drawn in the yard. The portrait of the annoying bloke who watched the chess games was scruffy, but it was accurate enough for Larry to recognise him. He read out the poem I'd written.

> Day dawns dull but bright No sun but light Clouds wind of home

Larry closed the book and handed it back to me. 'That's nice. It's like a haiku.' He pulled out a sheet of paper that was marking his place in the creased copy of Durrell's *Mountolive*. 'I've written a poem. D'you wanna hear it?'

Larry sat on the edge of his bunk with his elbows on his knees and began to read. The paper shook in his hands, but that could have been the breeze coming through the bars. Whatever the reason, the deep thoughts and powerful images took me by surprise. I'd had no idea he had all that stuff going on in his head. He glanced up at the end, looking more like a schoolboy than a tough New Yorker.

'What d'you think?'

'It's great. I love the line about eternity – drinking from a cup of time. It would be a good poem to illustrate, actually.'

Larry's face brightened.

'Really? Man, it would be so cool to see what you did with it.' We stumbled into the yard after siesta and I sat down with my back to the wall. Nothing had changed since I first came in, except now my knees were sticking through the white threads of my Levis and the downtrodden backs of my shoes had been cut off. I opened my book on my thighs and tucked Larry's poem between the pages so it wouldn't blow away. The chess guy I'd sketched that morning seemed to be looking down into the white space below him, so I put him in the clouds above Larry's picture. Drawing every day for the last month had speeded up my technique, so it was finished way before the bell rang.

I'd drawn Larry's profile resting on a desert with his open mind stretching out into an eternal wave, but the rest of the drawing was such a jumble of images that I realised I'd have tc write the poem out or it wouldn't make sense. I wrote it in the copperplate script that my friend Tim Daly had taught me just before he bombed the Imperial War Museum. I checked to make sure that the guard wasn't around, then wrote the poem in one go, confidently looping curls and swirls into the text, enjoying Mike's smooth olive wood pen holder and the new-found steadiness of my hand.

When it was finished, I leant back, pleased with how neat and even it looked. It made me feel good. On my first day in the yard I hadn't been able to think straight, never mind write in a straight line. I closed my book and let the warm sun shine a golden haze through my eyelids until it filled the whole of my mind.

Zorro hadn't been around for ages, so it was a shock when he stormed into the cell. I swung off my bunk as he yelled into my face. He must have smelled the soup simmering inside the orange- box, but all I understood was *Follow me*, so I did. My mind was racing as fast as Zorro's shiny jackboots. *At last!* I thought. *I'm going to find out about my trial*.

We descended into the dark prison interior and my heartbeat began to quicken as we clattered through a sequence of unfamiliar gates. We were going somewhere I hadn't been before. I glanced around quickly, taking in the painted walls and a neat notice board while Zorro unlocked a small door.

Larrys Poem Free food for Thought ; Aunny, it tasks like musty And Metatic turghlight Gereams in dealening Rage The unspeckable grayness of its Cage A Thousand Tears, each one a Frozen Dessey Through primevil Mountains and Hawning plains Nothing gained Pomething Lost and One Black Rose lies cruging still CU Deering petals in Arenzie lust 2 Fill White Morning Yun sights light on To lay my head softly on the ground Surdling from a cup of time; such musty wine On eternity newly found.

It opened into a series of booths like the ones they'd used to have in the music shop in Leeds arcade. The door locked behind me and I faced a scratched plastic circle set into double-glazed sheets of scuzzy perspex. It separated me from an empty waiting room and I stared through the round window at a distant corridor, waiting for what I knew was going to happen.

A short while later, a blonde figure in blue jeans and a white shirt came out of the shadows. Hanna stopped, looked around, then froze when she saw me. It was so strange to see her in Modelo that my heart jumped as she walked towards my booth. She looked so clean and pink and fresh, that it seemed wrong that she was in the grey prison.

I looked at her worried face through the hazy plastic circle and realised she was talking, but I couldn't hear a word. Hanna pointed at something to my right and her distant voice came through a small grill in the corner.

'Can you hear me?'

I called back.

'Yeah. Can you hear me?'

It was terrible. We couldn't see each other and talk at the same time. I'd imagined holding hands across a table and looking into each other's eyes. Her disembodied words drifted through the grill.

'This is crazy. Let's have a look at you.'

I stepped in front of the perspex and we inspected each other in silence. I felt bad because I was wearing my ripped, ink-stained jeans and long threads were hanging from my torn cuffs. My jacket collar had almost been ripped off in the beating, but I hoped she wouldn't notice through the obscure scratches.

Hanna looked pretty much the same – long blonde hair falling over big blue eyes – but her lips were tight with

ccncern. She slid a finger down her hair to pull a strand from her face. The familiar mannerism brought back all our old intimacy. Her mouth began to move, so I leant into the shadows, resting my head in the corner as she spoke.

'The consul thinks you should hold on for a trial in May.'

'I have to anyway. Mum gave everybody the bail money back.'

'What?'

She was shocked, but it was too complicated to explain. We kept moving from side to side, missing snatches of conversation as we tried to catch the expressions we desperately needed to see. It would have been funny at any other time, but we ended up just staring in confusion at each other's faces through the plastic circle. Hanna tried to look happy, but we both knew it was a crazy way to meet for the first time since breaking up.

All too soon, the door behind me creaked open and Zorro led me back to the cells. I felt so bad that I didn't raise my eyes once from Zorro's boot heels.

There was a plastic bag on my bunk when I got back. I tipped it up and a whole load of fruit tumbled onto the blanket. It was mainly oranges, the one thing we had tons of in Modelo.

Larry swung his long legs out of his bunk.

'Did she get you any chocolate?'

I shook my head as I rummaged in the empty bag.

'Not even a packet of fags.'

'You're kidding?'

'Man, it was so weird. You're talking with somebody you know really well, and it's almost like you're together again. Then, when they walk out through the door, you can't go with them. It's awful.' Larry eased back onto his bunk. 'When you're that close to something you can't have, you'd rather not know.'

'Yeah... There's a high window in the *talleres* that overlooks the road. I only looked through it once. It was so beautiful to see the street, I couldn't bear to look at it again.'

The vision of Hanna's face in the round window kept appearing in my mind that night. She'd tried her best to look happy, but seeing me caged up had obviously upset her. It was my fault. None of this would ever have happened if we hadn't broken up. For ages after we split, another Dylan song had kept running around my head:

> I must have been mad I never knew what I had Until I threw it all away Until I threw it all away

It was terrible to think she'd travelled so far for so little, when all I'd done was walk down a staircase to look through a window. It reminded me of a dark room at the zoo, hidden underneath the rocks that surrounded the polar bears' pool. It was like the Batcave down there. The only light came from a thick glass window set high in the wall. Through it you could see ripples of light in the deep blue water. The keeper would tap on the glass with a coin and seconds later there was a flurry of bubbles and a massive white head hit the window with an underwater thump. At the time I thought it was awesome, but now he seemed to be diving down for a brief glimpse of a world he could never be a part of. Larry was right, you don't want to be that close to something you can't have.

Larry and I spent hours planning elaborate escapes: sawing through bars, climbing over the *talleres* roofs and sliding down ropes made from blankets into the street. But it was impossible – you'd be shot before you got anywhere near the walls. I glanced up to the pale sliver of moonlight shining through the solid iron bars. Their long shadows sloped down the sill at a steep angle. Except for the bars, the window was a smaller version of the ones Dominic and I had once shinned up in the ruined remains of Harewood Castle. My palms went damp just thinking about it.

We'd nicked off school and caught the cream-and-green Ilkley bus out of Leeds. Then we clawed our way through brambles and saplings until we reached the broad, mossy walls. Dom looked over my shoulder as I stood in the arched entrance and stared down into the rock-filled dungeons. Then we looked above our heads. There were no floors, so we could see every gaping window, doorway and fireplace all the way up to the jagged square of blue sky at the top.

From the bottom the climb looked easy. All you had to do was zigzag from door to window to door until you reached the battlements. I stood on the first doorstep and jumped across the corner to the window. I managed to get my body far enough over the deep sloping sill to stop myself slipping back down into the rocky cellar. Then I tiptoed my feet up the wall and stood on top. Dominic looked up as I called down to him,

'You've got to get right over or you'll slide off.'

Dom shouted back, 'Bugger off then and let's have a go.'

Dom threw himself across the window ledge as soon as I started climbing to the next doorstep. We began to work our way silently upwards. The higher we went, the stronger the wind blew. It wasn't a problem. The only hard bit was scrabbling up the smooth curve of the sill if there were no good toeholds below it. When I got to the last window, the only route to the top was by a short traverse along the outer wall. This led to a smaller tower that was capped off on the same level as the window ledge I was standing on. My shirt buttons scraped around the rough corner as I eased myself outside, dust blowing into my eyes from the mortar I'd disturbed with my fingers. I edged slowly along the wall with my toes in the cracks. The traverse was easy until my foot slipped on a loose chunk of stone. I seemed to cling in the breeze for ages until it smashed onto the rocks below. It made me realise how high I was and my palms began to sweat.

When I stepped onto the grassy earth of the small tower I looked down and saw tiny cars passing under the distant trees beneath me. All I could hear was birdsong and another sound that I couldn't quite place. It took me a moment to realise that my name was being called in a low urgent whisper:

'Will... Will!'

I looked back towards the window I'd just left. Dom's face was slowly disappearing as his outstretched arms slipped down the curve of the sill. There was only one thing to do. I dived across the gap and grabbed Dom's arms as I crashed into the wall. We clung to each other for a while, hanging over either side of the window with our legs dangling in space. Dom's fingernails dug into my skin as we climbed up each other's arms to safety.

When our breathing had settled down, I traversed back to the small tower with Dom behind me. Then we climbed the uneven castle wall that led to the battlements on top.

Wind whipped our hair as we looked out over the whole of Otley and Ilkley, shouting our triumph to the world. Weathered pebbles stuck out of the old cement like frog's eyes and we snapped off a couple and swore we'd keep them forever as a symbol of our friendship.

I opened my eyes and looked round the grey walls of the cell. It was almost like being back inside the tower. Dom often went on about what I'd done, but I always felt bad about what I *hadn't* done on that day.

We were terrified when the cops came and shouted at us to get off the castle. Dom retraced the diagonal climb down the crumbling wall to the capped-off tower, but I got stuck halfway. I couldn't find a foothold anywhere and I was losing my grip. I yelled out in panic, 'Dom! DOM! Where's the foothold?'

'Down a bit... A bit more. Now forward... That's it!'

My foot touched hard stone and I pushed off blindly towards Dom's voice. His firm hands grabbed me as I crashlanded onto the grassy tower.

That's what made me feel bad. I never told Dom that I was already falling backwards when I called him. His quick thinking had saved my life as surely as I'd saved his. I never told him because I wanted to be the hero and I didn't want what he'd done to cancel that out.

No wonder I hadn't looked back on my life before. Every time I found something good I'd done, there was something bad to go with it.

24

HARM WRESTLE

I get the blues when it rains. Blues I can't lose when it rains. Big Bill Broonzy

We lined up to cross the grey *talleres* yard, heads bowed against a rare shower. The downpour reminded me so much of Yorkshire that I actually enjoyed it.

In the studio I slipped my book from my jacket and got out my pen. I sketched myself sitting at my drawing board in our little workshop. It was just a scruffy cartoon, but it warmed my pen up for the real work of the day.

I'd almost finished drawing the snakes on the Gorgon's head when a slight increase in the workshop conversation made me look up. There was something going on over Paco's shoulder, half-hidden by the lines of workers. Somebody leaned back and I got a glimpse of Ramon's GI haircut. Ramon often sneaked into the workshop with the *pasta* guys. He was one of the *petanca* crowd, and his broad shoulders and thick wrists were perfect for arm wrestling.

A buzz went round as one stocky challenger worked his way through the tables. Money started to pile up on the end of the worktable where Ramon was sitting, his head bowed so the guard wouldn't see him. The challenger sat down across from Ramon and they locked arms. Paco stretched forward for a better view as they took the strain. Their fists quivered violently for a moment, then suddenly Ramon turned his wrist and slammed his opponent's arm onto the table. There was a hushed collective groan as Ramon scraped up the pile of cardboard money and his defeated opponent skulked off. Ramon flicked his eyes around the room and whispered a husky, '*Más*?'

Manuel flapped his hand at me and hissed, '*Oye, Weeyaam. Venga, hombre..*'

I squeezed between the crowded tables as Manuel patted a five down on the tabletop. A stream of weathered hands put down more and by the time I sat down, a thick pink and blue pile had built up.

Ramon nodded to me in a businesslike way. I grabbed his calloused hand, my heart pounding. His fist was as big as mine, but his arm was shorter which meant my angle was weaker than his. We took the strain for a while, slowly increasing the pressure, trying each other out with little bursts of strength. I could tell he was about to go for it and, when he did, I was ready. I turned on the power and held him with our fists shaking but still upright. I knew then that I could take him, but before I could make my move he twisted his wrist inwards and hunched his shoulder right over the top of it.

In a Yorkshire pub he'd have been kicked out for cheating, but there were no rules in the prison. Pain shot through my arm as I made a desperate struggle, but there was no way I could support the weight of his body and I had to let it go.

The soft moans of disappointment hurt me more than my wrenched shoulder. Paco didn't say anything as I sat down in front of my drawing board. I wanted to get straight back to work to show that it hadn't bothered me, but I knew my hand would be too unsteady to draw. I leant back, holding onto the board, pretending to examine my drawing. It was my best yet. I'd already drawn the outline of Andromeda chained to the rocks and Perseus hovering above the sea monster with the Gorgon's head wriggling in his hand. All it needed now was the details.

Paco leaned over.

'Let me see.'

I tilted my drawing board towards him and he slurped his coffee annoyingly as he studied it.

'Is berry good drawing.'

Paco sucked in another mixture of air and coffee.

'Why they don't let you go to art school in England?'

My fingers still felt shaky, so I was happy to talk.

'You had to have qualifications and I never got any.'

Paco gave me one of his Uncle Fester looks, but he sounded like Mr. Freedman from my junior school.

'Did you *try*?'

'I did actually. I went to a further education college, but I failed all my exams – except for art.'

Paco slurped his coffee again.

'Why did you fail?'

'I dunno. Because I was stupid, I suppose.'

'Why you think you are stupid?'

I felt like saying, 'If I knew that, I probably wouldn't be banged up in here with idiots like you.' Instead I told him that my head had been squashed out of shape by forceps when I was born. That was true, but Paco just rolled his cartoon eyes and turned back to work. Paco was annoying, but I knew it was a good question. And after six months of wondering, I still didn't have an answer.

My fingers felt reasonably steady as I unscrewed the cap of my Rapidograph. I wiped the nib carefully on my jeans, then started filling in the craggy detail on the rocks.

Paco didn't talk to me for the rest of the day, which was probably for the best. I hated that I'd lost, especially after my workmates had put money on me to win. But more than anything, I hated cheats. It was only when we started packing up that Paco looked at my picture. 'You must be pleased, no?'

'Yeah.' I grabbed my jacket. 'It's coming on.'

Paco frowned as I carefully pushed my hand into my sleeve.

'How is your arm?'

I didn't think he'd noticed and I softened my tone.

'It's okay, thanks.'

Paco helped me into my jacket and hissed in my ear. 'He cheated.'

I nodded back, unable to trust my voice. We walked off to join the queues for our respective galleries and I thought: that's the annoying thing about Paco – he could be a really nice bloke if he wanted to be.

When I got back to the cell there was an empty space next to the sink. Larry was flat-out on his subterranean bunk reading *Mountolive*.

'Where's the stove?' I asked.

'Don Juan took it this morning. Sorry, man – he got your drum too'.

I pulled my book from my jacket and tossed it up onto my mattress.

'I knew he could smell the soup.'

My arm twinged as I climbed up the back bunk bars. Ramon was a cheat, but I hated Zorro even more. I was worried he was after my book, and I vowed to keep it at work after the weekend.

But it didn't stop me writing about him:

The bane of my life is back The tall one Ripping off our stove and drum I'd love to see the B on the streets Of my home town...

I didn't finish the end line in case he read it and had me beaten up in the *Quinta*. Not that it would have made much difference. If he found it, he'd burn the book anyway – and me with it. I knew I shouldn't draw him again, but I didn't care anymore. I drew his power-crazed face, then put him in my clenched fist like a puppet while my masked face smiled at him.

I closed my eyes and imagined myself back in Leeds, walking through the city centre. Suddenly I catch sight of Zorro, visiting on holiday. He turns pale as I walk towards him with my fists curled. His head rocks backwards with each punch that smashes into his face. He doesn't even have the guts to fight back. He knows that in a one-to-one situation he doesn't stand a chance.

It was at times like these that I could have done with Mike to calm me down. I didn't want to admit it to myself, but I was really missing him. Nothing had happened about my trial and May had already begun. I reached under my blanket for *The Way of Zen*. Watts wrote about the indivisibility of things. It was a tough concept to take in. I'd always liked the idea that we were made of stardust, but it was hard to get the idea that everything – even separate objects – was joined together. I thought: *surely a snail is different from a hammer*?

I read on for a while, then closed my eyes to think. Watts said that we classified things to communicate with each other, but really everything was interrelated. Even the boundary of our skin can't make us separate because skin absorbs sunlight and we take in oxygen through it. The book was full of mystical poems and sayings that were intended to illuminate the idea:

Open your eyes on a mountain top. What you see is yourself.

I opened my eyes and saw Robert the French bounding into the cell. He was followed by a powerful-looking man. An impressive set of eyebrows frowned up at me as the Spaniard offered his hand. I shook it, hoping he'd notice my watch.

Robert said, 'This is Bach. He's an artist too. He want to see your book.'

I jumped down and pulled it from my suitcase. For once Robert didn't mind us sitting on his bed. Bach went through each page slowly, making occasional comments that I couldn't understand. He closed it carefully at the last page and spoke rapidly to Robert. Robert took a deep breath before he translated.

'He say you draw very well... He especially likes the chess drawing.'

I thanked Bach and asked him what kind of stuff he did. He smiled as he spoke. 'All I can to say in Ingles is: My tailor is berry rich.'

'He makes funny portraits – zey are *incroyable*,' said Robert.

I remembered that Robert had told me about this guy before. He was from Catalonia and he'd got into trouble for drawing a political cartoon of Franco. I asked him if I could see any of Bach's work.

'He says the Guardia took all his cartoons away when they arrested him. I hope they die laughing!'

Bach said he'd draw my portrait to show me what his work was like. I offered him my pen, but he took a stubby pencil out of his pocket and said something to Robert, who translated in a stage whisper: 'Be careful, William. For him ze pencil is a weapon!'

I didn't like the sound of that and sat with my eyes fixed on the wall beneath the bars as Bach eyed me up like a boxer. He drew with incredible speed. There was a flurry of marks, followed by delicate shading. All the while he talked through Robert.

'He say you have a good face to draw: strong cheekbones and defined features.'

I thought, Yeah, I bet he says that to everybody. But I was itching to see what he'd done. Bach studied the finished drawing at arm's length, then smiled as he turned it to me.

'Vale. Aquí está...'

I was horrified. I looked like a madman. Maybe I didn't recognise myself because I hadn't seen a mirror for ages, but my staring eyes and manic grin freaked me out.

Robert was thrilled. '*Incroyable*! You have him. What do you sink, William?' I told Bach it was a great drawing, but I was thinking to myself: *I'll get my revenge, you Catalonian bastard*! After he'd gone, I couldn't bear to look at it. I knew

why. It was as though Bach had looked into my soul and had seen The Mad Freak of Fear howling inside me.

The cell light went out and the darkness seemed to seep into my mind. I tried to remember what Alan Watts had said about language to stop me thinking about the breakdown I'd had in Colditz. Watts had begun by saying that words separated things from the real world by putting them into boxes. I'd got that – holding a river in a bucket or locking animals in a cage took them out of context and destroyed what they really were. But his true point was that the separation of Man from Nature had begun with the word of *God*. We'd learnt all that in Sunday school: the Word said that Man should have dominion over animals just as God had dominion over us. That didn't sound right any more. If we were all made of the same stuff, then we were all equally important, so nobody should have dominion over anything.

The night was empty. Not even a siren or a barking dog broke the silence. I held my watch to my ear. This was the only time that it was quiet enough to hear it ticking. The inside was just as beautiful as the face, with four of its fifteen jewels visible. In the daytime I loved to lie on my bunk and gaze at the almost invisible hairspring spinning the balance wheel backwards and forwards. It was more like a piece of mechanical jewellery than a watch. All the cogs rotated at different speeds, each dependent on the other. That seemed to me to be the point Watts was making - Tao and Zen see everything as equally important, whereas Christianity divides and rules. It was almost as though he was asking me to choose between two different paths. One was like Franco's dictatorship, where a father figure told everybody how to think; the other was like Sylvie's commune, where everyone was equal. I knew which one I'd go for any day.

25

DAISY CHAIN

Got some friends out there who care a little 'bout me And they won't let the poor boy down Chuck Berry

I'd been dying to draw a picture of the Stones' Midnight Rambler. The track had been playing in my head ever since the guards had dragged Mel away in the middle of last night. Robert stood on tiptoe next to my bunk as I drew an acid trip version of Jagger's ravaged gob.

'C'est incroyable!' he said. 'What is it?'

'The Midnight Rambler. It's inspired by Mel. Where do you think they took him?'

Robert grinned as he shoved his finger through his fist.

'To the place of penetration!'

Robert was about to make tea when a guard suddenly marched into the cell. Larry jumped off his bunk and Boris stood up, holding his tray in front of him like a butler. It took a few moments to understand that the

guard wasn't going to throw me in the *Quinta* for making another stove. He was telling me that my consul was waiting to see me. The guard turned and stamped out, with me close behind him. Wild thoughts ran around my head as we descended into the dungeons. Surely this had *got* to be about my trial.

I scanned Mr Bradley's face through the wires of the cage, trying to pick up on his vibe. Nothing. He never looked happy, but at least he managed to smile as he shook my hand.

* * *

'So how are you keeping, William? No teeth lost, I hope?'

I didn't want to be softened up. I just wanted to know what was happening.

'No. I think the vitamins must be working.'

'Good, good. Now about your trial...' He paused and I hung on through the longest second of my life. 'It's scheduled for 15 May. That's in ten days' time.'

I just couldn't believe it.

'How sure are you?'

'Very sure. I've been bribing the court officials for some time now and they've...'

'You've been bribing them?'

He smiled again. Suddenly he stopped being a suit and became a human being who was helping me find a way out.

'It's not uncommon. Only a box of chocolates here and there and the occasional shirt, but without them your papers would still be languishing at the bottom of the pile.'

Typically, I let the moment pass without thanking him. We talked about court procedure until the cage lock rattled and the guard ordered me out. 'How long do you think I'll get?' I asked. Bradley stood aside to let me go through the chicken-wire door.

'That I can't say. But I wish you the best of luck.'

I forced myself to look into his eyes as I reached for his hand and managed to say, 'Thanks,' hoping he'd know how grateful I was for what he'd done.

It took a couple of seconds for the coiled orange filament inside the bulb to fade the cell into blackness. I'd been waiting for this moment to savour the date of my trial in silence. It was a huge breakthrough, but it also meant that jumping bail and slipping over the border was no longer an option. I would have to take whatever sentence they gave me. My only consolation was that I'd finish my time at the penitentiary. I might even land up on the foreigners' gallery with Mike and Patrick. That would be great, but I'd almost certainly lose my book. It would never survive leaving Modelo and going in and out of the penitentiary. In a few weeks I was going to be twenty-three years old, and I hadn't achieved a thing. The book was the only thing I'd ever done that was worthwhile. For the first time in my life, I'd tried hard to do my best.

If I lost my drawings, then all I'd been through would count for nothing.

For some reason I'd decided to clean the tea pan before the morning inspection. I hadn't trimmed the wicks for a while and flakes of jet-black carbon fell all over the wet floor just as the guard began to strut along the opposite walkway. We stood to attention until he'd marched down to the far end of the gallery, then I dropped down and frantically tried to wipe up the mess. For some reason the black streaks got worse and worse. I realised with horror that the carbon was on my shoes. I'd been spreading it all over the soapy floor as I moved backwards. Larry knelt down to help as the guard's jackboots approached. In a state of panic, I slipped over backwards and my heels shot up into the air. Larry cracked up and I started laughing too. We scrubbed around in helpless giggles as the footsteps got closer. At the last second we scrambled up to attention, holding the rags behind our backs and our faces as straight as we could. The guard stopped to inspect us. We fixed our glassy stares at the far wall, knowing that just a glimpse of his pompous face would make us explode with laughter. The trustee shouted out the numbers, then as soon the two of them marched off we curled up on the wet floor, howling in silent hysterics.

I was still smiling inside when I arrived in the workshop. Paco raised a quizzical eyebrow as I pulled my book out of my jacket and hid it under my drawing board.

'You are moving into the talleres?'

'I wish I could. There are too many searches in the gallery.' 'So how will you draw?

Louis bellowed across the glue tables and I reached for my pen.

'I don't have time to draw my own stuff. There's too much to do here.' Perseus hovered above Medusa on the smooth leather in front of me. The drawing was almost finished and I was already planning the next. I rattled my Rapidograph to get it going.

'You will have to make art like Yoko Ono,' said Paco, circling his unlit cigarette in the air. 'In your head.'

'I don't want to be a performance artist. Anybody can do that.'

'Yes, but then you don't need art school. You could be an artist this minute!'

Performance art really pissed me off. The first time I'd

seen it was when I was walking past Leeds Art College in my donkey jacket and muddy boots. I was only a few yards from where I wanted to be, but it seemed a million miles away. Suddenly a student jumped out of the shrubbery dressed in a baggy Superman costume. He held up a limp hand to stop me and said, 'Fear not, citizen, for I, Superman, will protect you.'

He stood for all the fun I wasn't having and all the things I'd never get to do.

I yelled, 'Fuck off !' and stomped past him. The only thing I needed to be protected from was idiots like him who got into art school with certificates instead of talent.

Daisy and I took our art to the street once. We'd decided to hold a protest exhibition outside Leeds Art Gallery because it was stuffed full of boring old Henry Moore sculptures, while exciting young artists like us couldn't get a look in. Daisy and I pushed our pictures down Woodhouse Lane in a pram and lined them up outside the gallery entrance. Then we phoned the *Yorkshire Evening Post* pretending to be passers-by, and told them to come and look at the fresh new talent. Nobody came, so when a bloke from the gallery told us to clear off, we did.

I leaned back from the sheet of leather to let the ink dry. The great thing about drawing was that time passed without you realising it. I spotted a great place to hide a peace sign in the rocks and got back to work. By the time I'd finished the picture, the whole day had gone by.

Larry swung straight out of his bunk when I got back to the cell that evening. He held up his hand and said, 'Bad news, man...' Terrifying possibilities ran through my head until he added, 'Don Juan got your guitar.'

He had no idea how relieved I was. I frowned across the gallery.

'I bet somebody over there squealed on us.'

Larry picked up his book and grinned. 'Yeah – but it was worth it.'

I had to smile, but it still made me angry. Zorro ripped off everything I made. What harm could a guitar do? I guessed that the only reason I wasn't in the *Quinta* was because the guitar had been in Larry's bag and he hadn't let on that it was mine.

I thought back to when Zorro took the stove. Larry hadn't let on that that was mine either. I looked at him as his eyes scanned the pages of Durrell's *Clea*. Larry was a reading machine. He'd been so thrilled when I'd shown him that I'd written out his poem, he couldn't stop thanking me.

'Hey Larry,' I said. 'I saw my consul yesterday. My trial's ten days away.'

'You're kidding?'

'He bribed the court!'

It was funny. Larry looked happier than I was.

The next morning, as we queued for the talleres, I detected the exotic scent of the Spanish summer in the air. It made me think about Mike. Maybe he was out in the penitentiary gardens. I wished he was still around so I could tell him about my trial date.

The fragrance was soon blown away by the stinking glue pots of the workshop. Paco was already drawing when I edged into the studio. He looked up in irritation when I said, *'Buenos días. Cómo estás*?'

'Déjame en paz – the artist is at work!'

I looked at his scruffy drawing, but I didn't leave him in peace. 'I got my trial date – it's in ten days.'

Paco frowned at his drawing board. 'Seguro?'

I ploughed on. 'I'm pretty sure. I don't think he'd have been that specific unless he really did have a date.'

I glanced at Paco's intense expression as I sat down. I was expecting a sarcastic remark, but he said, 'First Patrick, then Mike and now you – soon all the artists will be gone.' He sounded angry, but I didn't mind. As much as Paco annoyed me, it felt good to be included among his friends. I was about to start work when Paco tilted his drawing board towards me. There was so much rubbing out and reworking that it was hard to make out the shape of a bag.

'How does it look?'

'Not bad. But I think you could simplify it a little.'

Paco slid his board across the desk.

'Show me.'

It was clear where he was going with the design. He just hadn't got there yet. I evened out the proportions on one side and rubbed out what he'd drawn on the other. Then I folded the paper in half and traced through the back to make it symmetrical.

Paco pulled the board back looking pleased. 'Now to add a touch of genius!'

I smiled at Paco's black poncho hunched over the paper, his dark eyes following the stubby pencil intently as he drew an elaborate clasp. I'd tried to draw Paco once but he wouldn't stay still. In the end I drew over his portrait with a felt tip pen. It was a shame I couldn't catch his enigmatic character, he was really a great looking guy.

Manuel sang over the murmur of the workers. His husky voice floated through the warm air, heavy with the solvent-based glue. I got back to my latest drawing of Odysseus blinding the Cyclops. The first thing I did was hide a yinyang symbol in the eddies of water that swirled around a jagged rock. I'd stopped worrying about the hidden signs. Even if Señor Vendrell saw them, he probably wouldn't know what they were. The turbulent water reminded me of what Mike had said about flowing – that Franco was a boulder in the stream of his life and he had to learn how to flow around him. That's what I had to do. Whatever sentence I was given, I had to flow around it.

Manuel stopped singing, so I sang the song that had been going through my mind for weeks as I drew the Buddhist sign in the water. It was a Byrds track, but I knew Dylan had something to do with it.

All he wanted Was to be free And that's the way It turned out to be Flow, river, flow...

A slow weekend dragged by and Monday found me working away at my tenth drawing on leather. It was Jason again, but this time he was in a clearing, wielding his sword between his lover and the Hydra. The glade shone with the glow of the fleece, while the forest grew darker as it reached the edges of the leather. I knew that the aging process would add to the effect, but I thought it needed something else.

'I'm thinking of putting in a few Argonauts, creeping through the trees.' I said.

Paco stopped stitching his cardboard bag. He studied the drawing and then said emphatically, 'No. Do not make another line. You will spoil it.'

He was right. It was finished. That meant I had the whole day to add my secret signs before it was taken away. I relaxed in my chair. There was less than a week to go until my trial. The thought gave a tingling feeling of freedom that threatened to run away with my mind. I wondered what Mike would have said about it. He'd probably quote Watts at me: 'If you try to float, you'll sink.' That was true – as soon as you thought you had something, you lost it.

I took my book back to the cell for siesta. While the others slept, I made a few rough sketches of small figures, enjoying the athletic flow of their movement. Then I started on a nude figure of a dancer. He floated across two pages in my book, half-asleep, deep in a dream of freedom.

Without a model, the musculature was all wrong – like those weird drawings William Blake used to do. The dancer looked a lot like Daisy and I wondered whether he'd managed to become a real artist in London. The thing with Daisy was that he pushed life to the limit. That was why his paintings were so strong. Nobody else wanted to go where he went.

I looked at the dancer's sleepy face and remembered waking up Daisy one morning after a heavy night out.

He screwed his eyes up when I said, 'Man, you were crazy last night!'

Daisy held his head in his hands and groaned, 'I don't want to know.'

That didn't stop me. I told him about how he'd jumped over the university wall after we'd left the pub and run through the campus waving his cane around like a madman.

Daisy moaned again, but I carried on. 'You stopped in the alley under the engineering building – the one with that long line of overhead lights...'

Daisy opened his eyes at that. 'What did I do?'

I laughed.

'You took a running jump and smashed one of the lights with your cane. There was a big blue flash and a shower of glass. Man, it was a-*mazing*!' Daisy looked so dumbstruck, it had me laughing again.

'Then you ran down the alley, smashing every single bulb, one after the...'

Daisy covered his ears and yelled, 'Stop it! Stop it! I don't want to know.'

I closed the book. Daisy didn't know when to stop. It was the reason he'd taken all the acid in Paris. It wasn't my fault, I said to myself. I was hoping that that would draw a line under it. But it didn't. I still felt guilty.

Even with the date fixed, I didn't really believe my trial was going to happen. But a few days later I was standing by the cell door in a dark blue cotton jacket with white trim round its wide lapels. Boris had borrowed it from one of his suppliers. He said I couldn't go to trial looking like a scruffy hippy. At one time the jacket must have been trendy, but after years in Modelo it looked like a reject from an Edwardian pantomime. On top of that I'd got a crappy crewcut that had cost me five packs of Celtas. I was so nervous that I wouldn't have minded if they'd pulled the old *mañana* trick and called the whole thing off.

* * *

Amazingly, they didn't. Larry patted me on the shoulder and disembodied voices floated from the cell wishing me good luck as I was marched down the gallery. Gates, guards and thick metal doors passed in a blur until I was stuffed into a dark van lined with handcuffed prisoners. I gazed through the grill at the front as free people crossed the road calmly around us, completely unaware of the dreaded vehicle we were in. My anxiety grew to such a pitch that I was grateful that the swerving van hid my quaking legs and rattling teeth as we sped towards the Palace of Justice.

I was shocked by the grandeur of the courtroom. It wasn't

the tenths during is finished and as many days to go to the trial all is quiet, and as yet there is no spaniard in the works get a tringling feeling of freedon when I think of the trial which I suppress; its far too nice to run away with. It love to write more a page or two at loast but lin worried that with too many words They night not let me take the book out. Pictures. Sculptures.

just the ornate woodwork and gold-leafed crests. The sight of three judges hammered home the seriousness of my crime. A wave of horror came over me.

The prosecutor was harsh. I didn't understand his words, but he seemed to be angry with me personally. The judges stared impassively as he ranted. One of them even looked sleepy, but the heavy-faced one in the middle sat on his elaborately carved throne looking grave and attentive under an ancient, curly wig.

I couldn't bear to look at the long line of police witnesses. Terrified in case the one I'd kicked still had a bandaged head or a dopey expression.

Señor Juchau got up to speak for me. He looked smart and charming with his neatly trimmed moustache and slicked-back hair. His hands made flourishing gestures like a melodramatic actor. Watching the way his fingers plucked imaginary thoughts from the air made it seem like he was making precise and subtle arguments. All I could do was try to look like a nice guy who was sorry for what he'd done. It wasn't that hard because I really was sorry. I was sorry for everything I'd done.

Larry and Robert pressed me for details of the trial when I got back. The thing was, I had no idea how it had gone. I'd had a brief chat afterwards with Mr Bradley, who told me that the prison officials would let me know the verdict in due course. The only other thing he'd told me before they bundled me back into the van was how my lawyer had summed up my defence: 'This boy is no hippy, no freak – pardon the expression. He *loves* his mother!'

I got out my book to draw Señor Juchau and thought, 'I'm not even sure about that any more.'

26

REVERSE GEAR

When the night has come, and the way is dark, And that moon is the only light you see. Ben E. King

I'd been perching on edge of the seatless bog at mail call every day for a week to make sure I caught each word the town crier yelled. Nobody knew how long it took before your papers came through – because they'd never seen it happen.

A red blur bounced into the cell. I grabbed hold of my book before Crazy Bob knocked it off my knees. He hopped around behind my back, looking at the picture I was drawing of Boris. Bob giggled when I drew a pair of horns on the old devil's forehead, then clicked and popped as he begged me to do his portrait.

I only agreed to quieten him down so that I wouldn't miss hearing my name. Surprisingly, Bob stood still. He looked like a naughty schoolboy with his hands behind his back and his red shirt hanging out. For once, Crazy Bob seemed innocent and sweet, and I concentrated on getting the best likeness I could.

Then I got a surprise. There was a short pause as the echo of '*Correo*!' died down, and then the crier yelled out the Spanish version of my name. But it wasn't for mail. I was being called to the office.

I asked Larry to interpret for me and we clattered down the steps with my heart pumping. Zorro was sitting at the desk, looking like a Gestapo officer.

He read from an official document at the top of his voice while Larry translated in a whisper. 'They're asking for a fine of ten thousand for theft and two years' imprisonment.'

I almost grabbed the desk.

'What? No!'

'No... hang on. He's saying that's what they *wanted*. This is what you've actually *got*.

I held my breath as Zorro spoke, then paused for Larry to translate.

'Basically, you've got sixteen days' imprisonment for theft... and five more days for injury to the policeman...'

Larry concentrated as Zorro continued to read.

'Then you've got six months and a day for assault...' My heart jumped, but I held on as Larry spelt it out. 'There's also trial expenses to pay and compensation of five thousand for the policeman you assaulted. He says you can either pay these or spend two more weeks in prison.'

The office went quiet as Zorro stared at me. I asked Larry if that was it.

'Yeah, that's about it.'

'Tell him I'll do the two weeks.'

Zorro signed the paperwork with an extravagant flourish then thrust a copy of the notification towards me. I wanted to look him in the eyes, but I didn't dare while he still had power over me. I took the papers and murmured, '*Gracias*,' as he dismissed us with an aggressive shout.

I walked slowly up the first flight of stairs so as not to give Zorro any reason to haul me back, but I was almost flying by the time we got to the top. I'd been doing rough calculations in my head and I reckoned my sentence must be around seven months altogether. I'd already done more than six.

Robert looked up as we burst into the cell.

'Qué pasó?'

'Libertad!'

Robert jumped to his feet, his face was beaming. '*Incroyable*! When do you leave?'

'A couple of weeks, I think.'

Larry smiled as he shook my hand.

'You've done it, man. You might even make it home for your birthday.'

'Thanks, Larry. Thanks for everything.' I looked at the copy of the judgement clasped in my hand. 'I heard it all, but I still don't believe it...'

Larry and I scanned the document. It was hard to read because the purple ink had bled into the paper like the cheap photocopies we used to get at school. Larry found it.

'There you go, seis meses y un día – six months and a day.'

That's when it hit me. It felt like the undertow of a massive wave of tiredness was pulling me down. I realised that I'd held myself together waiting for this moment and now that it had come I was completely drained. I climbed up to my bunk as the drunken bugler wailed out the call for the locking of the doors. The metal bars of the bunk felt reassuringly cool on the back of my neck as I unscrewed the nib of my pen. I opened my book and gripped Mike's lucky wooden barrel to record the moment. It felt so heavy that I couldn't bring myself to write.

The thought that I would actually be free wasn't sinking in – and I didn't dare let it. I knew I wouldn't believe it until I was standing on the other side of the Modelo gates. Or more accurately, when I was standing on the other side of the Spanish border.

Boris slipped into the cell as doors began to slam in the distance. I was so tired, I could hardly raise myself to speak.

'Hey, Boris, I got my verdict,' I called. 'They're gonna let me out in a coupla weeks.'

I watched him slowly lay out his tools on Larry's bunk.

'What will you do when you leave?'

It was typical Boris. He hadn't even looked at me. I told him I'd probably get drunk.

'Yes, yes. But what will you do?'

'I don't know. I've got debts to pay, so I might start making bags... and belts.'

Boris put his table on his knees and peered through his eyepiece at yet another broken watch. His voice sounded as cold and mechanical as the timepiece he was working on.

'Well, good luck to you.'

I sank back onto my bunk. He was only pissed off because I was going and he was still waiting for a trial. The last of the cell doors slammed and the familiar monastic silence settled on Modelo. I folded my arm over my eyes, enjoying the absence of sound until Robert's husky rasp floated up from below.

'William?'

'Yes?'

'You are lucky to be going home.'

'I know.'

'Because Picasso can never go home.' 'I know. You told me. Not until Franco dies.' 'No, he can never go home because Picasso *est mort*.' 'No!'

It felt like a friend had died. I reached for Mike's Picasso book and opened it on a photograph of Pablo looking young and strong-willed. There was just enough energy left in my body to copy it into my book before a deep sleep claimed me.

The next morning, Manuel was standing up at his worktable as I came in to the *talleres*. I squeezed towards him through the noisy workshop and he gave me a big grin when I greeted him in my best Spanish.

'Buenos días, Manuel. Qué pasa?'

Manuel waved his arms at piles of cardboard shapes waiting to be cut. He shook his head in mock despair, then grinned. '*Pasa mucho*. *Que pasa contigo*?'

I grinned back. 'Libertad!'

'No! Cuándo?'

I shrugged. 'Dos semanas. Posiblemente más.' I saw Louis marauding his way towards us and moved off. Manuel called after me in slow Spanish, so I could understand him. He told me to drink a beer for him in the street. I called back, equally slowly.

'Con gusto, muchacho. Con mucho gusto!'

Paco beamed as I approached our little studio. That was a first. I tried not to smile. 'What are you grinning about?' I said.

He stood up with his black poncho spread wide and for an awful moment I thought he was going to hug me. He probably saw my look of horror and at the last moment he gripped my arm as he shook my hand.

'I heard the news. I am so happy for you.'

'Thanks, Paco. I can hardly believe it's true.'

He sat down and offered me a Ducados from a silver-andblue soft-pack.

'Now what will you do?'

I lit up before I answered.

'The first thing I'm going to do is give up smoking.'

Paco frowned. 'Why not give up now?'

'I'm not ready for it yet.'

Paco took a long, suspicious drag on his silver-tipped cigarette, his eyes fixed on mine.

'Are you ready to be an artist yet?'

I looked at the half-finished picture on my desk. The figure drawing didn't look that great. Most of the muscles were made up from memory, and I hated that.

'First, I'll have to earn some money to pay back the lawyer's fee and everything else.'

I reached for my pen as Louis lurched towards us, but instead of his usual growl, he gave me one of his Addams Family grins.

'So, you 'ave decided to leave us?'

I wiped my pen on my jeans. 'I'd love to stay, but you know how it is...'

Louis looked over my shoulder as I started drawing.

'Señor Vendrell will be very disappointed. He like your pictures very much'

'It was lucky I had my pen with me,' I said.

Louis nodded, then his heavy face dropped like a stone. 'You will finish zis one in time – yes?'

Paco rolled his eyes and I tried not to smile.

'Yeah.' I could see they weren't going to let me go without a fight. It looked like Louis was about to leave, but he turned back to me.

'You remember ze bag you made for under ze harm?'

'The moon bag – yeah.'

It sell very well.' He shrugged his shoulders. 'We have to make *mucho más..*'

Something caught Louis's eye in the workshop and he strode away. Paco watched him go then raised an eyebrow.

'You have success and freedom. Now you are happy - yes?'

I gave him the thumbs up as Louis leant over the crowded tables to bawl out some poor worker. Paco was right as usual. I was more than happy to be leaving, but I still hadn't worked out why I'd been stupid enough to get myself locked up in the first place. I'd been through everything, but in the end it all just seemed one big jumble of events and excuses that didn't add up to anything.

My eyes lost focus as I stared at my old handbag patterns hanging on the grey walls. Besides learning how to make bags, all I'd learnt in prison was how to ask for a piece of wood in Spanish. What else? Oh yeah, the Israeli national anthem and how to make mayonnaise. A fat lot of good that lot was going to do me.

I tried to think of something else. I'd also learnt how to cheat at arm wrestling, raise one eyebrow and I could light and close a Zippo with three snaps of my fingers.

But I still had no idea why I was *really* there – or when exactly they were going to release me.

I found out that evening. The town crier called me to the *oficina*, where I was told that in two weeks and one day I was to be ready to leave Modelo. I grinned like a schoolboy as Larry raced me back up the metal stairway. We stopped at the top to get our breath back.

'Good news, man!' Larry said. 'You *are* gonna be out for your birthday.'

Two weeks later I took up my place by the paint-chipped doorframe. I'd stood there so many times for inspection or the food bucket or mail call that it was hard to believe what I was waiting for now. I stepped out of the cell door and leant over the railings. It didn't matter how often I'd looked down, the drop to the gallery floor still gave me vertigo. But it wasn't just the height – a different kind of fear was eating me. I'd wrapped my book in my filthy jeans and stuffed them at the bottom of my case with the rest of my tattered clothes in the hope that it would look like dirty laundry. I'd put myself through months of hell worrying about getting out of Modelo; now that I was finally leaving, I was just as worried that they'd rip off my book. If that happened, everything I'd worked for would be lost forever.

We all stood in silence while the long and tedious mail call echoed around the gallery. There were so many false alarms in the prison, nobody ever said goodbye until they heard the words '*con todo*' after their name. My body stiffened as the crier concluded the list of names with a hoarse shout of '*Correo*!' I held my breath and waited, but the long silence continued right up to the bugle.

I dumped my bedroll back on the bunk. Even though I'd

been half-expecting it, it was a massive let-down. I unrolled my mattress, trying to put aside the thought that something dreadful had happened to the policeman I kicked. Larry patted me on the shoulder with a sympathetic sigh, but Robert exploded. 'Stupid Spaniards! Zey do zis wiz Mike! For years zey don't want to let him out!' The rest of his tirade was in French, but we knew who it was aimed at.

I curled up on my bunk and turned to the wall. Robert was only being protective, but I really liked the Spanish people and it was a big regret that I wouldn't be able to come back and visit Spain again. Still, at that moment all I wanted to do was get far away from Franco's mad, medieval country as soon as I possibly could.

The light had gone out some time ago and the deep-walled silence of Modelo encased me like a tomb. The days had been slipping by and I'd heard nothing. Nobody had told me what was going on. Sleep was like a faraway land that I had no hope of reaching. A stray phrase that had been circling my brain ever since I'd received my sentence kept nagging me: 'What more to know before I go?'

I was still awake when the ice-blue moonlight cut through the window arch, projecting the sharp shadows of the bars onto the wall. Even the prospect of freedom didn't stop them sending a chill of fear shooting through my heart. All the memories I'd dragged up during my time inside began to confront me, like the cold strips of moonlight that marched slowly across the cell.

Before prison, I'd believed that my childhood had been full of fun, adventure and happiness. That was still true, but when I looked deeper I saw that we'd been abandoned by an alcoholic father and neglected by a mother who'd been too depressed by her own rejection to care for us. For the first time in my life I began to feel the hurt that I'd suppressed for years. I turned my back on the bars. I wanted to break my rule and cry, but the ache of sorrow stuck in my throat.

For hour after hour I rolled on the bunk in anguish. Yet through it all, there was another me, watching in calm detachment, saying, 'It's okay – you're still you, and you're going to be fine.' But I wasn't fine. I clawed the mattress in desperation, wishing I could beat the memories out of my skull with my fists. They rose from the depths of my mind like bubbles from a stagnant pool, each one filled with the pain that had put them there.

It was only when I pictured my mother's face in the circular hospital window that the connection struck me. Her strange, silent expression was like the one I'd seen on Hanna's face through the plastic circle when she'd visited me.

The prison was just like the hospital! Both were institutions from which I couldn't escape. I was recovering from polio in one, and from a beating in the other. Both of which had temporarily paralysed me. Floodgates opened. The children's home was another institution I'd been locked in – and I'd been hit on my face when I was taken into the home, just like my face was hit when I was taken to jail.

I was hit on the farm, hit in Ward X and hit at every school I'd been to. The buildings I'd been trapped in lined a street that stretched back into my past: the isolated farmhouse, the isolation ward, the halfway house, the schools, the children's home, the slum house and the foster homes. Then the sewers, the zoo and finally, the prison. The same pain-filled situation was repeating over and over again.

I dragged myself up onto one elbow. Maybe that was what

I had to know – that it was only when you realised what was happening to you that you could stop it?

I lay back. It was uncanny that Hanna's anxious face in the plastic circle was so like my mother's face in the round window – and that learning to play basketball was like learning how to walk again. An awful thought occurred to me: if the prison was the hospital, then my book was my bear. One was stitched with cotton, the other with leather, and both were full of everything I cared for. That meant that trying to take my book out of prison was like trying to take my bear out of the hospital – impossible.

All the forgotten feelings of loss and helplessness returned. I twisted and turned as the moon projected the prison bars across my body. But at the same time, the other part of me smiled down at my situation from a languid place that was detached and different from the one I was in. It was as though this person was the person I *could* have been, if everything had worked out with my life.

I didn't know it at the time, but that night set me on a journey to get back to that state and become the person I should have been, instead of the idiot I'd become.

The next day I sat on the end of Robert's bunk to draw. The few sketches I'd made since getting the verdict were as incomplete and directionless as I was. I looked at the unfinished drawing I was working on. The broken face of a clock in front of a waterfall was meant to symbolise the end of my time in prison, but more than a week had gone by since my aborted release and I hadn't heard a thing.

I left my book open to dry and pulled my case from under Robert's bunk. There was an unspoken rule in Modelo that you left behind anything you didn't need on the outside. Having Mike's books in my hands made me want to keep them, but I knew I could easily get copies outside.

'Hey Larry,' I called. 'These were Mike's – would you like them?'

Before he could answer, an official marched into the cell. I stood up as he shouted, '*Cuál es su nombre*?'

I pronounced my name Spanish-style so there would be no confusion:

'Weeyaam Estuart McLeyaan.'

The guard announced that I would be released in seven days from this exact moment and I must be prepared *with everything* I owned, including all prison property. The magic words made me shake. *Con todo*. With everything.

Larry shot me a wide smile when the guard marched off. 'They've got to mean it this time, man.' I grinned back and sat down on Robert's bunk with Mike's books in my hand. *The Wisdom of Insecurity* and *The Way of Zen*. Mike had been right about the old reversed effort. I'd found my future by looking into my past. I'd realised it last night, but I didn't dare believe it until I'd got my release date.

Larry gave me a nod of thanks as I passed him Mike's paperbacks. I nodded back, knowing he would treasure them. I picked up my book and took out my pen. Everything felt as though it was falling into place as I held Mike's olivewood barrel and began to write:

> So there it is, the first adventure comes to an end. I go free in seven days. Almost as I drew the broken clock, the magic sign, they told me time was ended and now the river flows. I walk the road by the water.

27

CON TODO

Freedom's just another word for nothin' left to lose Nothin' ain't worth nothin' but it's free. Janis Joplin

Robert the French caught me sitting on his bunk when he returned to the cell with Bach. He gave me his usual glare, but Bach smiled warmly as he shook my hand. My book was on my knees so I offered to draw his portrait. Bach faced me on Larry's bunk and I sized him up. He had a great face to draw, full of character and determination. I'd intended to get my revenge for the freaky cartoon he'd done of me, but once I started drawing, I tried to capture him exactly as he was.

Bach studied the finished portrait, then asked to borrow my pen. I thought he was going to correct it, but instead he drew a speech bubble coming out of his mouth and wrote a message in Catalan inside it. He handed back my book and said in Spanish, 'Please show to my wife in Londres. I have her address...' He praised my drawing as he passed over a scrap of paper. *Gracias. El dibujo es muy bueno.*'

Boris leant down from his toadstool mattress to take a look. 'Yes, yes! It looks just like him. You should be a street artist, William. It would be much better than making bags.'

I imagined myself struggling for a likeness with a crowd of tourists looking over my shoulders and said, 'I don't think I'd have the confidence.'

'Then why do you want to be an artist?' said Boris.

He sounded waspy, but it was a good point.

I shrugged. 'It's all I can do.'

'Then do it.'

Bach must have understood Boris, because he nodded. Even Robert chipped in:

'Certainement. Why do something you don't want?'

'It's just that I don't feel ready.'

Boris's eyes blazed. 'Since you've been here, you've designed bags, you've made stoves, a guitar and you've drawn your book... *and* they're selling your pictures in America. If you can do all that in prison, just think what you can do when you're free!'

Everybody was looking at me and I couldn't help smiling. Boris was an annoying bastard, but he was annoyingly right.

When Bach left, I dipped a brush into my ink dispenser and painted an earthy, physical body contemplating the spirituality of the soul. It gave me a faint glimmer of what Mike and Alan Watts were trying to tell me, but I still had a long way to go.

I leant against my stripped-down bunk for the second time. My case was packed with my book on the bottom, hidden in my dirty washing. The drunken bugler blew for mail call. His pathetic wail was followed by the hoarse voice of the town crier echoing around the gallery. A whole week and my twenty-third birthday had gone by, but everybody said they'd *got* to let me go tonight.

Larry sat on his bunk with a book in his hand, but he wasn't reading it. Robert lay in his pit, silently cursing each Spanish name as it was called out. Even Boris seemed to be listening out from his lofty toadstool as he patched his tattered shirt.

I felt sick with worry. It wasn't just about getting out. I couldn't lose the feeling that my book was going to be burnt like my bear. I thought back to how I felt leaving the hospital. I was so happy to be going home. I ran up and down the ward, saying goodbye to everybody. I'd be like that now, only it seemed like I was still stuck in the same cycle of pain, with any chance of happiness swiftly followed by loss.

The mail call ended and I drifted quietly towards the doorway. I'd tried to prepare myself for nothing to happen, but the town crier started to rattle off another string of names and my heart began to beat faster. I hung on the doorframe until the Spanish list ended. Silence. Then after a pause that made the world stand still, I heard the words I'd been longing to hear:

'Weeyaam Aystewaarr MurcLeeeyaaannn... Con... TODO!'

There was a flurry of activity in the cell. Larry lifted the bedroll up onto my shoulder and Robert passed me my suitcase. I was thumped and patted with words of luck and friendship on the way to the door where Boris was standing, stiff as a board. He pulled the miniature pipe he'd made in the *Quinta* out of his waistcoat and shoved it into my Levi's jacket pocket with a fierce smile.

'Always remember, William – with freedom you can do *anything*!'

I smiled back at him, honoured that he'd given me his precious pipe. 'Thanks, Boris. I won't forget.'

He stepped aside and I began the long walk down the gangway with 'Bon chance, mon ami!' bouncing off the brickwork behind me. I zigzagged quickly down the iron steps with the huge bedroll pressed to my head and my suitcase banging against my legs, hoping they wouldn't send me back for being too late.

As soon as my feet hit the stone paving at the bottom, I was escorted across the hall towards the magical gate in the wall of bars that stood in front of the shiny corridor. I wanted to turn and take a last look at my friends, but the pull of the gate was too strong. I ducked down to squeeze the fat mattress under the bars, then followed the click-clack of the guard's boots towards the distant door to freedom.

We were almost at the end when we turned into a small dark room with a mahogany counter. My bedroll, spoon and dish were checked over by a solemn official who then asked me to open my case. I knew I should just act casual and look around the room, but my eyes were riveted on his coarse hands. They flipped through my few possessions, then shuffled through the dirty clothes until they stopped at my jeans. My heart sank as I watched his brown fingers unwrap them and then hold out the bag at arm's length. The official looked the patterned leather up and down like a judge. I hoped he wouldn't suss it was stolen from the *talleres* and held together by Modelo rivets.

I watched helplessly as he opened the flap and pulled out the book. There was no hint of expression on his face while he slowly flipped through eight months of my life in pictures.

I couldn't see what he was looking at, but I knew if he saw the pictures of the suicide I'd be sunk. He flipped another page and stared at it for a while. I had no idea what the picture was. I just hoped it wasn't one of the drawings of Zorro.

Suddenly he made up his mind. He slammed the book shut and pushed it roughly back into the leather bag. My whole existence seemed to narrow to this one moment as I watched the direction his hands would take.

When I saw them fold the bag back into my jeans and place it in my case, I almost reached out and embraced him. He turned the case towards me and I snapped the clasps shut. My heart leapt again as my wallet appeared from a drawer. I signed for my money and passport in a trance. Then across the counter came my ivory white guitar case with the brown plastic trim. It was as though he was giving me my life back, and I could barely stop myself from grabbing his hand and shaking it. The guard led me down a small corridor. He stopped by a reinforced door and selected a large key from his belt. He pulled the heavy door open and the twilight warmth of the Barcelona street blew softly into my face.

The next thing I knew, I was standing on the pavement alone. I'd never felt so naked in my life. Not just because the huge walls were behind instead of around me. It was also because I felt that anything could happen to me and I could end up back inside.

I followed Mr Bradley's directions to the hotel. Every car and every passer-by seemed as though they might be police who would stop, search and arrest me again.

It was only when I sprung open my case in the safety of the hotel room and saw the corner of my leather bag that I understood what had happened.

I'd got my book out. And I'd broken the cycle.

I walked around the musty room trying to fix myself in my new reality by examining the details on the furniture. Propped against the varnished bed head were two fat, embroidered pillows. Standing on a little white cloth on the bedside table was a carved wooden light with a parchment shade.

It was like I'd gone back to square one and could begin again – and get it right this time. I studied the ornate corners of an old brown wardrobe and thought: *This is what living in the present is all about. This is the moment and this is where I am and where I always want to be.*

I started my new life by stripping off all my clothes. There was a long mirror clipped to the door in the dim bathroom and I stared at my unfamiliar face with fascination. Then I looked down at my body, watching it twist and turn as though it belonged to somebody else. I couldn't stop the smile that kept spreading across my face – it kept coming back like a spring, along with overpowering waves of sheer relief.

I took a long, warm shower, trying to scrub away the layers of Modelo's ancient grime with lavender-scented soap. Then I dressed in the worn-out clothes I'd lived and slept in for so long. I knew I was going to do the one thing Mr Bradley expressly told me not to. I just couldn't help it. I had to go out.

The bright yellow lights of the bar looked inviting on the busy main road. I walked through the open entrance and caught the eye of the young, blond-haired barman.

'Una cerveza, por favor'.

He glanced suspiciously at my short-cropped hair. I could tell he knew exactly where I'd just come from. I watched him walk down the long bar to get my drink and my eyes flicked nervously towards the open door. Cars and people passed by in the dark street. It was just like the view I'd had when I'd tried to escape from the police station and the urge to run out while I still had the chance was almost too strong to resist.

I began to relax when the barman returned. He gave me a slight smile as he passed me a tall glass, full to the brim with a light golden liquid. When I felt its weight in my hand, I knew that this was the real moment of freedom. My lips touched the glass and I took a drink. The cold, sharp taste of *cerveza* in the warm, mellow night filled me with peace, as a circle of delicious emptiness expanded around me.

28

TRY AGAIN

I've seen lonely times when I could not find a friend, but I always thought that I'd see you again. James Taylor

I sat at the front seat on the top deck of the red London bus so that I could look out for the art college when we got to Hornsey. My Modelo bag with my book in it had been easy to carry up, but the rest of my artwork weighed a ton. It had taken me a year to do enough drawings to replace the stuff that had been lost when I left Hanna. I was nervous about the interview, but I only had one real worry. It was obvious from my book that I'd been in prison and I didn't want the authorities to know that.

Whenever I had a worry, I tried to imagine what Mike would say. The lazy rocking of the bus and the drone of the engine lulled me into a reverie as I thought of him. He'd come over to see me in London before flying back to the States. I hadn't been sure when he was going to turn up, but I'd instantly recognised his slight figure through the net curtains of the bedsit I shared with my girlfriend, Judy.

I rushed to the door in excitement. There was Mike 'El Motherfucker' Pearson, standing before me as a free man.

We couldn't stop grinning as I carried his bag into my room. He didn't look hunched any more. It was as though a weight had been lifted from him. His voice sounded lighter too.

'So how have you been since they threw you out of the calaboose?'

'A bit rough for a while – but I've been working and drawing and I'm feeling a lot better now. How about you?'

Mike still looked happy, but there was a lot behind his smile.

'To be completely honest, I don't know. The thrill of getting out is still there, but I get the feeling that something heavy is gonna creep up and hit me one of these days.'

We both laughed at that. We didn't really care. This was the moment we'd been waiting ages for and nothing on earth could spoil it.

I smiled out of the bus window, picturing Mike's happy face as he asked me to play my guitar in my one-room flat. I played 'Nashville Skyline Rag' with a plectrum, having just learnt it note for note from the album.

Mike whooped when I finished, as if he was at a rock concert.

'I could tell by the way you played the old cigar box that you knew your stuff, but that was something else!'

Mike's praise made me remember how he'd always kept my spirits up in the prison.

The walk to the pub was as easy as walking across the prison yard, especially as we knew that the long-awaited drink we'd always promised ourselves was at the end of it. We lifted our glasses of beer, and I held Mike's gaze as he said, 'To freedom.'

My shaky voice echoed his toast and we drank together as free men. Normally I could never think of the right thing to say, but I'd been thinking of this moment ever since I left Spain.

'You were right, you know,' I said.

Mike made a quizzical expression.

'The reversed effort. I finally got it, just before they let me go. My past was shaping my future. I only had to realise it.'

Mike raised his glass again, a big smile on his clean-shaven face. 'To the future.'

A sudden movement of the bus startled me and I grabbed the handle of my portfolio. We stopped outside a building with a giant metal cockerel over the gates. I heaved my gear downstairs and jumped off. The cockerel building turned out to be a school, so I continued walking.

At the end of the road I looked down the hill and saw a large Victorian building with studio windows. It had to be the art college. Gerry and his wife, Vo had fired my imagination for Hornsey when I used to babysit for them in Leeds. They'd told me there was a model there called Peanuts, who used to do amazing poses on one leg. He also kept getting erections, so there was a lot of rubbing out and re-drawing going on. Peanuts would be long gone by now, but the Hornsey reputation still excited me.

I stopped at the entrance to check the address my girlfriend had given me. Gerry had inspired me to apply, but without Judy firming up the details, it would have been hard to get it together. The heavy municipal stonework triggered my old feelings of rejection and inferiority. I shrugged them off. They hardly registered on the Modelo scale.

Inside, it was pretty much like Bradford Art School - lots

of tables in a big hall, with silent tutors flicking through the students' work. There was an empty table at the bottom of the steps, tucked away in a shady corner. I opened my folder on it. I knew I had to keep my expectations low. Even if they did accept me, they wouldn't let me know for ages, and then the council would probably keep me waiting for months before they told me I couldn't have a grant.

A tutor in baggy clothes passed by as I started laying out my stuff. He stopped and looked sideways at a pencil drawing for a few moments.

'That's nice. Did you draw it from life?'

'Yeah, I was just trying to get the proportions right, really.' He sifted through a few more sketches, then glanced at me. 'Do you like Ingres?'

'I'm not sure I've heard of him. How do you spell it?'

The tutor spelt out I-n-g-r-e-s and I realised who it was.

'Oh him... Yeah, he's got a great line. I love all the guys who can draw – Lautrec, Degas, Picasso, Michelangelo, Augustus John...' I ran out of artists, so I took my bag from my shoulder and began to open it. He examined the patterned leather, then held out his hand when my book appeared.

'May I?'

His fingers turned the pages as he absent-mindedly asked why I had applied to Hornsey. I told him that an artist called Gerry Keon had inspired me, in the hope that the tutor knew him, but he didn't seem to be listening. I dried up and just stood there, secretly looking at the pictures out of the corner of my eye. Each drawing seemed to tell a story that I wanted to hide. The drunken scooter ride, the police beating me up and the judges at my trial. It made it all too clear.

The tutor's hand slowly closed the cover and he looked directly into my eyes.

'Where did you do this?'

'I did it last year. Mainly in Barcelona.'

He raised his eyebrows, and held my gaze until I added: 'In prison.'

This wasn't going as I'd planned. He gave the book back to me.

'Barcelona prison – isn't that where they just used the garrotte?'

That shocked me. It gave me flashbacks of Zorro and the dungeons for the first time in ages.

'I knew they had a garrotte, but I didn't know they still used it.'

'Well, they do. They killed a young anarchist earlier this year. He was about your age.'

The tutor leaned away from me, indicating the door with his thumb. 'Would you mind holding on for a minute? I'm just going to get the principal.'

For a mad moment I felt like doing a runner. Mr Bradley had done me a big favour by not passing on my file to the UK police and now here I was, revealing all I'd done to the authorities like an idiot.

The tutor returned as I was nervously stuffing my artwork back into the portfolio. He was followed by a tall, boyish-looking man with white curly hair like Harpo Marx.

'This is Max Shephard. He'd like to take a look at your book.'

I watched their deadpan faces as they turned each page in silence. Occasionally they'd point something out. I didn't know what it was, but it was easy to see they knew what I'd done. Eventually the principal closed the book and looked at me with clear, serious eyes. I braced myself for the inevitable.

'I can tell you right now - you've got a place.'

That was a surprise. All the excuses I'd prepared suddenly

evaporated. I didn't want to spoil the moment, but I had to say what was on my mind.

'That's really great.... Thanks. But I probably won't be able to take it. I don't have any qualifications, so the council won't give me a grant.'

Max Shephard shook his head with a confident smile.

'That's not a problem. We have the authority to award you a grant for special talent.'

I really didn't expect that. All I could do was stand there with my mouth open. The principal leaned across the table and offered me his hand.

'Congratulations,' he said. 'Welcome to Hornsey Art School.'

29

BACK TO THE FUTURE

Thank you for the days Those endless days those sacred days you gave me Kinks

As far as I'm aware, this is what happened to the people and places I knew. They're roughly listed in order of appearance. If any reader knows any of my missing friends, please put them in touch with me.

'Daisy' Dave Stanhope disappeared. The last person to see him was my electrician brother, Jack. Twenty years ago he went to turn off the power in a derelict house and was surprised by a vagrant. He was even more surprised when he realised it was Daisy. Jack thought he must have been living there for some time because one of the rooms was full of empty tins of pet food. Daisy hasn't been heard of since. This is the chess picture he painted with house paints when he was 15. It impressed me then and it still does now. We never stopped being members of the Avant Gardeners movement.

Hanna found a fabulous husband, had a wonderful career in teaching, travelled the world and raised a fine family. We always try to meet up whenever I go back to Leeds.

Clive and I ran into each other in Shepherd's Bush shortly after I'd left Hornsey. He'd done well at university and was as bright and delightful as he'd always been. We wished each other luck, but didn't keep in contact.

I never saw Maurice, Sylvie, Bird or Monique again, though not for lack of trying. For me, Rue Vavin was like the magical chateau in Alain-Fournier's *Le Grand Meaulnes*. I'd love to meet up with them in Paris one day and walk and talk in those streets again.

Annie Roy and Brigitte Dupre slipped out of Rue Vavin and out of touch.

Michael Schneider has been impossible to track down. With luck, he'll read this and get in touch. I owe Canadian Mike too much to say here.

Mike 'El Motherfucker' Pearson kept in contact with me for a few years after leaving prison. Unfortunately, we both moved around so much that we lost touch. I'd rather find Mike than meet up with an alien, climb Everest, swim with dolphins or have my picture on the cover of *Rolling Stone*. Mike's last address was 937 Belmont, Long Beach, California, and his folks once lived at The Plum Tree, 1001 Whipple Street in Wickenburg, Arizona. Where are you, Mike?

Jean-Patrick Beau must have made a career as an artist, but I haven't traced him yet. I hope he managed to smuggle his sketchbooks out of Modelo. I'd give anything to see them, and him, again.

Paco (Francisco) Bonet hasn't turned up either. He last lived at Casanova 170, Barcelona 11. 'The Artists' have a lot of catching up to do.

I often wonder if Zorro published his prison novel. Maybe one of us inspired a character.

I hope Peter finds this book and me. He was a good friend when I really needed one.

Jaume Bach lives and works in Barcelona. We recently got in touch and I retraced my footsteps from London to Paris to meet him in Barcelona. He has had a successful career in graphic art and design and still draws a mean caricature – especially of dodgy politicians. His wonderful wife and gifted son looked after me throughout my stay. Jaume was a comforting presence when he took me to see Modelo. The next day, we drew each other again, 42 years on from the dark days of the prison. This time it was in his beautiful apartment in the bright heart of the city. I'm looking forward to us drawing each other again.

I learned from Mr Bradley that the officer I attacked made a full recovery. I hope he is still okay and has forgiven me. I hope that Mr Bradley has forgiven me too. I never really thanked him and Señor Juchau for all the good work they did for me.

My mother, Stella, died from cancer in 1987 at the age of 63. Her last request was to see my father. After 29 years of silence we thought that he was dead, but the Salvation Army managed to track him down. When Stella heard that Dad was still living with Ruby, the woman he left her for, she decided not to see him again. After one visit to Dad's home, his children didn't see him again either. It is my one big regret in life. Only Jack and I went to his funeral. Isobel and Jeremy had said goodbye to him long ago.

That's me on the left. Sadly, Isobel, Jack and Jeremy are all dead. Issy died from cancer aged 52. She had once attempted suicide and smoked incessantly. Jack suffered from depression and killed himself three years later at the age of 57. Ten months after Jack's funeral, Jeremy died in an operation that went wrong. He was 63 and had almost become a recluse. We had all fallen out when Mum passed away and I'd been hoping this book would bring us back together. I started writing it before Isobel died, stopped for a while after Jack's suicide and then finished it just after the inquest into Jeremy's death. I still hope it will bring us together.

Hornsey College of Art got swallowed up into Middlesex Polytechnic. The historic building with its purpose-built studios is now a school. I was lucky to catch the tail-end of this famous college and finally get to study figure drawing on a fine art degree course. I also discovered film and animation there. By the time I left Hornsey I'd made experimental music videos, underground comic strips and animated films.

The musician, Graham Parker, saw my final-year comic and commissioned me to illustrate a book he had written called *The Great Trouser Mystery*. Joe Jackson saw this and asked me to illustrate the cover of his album *Beat Crazy*. My illustration studio soon turned into an animation company and, five years after leaving Hornsey, I received a D&AD silver award at the Royal Albert Hall for my first commercial.

Tim Daly became a poet, a philosopher and a lyricist. We were reunited when I got into Hornsey and he introduced me to a young singer/songwriter called Dave Stewart. He and his girlfriend, Annie Lennox, asked me to make back-projection films for their band, The Tourists. I also filmed their early gigs on my Nizo Super 8 Camera. After forming Eurythmics, they asked me to make an animation/live-action video for 'Baby's Coming Back'.

I went on to direct music videos for many of my heroes: George Harrison, the Beach Boys, Johnny Rotten, the Traveling Wilburys with George, Bob Dylan and Roy Orbison. Dion with Lou Reed and Paul Simon, Bob Geldof, and more Eurythmics. I've finally made a video for myself, and I'm still hoping to do one for the Stones.

It's sad that I lost touch with my Modelo friends, but I still hope to find them. You never know. One day I was chatting with my long-time production designer, Dennis de Groot, about our respective art schools. He told me he'd studied fine art at Leeds and I asked him what kind of work he'd done. He said, 'Mainly conceptual stuff. I used to dress up as Superman. Then I'd jump out in front of people in the street and say, "Fear not, citizen, for I, Superman, will protect you."

If you wrote that in a book, no one would believe you.

One Modelo inmate I don't expect to see again is Manuel. But anything is possible. When I meet up with Bach again, he may tell me that he is now a famous Spanish singer. As Manuel once said to me, '*Siempre esperanza*'. He was right: you always have to hope. Hopefully Robert the French, Boris and Larry have found success in the world. I wish I could remember their surnames. Perhaps they'll get in touch with me one day. I have a lot to thank Boris for. The pipe he gave me has been a constant source of inspiration. I still have it and try to live by what he told me: With freedom you can do anything.

Modelo prison has just closed. As I write, the Department of Justice is curating an exhibition that is open to the public. I got a shiver of fear when Jaume Bach asked for my passport details to book us tickets. It will be an emotional experience.

Alan Watts is far from being lost. He's still being discovered by many, including Trey Parker and Matt Stone who have made excellent short films of his talks. My beautiful jeweled watch still works and remains a perfect metaphor of the oneness of everything.

My back recovered, although it still acts up when I play too much tennis. I'm still drawing from life as well as making sculptures, music and films. If you'd like to take a look, they're on www.willysmax.com. Please let me know what you think of them. And if you know any of the above felons, drop me a line.

Ch.1 - BROKEN

Hey, That's No Way to Say Goodbye Performed and written by Leonard Cohen.

Jumpin' Jack Flash Performed by The Rolling Stones; written by Jagger/Richards.

Ch. 2 - BAD TRIP

Sunshine Superman Performed and written by Donovan.

Ch. 3 - GOOD TRIP

Je t'aime moi non plus Performed by Jane Birkin and Serge Gainsbourg.

Ch. 4 - BARCELONA

Marrakesh Express Performed by Crosby Stills and Nash; written by Graham Nash.

Ch. 5 - PAIN IN SPAIN

I Fought The Law Performed by The Bobby Fuller Four; written by Sonny Curtis.

Ch. 6 - PIGSWILL

Fire and Rain Performed and written by James Taylor.

Ch. 7 - GUTEN MORGEN

The Auld Triangle Performed by The Dubliners; written by Brendan Behan.

Ch. 8 - INSIDE OUT

Moonshadow

Performed by Cat Stevens; written by Yusuf Islam.

Ch. 9 - OUTSIDE IN

Goin' Back Performed by Dusty Springfield; written by Gerry Goffin / Carole King.

Black Hills of Dakota Performed by Doris Day; written by Sammy Fain and Paul Francis Webster.

Ch. 10 - ONCE BITTEN

Spanish Is the Loving Tongue Performed by Bob Dylan; written by Charles Badger Clark Jr.

Streets Of Laredo (aka The Cowboy's Lament) Traditional

Ch. 11 - WORK SHY

Friday On My Mind Performed by The Easybeats; written by George Young/Harry Vanda.

Rainy Day Women #12 & 35

Performed and written by Bob Dylan.

Ch. 12 - JOINT EFFORT

And It Stoned Me Performed and written by Van Morrison.

Let It Bleed Performed by The Rolling Stones; written by Jagger/Richards.

Ch. 13 - WARD X

Like a Rolling Stone

Performed and written by Bob Dylan.

Mellow Yellow Performed and written by Donovan.

Ch. 14 - IN THE BAG

Gimme Shelter Performed by The Rolling Stones; written by Jagger/Richards.

Strolling Down the Highway Performed and written by Bert Jansch.

Ch. 15 - LAST NIGHT

Chirpy Chirpy Cheep Cheep Performed by Middle of the Road; written by Lally Stott.

Ch. 16 - HEAD CASE

19th Nervous Breakdown Performed by The Rolling Stones; written by Jagger/Richards.

The Water Song Performed by The Incredible String Band.

Come Together Performed by The Beatles; written by Lennon and McCartney.

Ch. 17 - WHAT'S IN A NAME?

Mailman Passed (And Didn't Leave No News) Performed by Snooks Eaglin.

Midnight Special Traditional; performed by Lead Belly.

Ch.18 - PIGS WILL FLY

We Gotta Get out of This Place Performed by The Animals; written by Barry Mann/Cynthia Weil.

Plaisir d'Amour

Performed by Joan Baez; written by Jean-Paul-Égide Martini.

Are You Lonesome Tonight? Performed by Elvis Presley; written by Roy Turk/Lou Handman.

Ch. 19 - MIDNIGHT SPECIAL

After The Goldrush

Performed and written by Neil Young.

Ch. 20 – UNDERGROUND

The Joker Performed by the Steve Miller Band; written by Steve Miller.

Ch. 21 – HASTA LA VISTA

Help! Performed by The Beatles; written by Lennon/McCartney.

(In the Summertime) You Don't want my Love Performed and written by Roger Miller.

Blowin' in the Wind Performed and written by Bob Dylan.

Chimes of Freedom Performed and written by Bob Dylan.

Mr. Tambourine Man Performed by The Byrds; written by Bob Dylan.

Mr. Tambourine Man Performed and written by Bob Dylan.

Ch. 22 - INK SPOTS

Don't Get Around Much Anymore Performed by The Ink Spots. Written by Duke Ellington/Bob Russell.

Ch. 23 – GIRL OF THE NORTH COUNTRY

Bird on the Wire Performed and written by Leonard Cohen.

Girl of the North Country Performed and written by Bob Dylan.

I Threw It All away Performed and written by Bob Dylan.

Ch. 24 - HARM WRESTLE

I Get The Blues When It Rains Performed by Big Bill Broonzy; written by Klauber/Stoddard.

Ch. 25 - DAISY CHAIN

Promised Land Performed and written by Chuck Berry.

Midnight Rambler Performed by The Rolling Stones; written by Jagger/Richards.

Ballad of Easy Rider Performed by The Byrds; written by Roger McGuinn.

Ch. 26 - REVERSE GEAR

Stand By Me Performed by Ben E. King; written by King/Leiber/Stoller.

Ch. 27 - CON TODO

Me and Bobby McGee Performed by Janice Joplin; written by Kris Kristofferson.

Ch. 28 - TRY AGAIN

You've Got a Friend Performed by James Taylor; written by Carole King.

Nashville Skyline Rag

Performed and written by Bob Dylan.

Ch. 29 – BACK TO THE FUTURE

Days

Performed by The Kinks; written by Ray Davies.

ACKNOWLEDGEMENTS

I'd like to thank...

Keren Luchtenstein, who supported me with tea, cakes, endless readings and an unerring ability to see to the heart of the matter.

Ed Fenton from the Writer's Workshop, who believed in my first rambling chapters, and whose editing and advice gave me a crash course in how to write.

Nick Cash, who was the first to read my early pages then stuck with me throughout. His sustained suggestions and help culminated in me finding a publisher.

David Reynolds for taking my manuscript to Old Street Publishing.

Ben Yarde-Buller, for wanting to publish the book. His total commitment to bringing the best out of it has made the whole process a delight.

Matthew Baylis, for his perceptive edit and encouraging review.

Vanessa Tyrell-Kenyon, whose excellent proofread brought everything into focus.

Kate Pool at the Society of Authors, whose advice meant that I didn't need an agent.

Lucia Solz Frasquet, for her corrections to my pathetic, phonetic Spanish.

Alex and Sonia Gerlis, who amazingly traced my old cellmate, Jaume Bach.

Richard, Warren, Tom and Ravinda at Kall Kwik Ealing for all your friendly help.

The good friends that read my efforts in various stages along the way. I'm eternally grateful for their invaluable encouragement, critiques and conversations: Allan Payne, Alex Gerlis, Alex Hughes, Anna Kew, Annie Lennox, Anusia Kotowicz, Chrissy McKean, Christine Simpson, David Kew, David Tonge, Hannah Parry-Jones, Ian Willox, Jack Britton, Janey Laddiman, Jeremy Myerson, Krystyna Maroudi, Linda Black, Marta Parry-Jones, Martin Arnold, Michael Forte, Nathan Myerson, Nick Carson, Peter Grelliac, Peter Till, Phillip Jackson, Rachel Goff, Rob Marshall, Roger and Hilary McGough, Ruth McCarthy, Saul Sorrell-Till, Simon Bere, Simon Stark, Sue Cash-Davidson, Susie Freeman, Suzie Zamit, Zillah Myers. **OPPOSITE:** The author with his journal at the *Modelo* prison, Barcelona, in 2017 – 45 years after he was released.

BELOW: The author in 1968, four years before his imprisonment.